RUBENS: A DOUBLE LIFE

RUBENS:
A DOUBLE LIFE

Marie-Anne Lescourret

ALLISON & BUSBY

This edition first published in Great Britain in 1993 by
Allison & Busby
an imprint of Wilson & Day Ltd
5 The Lodge
Richmond Way
London W12 8LW

Originally published in France under the title
Pierre Paul Rubens by Editions JC Lattès

Translated from the French by Elfreda Powell; abridged.

A catalogue record for this book is available from the British Library

ISBN 0 85031 858 0

Typeset by TW Typesetting, Plymouth, Devon
Printed and bound in Great Britain by
Mackays of Chatham Ltd, Lordswood, Chatham, Kent

For
Jacqueline and Pierre

ACKNOWLEDGMENTS

ALLISON & BUSBY gratefully
acknowledges the permission given by the
copyright holders to Editions JC Lattès for
extracts used in the book worldwide

CONTENTS

ILLUSTRATIONS

INTRODUCTION

'Revered but ignored'; 'More decorative than civilised'. Both these opinions voiced by two of Rubens's most ardent admirers, Eugene Fromentin and Paul Mantz, are justified. Peter Paul Rubens's work is as famous as it is misunderstood. There are few who have not heard of him, yet few have much real knowledge of his work. Most think of him as an artist who painted fat women, a man whom the Pre-Raphaelite Brotherhood condemned, '. . . the flesh Thou madest smooth/These caked and fretted . . .',[1] calling upon God not to think mistakenly that they might be following in the footsteps of painters like Rubens and Correggio.

Rubens is such a monument that everyone believes all that could be written has been written. This is not so. Indeed, his works have been catalogued, his correspondence has been published, but the man has not yet emerged. It has been said that his correspondence is not interesting, merely the letters of a businessman concerned with selling his pictures and protecting his copyright. It is true that he wrote hardly anything about his own emotions yet, by drawing on his letters to an extent that has not been done before, it becomes the richest source of insight into the man and the artist, for it reveals his resolute character, his active, mercantile, even calculating mind. It shows clearly that Rubens was intent on forging a life to suit himself, not only successful as a painter but as a man, from the moment he began his late and long apprenticeship until he died covered in honours.

This is a biography of the master painter, Peter Paul Rubens; an artist moulded by a difficult childhood, from a country riven by conflict and in cultural decline, born into a world that was undergoing huge changes brought about by great scientific, geographical and medical discoveries. On the brink of both the Renaissance and the Baroque periods, Rubens was definitely a man of the Baroque and perhaps a model for our own times in the way in which he was able to move through all the various European cultures, assimilating them without compromising or losing his own strong identity.

Rubens was a man of many images: a painter who aspired to nobility; a painter who was also a considerable diplomat; a devoted husband and

1

father who revealed nothing of his feelings. This ambivalence lies at the heart of his character, life and career. A biography does not pretend to explain the work of an artist, but in retracing the story of the life, its events, its aims and creative process, it shows what that work says about the artist himself. The aim of this biography is to do just that. The reader can then make up his own mind.

A DIVIDED CHILDHOOD
(1577-1600)

Jan Rubens and Maria Pypelinck

One of Rubens's rare self-portraits was painted shortly after he returned from Italy and married Isabella Brant. It reveals his new-found happiness. Under a bower of honeysuckle,[1] Rubens is depicted leaning down towards his young wife. His face has a gentle expression with lips half-parted. In his right hand he holds a knight's sword. Only the pommel is visible. But the detail is revealing about his aspirations. Was Rubens really entitled to this sword? Neither the King of England nor the King of Spain had ennobled him at that time. Elsewhere, he was barely known beyond Flanders. He was not then 'the prince of painters' - as he would come to be called; at best, he could be described as the painter of princes. As his appearance shows, at this period in his life he was a rich burgher. Some critics claim that Rubens was wearing a hat to conceal premature baldness. In this Antwerp painting, however, any lack of hair is compensated for by his magnificent doublet and hose. His clothes and those of his wife are embroidered with gold. He is wearing a wide lace collar, while Isabella's neck is encircled with a three-tiered ruff and each wrist bears a bracelet of precious stones. Here we are being shown a young couple in all their finery, and joyfully in love; and yet the pretensions to nobility in Peter Paul's dress clearly betray other ambitions.

Was this simple pretension a desire to leave a flattering image for posterity, or to make his ambitions clear and precise? The sword bears a message which is as much historical as personal: by wearing this sword Rubens is claiming along with others before him - Vasari and Pacheco, even the great Aristotle - the right for painting to be recognised as one of the liberal arts, the occupation of a free man, not of an artisan. In the seventeenth century this was not so; artists were under an obligation to those who paid them. Not Rubens. He indicates by wearing the sword that he would be on equal terms with those who commissioned his work. This sword prophesies his future achievements and makes them even more remarkable, for what was only appearance in 1608 became a reality.

Nothing in Peter Paul's background foretold the greatness to come. On

3

the contrary, Peter Paul's childhood was certainly not spent surrounded by luxury, for he was deprived even of the normal comforts one would expect to find in a respectable family.

The town records of Antwerp show that the Rubenses and Pypelincks both enjoyed a comfortable lifestyle: they owned property. However there was no nobility in the Rubenses' ancestry, and no interest in art either. They were tradesmen, and the only family member who showed any intellectual inclinations was the second husband of Rubens's paternal grandmother. Left widowed with a son, Jan Rubens's father, she remarried Jan de Lantmetere, a grocer, who was good to his wife's son. Breaking away from the commonly held traditions amongst tradesmen, he offered to pay for his stepson to study at Louvain. It was he who tore the Rubenses away from their market stalls and enabled them to pass from trade to the magistracy.

Jan Rubens was a good student. He decided to go into law, and, not satisfied with the teaching he received at Louvain, at that time one of the greatest universities in Europe, on 29 August 1550 he left Flanders for Italy. In Rome he enrolled at 'La Sapienza' University where in 1554 he gained a doctorate in both ecclesiastical and civil law. Having obtained his degree, he finally returned to Flanders in 1559.

On his return, his first objective was to find a decent Flemish wife, Maria Pypelinck. Held in high regard by his fellow citizens, both for his learning and his handsome, imposing presence, he was elected deputy magistrate to the burgomaster of Antwerp in 1562.

It was a good beginning. Living in the most important financial centre in Europe, Jan Rubens was prepared for the life of an enlightened burgess in a country at the peak of its industrial and financial development, a country which had also sheltered the most illustrious of the new thinkers from persecution.

In the middle of the sixteenth century, Antwerp was not only the business centre of Europe but also the city of printers. The city spread as many ideas as it did exotic commodities. Antwerp was the financial and commercial link between the bankers of High Germany and the Italians, Spanish and Portuguese, who traded in produce from the new territories. At the same time, through its printing trade, Antwerp also propagated the works of the Belgian Renaissance. A native of Touranges, Christopher Plantin, had founded the biggest printing works in Europe on the banks of the River Schelde. Using his six presses, in 1572 Plantin published the *Polyglot Bible*. This monument of Christianity offered the holy scriptures in five languages, with glossaries and grammars to back them up.

As an Antwerp magistrate, Jan Rubens occupied a choice position in a

city which was both financially and intellectually well endowed. Unfortunately the political situation and the role Rubens the magistrate chose to play in it, even his very personality, soon cast a shadow over these promising prospects.

When Jan Rubens returned to Antwerp, the prosperity of the port was in jeopardy and Spanish domination over the Low Countries was foundering. In fact, Charles V had grown tired of his role as Holy Roman Emperor and, as he had vowed to do in his youth, had retired to the Hieronymite monastery of Yuste in Estremadura. In 1555 he divided his empire. His brother Ferdinand was given the German imperial crown, and when Jan Rubens returned home, Charles V's son, Philip II, ruled Spain and the seventeen provinces of the Low Countries. Dividing such a vast territory between two sovereigns was a wise precaution, for only the personal charisma of Charles V and his political astuteness had enabled him to maintain unity, especially when Luther and his supporters caused a rift in the Roman Catholic Church and sowed the seeds of civil war throughout the Empire and Europe.

Although Charles V was a devout Catholic with a faith which pushed him to embrace monastic life at the age of fifty, he was wise enough to recognise the need for religious tolerance to keep peace throughout his domains. In so doing, he was able to resist the threats posed by the wave of Protestantism which spread over his northern possessions.

The seventeen provinces certainly held a special place in the heart of this Burgundian, as he had been born in Ghent. Charles V was also perfectly aware of the economic and strategic importance of the Low Countries to his empire: he knew that the Flemish, with their banks and ports, assured the hegemony of his empire through their financial operations, on which the whole of Europe depended. Buoyed by this economic and political argument, the Low Countries experienced a golden age under his rule. Antwerp had become the refuge for Protestants, who were hardly threatened by the sham Inquisition which left it to the local burgomasters to ensure that the religious fervour of their citizens did not get out of hand.

Philip II had neither his father's wisdom nor strength and was not able to maintain either cohesion or unity in the face of Calvinism. Unlike his father, he felt only aversion and suspicion towards the Low Countries and he preferred the desolate plateaux of Castille. Philip would countenance no criticism of his religion, which he looked upon as the spiritual guarantee of his power. Moreover, he was obsessed by the idea of equalling, even surpassing, the glory of Charles V. Unfortunately, he lacked his father's tolerance and his natural authority. His fanatical Catholicism and his propensity to govern from the secrecy of his palace earned him the

nicknames of 'the Monk-King' and the 'Bureaucrat-King'. To further his grand designs and heavy responsibilities he had only 'his mediocre intelligence, his hesitancy, his incurable slowness, his pettiness and taste for minor intrigue'.[2]

In August 1559, the year Jan Rubens returned to Antwerp, Philip abandoned his palace in Brussels, from which he had scarcely emerged during his stay in Flanders, and returned to the royal residence in Valladolid. When the construction of his monastery-palace, the Escurial, was finally completed in 1584, after twenty years of work, he immured himself there for the rest of his reign. However, before leaving his possessions in the Netherlands, Philip took several precautions intended to ensure his lasting power – the chief one of which would compromise Spain's rule for good and all.

His reasoning was simple: for Spanish rule to endure all that was required was to remove the native aristocracy from power and hand over the administration to the Spanish. He excluded them from all government posts. In addition, he confided the regency to his half-sister, Margaret of Parma, who had no affinity with the seventeen provinces, except for the fact that her mother – a linen maid for whom the adolescent Charles V had had a particular weakness – came from Brabant. To exacerbate matters even further, Philip placed the country in the charge of Spanish troops. Finally he decreed that the inhabitants of the Low Countries would be Catholic, or cease to exist.

Philip II was blinded by his desire for power, by his ignorance of political, economic and social realities, by his disdain for everything that was not Spanish. He underestimated the capacity of both nobility and people to resist. He failed to understand that the Reformation was an established and irreversible fact. He failed to perceive the strategic danger of Protestantism.

Closeted in his whitewashed cell in the Escurial – a cell which served both as bedroom and office – and surrounded by maps of the world, Philip II sat 'like a spider in the centre of his web'.[3] In spite of his planning he never managed to form useful networks or grasp political essentials. He could not foresee that the distress of the Protestants in the Netherlands would arouse the compassion of their English co-religionists. He did not understand that the English were keeping watch over the northern maritime provinces, whose ports controlled the trade routes for spices and precious fabrics, and by supporting the Dutch Calvinists the English automatically earned for themselves a window on the Orient, and were thus able to wrest overall control of international commerce from the Spanish. Such astute considerations escaped Philip II. He considered maintaining order only by force and was incapable of imagining for an instant that the rebellious

lowlanders could possibly resist Spain. The seventeen provinces belonged to him by divine right. They would continue to belong to him and fill his coffers and his granaries. Consequently he would not negotiate, and so he conceded nothing which might weaken his authority, even in the interests of peace. Nor would he tolerate an Inquisition which was nothing more than a sham. Faced with the spread of Calvinism, he proved unintelligent, indeed pitiless.

This new spirit of fanaticism and intransigence was the prevailing order in 1562 when Jan Rubens took up office as magistrate and found himself under an obligation to apply Spanish law in a city which contested it more vigorously than anywhere else, and which possessed the means of resistance.

Antwerp was the richest, the most enlightened, the most autonomous city of the seventeen provinces. Its cosmopolitan population was open to new ideas and questioned the old order. As a port open to the world, a market-place for Europe, a financial centre, Antwerp received merchandise from the new territories, the 'hidden continent', which it converted into capital in its financial institutions. As both banker and granary for the Low Countries and Europe, it could sustain a siege and feed its inhabitants. Furthermore, from the fifteenth century onwards Antwerp had acted as a refuge for Protestant immigrants and had continued to do so under Charles V. Calvinism had come to stay and found followers in all strata of society. Disaffection turned into dissent, breeding a sense of national identity which resented Spain's interferences. Ultimately, its aspirations suppressed by Philip II and his Regent, Antwerp broke into open revolt as William of Orange, the leader of the Protestant rebels, defied the might of Spain.

All this was too much for Philip II, who sent in his troops under the 'ferocious Duke of Alba'. The troops unleashed an orgy of pillage, massacre, rape and torture. Antwerp was singled out for special treatment since it was considered guilty of having given the signal for civil war in 1566. It was ransacked and its leaders executed.

Jan Rubens the magistrate had been a member of the revolutionary movement, acting as an intermediary between Antwerp and the Prince of Orange. Whether his support was motivated by religious principle or ambition is not certain, though masquerading as the servant of one master while serving another was the norm in those insecure times. Yet despite having converted to Calvinism, when the cause came to a fight Rubens proved less than a martyr.

In 1568 the burgomaster of Antwerp, Anthony Van Straelen, was executed, and the city's officials were forced to justify their decisions on matters of heresy. Following Van Straelen's execution the Catholics of

Antwerp rose in protest, accusing the Calvinists of putting their city in jeopardy. A lampoon was circulated denouncing them by name. One of those cited was Jan Rubens. He decided on the safest course and, with his wife and four children, fled into exile, to the city of Cologne near to where William the Silent and his family were also living in exile.

What followed is not totally clear. Rubens became the Orange family's lawyer in their action against the Spanish government of the Low Countries over the confiscation of their property. He was obviously a good and useful lawyer to the Orange family. He was also an attractive man, good looking, charming and probably flattered by the attention he received from the Prince and his wife. Then in March 1571 he was summarily arrested and imprisoned for adultery with Anne of Saxony, William the Silent's wife, who had given birth to a sickly girl. In his defence Jan stated that 'I would never have dared approach her if I thought she might refuse me'.[4] He denounced Anne of Saxony and begged his wife's forgiveness.

Maria Rubens bore up under the strain and was determined to save her unworthy and cowardly husband. Peter Paul Rubens's portrayal of women is sufficiently obsessive for us to examine those who mattered most in his life. His mother was one of these, but we wonder how she compares with his ample, sensual women whose faces are animated only by mutinous dimples and vacant expressions, women who for the most part seem to lack intelligence or even spirit. Maria Rubens certainly did not lack intelligence or spirit as she fought to rescue her husband.

Her first gesture was to forgive him: 'And don't write to me any more as "your unworthy husband", since all is forgiven', she wrote on 1 April 1571.[5] Alone, in exile, she confronted the powerful House of Orange-Nassau for Jan. Then, realising that submission was getting her nowhere, she threatened to make William the Silent's shame public. Anxious to avoid any scandal the family gave in and Jan was released in 1573 on payment of a fine of 6,000 thalers. She raised the first instalment of the money by selling her possessions in Antwerp. Once paid, the couple moved to Siegen where Maria kept the family alive by subletting rooms and growing her own food. It was there that her son Philip was born, and in 1577, Peter Paul. Thereafter they moved to Cologne to a house in the Sternegasse.

No longer a confidant of William of Orange, Calvinism proved an inconvenience to Jan Rubens, so he recanted and returned to the Church of Rome, thus enabling him to practise once again as a lawyer, even taking part in the negotiations which Philip II initiated to reconcile Spain and the disaffected provinces of the south Netherlands.

In 1587 Jan Rubens died of fever and, without her husband, there was nothing to keep Maria and her young family in Germany. Antwerp was

no longer a danger so she returned there, arriving in 1588, and set about making a life for the three youngest children who were still at home, the others having died or left.

During her eleven years of exile the Low Countries had endured two upsurges of rebellion which culminated in a separation between the five provinces of the north, which, together with the cities of Bruges, Ghent and Ypres, formed the Union of Utrecht in January 1579, and the provinces of the south. Whilst their independence from Spain was not official, thereafter the Protestant northern provinces abjured the rule of Philip II and accepted the leadership of the House of Orange-Nassau.

The Antwerp to which Maria returned with her children was not the prosperous bustling financial centre she had left. It had resisted Spanish domination until 1584, and whilst the fighting had ceased the ravages of war had taken their toll. The secessionists of the north had captured the mouth of the great River Schelde and thereby blocked navigation to the port of Antwerp. The port ceased to function, industry and commerce ground to a halt. Antwerp was but a shadow of its former self.

Maria found the family a house in the Meir, near the Exchange, one of the best parts of the city. Her husband's service to Philip II during the latter part of his life enabled her to get the sequestration orders on their property raised, and with this money she established a comfortable home and set about educating the two boys and marrying a daughter, Blandina, to a prosperous merchant.

Peter Paul was only ten and as a child had shown no remarkable traits. He attended one of the best schools in the city, that run by Rumboldus Verdonck, where one of his closest friends was Balthasar Moretus, the grandson of Plantin the printer. The friendship was to last all their lives and, when Moretus eventually took over the printing works, Rubens and he would collaborate in producing books, Rubens illustrating and Moretus publishing them.

During this period from 1587 to 1590 Rubens studied the humanities, learning Latin and Greek, reading Cicero, Virgil, Terence and Plutarch, learning passages by heart which later, in his voluminous correspondence, he would frequently quote. His passion for the classics would last all his life and grow deeper as he grew older; indeed it would in the future earn him the praise of one of the greatest men of seventeenth-century letters, Nicolas-Claude Fabri de Peiresc: 'In the whole domain of Antiquity especially, he possessed the most universal and the most excellent knowledge that I have ever encountered.'[6]

His schooling finished when he was thirteen and a half and though her resources were limited, Maria Rubens determined that her son should be

able to mix well in good society. She appealed to the Countess of Lalain to take him into her household. He moved to the Countess's palace at Oudenaarde in 1590 but he quickly tired of it and, barely a year later, as his friend Joachimi de Sandrart recorded: 'Being unable to resist his passionate yearning to paint, he at last obtained from his mother permission to devote his life to it entirely.'[7]

Rubens's announcement must have come as a surprising turn of events after a childhood marked more by family drama than by aesthetic emotions. Maria Rubens must have been astounded. Where did her son's sense of vocation come from? In her family, social advancement came only through law and letters, not through the fine arts. Lacking any family precedent or any appropriate milieu, his desire to paint seems to have been that much stronger. He was born far from Antwerp, from its masters, its guilds, its traditions. In Germany the Reformation had banished art from the churches, the only places where painting and sculpture could be seen by the public. And whilst paintings, panels and retables did hang in the castles and palaces of the nobility, Rubens's family, once it had severed its connection with the House of Orange-Nassau, had no access to them until Peter Paul went to the Countess's household at Oudenaarde.

Until the age of fourteen, Rubens would have had no introduction to painting other than 'copying the illustrations [from the Bible] published by Tobias Stimmer in 1576, which was hugely popular at the time'.[8] This anecdote is revealed by Sandrart, in whom Rubens the fifty-year-old confided as they journeyed through Holland together. It reveals both Rubens's passion and the means he employed to accomplish it.

A child artist in a troubled household, he began to draw. He did not scrawl whatever came into his head as did most children; he practised, he studied, he made himself do it well, as if he realised that painting is nothing without the draughtsmanship which gives structure to colour. This was both his first intuition and his last message. In the will which he drew up at the height of his fame and creativity, he made provisions which amply show his experience and success and echo, reinforce and exalt his childhood intuition. He left a number of drawings, based on great models made throughout his life, to whomever among his sons would become a painter. His intention is clear. The value of the drawings lay in their power to instruct rather than in their aesthetic appeal. They were a teaching medium rather than *objets d'art* - something to enjoy. They were primarily studies. What Rubens had practised as a child and never ceased to practise through his life - the need to copy, to make humble, patient drawings, to imitate the artists of antiquity - became a lesson for eternity. None of Rubens's children was to follow in his footsteps, and so many of the

drawings were lost while others are now in the Louvre. Nothing, alas, remains of the young Rubens's drawing exercises.

From an early life riven by domestic and social disappointments of two very ambitious parents, exile and religious tension, Rubens discovered a passion which enabled him to overcome his clouded childhood influence and rise to be the foremost painter of his day as well as a considerable diplomat and peace-maker.

Rubens's Masters

Both Rubens's birth and his entry into the world of painting came at a time of schism. In Flanders the artistic world which Rubens discovered was divided by an ongoing conflict between those holding on to local tradition, and the enthusiasts for the Italian school, who were called 'Romanists'. The young painter would come into contact with both schools, and would resolve the dilemma in his own way. First, he needed time to master his art.

Rubens was already fifteen when he began his apprenticeship. This was quite old for those times, when young painters traditionally began work in a studio at barely ten years old. The initiation was long: first they had to familiarise themselves with materials, then, after mastering drawing, they learnt technique. To begin with novices were limited to grinding colours, heating solvents, preparing panels and canvasses, and if need be running errands for the master. Gradually, through observation and through practice under supervision, they were entrusted with tasks that were more pictorial and less chemical: making a shop sign, painting in the background wash, that first coat of colour which would give the painting depth. Little by little they moved on to the picture itself and were given the right to brush in some details in an important work. Then, if an apprentice showed real talent, he was allowed to paint a whole picture, using the master's sketch *but* under his supervision.

Maybe because he wanted to compensate for his belated beginning, Rubens remained an apprentice for eight years. We do know he was twenty-three when he left his last master, Otto Venius, having already been admitted to the Guild of St Luke in Antwerp as a *francmaître*, a free master, two years earlier. Rubens chose to continue working in Venius's atelier, and while he was obviously no longer employed as a messenger boy he evidently feared relinquishing the experienced guidance of an older painter. However strongly he felt about his vocation, he trusted neither his passion nor his genius which for the moment was simply a desire to paint.

11

We know very little about Rubens's life as an apprentice. He began writing only when his travels and his business made it necessary, and he was always reticent about his feelings. The first biography, the *Vita*, was written by his nephew, Philip Rubens. Despite the distance in time he tried to fill in the vacuum of those early years. Unfortunately this brief Latin text is unreliable since it was written by an enthusiastic and partial relative. There is no reference to those works which moulded Rubens, so what he learned from specific paintings we do not know and Rubens has not said. What we do know is contained in his drawing notebooks: for example, he paid little attention to Verhaegt, Van Noort or Venius to whom he was apprenticed. In fact, Rubens had only mediocre masters who owe their immortality to having had him as a pupil.

No paintings by Tobias Verhaegt still exist. He was a distant kinsman of Maria Rubens, and so when her son decided on his career she asked the only painter she knew to take him on. Rubens obviously considered him unsatisfactory for, after only a few months, he joined the studio of Adam Van Noort in 1592. Van Noort was a better painter, something of a personality, with a busy school. Eugène Fromentin, the nineteenth-century art critic, found that the reputation of Van Noort was still alive when he visited the Low Countries: 'Flemish in race and temperament . . . he was a very real painter – through his power of imagination, his vision, his dexterity, his alertness, his indestructible aplomb.'[9]

Van Noort was a painter who expressed the very essence of Flanders, 'the opposite of Venius [Ruben's third and last master], the opposite of an Italian', and it was the spirit of Flanders that Van Noort taught Rubens for four years, until he left him for the most famous painter in Antwerp of the time, Otto van Veen.

Van Veen's influence on Rubens was not so much on his painting as on the development of his lifestyle. Descended from a bastard son of John, Duke of Brabant, he was conscious of his pedigree and lived accordingly. He had studied in Italy, where he absorbed the influence of both Correggio and Andrea del Sarto, among others, then worked for the Electors of Bavaria and Cologne. He soon realised that a painter was nothing without a prince, and set about securing a patron. He found one in Margaret of Parma's son, Alessandro Farnese, the talented Governor of the Low Countries. Van Veen was commissioned to paint the prince, portrayed him as Hercules, and was rewarded by being appointed Painter to the King of Spain as well as Engineer of the Royal Armies. But Parma died and Van Veen, who by then had Latinised his name to Venius, lost his protector and retired to Antwerp in 1592. Few of Venius's paintings survive to this day, and what does survive has earned only lukewarm praise: 'A clear and simple composi-

tion';[10] 'lacklustre colour';[11] 'Monotony, insignificance, accurate, painstaking talent, an excess of colour as if to compensate for the vapidity of the rest'.[12] At the end of his career it was said of him that 'allegory had become half his talent',[13] in short, by then he had nothing to say.

Why did Rubens stay for so long with a man whose influence on his painting seems to have been minimal when one sees that Venius's paintings bear little relation to Rubens's definitive style? It seems it was not Venius the painter but Venius the man who held Rubens. Elegant, erudite and extremely well read, he stimulated Rubens's interest in the sciences and antiquity, reading and commenting with him on the classics. More importantly, he showed Rubens what a painter could achieve provided he courted the right patrons and knew how to mix with them. This was a lesson Rubens never forgot. Venius achieved the highest distinctions a painter of his day could hope for, an achievement Rubens later surpassed, but the painting Venius left for posterity failed to equal it.

Venius had studied in Italy and had introduced to his painting the influences he had learned there; it was an eclecticism which corrupted Flemish art and was symptomatic of its malaise at the end of the sixteenth century.

Italian or Flemish Art?

In Venius's lifetime, travelling to Italy was no longer a novelty, and the time he spent with Zucchero, his master, was nothing out of the ordinary. Since before the fifteenth century artists from the north had been crossing the Alps, for Rome was considered the most important reservoir of ancient art; and during the Renaissance the fame of Michelangelo, Leonardo and Raphael had spread as far as the Low Countries. At that time there were no newspapers or art books, and knowledge of great works of art was broadcast through engravings and drawings. Since Flanders excelled in the manufacture of tapestries, Italian art had infiltrated into the country by yet another route. Italian potentates had a liking for tapestries and hung them on the walls of their palaces to keep out the draughts, and they frequently asked the greatest artists to supply designs. Raphael, for example, devoted a great part of his production to tapestry design. The cartoons were then sent to Brussels to be translated into cloth, and thus gave the Flemish a glimpse of Italian works of art. In this way a tradition of exchange was built up, from one country to the other, through the only media available at that time.

Italy was the aesthete's promised land and to some extent still remains so. Unfortunately, under its all too clement sky, travellers tended to forget not only their country of origin but also their traditions. The Flemish succumbed to Italy, but they came from the one country which itself had a comparable artistic heritage, if not a superior one.

Throughout the fifteenth century and the first part of the sixteenth, Flanders also had the advantage over Italy in painting technique thanks to the revolutionary discovery of the uses of linseed oil. Italian painters had then benefitted from that discovery as it released them from the limitations of rigid drawing and pale colours imposed by the *al fresco* method.

In those days painters took their pigments from nature: vermillion, cadmium, lapis, ceruse, carmine, gold. They used pure colours, and to lighten or darken a tone simply varied the quantity of the pigment. Because these substances required preparation, painters tended to be classed with alchemists who, swathed in vapours from their murky concoctions, attempted to turn base metal into gold. Until the Baroque period painters had to heat, melt, and mix their material. Flanders's greatest discovery, which owed as much to luck as to science, was the use of linseed oil as a medium.

As historians have pointed out, linseed oil was known in ancient times, and later both Heraclius and Theophilus were using it. Unfortunately it dried very slowly, and the method died out and was forgotten. Artists preferred egg white, water or size, which did not impede the progress of their work, even though this was sometimes at the expense of the colour's permanence.

In 1420, more than half a century before Michelangelo was born, the Van Eycks of Bruges, wanting to mix their colours and shade them off into each other on the canvas, had the idea of returning to the use of linseed oil. Since they no longer knew how to prepare it, they withdrew the oil from the heat when it seemed to have the required fluidity and discovered that while the oil was still liquid they could make one substance adhere to another when they were painting their panels. In addition, the opacity of the mixture of reheated oil and pigment meant that if light coats were applied layer after layer, for example when depicting water, they were able to obtain both a transparent effect and a feeling of depth as each successive coat was absorbed. The Italians soon appreciated this and exploited it.

Michelangelo may have mocked the artists of the north who, he wrote, 'painted only women, young girls, nuns, common people, without any great understanding for true artistic harmony',[14] but he recognised that the Flemish school of painting was to be taken as seriously as the Italian. He could not deny a tradition as ancient as his own, and which in many respects surpassed it in its achievements.

For Flanders was rich in an art which had been developing since the Middle Ages. Its first painters were the illuminators, painters who illustrated the holy books, bibles and antiphonies, in brilliantly coloured, precise drawings, which slightly resemble the style of Byzantine art.

The art of illumination had been descriptive, it told a story; not only the stories of the Bible but also of the changes of the seasons, of great deeds and romance. At the same time it was translated to and elevated by the retables, the altar panels, for it was at this time that the first painted wood panels appeared.

The invention of printing threatened illumination since it became obvious that the detailed work demanded of the artists delayed the spread of holy books on a mass scale. Printers, on the other hand, were able to use the woodcut for illustration, a technique known since the Middle Ages. Gutenberg's invention gave a new dimension to illumination which ceased to be a supplement to the text but something to be enjoyed in its own right. Princes and noblemen wanted illustration not just to enhance their reading of prayer books but also for the aesthetic satisfaction it provided. Until then, the limitations of the sacred word had left little room for initiative; now the illuminator could give free rein to his imagination. He ceased to work exclusively for the Church and began to work for secular powers. Illumination became separated from the book, as much in its purpose as physically.

The fourteenth century marks the real beginning of Flemish painting. It was filled with intense colour, mysticism, and a 'pious consultation of nature'[15] which earned it Michelangelo's sarcasm. Anthropocentric and naturalistic, paying as much attention to drawing as to colour, from the outset it had three main components: God, man, and their respective creations. Three great names were involved at the beginning: the Van Eyck brothers (Hubert and especially Jan), Robert Campin, the Master of Flemalle, and Rogier Van der Weyden, all painters patronised by the Dukes of Burgundy. In their simplicity each nevertheless shared certain aspects of Flemish primitivism: the meticulous draughtsmanship, the rich colours and a special spiritual quality which Michelangelo failed to notice. The more the painters rejoiced in the discovery and reproduction of the visible world, the more intensely did they feel the need to saturate all of its elements with meaning. Conversely, the harder they strove to express new subtleties and complexities of thought and imagination, the more eagerly did they explore new areas of reality.[16]

Michelangelo may have failed to appreciate Flemish art but he respected it, and until the sixteenth century the two schools of Flanders and Italy remained rivals, with Flanders having a certain advantage in technique.

Then peace came to Italy in the sixteenth century and the princes began to take an interest in their comforts. Power was exercised not through military might but through the sumptuousness of their courts, and attracted all those who could contribute to the luxury of their surroundings, thus creating a cultural resurgence not known for centuries.

The north by contrast was thrown into turmoil. For decades to come it was beset by civil and religious warfare which brought the usual deprivations in its path. And so began the flow of northern artists southwards to draw inspiration from Italy's new cultural revival. Dürer crossed the Alps, as did the Flemings, Schorel and Van Orley, to be followed by the Metsys. On their return, these Flemish artists who had found inspiration and influence in the new Italy formed a Society of Romanists to reflect their new ideas and style of painting.

But what effect had this on Flemish art? Its greatness lay not in the nobility or size of the paintings but in the manner in which they were treated. Michelangelo's vision is Promethean, Peter Brueghel's is ironic; Raphael's is as serene in its elegance as Metsys's is in its triviality. Michelangelo reproached the Flemish for their absence of the Ideal; what he was really reproaching them for was in drawing their inspiration from the ordinary, the humdrum. Michelangelo's ideal was a redesigned human body rather than a depiction of the onslaught of old age and sickness; he depicted a slave in revolt rather than a miser who limped; his was the art of heroes and gods rather than the money-lenders and yokels of Flemish art; heavens and palaces, not market stalls and farms. The Flemish ideal was the reality, the ordinariness of life which never ceased to astonish Flemish painters. And it was this ordinariness that they tried to blend with the heroic, metaphysical nature of Italian art – and did so in their restricted way. The Romanists no longer attempted to represent objects pictorially; they followed the Italians and in so doing laid aside their past greatness: their colour, the brilliant harmonies which had made their art great and been so admired even by the Italians. They became 'hybrid artists',[17] and posterity would condemn them.

Rubens in his second and third masters was caught between the very essence of Flanders in Van Noort and, as we have seen, 'the opposite of Venius, the opposite of an Italian'. It was this aesthetic divide, reflecting the political and religious schisms of his childhood, that Rubens would try to surmount in the brilliant syncretism characteristic of his genius. Aware that he needed to discover Italian painting for himself and not merely second-hand through Venius, aware too that he had outgrown Venius and inspired by Raphael, Peter Paul Rubens decided to cross the Alps. His beloved brother, Philip, had recently left to study law at the University of

Padua. And so, after the burgomaster of Antwerp furnished him with a certificate of good health and certifying there was no epidemic in Antwerp, on 8 May 1600 Rubens set out on horseback for Italy.

ITALIAN JOURNEY
(1600–1608)

Mantua, at the Court of Vincenzo de Gonzaga

Rubens was twenty-three when he left Antwerp, his mother and Otto Venius for Italy. His eldest brother, Jan-Baptist, whom he had never known, had just died there, and Philip was already there, following in the footsteps of his father. Filial piety and the affection he felt towards Philip certainly played a part in Rubens's departure, but it goes without saying that it was as a painter rather than as a son or a brother that he made this journey.

Rubens was already familiar with the Italian style, since Venius had been a pupil of Federico Zucchero, and he could see proof all around him that Renaissance Italy was *the* place to go.

Rubens's pilgrimage to Italy was thus in itself not unusual. What was of greater significance was the point in his career at which he decided to embark on this journey. Twenty-three was a reasonable age to set up in business for himself. He had taken all the necessary steps, yet he had produced nothing which signalled the beginning of a working career: simply the canvases which hung in his mother's drawing room, whose existence we know of through her will. 'I give to my two sons the *batterie de cuisine* and everything else, such as it exists at present, comprising all books, papers and writings belonging to me, with the pictures that are mine and which are not portraits; the other beautiful paintings belong to Peter Paul who painted them.'[1] According to Rubens's nephew, his first works were in the style of Venius – understandably, as Rubens was still under his influence. But was it a lack of self-confidence that prevented him breaking away? His departure for Italy would add years to his apprenticeship. When he arrived there his mind was like fallow land that had been freshly ploughed, prepared, waiting for the seed to be sown. Eight years of study and his admission to the Guild of St Luke were not enough. He had to discover *in situ* Raphael, Michelangelo and the other painters, the antique statuary he had developed a taste for through his classical scholarship. He did not leave for Italy to perfect his art; as yet he had done very little. Before launching into his own painting business Rubens, or so it seems, wished to arm himself with every available technique, learn

everything, so that he could exploit his talent to the full. This attitude reveals his surprising capacity to manage and use the most productive side of his genius and his life.

Rubens's first stop was Venice, the usual first port of call on the road from Flanders to Italy. En route he had first travelled through Germany, following the course of the Rhine, and then France, passing through Paris as his father and brother had done before him. Having reached Venice, the home of colourists, he would not have had time to discover either the ancient masters or the contemporary painters who favoured this style. In fact, by a stroke of luck - or perhaps Rubens had shrewdly sought an establishment in keeping with his social aspirations - in the hostelry where he was staying, Peter Paul made the acquaintance of a gentleman of Duke Vincenzo de Gonzaga's retinue. Gonzaga had left Mantua to take part in the carnival which then took place during June. Rubens was quick to show his new friend the canvases which he had had the foresight to bring with him, and the gentleman duly mentioned them to his Prince. Vincenzo already had one Flemish painter in his service: Franz Pourbus, whom he had made his official portrait painter. We cannot say for certain why - perhaps because he appreciated Flemish art, their tapestries, their painters, the country itself where he had just taken the waters at Spa, or perhaps simply because he liked to be surrounded by artists and did not count the cost - but Vincenzo immediately engaged Rubens. And so, having barely arrived, this young man had found employment, a salary, a protector and a place to live in one of the loveliest cities in Italy.

In spite of all the marvels to be found in Italy, Mantua today is still a very special town. It does not have the slightly morbid seduction of Venice, which is present at every corner of the canals, in the moss-covered façades of its *palazzi*, in its mists and greenish waters. It does not have the pomp of Florence, a museum city whose Uffizi gallery and Pitti Palace bring together the quintessence of the Italian Renaissance. And, of course, it does not have the monumental quality of Rome. It is a small town surrounded by calm, unruffled lakes. At dusk Mantua is shrouded by the mists which shield it, muffling sound, isolating it from the rest of the country. The town belonged then to a single family, the Gonzagas, who ruled there from the fourteenth to the seventeenth century. They moulded Mantua each one in his own fashion: the wise Duke Lodovico who sat for Mantegna surrounded by his family; Cardinal Ercole who was also president of the Council of Trent; Isabella d'Este who masterminded Balthasar Castiglione and commissioned her now vanished *studiolo*, its walls covered in the greatest works of the Renaissance; and then that fickle and unfaithful duke who brought about the curse of Rigoletto. All perpetuated a tradition of

magnificence and employed the most eminent artists of the period in that cause. Mantegna, Giulio Romano, Leone Battista Alberti have each left their mark in Mantua. Its basilica with its unique nave and gentle frescoes was conceived to bring together the faithful in the love of God, rather than to inspire fear in the congregation. Mantua was sacked twice: first in 1627, when the Gonzaga line came to an end and the French and Italians disputed the succession; later during the Napoleonic Wars. Nothing remains of the magnificent collections amassed by the Gonzagas. Nevertheless, the pillagers were unable to tear the frescoes from the walls or destroy the architectural proportions of the buildings, or remove from the streets the cobbles arranged in fern and chevron designs, or take the ochre colour from the walls or the golden mists from the sky. These forms, materials, colours – whether natural or manmade – keep alive Mantua's special atmosphere, that refined languor, which favours the famous *sprezzatura* (a casual approach) – characteristic of local boy, Balthasar Castiglione's *The Courtier*.

Even in his own extravagant times, Vincenzo de Gonzaga was known for his prodigality. He reigned over the most elegant and refined court in Italy. And he let the fact be known through the sumptuousness of his processions, through the wild amounts of money he spent on enriching his art collections, which were equalled only by those in the papal galleries. In his ducal palace, the Reggia, whose buildings were connected by hanging gardens, creating a town within a town, every inch of wall was covered: frescoes by Pisanello or Mantegna, tapestries woven in Flanders after cartoons designed by Raphael. Between the frescoes and the tapestries hung paintings by Bellini, Correggio, Titian, Veronese, Leonardo, Caravaggio . . . Thus, for the first time Rubens was given the opportunity to see Italian art with his own eyes.

The visitor's gaze was drawn to the caissons of the ceilings, the lintels of the doorways which opened on to interminable corridors, bordered with galleries highlighted by *trompe-l'œil* colonnades, surmounted by capitols of Corinthian foliage painted in fine gold leaf. Even the dwarves had their own apartments built to scale, their refectory, their chapel a miniature reproduction of the Scala Santa of San Giovanni in Lanterano. One day was hardly enough to see it all. It required weeks to discover the Reggia, so hard was it to resist the enchantment of its appearance, its sparkling colours melting into an amber mist.

Vincenzo spent his leisure hours in another residence, the Palazzo del Te, surprisingly close to the Reggia – it takes less than an hour to walk between the two. This is a low building, a villa in the style of Sebastiano Serlio, constructed around two inner courtyards; from the hallway one can

see straight through the whole building to the far outside wall. Serlio[2] considered it a 'model of the architecture of [his] time'. 'Arbitrary, open, flexible', inventive, audacious, it looks unstable as a building, as if it has been built – and today it gives this impression more than in the past – from stones piled higgledy-piggledy one on top of the other. Giulio Pippi Romano was the architect. At the behest of Federico II of Gonzaga, Isabella d'Este's son who, like her, was a great connoisseur of art, Giulio Romano also supervised the interior decoration. There are only thirteen rooms but each one is inspired by some great text from antiquity: Ovid's *Metamorphoses*, *The Golden Ass* of Apuleius. Dedicated to the Sun, to Phaethon, to the Muses, the Zodiac, Caesar, Giants, the encounter of Cupid and Psyche in rather prosaic frescoes, in a style imitative of Michelangelo and in the last instance of Raphael, they show the glory and anger of gods and heroes, and the vitality – also divine – that they put into matters of love. For it was here that Duke Federigo indulged in his adulterous affairs. The evocative images of the salons and loggias were extended further into gardens filled with innumerable flowers, orange and lemon trees, hedges damp with dew, fountains which Tasso celebrated in a poem entitled 'On the road to Te': 'You who long for shaded paths, for flowers, for cheerful grass, enchanted greenery.'[3]

In these luxuriously elaborate surroundings there was a fête, a concert or a theatrical performance virtually every day. Duke Vincenzo raised his ancestor's traditional patronage to a higher plane, maintaining a troupe of actors and an orchestra at his home. In 1601 his court welcomed Monteverdi who composed his *Orpheus and Ariana* there, but left seven years later, writing with bitterness: 'To conclude, I tell you that I no longer wish to accept either grace or favour from Mantua. All that I can hope in returning there will be to receive the *coup de grâce* of my ill fortune. No, I am too unhappy there.'[4] In 1606 Galileo too was a guest for a short while. Rubens may have met both musician and scholar but he makes no mention of the fact in the two letters that he later wrote recalling Mantua, on 15 June 1628 regretting that the Duke's collections were being dispersed[5] and in August 1630 deploring the sack of Mantua 'which grieved me very deeply for I served the House of Gonzaga for many years, and enjoyed a delightful residence in that country in my youth'.[6] It was also Vincenzo who in 1586 had liberated Tasso from the madhouse where he had been incarcerated by the Este of Ferrara.

The young Duke was interested in painting just as his ancestors had been, and paid agents in Italy and elsewhere to scout for works worthy of hanging in his galleries. According to the inventory drawn up in 1627, when King Charles I of England announced his intention of acquiring the

Duke's collections, they comprised three Titians, two Raphaels, one Veronese, one Tintoretto depicting the splendour of the Gonzagas, eleven Giulio Romanos, three Mantegnas, two Correggios, a Madonna by Andrea del Sarto, and *The Death of the Virgin* by Caravaggio, to quote only the most important, omitting the 'minor' painters such as Palma the Younger, Il Padovanino, and innumerable copies made by artists at his court. More cosmopolitan than his predecessors, Vincenzo attracted artisans, gold and silversmiths, jewellers, tapestry-weavers, from across the world. Once in Mantua, the artists handed over their art to the Mantuans and produced utensils, tapestries, wall hangings, dress fabrics and gold and silver ware for the Princes. Vincenzo also possessed a collection of antique carved precious stones, intaglios and cameos, which Rubens admired not only to the point of acquiring some for himself, but also twenty years later, of planning a book which would catalogue the most beautiful intaglios known in his day.

During the fêtes staged for the Mantuans's amusement, Vincenzo would cross the town whose streets he had planted with trees and flowers, throwing handfuls of silver coins into the crowd who had come to cheer him. But was that really enough compensation for the taxes with which he burdened his subjects in order to maintain his grand lifestyle? For Vincenzo had squandered the fortune so carefully acquired by his ancestors. One Mantuan chronicler, Ludovico Muratori (*Annali*, 1612) described him as a 'great gambler, a great spendthrift, much taken with luxury and women, for ever engaged in new love affairs, happy pastimes, fêtes, balls, music and plays'.[7]

Beneath the playboy appearance, however, there lurked a prince devoted to his subjects and a clever politician. He wrote in 1600: 'Amongst our most solemn thoughts concerning the States and the subjects entrusted to our care by the bounty of God, we cherish that of administering justice fairly, or ending oppression, of managing the public good in a proper manner, so that public and private interests and our own are not thwarted, that men of evil are eliminated, that those who are ill-clothed, living poorly and in scandalous conditions can be cared for.'[8] During his 25-year reign, legal and fiscal administration was enacted more promptly, supervision was more efficient. Vincenzo was respected by his subjects.

He was also an intelligent strategist in foreign affairs. His own territory was modest, but situated as it was between the centre and north of Italy it became, through its strategic position, a prey to the envy of other Italian states, of the papacy and of France. France would have liked to have had a presence on the peninsula, as did her hereditary enemy, Spain, which held the vice-royalty of Naples to the south and the duchy of Milan to the

north. Because he was also Duke of Montferrat, a title and possession conferred on his grandfather Federico II by the Emperor Charles V, Vincenzo had special ties with the kingdom of Spain. His task, therefore, consisted of maintaining certain alliances which at the same time preserved the independence of his States. He succeeded right up to his death in 1612.

As far as finding a protector and a court was concerned, Rubens had landed on his feet. If one can judge by the painter's work, such as we know it today, Rubens and Vincenzo of Gonzaga had a lot in common. They shared a taste for beautiful things, intaglios, women, that love of life, that vitality which shines through both the painter's work and the Prince's enterprises. In the 1600s Rubens allowed himself no time to indulge his predilections, absorbed as he was in furthering his ambition to paint. So, far from allowing himself to give in to the delights of Mantua, he considered the dukedom a *pied-à-terre*. From that, a special relationship evolved between the painter and the Duke, his master.

At the Gonzaga court Rubens behaved like a courtly gentleman: 'The secret motive which makes him behave is not the service of the rince, but his own perfection',[9] and thus turned the artist's isolated social position at that time to his own advantage. At the beginning of the seventeenth century the artist's status had been problematic enough for Francisco Pacheco, painter, Master and father-in-law of Vélasquez, to brood on his bitterness in his treatise on *The Art of Painting*. A century earlier the quarrels between Michelangelo and Pope Julius II had provided fodder for the chroniclers, who reported the Florentine's resentful moodiness, his fury when painting the frescoes in the Sistine Chapel, the provocative imagery which gave his anger expression. Vasari in his *Lives of the Great Painters* had made frequent allusions to the artist's special temperament, but without drawing any deliberate conclusions as to the relationship which the artist had with his patrons. Pacheco himself drove the nail home in the title of his Chapter 10: 'In which one draws conclusions on painting and on the reasons for its nobility and for the praise it merits.' He reviewed various tributes paid by the greatest in the world to the painters of their time: Emperor Maximilian of Germany asking one of his courtiers to bend down to make a stool of his back so that Albrecht Dürer could reach an elevated position, subsequently conferring on him the title and arms of the Painter of Nuremburg. He emphasised that in Greece and Rome: 'People of this status [the artist's] were forbidden to devote themselves to practices which would not have been "free", while they were painting, as painting was a noble activity.'[10]

Pacheco's definition of painting distinguished it from the work of artisans and elevated it to the rank of a liberal art, that is to say, art produced by

free men. And he showed that painting also won its entitlement to noble rank by serving religion, thereby contributing to the moral elevation of humanity. Step by step he retraced the irrefutable links that exist between the nobility of art and the nobility of the artist, arguing that the artist ought to continue to be honoured in the illustrious manner in which Dürer had been honoured.

But it would be the end of the century before a painter could rebel against his uncertain status: courted by the powerful while at the same time entirely in their pay; considered an artisan of superior quality but still an artisan because he worked with his hands. Only Salvator Rosa dared proclaim: 'I do not paint to enrich myself, but for my own satisfaction, abandoning myself to my enthusiasm and taking up my brush only when I feel the urge to do so'[11] – and did without disciples in his attempts to change the way artistic patronage was managed. The image of the artist which Rosa created was not fully appreciated or copied until the emergence of the Romantics in the nineteenth century.

Rubens, on the other hand, resolved the question without resorting to rebellion or anger but with the innate *savoir-faire* of the diplomat, giving a foretaste of his future achievements. What he actually thought we will never know for only his official correspondence with the Intendant General of the duchy, Annibale Chieppio, has come down to us. The letters he wrote to his family, in whom he might have confided, have disappeared. This is a pity, but Peter Paul's behaviour speaks for itself. The Mantuan archives tell us with certainty that Rubens was in Mantua during the summer of 1601, from April 1602 to March 1603, from 24 May 1604 to the end of 1605; in all, only three years out of the eight he spent in Italy.

Evidently, for reasons of his own, or those of the Duke, Mantua did not exert a monopoly on his time and talents. Maybe Rubens did not wish to settle like Franz Pourbus the Younger, who arrived in Mantua at the same time. Vincenzo had met Pourbus in Antwerp and invited him to his court. Pourbus was descended from a dynasty of portrait painters active from the sixteenth century in Flanders, and once installed at Mantua he continued to paint portraits for the Duke. He seemed content with this role, and at the Gonzagas' behest painted them young and old, alone, or kneeling in a group for prayer, with all the care that a Flemish painter could put into the rendering of lace, jewels and other ornaments signifying the dignity and social rank of his sitters – at the expense of excluding all scenery, all interior décor. Pourbus spent nine years in Mantua before moving on to render the same service to Vincenzo's sister-in-law, Queen Marie de Medicis in Paris. In his time he was considered the best portrait painter in Europe.

Had Rubens, perhaps, already firmly made up his mind when he left Antwerp about how he was going to exploit his stay in Italy? Or was he simply reacting to Vincenzo's attitude towards him? In his letter of 9 June 1607,[12] he remarked to Chieppio that the Duke's galleries possessed only a few of his works. It was true that Vincenzo had asked Rubens mainly for ornamental landscapes and some decorative paintings. But if, he went on, Vincenzo were to appoint Rubens curator of his collections fairly soon, the Duke could ask him to copy some of the great masters and complete his collection of portraits of the most beautiful women of his time. It would be two years, however, before Vincenzo gave Rubens his only important commission: a triptych for the church of the Jesuits in Mantua. Yet all the while he was more or less ignoring Rubens he seemed happy enough handing out money to his painter. And Rubens, for his part, was not slow in taking great advantage of the situation. Writing in December 1601 (scarcely a year after Peter Paul's arrival in Italy), his brother Philip's letter asks, 'I shall love to know what you think of Venice and the other Italian towns which you have visited – almost all of them.' For, without quarrelling, without drama, without any of the squalls which marked the relations between Michelangelo and Pope Julius II, Rubens removed himself from the guardianship of his patron, whilst subtly negotiating and preserving his services and interests. A *modus vivendi* grew up between the Duke and 'il mio pittore fiammingo' as he called Rubens, which allowed Rubens to satisfy his artistic aspirations.

When Rubens first arrived Italy was a country in turmoil: the art world was searching for an identity *vis-à-vis* the Church, the Academy and the people. The great painters were long dead, some for almost a century: Titian, Veronese, Tintoretto, Raphael, Michelangelo, Leonardo. Mannerism was unfurling its last 'serpentine lines'. Jesuitic art – the art of the Counter-Reformation stemming from the precepts of the Council of Trent – had begun to invade the churches, and the sculptures and paintings which decorated them. The recommendations issued by the last session of the Council in 1563 had already produced their effect. The idea of exalting the human body, which had survived so well in the nudes of antiquity found in Renaissance painting, was finished: for holy men, nothing must distract the believer from the religious scene represented in a painting.

The Holy Council forbids the placing in a church of any image that is inspired by an erroneous dogma and which can lead simple people astray. It wishes to avoid all impurity, and that no provocative appeal be given to pictures. To ensure that its decisions are respected, the Holy Council forbids any unusual picture to be placed anywhere,

even in churches which are not subject to the visit of the Ordinary [of the Mass], unless the bishop has given his approval.[13]

Enjoyment of the nude was therefore banished from religious iconography, and so from art, since the Church was then its principal consumer. Warned of this holy assembly's prejudices, and doubtless also aware that he had been more than a little provocative in the extensive use he had made of man's nudity in his Sistine Chapel frescoes, Michelangelo had asked his assistant Daniele de Volterra to add a veil to several figures in *The Last Judgement*. Veronese, too, suffered in his turn when in 1573 he was taken to task by the Holy Office for a very minor transgression – painting a valet bleeding from the nose and drunken soldiers in the foreground of a *Last Supper*. Two years later, in 1575, the church of Gesu was built in Rome, the architects being Vignola (1507–1573) and Giacomo della Porta (1541–1604). Its tormented façade marked the advent of the Counter-Reformation's rhetorical art. Its walls would soon be harbouring the paroxysms of 'Baroque', of which the Goncourt brothers have left a most telling description:

She [Mme Gervaisais] loved this vault like a golden arch over her head, crowded with ornaments, caissons, arabesques, illumined by bays from which protruded miserichords of the saints, shipped by the sun's rays. She loved this fiery celebration on the ceiling, where in a glorious Bacchanalia of colour, the Apotheosis of the Chosen was triumphantly gathered atop the vaporous clouds, like plumes of incense overflowing the swollen flowery borders, spreading into the tattered strips of sky, real clouds high up in the vault where great angels swung their legs and shook their wings. That undulating roll, that palpitating centre, that swooning spectacle, that half light pouring through the cerise of the windows, from whence glided arrows of light, those visible rays transfiguring groups of people at prayer with their floating colours, this light mingling a bedroom mystery with the mystery of the holy of holies, this passionate languor of attitudes at once ardent, abandoned, with heads thrown back, these avalanches of delightful forms, bodies and heads diminishing with the distance of perspective in the paintings and statues, with the smile of a race of celestial beings, ubiquitous floating suavity, whatever seemed to be divinely opening there with an ecstasy worthy of St Theresa filled Mme Gervaisais with an enchanted reverence, as if in this monument of gold and marble and precious stones, she found herself in the temple of divine love.

... But in the rest of the church, a chapel attracted her even more: the chapel of St Ignatius. On entering and leaving her step instinctively took her there. A grand, elaborate gate, a sombre bush of black bronze whose interlaced branches held the bodies of children, carrying on its pedestal of precious stones eight opulently contorted candelabra; a gold altar at the back, whose lighted lamp was a furnace of golden flame; gold everywhere, chased, plated, bedazzling, enveloping, under these superb glimmering lights, the green and yellow of ancient times; above the altar flashed the foliage of a frame, enclosing, hiding the massive silver Saint; the frame itself was supported, raised, crowned by angels of silver, marble and gold; above the architrave, its tempest, the swelling of its sculpted waves, a stream of polished splendours, a group of the Trinity and in the hand of God the Father, the globe, the largest piece of lapis-lazuli in the world; from each side of it flowing figures descending, groups, allegories, with fluid, undulating drapes, a luxuriant *rocaille* whose heavy blaze of gold enfolded the white of the marble; three walls of treasures, such was this chapel.[14]

Before the flowering of the Baroque period, with its excesses of gold, silver, colour, volutes, niches, cupolas, that persuasive art where each ornament functions as an exhortation to faith, the beginning of the Seicento in Italy was a moment of shadow: shadow which the Carracci of Bologna spread across their canvases, shadow which Michelangelo Merisi de Caravaggio used in his strongly contrasting, incandescent compositions, whose realism never ceased to scandalise the Church authorities. It was also a moment of balance, of the return to academia in the search for perfection, measured against the example of the great masters of the past. Art became syncretism and calculation, a quest for the purest line, the most finished colouring, in a synthesis of the teachings of Raphael, Michelangelo and the Venetian school. These quests culminated in the work of the Romano, Guido Reni, with its frozen elegance, its denial of extremes, its search for a happy medium, its geometric compositions whose background colour was greyish silver. He illustrated this new definition of beauty: 'This ideal condition where all links with nature are realisable and which instills a state of balance and moderation; it is a form in which all the unruly passions are ordered into a harmonious system and act in an orderly manner.'[15] The third and final innovation, besides those of moderation and the use of shadow, at the beginning of this century (insofar as one can glean general tendencies in such a varied period for art) was that painting should not be addressed solely to élites.

But was it really a question of finding a following among the general public, as Claudio Argan has claimed? One thing is certain: artists began to introduce street scenes into their paintings. Annibale Carracci dared to paint a butcher's stall. Caravaggio used street urchins as models. History does not tell us if their art reached the man-in-the-street but it did stop depicting mankind solely through the purple of prelates, the velvet and precious stones of aristocrats. Art confronted reality in all its forms. The countryside reappeared in painting. Art no longer drew its grandeur from the imaginary elevation, temporal or spiritual, of its models, but from a search for inherent truth.

This change can be seen in Caravaggio's St Matthew – an old man with big dirty feet, surprised at being summoned to Heaven by an ill-kempt angel with the grim look of a teenage thief. It can be seen in the same painter's dead Virgin who resembles a housewife fast asleep after a harassing day's work, with swollen belly and bare feet, mourned by a serving wench. The eternity of the masterpiece now no longer belongs solely to those rich people who can afford to commission it. The poor are also honoured with draughtsmanship, colour, scenography, with the artist's illumination. Painting is returned to a most ordinary world after the Renaissance's obsession with myth.

Annibale Carracci (1560–1609) and Caravaggio (1573–1610) were Rubens's most prominent contemporaries and were active while he was in Rome, but Rubens would not have been interested in meeting them, just as he wasn't in meeting the elegant Guido Reni, il Pomarancio, or the knight of Arpino. Nor would he have any truck with the fast-living, quarrelsome community of Flemish painters who lived near the Piazza di Spagna. Rubens preferred to stay with his brother Philip in an apartment staffed by two servants which they occupied in Via delle Croche. He did make the acquaintance of his compatriot, the landscape painter Paul Bril, and the great Adam Elsheimer, but only through a doctor named Faber, who had looked after him when he was ill with pleurisy in the winter of 1606. And even in these circumstances Rubens was less interested in the man than in his work. Nor had he come to Italy to be fashionable and copy the taste of the day, since it was Italian art as a whole which interested him. If he did a lot of travelling around Italy it was mainly to track down what he could find. The account of his travels which his brother asked for in Rubens's correspondence has not been preserved, so we turn instead to his sketchbooks, which he filled tirelessly, '[putting] to profit those things which were to his taste, sometimes copying them, sometimes writing notes on them which he accompanied with a quick pen-sketch, always carrying a notebook with him for this purpose'.[16]

These notebooks were acquired, after various misadventures, by the Louvre, but were partially destroyed in a fire which swept through the palace on 30 August 1720. However there is a description of them written by the historian Giovanni Pietro Bellori, at the end of the seventeenth century:

> We have yet to speak of the artist's habits: Rubens was not only a pragmatic person but also erudite. There is a book, in his hand, which contains some observations on optics, on symmetry, the theory of proportions, anatomy, architecture, and an enquiry into the principal actions and reactions chosen from among the descriptions of poets and the demonstrations of painters. There are battles in it, shipwrecks, names of things, and other passions and events. Some lines of Virgil and other Latin poets are transcribed in connection with paintings, principally Raphael's and those from antiquity.[17]

These writings are now lost though a number of sketches still exist. For Rubens, drawing served many purposes (copying other paintings, studies for his studio, sketches for paintings, preparatory drawings for engravings, whether of his own paintings or for the frontispiece of a book, work he did throughout his life for his friend, the printer Plantin), and he modified his technique according to the end product he had in mind. In all, he left more than a thousand drawings. No one has risked compiling a complete catalogue for to do so one would first have to draw up an inventory, then establish the authenticity of all the drawings which have been attributed to him. We will only consider the first kind here – copying.

The copies made in Italy by Rubens fall into two categories: those of works of antiquity, and copies of paintings by others. For an artist this type of work has two purposes. First, his hand becomes the hand of another painter, and so he learns from his predecessors. Apart from this teaching function, drawing was also the only means of recording works of art dispersed in houses and galleries which Rubens was not sure he would visit again. Since art books did not exist, he compensated by making up his own library, his personal catalogue.

Rubens therefore consigned Italian art to his notebooks, and worked on his drawing, building up a store of models for future works, preparing his archives for his own studio, teaching material for those of his children who would follow him – as we have already seen in the provisions of his will. Some people have claimed that he wanted to establish a catalogue of western art, but his copies are too selective to aspire to that. Instead he seems to be following his own leanings which in the first place veer towards

antiquity, then towards the Italian masters, according to his personal preferences.

As a humanist passionate about archaeology, he made studies of all the remains of the past: decorative sculptures, military weapons, religious artifacts, and domestic utensils. 'Everything that threw light on life at the time of the Roman Empire excited his interest: altars, trophies, armour, arms, furniture, clothing, vehicles, musical instruments.'[18] Some of these drawings were used in Philip Rubens's book on Roman costume which appeared in 1608. In addition, Rubens copied a number of heads and busts of Ancient Greek and Roman personalities, philosophers, writers, or others whose physiognomy appeared worthy of interest.

He lingered over those great sculptures of antiquity: the Bull in the Farnese palace, the Fisherman of Pompeii (which in the end proved to be a statue of Seneca), the group of Ares and Aphrodite (now in the Louvre), the Farnese's Flora and Hercules. Gaul killing his wife and himself, Apollo, and the Belvedere torso, Hercules and the infant Telephus, the child with the goose, the Hermaphrodite, barbarian prisoners, from the Cesi collection. He accompanied his sketches not only with Latin quotations but also with theoretical studies, like the one on the Hercules in the Farnese collection. After discussing Ptolemaic theories on proportion, Rubens showed that the impression of irresistible strength which comes from the statue springs not from accidents on the surface, dynamism of posture or exaggerated musculature, but in the use of basic forms, cube, circle, equilateral triangle, from which principles the enormous block of marble was cut. In the course of this study he omits neither eyebrows nor muscles around the eyes nor the shape of the forehead, and reveals the progression from cube to square, from triangles to angles, from circles to arcs. Reading his notes, one might conclude that this fabulous physique originated from pure mathematics.[19]

These schoolboy exercises apart, he did not spare himself more minutely detailed work: copying the reliefs on sarcophagi, arches, columns and triumphal arches (he made a dozen drawings of Trajan's Arch). Finally he took to copying the inscriptions carved on antique cameos, and even developed a technique for making moulds of them.[20]

It did not seem to worry Rubens that most of these antiquities were copies of works from the Hellenistic period made towards the end of the Roman Empire. According to Michael Jaffé, only three authentic Greek works fell under his pencil: a Pentelic marble (from quarries in the Attic mountains), a Canephora in the Villa Montalto, and a horse's head similar to the one in the Medicis collection of bronzes in Florence. This whiff of authenticity would no doubt have answered Rubens's prayers, but even as copies these antiquities had more value than their Flemish translations in

the hands of Venius or Bernard van Orley. What is more, Rubens was a fine enough connoisseur of antiquity to know that the Attic sculptures were very rare indeed. Undeluded by the quality of the models, he extracted whatever struck him as good.

As a consequence, busts and heads provided him with models for characters. Arches, friezes, elements of antique architecture helped him design the triumphal arches celebrating the entry of the Governor of the Low Countries into Brussels and Antwerp, work which he did in the very last days of his life. Nevertheless, he never made any deliberate 'quotation', for 'he had so profoundly absorbed the language of the Ancients into his artistic repertoire that he could speak it without a trace of a Flemish accent'.[21] From this perfectly assimilated knowledge was to spring a type of painting that became universally recognised for its instinctive character and spontaneity.

What is remarkable about Rubens as a copyist is that such devotion to the masters did not preclude a certain amount of criticism on his part. Rubens was not content merely to copy in a purely calligraphic way: he retouched. 'When Rubens encountered mediocre drawings, or badly preserved ones, created by the great masters, he took pleasure in retouching them, putting his intelligence to it, following his principles. He thus transformed them to his own taste, with the result that with this invention these drawings should be regarded as the great man's own output, and one can learn much from them as regards chiaroscuro.'[22]

Retouching was little practised – mostly when restoring damaged work – but Rubens was not satisfied with retracing a line in the style of that he was copying. He was to spare neither the masters of antiquity nor those of the Renaissance – Michelangelo, Raphael – not even his contemporaries, the Carracci, nor his compatriots, Van Orley and Vermeyen, who were his first victims. One such drawing was by Giovanni da Udine, a cartoon for a tapestry for the Constantine chamber at the Vatican, on which 'the artist's intervention seemed to be limited to a few light strokes of the pen and the addition of some coloured highlights which gave the composition a seductive quality'.[23] Rubens had less respect for Polidoro di Caravaggio's 'Perseus displaying Medusa's head to his enemies'. 'The comparison between the two pages – the original and Rubens's copy – shows that Rubens's alterations add relief and movement to the drawing which are absent in Polidoro's original.'[24] The commentator approved of Rubens's interventions, judging that his alterations were improvements. At this juncture it matters little whether Rubens's amendments made the original better or worse. What is significant is Rubens's total lack of servility in his homage to the ancient masters. These exercises reveal that Rubens had

clear ideas about this art. In the daring way he imposed it on his renowned predecessors he also demonstrates his clear awareness of his capabilities. Throughout his stay in Italy he worked at developing his talents through constant practice and exploiting them in the right circles.

During his absence from Flanders Rubens spent his time in three places: Mantua, where he lived for a total of three years; Rome, where he stayed when he wasn't in Mantua; and finally Spain, which welcomed him for a large part of 1603 as Vincenzo de Gonzaga's emissary to the court of Philip III – an experience which was to prove of great significance in the future. From Mantua he made several excursions to other cities, either on his own or in Vincenzo's retinue: to Milan first, to copy Leonardo's *Last Supper*; to Florence where on 5 October 1600 he took part in the marriage by proxy of Marie de Medicis, Vincenzo's sister-in-law, to King Henri IV of France; to Genoa where he accompanied Vincenzo in 1607; and to Verona where he visited his brother.

By taking him to his sister-in-law's wedding in Florence, Vincenzo opened up interesting prospects for Rubens. And no doubt Rubens profited from the ten days of festivities by visiting Michelangelo's house, the Medici chapel and all the buildings that would have aroused his artistic curiosity. And yet he was obviously particularly struck by the ceremony itself. Twenty years later when he was commissioned by Marie de Medicis, now Queen Mother of France, to tell her life story in a series of paintings which were first hung in Luxembourg Palace and are now in the Louvre, he could remember it well and painted the wedding ceremony almost entirely from memory. He even recalled details in a letter to Nicolas Claude Fabri de Peiresc the humanist, who thanked him for them in his reply of 27 October 1622:

> I learned with pleasure that you were present at the marriage of the queen in the church of Santa Maria del Fiori and in the banquet hall; I thank you for having recalled for me the Iris, accompanied at table by a Roman Victory dressed as Minerva, who sang so beautifully. I regret that we were not linked by the friendship then that so unites us today.[25]

We shall never know about Rubens's day-to-day life in Italy, and his voluminous correspondence reveals little. In Rome the Flemish lived in the Trinita del Monte area and, as contemporary chronicles show, they led a jolly, boisterous existence. The police annals of the time are full of accounts of their quarrels, fights, nocturnal revels and arrests – and subsequent fines. Rubens lived close by but did not mix with his

compatriots, preferring his brother's company and visits to the great collections.

If Rubens felt the Flemish revellers were beneath him, and even disdained the more refined celebrations in Mantua, this does not imply that he lived the life of a recluse. For a start he had a taste for splendour, undoubtedly because it signified power, and preferred the company of powerful people, working his way into their circles patiently and intelligently. When he arrived in Italy he knew only his brother. As we have seen, in Venice he succeeded in attracting the attention of a Mantuan courtier. Furthermore, in Antwerp his brother Philip had studied with William Richardot, whose father Jan was now Chargé d'Affaires for Flanders in Rome and whose secretary Philip became. Jan Richardot would later recommend Peter Paul to the Archduke Albert and Archduchess Isabella, governors of the Low Countries. In Mantua Rubens was rapidly drawn into the good graces of Annibale Chieppio, the Intendent of the Duchy, whether by calculation or out of genuine friendship we do not know. Chieppio in turn recommended Rubens to Cardinal Montalto in Rome. Montalto was the extremely rich nephew of Pope Clement VII and knew other people of rank. He introduced the young Flemish painter to Scipio Borghese, nephew of another pope (Sixtus V), himself a wildly enthusiastic collector and, as a bonus, official Protector of the Germans and Belgians in Italy.

Rubens seemed to know when it was politic to obey Vincenzo's orders and follow him on his travels – thereby gaining an entrée to other circles. In Genoa, where the Duke's bankers lived, he made friends with the Doria, the Spinola, the Pallavicini. And so one thing led to another: with each encounter he made a good impression and built upon his reputation; each new acquaintance invariably gave him one or two commissions of varying importance, which today are in museums and private collections. Rubens's Italian output is fairly substantial; but only three works were executed on a grand scale and each has its own tale to tell.

The first painting was destined for the Archduke and Archduchess in Brussels. Albert, King Philip II's nephew, had been titular Cardinal to the church of Santa Croce in Gerusalemme in Rome. Shortly after he became Regent of the Low Countries, he decided to pay tribute to the church he had left by donating a retable, hoping at the same time to be reconciled with the Holy See, which was ill-disposed towards him, because of his incapacity to quell the Flemish Calvinists. The Archduke was scouring Rome looking for a painter, preferably Flemish, to carry out his commission, 'on condition that expenditure did not exceed 200 gold écus'.[26] Jan Richardot, his representative in Italy, thought of his secretary Philip Rubens's brother, a young painter and too little known to demand an

exorbitant fee. This was not very flattering for Peter Paul, but it was an entrée. The order was signed on 12 January 1602 and by 26 January Rubens had already finished the centre panel, *St Helen Finding the True Cross*, thereby demonstrating for the first time what was to be one of his most enduring characteristics: his speed. Thanks to Richardot's intercession he obtained permission to extend his stay in Rome to finish the two side panels: *The Crowning of Thorns (Ecce Homo)* and *The Erection of the Cross*; returning to Mantua in time for the carnival on 20 April.

In July he was off again to see his brother in Verona. The two brothers went to a gathering of Philip's friends, and when Rubens returned to his protector he recorded this meeting on canvas: he himself - slightly bald - is in the foreground, surrounded by Philip, the philosopher Justus Lipsius, and the philologist Jan Woverius; in the background is Lake Mincio which he could see from his window in Mantua.

The time had now come for Vincenzo to take an interest in Rubens as a painter. His mother, Eleanor of Austria, had just died. She had been an ardent protector of the Jesuits and had had a difficult time getting them admitted into the duchy. Vincenzo had finally relented, not on account of their religious proselytism but because they were the best teachers of his time, and the Duke was keen to contribute towards his subjects' education. He had therefore given orders for a church to be built for them in his States and commissioned a triptych from Rubens for the ornamentation of the main altar which was built over his mother's tomb.

These three paintings - the first important commission he received from Vincenzo, and Rubens's second largest Italian work - were begun in 1602 and were finished three years later. They were unveiled on Sunday 5 June 1605, Trinity Sunday, and show the Gonzaga family worshipping the Trinity. Bearing in mind the speed with which Rubens worked they might seem to have taken a long time to execute. This delay is explained by another order of an unexpected kind which the Duke asked his painter to carry out, an order which would keep Rubens in Spain for several months - as the Gonzaga emissary to the court of Philip III.

Spanish Intermezzo

Vincenzo had returned to Mantua from a campaign against the Turks in Croatia, where he had been leading his army in support of the Emperor of Germany, Rudolph II. Vincenzo also needed to keep in the good graces of the King of Spain from whom he was expecting the title of Admiral,

traditionally given to a member of the Doria family of Genoa. So in 1603 the Duke prepared gifts for the Spanish sovereign and looked around for a suitable emissary. He needed someone who was capable, charming, who had a way with words, who would not only convey his gifts safely but would also be able to make the recipient appreciate their true value so that the Duke would in turn achieve the reward he expected. Aware of the young painter's talent and ambitions the faithful Chieppio recommended Rubens as just the right man. The prince unhesitatingly confirmed Chieppio's choice for he had already had occasion to notice his young painter's good manners and erudition. One day when he entered Rubens's studio he had surprised him painting and reciting Virgil's *Georgics* at the same time. Thinking to embarrass him Vincenzo started talking to him in Latin too. Without any hesitation Rubens answered in the same language and so revealed his perfect knowledge of Latin. Other sources tell us that this former page of Marguerite de Lalain 'had been well brought up, and knew how to behave in the presence of people of quality'.[27]

In accordance with a very ancient custom – the Duke of Burgundy, for example, had commissioned Jan Van Eyck to look for a fiancée for him at the King of Portugal's court – Duke Vincenzo gave his painter an ambassadorial role: his art would open the King of Spain and his ministers' doors, and perhaps their hearts. On 5 March 1603 he informed Annibeli Iberti, his representative in Madrid, that the painter Peter Paul Rubens would be accompanying the gifts – fabrics, crystals and a great many copies of old Italian and Flemish masters – for Philip III, and on that same day Rubens left Mantua.

It was a long journey and, for Rubens, an unexpected, unhoped-for experience, which would have great consequences for the future course of his life. His first surviving letters also come from this journey. He describes so many aspects of this trip that one is tempted to describe it in great detail, since each episode is so revealing of Rubens's character.

For some reason the caravan set out on a tortuous route, rolling through Ferrara, Bologna, across the Apennines to Florence, finally embarking at Leghorn; it would have been much simpler to cut across direct to Genoa.

In the course of this journey Rubens was received – one might almost say intercepted – by the Grand Duke of Tuscany. He was always curious about his neighbour and brother-in-law, and questioned Rubens about the purpose of his journey, at the same time showing that he was already reasonably well informed as to the contents of the coffers. In response Rubens was, or pretended to be, ignorant of courtly behaviour and again either was, or pretended to be, totally lacking in understanding as to the Grand Duke's insinuations. He was astonished, astonished by everything

at the beginning of his journey. His first letter, which has survived, is a very long, very detailed and very revealing letter, which displays the - judicious - innocence of its author.

And when he began to enquire, not without curiosity, of my voyage and other personal affairs, this prince surprised me greatly by revealing to what point he was minutely informed and in all the details of the quantity and the quality of the presents destined for such and such a person. Not without flattering my pride, he told me who I was, where I came from, what profession I exercised and the rank I occupied. . . . It is probably my naivete which arouses within me such astonishment before things that are doubtless ordinary at court. Forgive me, and enjoy this account by an inexperienced novice, and consider only his good intentions and his desire to serve his masters and you in particular. Your very humble servant.

PPR Pisa 29 March 1603[28]

Rubens eventually extricated himself from the Grand Duke's clutches, but these various delays cost him dear: each town he had passed through on his journey to the coast had exacted a fee for right of way, and the horses and his retinue all had to be fed. And so he turned to Chieppio to ask for further subventions, showing in a few sentences that his innocence never prevented him from exploiting his rights or defending his preroga-tives. 'Already expenses have grossly exceeded the narrow limits laid down by the small-scale ideas of the Intendant of the castle and of others, I will do what I can. The risk is the Duke's not mine. If he distrusts me, he has already given me a lot of money; but if he trusts me, he has given me very little.'[29] We shall never know if the Duke paid up. At all events Rubens took the boat and eighteen days later he disembarked at Alicante. The court had left Madrid and was at Valladolid. When the painter arrived on 13 May 1603 the King had left for Aranjuez to hunt rabbits, a hitch that the Duke of Gonzaga's envoy used to his party's advantage. During his journey across Italy, the voyage on the high seas, and beneath the driving rain from Alicante to Madrid, the paintings had been greatly damaged: 'The canvas appears to be ruined and one might say rotting. The colour has flaked off and lifted in bubbles in such a way that one would have said the only remedy would be to scrape everything off and repaint it.'[30]

There was no question of offering them to the Spanish sovereign, so Iberti, Vincenzo's legate in Spain, proposed that Rubens repair the damage with the help of a Spanish artist. Rubens was twenty-six at the time. He was not a true ambassador and therefore had no power in diplomatic

matters. As far as his standing as a painter went his reputation rested on the triptych for Santa Croce in Gerusalemme, done for a pittance, and the preliminary work he had carried out on *The Gonzaga Family worshipping the Holy Trinity*. These facts notwithstanding, he did not take kindly to Iberti's proposition. As he calmly explained to Chieppio: 'I do not wish to be contrary, but I have made it a rule never to allow my work to be mixed with someone else's, however grand he is. If the work is mine in part only, my reputation will suffer unduly because an insignificant work will be attributed to me, unworthy of the name that I have already made here.'[31]

It was true. When Rubens arrived in Spain the great and glorious Spanish painters, Murillo (1618–82), Zurbaran (1598–1664), Herrera (1576–1656) and Vélasquez (1599–1660) were all still to come into their own. It would be another twenty years before the golden century of Spanish painting began to shine in all its brilliance. Put into the perspective of the development of Rubens's career, this anecdote is worth savouring. At twenty-six Rubens arrogantly refused any assistance; in the future he, more than anyone else, would happily turn to members of his studio. To honour his numerous commissions Rubens entrusted many of his paintings to his pupils and he had no qualms in signing them with his own name, even when he had barely touched them with a brush himself – so much so that it is sometimes difficult to attribute these paintings to Rubens without insulting him. Luckily June 1603 saw the sun return to Spain, and the paintings were washed in warm water and dried. Rubens restored them on his own, 'adept and quick that he was'.[32] In order to replace the two copies of Raphael done in Rome by Pietro Fachetti, he painted a *Democrites* and a *Heraclites* (now in the Prado) from sketches he himself had made in Rome.

Finally, in the first week of July, the King and his Prime Minister, the Duke of Lerma, returned to Valladolid. Lerma received the travellers in his dressing-gown and took all the copies sent by Vincenzo to be originals. Rubens maintained to Chieppio that Lerma was a great connoisseur of art, but one must take into account the fact that the Duke was besotted with Rubens, gave him a number of commissions, and invited him to his summer residence, the Charterhouse of Ventosilla. Iberti, Mantua's resident envoy, on the other hand, showed himself less well disposed. Jealous of the favours Rubens had been granted he continually put him down, preventing him, for example, from presenting Vincenzo's gifts to the King in person. That same day, Rubens wrote two letters, one to Vincenzo, the other to Chieppio. In the first he gave an account of the success of the mission and the pleasure the King had shown on receiving the gifts, added a few warm words

regarding Iberti and praised his 'excellent judgement, [his experience] in the clever use of terms appropriate to [the Spanish] court'.[33] In the second, which was sent by the same courier, he revealed his deception to Chieppio, confessing that he had not been presented to the King in spite of the fact Vincenzo had expressly ordered Iberti to arrange it.

> I do not say this to complain, I am not a mischief-maker, nor hungry for flattery, no more am I vexed at being deprived of this favour. I am only describing exactly what occurred, being convinced that M. Iberti would have changed his attitude if the Duke's command, though recent, had not escaped his memory at the moment of the ceremony. He gave me no explanation of the change of plans that we had made together only half an hour before. There have since been plenty of occasions on which he could have mentioned it, but he has not said a word about it.[34]

Rubens managed to overcome his disappointment. As usual he began to make copies of the paintings in the highly prized royal gallery of the Escurial. This was his first chance to come into contact with a cross-section of Titian's paintings, for the Spanish court possessed the greatest collection ever made of the famous Venetian: seventy canvases painted for Charles V or acquired by him. The Emperor admired Titian so much that, one day, so the story goes, he even bent down to pick up Titian's paintbrush for him. Rubens was anxious to copy some of the Titians to take back to Italy – and Antwerp, when he finally went home. On his death they would return to Spain after being acquired by Philip III's successor, Philip IV. Rubens also painted several originals: a suite of the twelve apostles, several portraits of Lerma's son and the Duke of Infantado's family, to whom he was presented by Iberti.

Rubens's stay in Spain proved worthwhile. He painted quickly, partly because of the limited amount of time at his disposal, but also because that is how he preferred to paint. His work and his technique show the effects of this style. 'Here and there, in the hair, the paint is applied quite thickly, but discreetly, which, done with care, is quite in keeping with the Flemish school's normal practice. Rubens would never deviate from this technique which enabled him to finish his paintings without too much effort and without overworking them.'[35] However, he did paint one of his first masterpieces, a portrait of the Duke of Lerma on horseback, 'the advent of Baroque art', a synthesis of Tintoretto and Titian in its grandness of manner. Michael Jaffé has noted how the foliage arranged around Lerma, the strong silhouette, the flamboyant use of light which edges the horse's

mane and tail, the anticipation of the army advancing in the distance, and the uncompromising brushstrokes which produce these effects, all show the extent to which Rubens was trying to rival the mature Tintoretto, as much as the mature Titian.[36]

The Duke of Lerma made him a proposal: that he become official painter to the Spanish court. Although he would have gained more recognition at the court in Madrid than at Mantua, Rubens nevertheless declined the offer. He would not be Titian's successor at the Spanish King's court yet. The time came for him to return to Mantua and Vincenzo's instructions were that Rubens should journey through France, visiting Paris, in order to complete his collection of portraits of the most beautiful women of the period. Once more Rubens rebelled, considering this task an unworthy one, returning by a direct route to Italy.

The beginning of 1604 found him back in Mantua where he intended to finish his triptych, *The Gonzaga Family worshipping the Holy Trinity*, and make two copies of paintings by Correggio belonging to Vincenzo, gifts for the Emperor of Germany, Rudolph II. Once finished, Rubens immediately concentrated on his personal affairs. In November 1605 he was back in Rome for his second stay in the papal city, a stay which would last for almost two well-filled years.

Philip was in Rome – working as a librarian to Cardinal Ascanio Colonna, whose family were powerful patrons, and who, among others, protected Caravaggio after he killed Ranuccio Tommasoni on 31 May 1606 following a quarrel which erupted during a game of racquets. The Colonna were little interested in Peter Paul and only brought a small oil painting on copper from him. Happily, Scipio Borghese had a better memory, recommending Rubens to the members of the congregation of the Oratory, who had just finished building their church, Santa Maria della Valicella, also known as the Chiesa Nuova. These disciples of St Philip of Neri were to commission Rubens's third great Italian work, a *Madonna* for the main altar of the most beautiful, most visited church in Rome – on condition that his sketches were acceptable. When Vincenzo sent word for Rubens to return to Mantua, Peter Paul asked Scipio Borghese to intervene and the Duke allowed him an extension of his leave, but only until spring. In the meantime the Duke asked Rubens to find him a house as his second son, recently made a Cardinal, was about to take up residence in Rome. In addition to his other duties, Rubens was now also curator of the Duke's collection, and it was in this capacity that in February 1607 he acquired Caravaggio's *Death of the Virgin* on Vincenzo's behalf.

In June 1607 Rubens returned to Mantua. Vincenzo was considering a trip to Spa, and Rubens was to accompany him. Rubens was overjoyed at

the prospect of seeing the Low Countries again, but the Duke changed his plans. His bankers, the Pallavicini, put their palace in Genoa at his disposal, so Vincenzo spent the summer there and Rubens went with him. He was not about to see his own country again, but compensated for the disappointment by meeting with new providers of commissions, some of whom would turn out to become lifelong friends. Over that summer he made friends with the Spinola, the family of the general who did so much for the military glory of Spain and the Low Countries; with the Doria, who supplied husbands for the Spinola ladies; and with the Grimaldi. He also painted half a dozen portraits. The Jesuits asked him for a *Circumcision* for their church and, as usual, he was busily filling up his 'books of passions' as he called his sketchbooks. This time he had a special motive: rather than embellishing his souvenir book or collecting background material for future painting, he was preparing an introductory book on Renaissance architecture for the Flemish. At the time when Europe had abandoned Gothic and rediscovered the Classical architecture of antiquity, the ravages of war had swept across the Low Countries, thus isolating them from mainstream innovations. So to record the new style Rubens began drawing the façades of the Genoese palaces. In a letter dated 26 August 1628 Rubens reveals that throughout his stay in Italy he was accompanied by a young disciple, Deodat del Monte. It was to this faithful admirer that he delegated the chore of taking the measurements of the buildings. From these drawings he put together one of his rare books, 139 plates of architectural plans, entitled *The Palaces of Genoa*, which was published in two volumes in Antwerp in 1622. We shall look at it more closely later.

Rubens was back in Rome in September 1607. The next few months would prove the last he would spend in Italy. Events were moving quickly and he lived in a state of agitation, almost panic. In February 1608 he hung his canvas above the main altar of the Chiesa Nuova, 'but the light falls so unfavourably on this altar, that one can barely discern the figures, enjoy the beauty of the colouring, and the delicacy of the heads and draperies which I executed with great care, from nature, and completely successfully, according to the judgement of all'.[37] He therefore had to reapply himself to the work and choose another base – this time stone rather than canvas – in order to avoid the reflections. His task was made more onerous by the fact that the Oratorians now demanded not only a picture for the main altar but also a monumental triptych. Simultaneously he was negotiating on Vincenzo's behalf for the purchase of a painting by il Pomarancio. The price was high. 'This sum appeared exorbitant to the [Most Serene] Madame who did not perhaps know the practice of these leading masters of Rome but believed she could deal with them according

to our fashion in Mantua.'[38] Eleanora de Gonzaga showed herself to be a narrow-minded provincial to the last and Rubens, who was acting as intermediary for the painter and his agent, was greatly displeased when the negotiations broke down. The ultimate rebuff came when he offered the Gonzagas the first painting he had done for the Chiesa Nuova – and Vincenzo refused it.

Were relations between the two men spoilt for good? Had Rubens gleaned from Italy all that he wished to learn? Was he tired of his exile? News he had received from Antwerp, where his brother Philip had returned at the end of 1606, filled him with anxiety: apparently his mother was ill. Rubens asked the Archdukes, the collective title of Isabella and Albert, to intervene so that he could return home, but Vincenzo politely yet firmly refused the demands of the Low Countries' governors: Rubens had come to Italy to study, and therefore he would study, in Rome. In October 1608 Maria Rubens's condition worsened. '[My mother] is so ill from a severe attack of asthma that, considering her advanced age of seventy-two years, one can hope for no other outcome than the end common to all humanity.' Rubens finished the triptych in the Chiesa Nuova, 'the least unsuccessful work in my hand'.[39]

'Mounting on horseback', as he signed his letter of the 28th to Chieppio, he imediately set out for Antwerp, sending his respects to the Gonzagas, voicing his distress to the Intendant and assuring him: 'On my return to Flanders, I can go directly to Mantua. This in countless ways will be very agreeable to me, especially to be able to serve you in person.'[40]

He would never see Italy again.

Art and Society

When he left Italy Rubens was thirty-one years old. His paintings from this Italian period signal the start of his fame. He had painted three monumental works: the triptych of Santa Croce in Gerusalemme, the triptych of *The Gonzaga Family Worshipping the Holy Trinity*, and the triptych of *St Gregory* for the Chiesa Nuova. He had also painted a number of portraits: *Brigidda Spinola Doria*, *The Duke of Lerma*, *Annibale Chieppio*, and *Massimiliano Doria*, his *Self-Portrait with Friends in Mantua*. A number of less important canvases date from that same period: a *Descent from the Cross*, an *Adoration of the Shepherds*, a *Young Genoese Patrician*, *Dead Adonis in the arms of Venus*, the *Circumcision* of Genoa, *Hero and Leander*, *Meleager and Atalanta*, a *Hercules*. To these must be

added the original works and about twenty copies done in Spain, and the paintings which feature in the catalogue of the Mantuan collection of 1627: two sketches of heads, a *Saint George*, a small *Nativity*, *Saint Elizabeth and Saint Joachim*, a *Bacchanalia*, a *Christ and Two Thieves*, and the *Resurrection of Lazarus*. One aristocratic Mantuan family were proud to have three canvases in his hand, there were five at Cardinal Valenti's residence, two in the family of another cardinal, plus the innumerable sketches which were to play so important a part in his future work. His output was already prolific, varied, uneven in quality, and showed evidence of great virtuosity. The paintings' titles speak for themselves: Rubens was articulating his main themes around mythology, religious subjects and portraits, subjects which conformed to the exigencies of the patrons of that period – religious orders and temporal powers. Equally they also reveal Rubens's way of coming to terms with the artist's station in life and financial conditions at that time: conformity, certainly, but only on the surface.

At the beginning of the seventeenth century, and over the next two hundred years, with the exception of Hieronymus Bosch, and Brueghel in his depiction of Hell, painting is representative, mimetic and commissioned. It therefore represents nature, history, what the artist wishes to say and what the patron wishes to see: the creator must adapt his talents and vision and find a compromise treatment for the object he is representing, bearing in mind the social power of the paymaster who has commissioned it. Through his lifestyle and the work he did during the latter part of his career, Rubens would strive, more than anyone else, to resolve the problem of freeing the artist from patronage as much as from realism.

By the time he arrived in Italy in 1600 Rubens had a few works behind him, the most successful of which was the *Adam and Eve* now hanging in his house in Antwerp. The figures of Adam and Eve are monumental, their pale flesh emphasised by too strong a pink; it is a static composition which highlights the ridiculousness of those obedient bits of foliage which happen to position themselves just below the man's and woman's navels. One can see Venius's influence in the icy cold flesh tones and the careful drawing. The huge size of the canvas and the immoderate use of the nude show that Rubens was already painting in the Italian manner either from personal preference or in obedience to his master. But Rubens was never satisfied, for even in December 1606, when he had been in Italy for six years, he was writing to Chieppio: 'I've sacrificed the whole of this summer to the study of art.' He was constantly trying to perfect his own style.

Having absorbed Italian art, Ancient Greek and Roman art, Renaissance art, Mannerist art, what had he retained of Flemish art? As we have seen,

the list of paintings he did between 1600 and 1608 left little room for the specialities of his own country, the landscapes and genre scenes.[41] The difference between Rubens and his northern compatriots, Paul Bril and Adam Elsheimer, was that Rubens never succumbed to the hills, the umbrella pines, the light of Rome and Tuscany. The most he conceded was in the background of his *Self-Portrait with Friends in Mantua*, in the gentle vista of the Mincio, the lake which bordered the Duke of Mantua's domains. This was a far cry from drawing inspiration let alone style from nature, the sunrises or luminous morning mists of the peninsula which would captivate Claude Lorrain in the 1620s. In Italy Rubens was interested in human creations and not in nature at all, but when he painted it was to order. He doubtless added his own interpretation to the scenes he portrayed but first and foremost they were dictated to him by his patrons. So trapped did he seem between tradition and patron that it is worth examining how Rubens eventually reacted against these artistic and social constraints as a scrupulous but ambitious painter.

It was not long before his drawings revealed that he had not completely submitted to his acknowledged masters and that he had no hesitation in correcting the greatest of them. Nevertheless, experts can detect some overriding influences in his Italian style: Jakob Burckhardt sees the influence of Veronese's straight line, Michael Jaffé's review of the great Italians traces characteristics which can be found in Rubens's work – Raphael's purity of line, Michelangelo's muscular men, Carracci's shading. But can one identify these borrowings with certainty? And, ultimately, what is the point of the exercise? Anyone who looks can make his own sometimes surprising discoveries. He will find Rubens's work steeped in Italy, and yet recognition of various influences won't significantly change his appreciation of Rubens. Linger for a while in front of *The Descent from the Cross* in Antwerp Cathedral and also look in the first side chapel of the church of the Trinita dei Monte in Rome. There you will find the diagonal composition once again, and Christ's companions, so admired in Antwerp, taking turns beside the cross to remove the body and hold it in their arms – however, this *Descent from the Cross* is signed Daniele da Volterra. The relationship between the two pictures has nothing to do with their individual uniqueness. Would Rubens have been familiar with Fenzoni's *Laying in the Tomb*, a work which is frequently on display at the Grand Palais in Paris: a wan-looking Christ who occupies almost the whole of the canvas, shown full face, whose knees are pushed against the lower part of his torso in a startling display of perspective already used by Mantegna? Flamand has used the same setting, the same perspective, in his painting which today hangs in the Museo Capitolina in Rome. It will

appear again much later in the *Holy Trinity* in the Royal Museum of Fine Arts in Antwerp. Coincidence or copy? Should one condemn Rubens for being 'the greatest eclectic of the period'?[42] The art historian Bellori reproaches him thus in his *Vite*,[43] as if Rubens's idiosyncratic use of the discoveries made by the old masters reduces him to being nothing more than a perpetrator of clever pastiches. Yet can the quality of a work of art really be assessed using the criterion of 'novelty'? One thing is certain: it is difficult to detect a unity, and consequently a stylistic identity, in Rubens's Italian work. He had not yet found his colours: his vermillion red, his mottled pinks, the light gold of his hair, his quivering flesh, nor yet even the particular preparation of his canvases which have made them so resistant to the ravages of time. And his first pictures, of which we are considering only the most important, are not without touches of awkwardness, even lapses of taste.

In his first great work, the triptych of Santa Croce in Gerusalemme, Rubens depicted a monumental St Helen surrounded by thin little angels. The saint's head touches the top of the vaults under which she is standing. Her eyes turned heavenwards are almost white. And perhaps because he is Flemish, and therefore a pragmatic sort of person, Rubens is unable to visualise drapery in a picture without it hanging from somewhere, as for example in Caravaggio's *Death of the Virgin*, with its heavy folds of material falling towards Christ's mother, guiding the eye towards the head of the bed. So, since there was a curtain in the composition, Rubens attached it to some copper rings on a rail. Both the side panels, *The Crowning of Thorns* and *The Elevation of the Cross*, show Christ as a muscular man with abundant hair and a thick, crow-black beard. All the characteristics which biblical history and physical detail demand are present. The Christ who is put on the cross already has his hands nailed on to planks. In the foreground there is a black slave with back turned; he is holding his arms under the crucified man's legs. Evidently he is there to hold them up. Yet since there is no tension in his stance, no indication of any effort involved, Christ's body seems to float in the air, following an immaculate diagonal, while our Saviour pensively contemplates the preparations for his torture with his head leaning towards the left.

The Gonzaga Family Worshipping the Holy Trinity is transfixed by the same hieratic rules. This painting was originally destined for the Jesuits' church in the duchy but is now on exhibition in the Reggia in the antechamber to the ducal apartments. The work was partially destroyed during the sackings of Mantua as a result of which the left and right panels of the triptych have disappeared and only the centre panel remains. This consists of a composition on two levels, joined by a scar born of the

painting's misadventures. The Gonzagas in full attire occupy the lower part. The reigning Dukes are dressed in ermine, kneeling on prie-dieux upholstered in purple fabric. Judging by re-discovered fragments the Princes are surrounded by their relations, children and servants. The power and status of the family is shown in the magnificence of their dress, of course, but also in certain more intimate details, such as the little dog which accompanies one of Vincenzo's daughters: even when facing the Holy Trinity the Gonzagas refuse to abandon their earthly privileges.

Christ and God the Father are positioned in the upper part of the picture while the dove of the Holy Spirit hovers between them and shines out with evenly spaced golden rays. The group is assembled under an ochre dais held up by strong, sunburnt angels. As a background Rubens has painted the Mantuan sky in grisaille. Taken as a whole the colours clash: the purple of the prie-dieux clashes with the ochre of the divine dais, the reds and browns are too pronounced, being juxtaposed with the ducal ermine for which Rubens has chosen a silvery white.

Here Rubens was practising the art of persuasion embraced by the Jesuits for whom he was working. He has painted an aristocratic family decked out in all the attributes of grandeur. The more manifest their power, the greater the piety which brings them to their knees before the spiritual power of the Holy Trinity. In this celebration of the Princes' faith Rubens has bowed to the painter's duty: that of serving the proselytic designs of the Catholic Church, discredited by the Protestants.

The second great religious work, the triptych of the Chiese Nuova, is stunning; monumental. Rubens has adopted a sculptural treatment of the figures – in the style of Veronese. The cherubs have got fatter. St Gregory and St Domitilla seem to be held up by the stiffness of their garments. The fabrics are finely, richly painted: the shimmering of silk, the raised embroideries. Hair, a light chestnut, is plastered down. The colossal figures affect the dynamism of the whole picture. This is a decorative painting. The panels above and on either side of the main altar are treated as academic compositions, celebrating the glory of the saints revered by the Oratorians. The colours are contrasted, light for the garments and haloes, dark for the background, in the austere style of Carracci, without Caravaggio's radiant effects.

The impressive build of both males and females apart, there are no characteristics common to these works which lead us to identify the infallible mark of one artist. Rubens was not yet using his own special range of colours. He was experimenting: whites, Veronese and Giulio Romano greens, Titian ochres, the sombre colours of Carracci.

His mastery is most apparent in the quality of the drawing, the rendering

of fabric, in description rather than interpretation of the world. He had not yet acquired the lyrical vision which would later distinguish his work, was not yet the painter of ardent vitality. Legend would have us believe that during this time in Rome, the elegant, coldly natured Guido Reni marvelled at the quality of his northern colleague's flesh tones, saying that they quivered as if the Flemish artist had mixed blood with his paint as he worked. Reni could not have known Rubens's mature work at this time. Nevertheless it is true that if one looks at Reni's refined lines, his fluid drawing of limbs, the leg and arm muscles marked so precisely with a shadow that outlines and defines them with a barely thicker, barely darker stroke, the contrast with the sinuosity of Rubens's nudes is arresting. Some people see only rolls of cellulite in these exhaustive declensions of the curve. Perhaps it would be more accurate to see them as the detailed observations of a painter who, in order to animate sculptural masses, has borrowed his relief from sculpture and explored brushwork to the full – the subtlety of tiny brushstrokes, the dappling of colours – in order to show the vibration of muscles and the circulation of blood under the skin.

One can first see this version of Rubens in his drawings, then in his love of small chubby children in the *Romulus and Remus*, to be found in the Museo Capitolino. He never plays down a dimple, whether under the chin, on the cheeks or in the small of the back, nor any crease in the wrists, neck, or tops of thighs of small boys. Rubens greatly admired Leonardo's knowledge of anatomy and tried to duplicate it in his own graphic and theoretical studies of antique art. The significance of this research, even of the many copies he made of Michelangelo's work, becomes apparent in the bulging musculature of the old man embracing a young woman in the background of *Romulus and Remus*. Leonardo's and Michelangelo's lesson can also be viewed in the right-hand panel of the Trinita dei Monte triptych, *The Baptism of Christ*, now in the Musée Royal des Beaux-Arts in Antwerp. Framed in a Leonardo-like green setting is a band of young athletes and a Christ with a flat stomach and broad shoulders who is preparing to be anointed by John the Baptist.

During this period Rubens's genius finds confirmation in portraiture: a genre which he usually looked down on and would subsequently leave behind. At the Gonzaga court he had refused to use his talent for that purpose. He would, however, still paint a number of commissioned portraits for grand clients like the Duke of Lerma, the King of Spain's favourite, the Doria of Genoa, and his Mantuan protector Annibale Chieppio. In these works he followed the dictates of his love of painting only indirectly: he pursued a strategy which would allow him to realise his ambitions as a painter to the best of his ability, in keeping with the social circumstances

of the period. He painted portraits in order to get other commissions from his sitters or because he was indebted to them, or because he was seeking their protection and help. He said so clearly: 'The pretext of the portraits, even though a humble one, would satisfy as an introduction to greater things.'[44] And so he immortalised the face of Chieppio, who guaranteed the Mantuan court's regular payment of his wages, and the faces of the Spinola ladies, who belonged to one of the most aristocratic families in Genoa.

Aided, it is true, by the young ladies' beauty, he employed a feminine style, a classical style. He copied their faces, lingered over the quality of their jewellery, their lace, celebrating an opulent, protected world – one which, as the son of an exile, he would conquer and offer to his two wives, Isabella and Helena. The paintings are faultless in design, composition, colouring; their academicism makes them boring. Rubens took no risks: he was content to reproduce a flattering picture of a society he envied.

More revealing are the paintings which allow a glimpse of Rubens's unexpected humour. This does not, however, come anywhere near Titian's ironic portrayal of Pope Paul III with his two inheritors, the Cardinals Alessandro and Octavio Farnese. In this Venetian painting the emaciated uncle is casting a piercing, sardonic glance at his nephew, who is leaning towards him and whom he knows to be savouring the hour of his death more than his possible return to health. Rubens is audacious in a more subtle way and would not put such a show of hypocrisy into a painting of his. Nor did he favour caricatures along the lines of Goya. He expressed phenomena exactly as they were, whatever they were. On the triptych of the Gonzaga family he creates a pitiless portrait of Eleanor of Austria to whom the painting was dedicated. She is dressed entirely in black, her red face the shape of a baked apple, surmounted by a head-dress which is also black. The white flounce which edges it half hides her face, thus accentuating her thick sanguine lower lip. The painting was intended for no less than the main altar of the Jesuits' church in Mantua: Vincenzo accepted this remembrance of his mother in spite of the fact that it was totally lacking in flattery.

As an official court painter, and as such dependent on the Intendant Annibale Chieppio's favours, Rubens devotes his talent to the service of his protector. He does not show him full length but in close-up, dispensing with the need for a setting. Chieppio is in ceremonial dress which confers a certain nobility on his person, while turning attention away from exclusive contemplation of his face. He appears as fat as a cardinal; the first of his chins is garnished with a fine beard while the second rests directly on his shoulders. Two straight lines outline the sides of his face, at right angles

47

with his narrow, black functionary's eyes. Retained within its frame of flesh Chieppio's face becomes imposing, the more so because he displays his size rather than trying to hide it. By giving this fat man the close-up treatment Rubens refines him, endowing him with the mind of a man who knows his faults and makes fun of them.

Like his contemporaries Rubens had completed his initiatory travels in Italy. Unlike Bril or Elsheimer, however, he had not renounced his own country or his family. We shall never know whether it was merely anxiety about his mother's health or the desire to paint in his homeland again which drew him back. He left Antwerp emulating Venius, the Romanist; he was returning an admirer of Michelangelo, Raphael, Giulio Romano, Veronese, the art of Ancient Greece and Rome. His reputation was not quite as great as he had been claiming since his return from Spain; he was known, certainly, but he was not the Rubens we now know. How would he react, how would he paint when he reached his own country? What stance would he adopt towards Flemish art which he knew only through the perverted teaching of Venius and had perhaps forgotten after eight years of painting in the Italian manner or under the influence of Ancient Greece and Rome? Was he Flemish or Italian? Would he syncretise as he had done in borrowing from antiquity to add to Italian and Flemish art? He still did not know himself, as is indicated in a letter of 10 April 1609 addressed to his Roman doctor Faber: 'I have not yet made up my mind whether to remain in my own country, or to return for ever to Rome where I am invited on the most favourable terms.'[45]

THE PAINTER OF ANTWERP
(1608-1622)

The Return Home

Rubens's journey from Rome to Antwerp took five weeks - almost 400 hours on horseback. On the way he learned that his mother had died on 14 November 1608. By the time he reached Antwerp all he could do was visit her tomb in St Michael's Abbey. His haste to be at his mother's bedside and the grief he felt on losing her, not having seen Maria since his departure eight years earlier, was proof enough of his attachment to her.

Antwerp, December 1608. Rubens's first act was to place on his mother's tomb one of the first paintings he had done for the Chiesa Nuova, a canvas which he had brought from Rome. His grief was so overwhelming that he needed to retreat into a monastery for a few weeks, and it was not until January 1609 that he reappeared in Antwerp. What had started out as a son paying his last respects to his dead mother now determined and shaped his whole future as a painter.

In fact, when he had left Italy it seemed that Rubens intended to return there. On several occasions in the past he had been obliged to ask powerful people to persuade Vincenzo de Gonzaga to authorise him to return to Flanders, particularly when distance weighed upon him and he longed to see his family. Yet it seems clear he had never envisaged leaving Italy for good, and even six months after his return, as his letter to Johann Faber[1] shows, he was still undecided between Flanders and Italy. It is noteworthy that in spite of the speed of his departure - he posted his last letter to Chieppio 'mounting on horseback' - Rubens had nevertheless taken the trouble to pack a number of his paintings, in particular the one he had placed on Maria's tomb: the very one Vincenzo had deemed unworthy of his galleries (or too dear for his purse?). He had brought away his most precious possessions, perhaps in the hope of finding a buyer in Antwerp or maybe because he already felt that his return to Italy was more than improbable. Though he would live for another thirty years, he would never see Italy again. It must have seemed to him as though everything and everybody were conspiring to keep him in Antwerp, and in the end it didn't bother him any more.

In the Low Countries, though, political, family, economic, religious and social contexts augured well for Rubens's career. Flanders had been relatively peaceful since Archduke Albert came to power in 1596. In the north the United Provinces, under the leadership of Maurice of Nassau, Prince of Orange, had not abandoned their demands for independence, in fact, quite the contrary. Nevertheless, open hostilities had ceased. In the south the Low Countries were dressing their wounds. Thanks to Alessandro Farnese's moves towards a peaceful settlement, the tensions between Calvinists and Catholics, the Flemish and the Spanish, were less acute than thirty or even ten years earlier. The southern provinces were weary of religious wars and Calvinist vindictiveness and had returned to Catholicism. They were becoming accustomed to being subjects of Spain, the guarantor of relative calm. Before his death in 1598 King Philip II had introduced several conciliatory measures which had been put into action by Farnese: he had withdrawn some of his troops, thus removing one of the main causes of discontent, and rallied the nobility by inviting them to sit on the Council of State - late, cosmetic concessions, but apparently enough to appease the Belgians. Elsewhere the Habsburgs of Austria continued to dominate northern Europe.

When Farnese departed, removed for being too successful, Philip II had at first entrusted the regency of Flanders to his nephew Ernest of Austria, one of the many sons of Maximilian II, the Holy Roman Emperor. When Ernest died prematurely Philip II called upon his brother the Archduke Albert, who made his triumphal entry into Brussels in 1596. It was decided that Albert should also become Philip II's son-in-law. To avoid the loss of Spanish control of his Burgundian states Philip II had instigated an alliance whereby the Burgundians would always be ruled by a Habsburg prince. Spain and Austria were both ruled by the same Habsburg family and thus were directly descended from Charles the Bold, Duke of Burgundy, inheriting through his daughter Mary. Philip's daughter, Isabella Clara Eugenia, born of his marriage to Princess Elisabeth of Valois, would marry her cousin Albert, since Ernest to whom she had been promised was dead, thus allying the two branches, and both would rule the Low Countries. As Philip II was very fond of his daughter, he gave the couple a certain autonomy in exercising the regency of their provinces. The Act of 6 May 1598 may have ceded the Low Countries to their sovereignty, but in reality they were never more than governors, for four months later Philip II died and Isabella's brother became King.

Philip III, Charles V's grandson, acceded to the throne of Spain on 13 September 1598. Philip reigned over twelve kingdoms and spent his lifetime simply trying to preserve these sovereignties intact, since the

mounting power of Protestant England and Catholic France rapidly stifled any vague desire he may have had for European hegemony. Unfortunately, like his father, he was also to commit the error of mistrusting his Belgian subjects, rebellious or not, and failing to understand their political and economic importance in Europe. He also failed to understand that because the southern Low Countries had been ruined by the silting up of the Schelde he could no longer count on their taxes and food supplies as his grandfather had been able to do. Philip again failed to appreciate the importance of the secessionist states to England and that their economic interests would inevitably lead England to support Maurice of Nassau under the pretext of protecting their fellow Protestants, and that if Spain fought the Calvinists it would also have to contend with English opposition and troops.

Philip III was both arrogant and blind: he saw the whole of the Low Countries as Spanish territory. He believed he had the power to subdue the rebels of the north and compel Maurice of Nassau to agree to reuniting the seventeen provinces under his own authority. Since he considered that everything emanated from Spain and should therefore revert to her he would never give Isabella the economic and political support she needed to avoid the partition of the Low Countries. On the contrary, when the galleons from the colonies no longer provided the necessary finances for Spain, he merely increased fiscal pressure on the southern Low Countries, failing to back up his action by despatching troops to maintain his offensive against the Calvinists. Finally, and most importantly, he was reluctant to loosen his hold on the Low Countries and was unhappy at his half-sister and her husband's semi-autonomy. In his eyes the couple, who had made their triumphal entry into Brussels in 1599, had failed in their mission of reunification by losing the town of Bois-le-Duc, which had become the bridgehead for the Calvinists in Flemish territory. Philip used this defeat as a pretext for gradually removing all decision-making powers from Isabella and Albert. In 1604 he decided Albert could no longer manage the funds which came from Spain; the following year he removed Albert as leader of the armies.

The new army commander was General Ambrogio Spinola, a young Genoese nobleman aged thirty-three, who had put his fortune and followers at Spain's disposal. Spinola, a great strategist, drove back the Calvinists and forced them to sign an armistice in 1607. Philip III then secretly invested him with powers which effectively made him the highest functionary in the kingdom, entrusting him with the mission to return Isabella to Spain in the event of Albert's death. Alternatively, if Isabella should die, Spinola had to make Albert swear an oath of allegiance to Spain. As it was, every decision taken in Brussels already had to await the endorsement of Madrid before it

could be carried out. Madrid frequently delayed ratification since Philip III had inherited his father's tendency to prevaricate.

In reality, therefore, nothing had changed since the death of Charles V. If anything, faced with the growing organisation of the states in the north, the negligence and pride of his successors had merely succeeded in precipitating the break-up of his empire.

In as much as she was a direct descendant of Charles V and the dukes of Burgundy Isabella was given a warm welcome by the Belgians. She would prove to manage her relative independence well, and when her husband died, contrary to Philip III's plans, she would keep the Flemish throne. Both Albert and Isabella had little charisma but they did not lack character. For their official portraits they chose to pose in black, their necks hidden by high lace ruffs. Isabella is as massive as her husband is puny. She has big dark eyes and a determined expression; her lips are too thin for her coarse face. She had inherited her father's austere piety and, on being widowed in 1621, she cut her hair short and henceforth wore the sombre habit of the Poor Clares, for she had been brought up in their convent in Madrid. Isabella married when she was thirty-two and, realising that her marriage would be childless, chose to lavish her maternal affection on her followers. In private she was a gay and lively person. In times of war she would assemble the women at court and together they would tear up sheets for dressings.

Like her father, who had introduced her to affairs of state, she was a hard worker: it was not unusual to find her still at her desk at four a.m. Unlike Philip III, her brother, when she chose her retinue she avoided giving positions of power to second-rate favourites. However, in Brussels she insisted upon maintaining the devoutness and etiquette of the Escurial. Her counsellors were Spanish, tuned in to Madrid, where Philip III had quickly re-established the Council of Flanders, presided over by a Spaniard, effectively silencing the Belgian noblemen who were convened there and curtailing their participation in decision-making even further.

Throughout her marriage Isabella proved a discreet and faithful adviser to her husband, who was less popular than she in the Low Countries. Albert was thin, with sandy hair and a small beard which did little to conceal the long Habsburg chin. Albert was as much an art-lover as his wife was devout and possessed more than 200 paintings, one of the finest collections of the period. Because his frail constitution made him unfit for a career in the army, he was made governor of Portugal in 1581 by Philip II. His uncle, who brought him up, also made him a cardinal at an early age before dynastic reasons obliged him to take the place of his brother Ernest as Regent of the Low Countries. But he was no warrior and his military

failures against Maurice of Nassau earned him the mistrust and contempt of his cousin, Philip III.

Opinions on the Archdukes differ. For some Albert and Isabella were Spanish foreigners in Flanders with no hope of founding a dynasty there, and with no power to take initiatives of their own. Their only refuge was in religion and they became zealous propagators of the Counter-Reformation, working to re-establish the Catholic faith by sheer effort and miracles. In the process, it is argued, they ended up neglecting their subjects' welfare, turning their palace in Brussels into an 'offshoot of the Escurial'.[2] Others saw Albert and Isabella as motivated by a desire for peace. This school of thought believes they conscientiously fulfilled their duties for the good of the Belgians, pointing out that under their rule Flanders enjoyed twenty years of calm and prosperity. These two opposing views are in fact complementary: Albert and Isabella were incapable of bringing total peace to the Low Countries but were able to maintain the calm which had been re-established by Alessandro Farnese.

Because the international economic and political situation had changed neither Brussels nor Antwerp regained their former pre-eminence. The Schelde was silted up and commerce had been interrupted in the Flemish ports. Little by little Germany and England became the centres of commerce and finance the Low Countires had once been. Appropriately enough Albert and Isabella took charge of reviving the traditional industries – textiles, lace, tapestries, arms, drapery, naval construction, gold and silver work, glass-making – which had made their country's fortune and whose renown and quality had outlasted the civil war. They also attempted to put some order into financial practices which had developed in an anarchic manner, as many bankers, notably those from Antwerp, attempted to compensate for the losses they'd made as a result of the decline of the port by taking up money-lending.

There must be money to stimulate economic activity. The merchants and the nobility who still had a little lent it out at exorbitant rates. There were quicker profits, requiring less effort, to be made in a shop lending money against security, than in working in the fields. Landlords increasingly became financiers and allowed their lands to go to waste, so food supplies accordingly became short. In order to put an end to the unbalanced state of the economy, Albert and Isabella began to limit interest rates to twelve per cent. When this measure failed to put a brake on money-lending they advanced what had originally been an Italian idea for producing liquid assets for businesses: municipal credit. So it was that Albert and Isabella introduced state-owned pawnshops into Belgium in 1618.

As for their relations with the United Provinces, it was during the

Archdukes' regency, on 9 April 1609, that the Twelve Year Truce was signed. Fighting ceased, to be replaced by mutual monitoring. Maurice of Nassau had succeeded his brother as leader of the secessionists of the north; but the help he received from England did not prove sufficient to take the southern provinces. Calvinism's victory over Catholicism in this corner of Europe mattered little to the English: they were preoccupied with securing a maritime window on the continent rather than anything else. Consequently they calculated the amount of financial and military assistance they would have to give to keep the United Provinces under their supervision, paying them subsidies which were just big enough to obtain commercial facilities but not large enough for the Hollanders to manage without them and thus close their ports to English trade.

Isabella, for her part, could not count on Spain, whose international prestige had largely evaporated after the disaster of the Invincible Armada and who now had to counter the hostile threats of France and Cardinal de Richelieu. A *modus vivendi* between North and South was reached, only occasionally disturbed by guerilla naval attacks mounted by Calvinist sailors, while the Flemish concentrated on building embankments and fortifications. The truce may have only been agreed for twelve years but it unofficially confirmed the Union of Utrecht's secession and the Hollanders' determination to sever themselves from the south, whatever the cost. Its terms made no mention of the federation sought by William the Silent, who wanted to rid the Low Countries of the Spanish altogether while preserving the unity of the seventeen provinces. Nevertheless it implied recognition of the partition of the United Provinces, the carving up of the King of Spain's Burgundian inheritance, and also a *de facto* recognition of the Northern provinces as a legal entity. The situation appeared ratified, secession irreversible.

In a biography of Rubens this is an important point. The breaking up of Charles V's Burgundian possessions seemed an inevitable if unwelcome fact – given the blind, intransigent attitude of the Spanish. But where did Rubens's loyalty lie? He was patronised by both the Archdukes and the Spanish Habsburgs.

Let this question remain unanswered for the moment. Rubens had escaped the last skirmishes and he returned home just as peace was being established. The Archdukes set about stimulating economic activity and encouraging a renaissance of the arts for, as the business class made up a large part of an artist's clientele, the two went hand in hand. The Counter-Reformation was at its height, and the Catholics intended to regain ground which had been lost during the period of Calvinist iconoclasm. Thus they set about rebuilding their churches, filling them with the

persuasive ornaments, sculptures, volutes, statues, paintings, clouds of marble and rays of gold and silver which would drive the faithful back to the Church. Here as elsewhere, those who worked hardest at this religious revival were the Jesuits. At first they were not welcomed, for Philip III mistrusted these monks who took orders only from Rome and meddled in the people's education.

Like everyone else, the King of Spain would give in when confronted by these zealots of St Ignatius. The other orders followed close on the heels of the monk-soldiers in the sumptuous re-establishment of the Catholic cult. The clergy resumed their function of patronage. Under their aegis and with support from the pious Archdukes, Flanders regained a little of the splendour it had known two centuries earlier. Nevertheless there was a singular lack of literature. Since Erasmus the Low Countries had produced no more great writers. Humanism had passed. Now the Jesuits controlled education and they gave priority to scientific study. As far as literature went, learned men like Rubens and his acquaintances could only draw on Ancient Greek or Roman texts or literature from foreign countries. His family's social position and the reputation he had acquired in Italy soon helped Rubens find his place – at the top – in this new stage of his life.

His brother Philip, who had returned to Flanders earlier on, had become an Antwerp magistrate taking over his father's old post. Philip was well-educated, a humanist and lawyer like his father, and was devoted to his younger brother Peter Paul. He played an important though brief role in his life, since Philip was to die in 1611, scarcely two years after Rubens's return to Flanders. As a Latin scholar of repute Philip was particularly interested in the daily customs and religious rites of Ancient Rome. He wrote a book on the subject with illustrations by Peter Paul which was published by Balthasar Moretus. Philip was a favoured disciple of the philosopher Justus Lipsius, whose standing in the Low Countries then equalled that of Erasmus, and it was thought that Philip might succeed Lipsius at the University of Louvain in 1606. But Philip was tempted more by municipal administration than teaching, feeling his qualities as a philosopher in no way equalled those of his master, and so refused.

In so doing he once again revealed his characteristic modesty, a modesty which led him to adopt an admiring, almost fawning attitude towards his younger brother and blossomed into flowery dithyrambs about him during their stay in Italy.[3] Naturally enough, in view of this close bond, it fell to Philip to reintroduce Rubens into Antwerp society. Welcoming Peter Paul into his house, Philip set out to find him likely patrons, introducing him to the most eminent people in the cultural milieu in which he moved. In her sons' absence Maria Rubens had cultivated the élite of Antwerp, and

now Peter Paul discovered that he had a fair number of social contacts. As we have seen, he knew how to take great advantage of these acquaintances, all the while aiming for the ultimate prize – the favour of the Archdukes.

Albert and Isabella soon made his acquaintance, since Rubens was a painter of established renown who had already done some work for them, and invited him to Brussels. According to the first mention of Peter Paul in the archives of the Archdukes, dated 8 August 1609, it appears that Albert had only a vague memory of the artist, whom he described as 'a painter called Peter Paul Rubens, who resides in Antwerp'. Nevertheless he and his wife commissioned Rubens to paint their portraits and immediately made him court painter. They were so eager to use his services that they accepted all his conditions: a high retainer as well as a separate fee for each painting. In addition, Rubens, like all the other painters who were members of the Guild of St Luke, was exempt from taxes and obligations. Similar advantages were not accorded Jan Brueghel, his contemporary, whose reputation equalled Rubens's at that time. His final stipulation was revealing: he would not be obliged to live in Brussels. Instead he chose to live in Antwerp.

This is significant. It could simply be that Rubens's dislike of court life had not changed since the time when he rapidly abandoned his employment as a page at the court of Marguerite of Lalain. According to Roger de Piles and Rubens's nephew, Rubens refused to live in Brussels 'for fear that the affairs of Court which imperceptively lead from one thing to another might prevent him from attending to his studies in painting, and acquiring all the perfection of which he felt capable in his Art'.[4] The explanation is plausible, bearing in mind Rubens's earlier record of hostility to court life, be it at Oudenaarde or Mantua. But the way his career developed tends to contradict this apparently simple interpretation, for the painter maintained relations with princes throughout his life, and even during relatively important periods in his life Rubens voluntarily indulged in activities which could only distance him from his painting.

From what we already know of Rubens's life up to 1610, he was clearly attracted to the powerful of his time. In Italy he lived in the Gonzaga entourage at Mantua, with the Borgheses in Rome, the Pallavicinis and Spinolas in Genoa. In Madrid he set about attracting the attention of the Duke of Lerma and the King of Spain, countering the Mantuan ambassador Annibeli Iberti's dirty tricks when the latter tried to relegate him to his lowly function of artisan. Later on he would set about attracting the patronage of the Duke of Buckingham, the King of England's favourite, and the Queen Mother of France, Marie de Medicis. Nevertheless, it is

true that even in the midst of all these society intrigues he remained a Flemish bourgeois at heart.

He never elbowed his way into the aristocracy (who repaid him well). He was not motivated by a liking for pomp, fine manners or luxurious surroundings, but rather a concern for fame. He never behaved like an obsequious courtier, bragging and strutting. If he observed social etiquette it was because a low bow could lead to raising his head even higher. And if he moved among powerful people it was not to be at their beck and call: he was using them. The services he rendered would not push him up the social ladder but to the heights of fame. He didn't care about being one noble among so many in Brussels when he could be Antwerp's finest painter, the only painter of any note in Flanders or even Europe.

As for luxury, elegance, the niceties of court life, he would soon be enjoying them in his own house in Antwerp, where he would receive the political élite of Europe, including the Archdukes. He was hardly prejudiced against court life, since he recreated his own around him. If he refused to live in Brussels it was not simply because he preferred a quiet life. He was now methodically laying the foundations for his future, and distancing himself from court gave him the opportunity to re-examine his commitments in the long term as he played with the idea of returning to Italy. What he wanted to do more than anything was to escape the clutches of the Archdukes and keep his own life intact.

At first Rubens stayed in the family home in Convent Street beside the church of St Michael where his mother was buried. Around his neck he wore the gold chain given him by the Archdukes, along with a medallion bearing their likeness which had been specially made for him. Whether he was referring to emoluments or privileges or this piece of jewellery, it was not just metaphorically that his brother wrote: 'Our Prince has noticed him. To prevent him from returning to Italy whither he was being enticed with great financial benefits, he secured him with a gold chain.'[5]

Rubens forged other ties of his own free will: marriage ties. The model of sobriety, who was frightened when his brother married: 'I myself will not dare to follow him, for he has made such a good choice that it seems inimitable',[6] Rubens married almost as soon as he returned to Antwerp. He did not look for long, nor far afield, for he chose his neighbour, Isabella Brant, his brother's niece. She was the daughter of the sister of Marie de Moy, whom Philip Rubens had just married. Isabella also belonged to 'good' Antwerp society. Her father had been town secretary for thirty years, then an alderman. In his retirement he published Caesar, Cicero, Apuleus. Like many learned men of Antwerp, he practised Justus Lipsius's humanism, for, with Erasmus gone, Lipsius was undoubtedly the great man of his age.

Rubens's decision was so sudden that one can only conclude it was love at first sight. We only learn his opinion of Isabella seventeen years later on her death: 'She had none of the faults of her sex.' Rubens, painter of women – or at least of a certain type of women, always the most carnal, the most sensual – distrusted their seductive power, which would explain why he had passed over the spirited Italians in favour of a rather heavy-looking Flemish girl. When they married on 8 October 1609 he was thirty-two, she eighteen. Going by Rubens's account of Philip's wedding which he sent to Faber, in the course of which he had 'been unable to attend to anything but serving the ladies',[7] this second ceremony would also have been a smart and jolly occasion. We have no record of it, except for the epithalamia which Philip Rubens composed for the occasion. As was his habit, he wrote in Latin. Judging by the epistles with which he graced his brother in Italy (see p. 241), he seemed to be a man given to apologia. For Peter Paul's wedding he appeared in a totally different light, larding his 'Invocation to Hymen' if not with 'saucy crudities' (according to Emile Michel) at least with tasteless hints:

Thou, mediator of love divine, we call upon thee on this night of my brother's great happiness, this night for which he has yearned so ardently, and you young wife, you also call. Certainly your virginal impatience is more restrained today, but tomorrow you can say that tonight bore you away to a beautiful awakening. . . . But already the god Hymen is impatient to light the nuptial candle, and to penetrate the domestic sanctuary, where the marriage bed can be glimpsed, Venus's areas detined for gentle struggles. . . . May your wife soon count the days and the months, when she rejoices to see her womb grow round, and, before the sun with its golden halo has accomplished its annual round, she will swell with pride with a descendant who resembles her husband.[8]

Here we have a small, winsome and trivial part of Flemish tradition making its appearance.

But how was Rubens re-adapting himself into his country, Flanders? For the time being he was the beloved child of fortune rather than anything else: 'He is tall, and has a majestic bearing, a well-formed face, vermillion cheeks, chestnut hair, his eyes shining but with a tempered fire, a gentle and honest air of laughter. His manner is engaging, his humour easygoing, his conversation relaxed, a lively and penetrating mind, his manner of speaking composed and the tone of his voice very agreeable, and all makes him naturally eloquent and persuasive.'[9] His gentle warm expression would

soon reveal other lights. He favoured a short blond beard and always wore a hat to hide his thinning hair. His wife was quite plump, with dimples in her cheeks which accentuated the mischievous look in her upward gaze. The young couple were a picture of calm, cosy happiness in their honeysuckle bower, where Peter Paul took pleasure in revealing his union with Isabella.

Italy was now a memory which he would summon up at meetings of the Society of Romanists, that assembly of young Flemish painters who had completed their pilgrimage across the Alps. They had admitted Rubens's friend Jan Brueghel to the society on 29 June 1609. Gradually Rubens found his feet in this country whose characteristics he reflected. Like Flanders he was torn between two identities, between Italy and the Low Countries, just as Flanders was torn between Brussels and Madrid and between two religions – Catholicism and Calvinism – without openly deciding in favour of one or the other. And so, navigating between his painting and court life, his bourgeois existence in Antwerp and the Spanish Archdukes, he became fully practised in Flemish duplicity. Gradually Rubens became part of this lighthearted, ill-treated civilisation which simultaneously revered all things Spanish and Catholic, as well as the pagan art of the Renaissance, and found its faithful reflection in the life and work of Justus Lipsius, master of Flemish thought in general and Rubens in particular.

Justus Lipsius was born in 1547. His father was commander of the civil guard in Brussels. Justus was first taught at the Jesuit college of Cologne in that second half of the sixteenth century when people's minds were in a turmoil over religious and political questions. As a young student he soon learnt to take part in debates and harangued his fellow students. He also studied Greek and Latin and was passionately interested in moral and political philosophy. The Jesuits would have liked him to enter their order, but Justus's parents withdrew him and enrolled him at the University of Louvain just as the Duke of Alba's bloody persecutions began. Lipsius sought a protector: he wrote a number of critical essays on Latin authors and dedicated them to Cardinal Granvelle, who had been Marguerite of Parma's principal adviser in the Low Countries and now spent his time peacefully in Rome. The Cardinal invited this young admirer to come and see him, and introduced him to the Vatican library, where Justus Lipsius was given permission to study the manuscripts of Seneca, Tacitus, Plautus and Cicero at his leisure.

After leaving Rome for Vienna he earned the trust of Emperor Maximilian II to such an extent that when he was only twenty-four years old and a Catholic to boot he was nominated Professor of Rhetoric and History at Iena, in a Protestant country. His colleagues rebelled when he was made

Dean of the University, whereupon he sought refuge in Cologne where he married and completed several works on Plautus and Tacitus. Returning home during the civil war in the Low Countries he at first hid in Antwerp at Christopher Plantin's house, then in Holland.

There, in return for his conversion to Protestantism, he gained the protection of the Prince of Orange and a chair at the University of Leyden. In spite of everything he still sympathised with the sufferings of his Flemish compatriots who were being decimated by Spain's repressive measures, and for their benefit edited a *Treatise on Constancy*, in which he attempted to adapt the tenets of Stoicism to Christian morality. While still working in the United Provinces he wrote a political treatise in which he stated that a head of state would tolerate only a single religion in his country and recommended, in the style of Cicero: 'Cauterise and cut out, it is better to lose one limb than to lose the whole body.'

The effect of this statement was to trigger off a general outcry in the Low Countries, torn apart as they were by their religious crisis, and violently partisan. Justus Lipsius fled and took refuge with the Jesuits of Mainz, who backed his nomination for a chair at the University of Louvain in 1592. When the Archdukes took over in the southern Low Countries, in their role as protectors of the arts and letters they welcomed people whom Philip III had considered heretics worthy only of the stake. Justus Lipsius converted to Catholicism again, and as a guarantee of his faith, dedicated three works to the 'Torture of the Cross' and to different miraculous Belgian Virgins.

Nominated a member of the Council of State by Albert, Justus refused to take up his seat. He died in Louvain in 1606, an honoured man, content to have applied what he remembered of Seneca and translated as: 'Because of our commitment to support mortal things, we are obliged not to trouble ourselves with what we cannot prevent. We are born under a master's authority to obey God; such is freedom.'[10] Such was Justus Lipsius: Catholic or Protestant, depending on which frontiers he crossed; a convert to pagan stoic wisdom, and an apologist for popular beliefs; in a word, an opportunist – and the man whom both Philip and Peter Paul considered their spiritual director. In a country which lay in ruins, Justus Lipsius's lessons were without a doubt relevant to furthering a painter's career.

The House beside the Wapper

Rubens was sworn in as Painter to the Court of the Archdukes on 9 January 1610, immediately after which he returned to Antwerp at his own request.

Antwerp was a city in decline. It had been gradually losing its pre-eminence from the sixteenth century on and would continue to do so until Napoleon's time, with one or two remissions: notably the first half of the seventeenth century (when Rubens made his fortune).

When he returned from Italy, Brabant and Flanders were the two provinces most affected by the ravages of civil war. A contemporary, Theodore Overbury, described the country as devastated, its inhabitants discouraged, discontented with their government, more than furious with their enemy, the nobility and merchant class in a state of decadence, the peasants labouring to survive with no hope of improving their lot, the towns half in ruins and over all a general air of poverty, in spite of taxes which were much heavier than in the United Provinces.[11] 'People are going bankrupt every day,'[12] added the Marquis d'Havre, a Belgian nobleman and Minister of Finance. And Dudley Carleton, English Ambassador to the United Provinces, filled in the picture in a letter to England in 1616:

We came to *Antwerp* wch I must confesse exceedes any I ever saw any where else, for the bewtie and uniformitie of buildings, heith and largenes of streetes, and strength and fairenes of the rampars ... But I must tell you the state of this towne in a word, so as you take it literally, magna civitas magna solitudo, for in ye whole time we spent there I could never sett my eyes in the whole length of a streete uppon 40 persons at once: I never mett coach nor saw man on horseback: none of owr companie (though both were workie dayes) saw one pennie worth of ware ether in shops or in streetes bought or solde. Two walking pedlars and one ballad-seller will carrie as much on theyr backs at once as was in that royall exchange ether above or below ... In many places grasse growes in the streetes, yet (that wch is rare in such solitarines) the buildings are all kept in perfect reparation. Theyr condition is much worse (wch may seem strenge) since the truce then it was before; and the whole countrey of Brabant was suitable to this towns; splendida paupertas, faire and miserable.[13]

Eight years later the historian Golnitzius went further: 'But of all that [the former bustle of Antwerp], there remains only an immense solitude, the shops are covered in dust and spiders' webs. One never sees a merchant or a courier. All has vanished, all has foundered in the waves of the civil war.'[14]

Antwerp was ruined by the closure of the Schelde. Foreign companies abandoned the city. The Exchange, whose glass dome had dominated the

four streets which spread out, in a cruciform, from its galleries, and which in the previous century had brought together merchants from all over the world, was empty. Soon it would house the town library; then, as a sign that money had changed hands, it would pass from the merchants to the small manufacturers and weavers who would install their workshops there. Maritime business was in a state of collapse for Philip III was incapable of protecting his port. Ever since the Spanish fleet, the Invincible Armada, had come to grief off the British coast, he had had no naval force capable of breaking the blockade which the Calvinists were maintaining in front of the ports of Flanders, or of countering their acts of piracy on the high seas. All that Antwerp could do was turn to the hinterland and try to cement commercial relations not just with the other Belgian provinces but also with Germany, whose inhabitants understood that the old medieval guilds had to give way to 'capitalist' manufacturers. The figures speak for themselves. In the sixteenth century Antwerp had 100,000 inhabitants; in the thirty years that Rubens was to live there it had half that number.

Rubens would go on living in Antwerp until his death. He had the choice of Brussels, the capital city, seat of the Archdukes and the court, and Antwerp where his relations and ancestors had been born. He chose Antwerp. Rebellious Antwerp, the most nationalist of all the southern cities, the first to rise up against Spain, the last to toe the line, twice sacked, twice resurrected, a town which, once Spanish order had been re-established, accepted legislation from Brussels only if it had been ratified by the aldermen of Brabant. Antwerp, a ghost town, an arrogant vestige of an undying splendour – and the town which brought the Flemish renaissance to the southern Low Countries. One has to set against its desolation the compensations Rubens received from Brussels, which would commit him to living far from Italy, in this bloodless city whose history and status explained the political views he would subsequently develop there. Choosing Antwerp rather than Brussels was choosing Flanders rather than Spain.

After his marriage Rubens moved in with his parents-in-law as was customary at the time, and thereby established himself in the business quarter where he had spent his childhood and youth. With its derelict narrow streets and its curious houses, the area was virtually an architectural memorial to Antwerp as it had looked in its glory. Buildings abounded: churches, houses of the guilds, mansions, testimony to the local artists' attachment to Brabant Gothic. The harmonies and balance of the Renaissance were never truly applied in Flanders, although printers translated and published the treatises of the great Italian masters, notably the encyclopaedic work of Sebastiano Serlio who publicised the teachings of Vitruvius in his *General Rules of Architecture in Five Types of Building*.

The local materials, the soft white stone, blue stone, grey or red sandstone held great attraction for talented local artisans. As a result a row of masterpieces stretched from the Exchange to the port: the Church of St James with its slender archways and rounded columns, the Cathedral of Our Lady with its clock tower 'pointing straight up like a cry to heaven, beautiful as a mast, as light as a candle',[15] the Butchers' Hall all in red brick, alternated with layers of a paler stone, whose tall polygonal towers look down on the grey Schelde.

There are numerous churches in this part of Antwerp. Outside are white stone walls; inside, furnishings in dark wood, pews, pulpits, confessionals, organ cases, all heavily carved – the lugubrious heritage of the austere and fanatical cult of its former Spanish occupants. The floors are invariably covered in black and white tiling, in a surprising contrast to the brightly luminous pictures of the Holy Scriptures in the multicoloured windows. This chromatic distortion to a certain extent reflects cultural syncretism and it can still be seen today in the museum of Antwerp, in the alternation of Golgothas and fairs.

In the town centre, surrounded by patrician houses whose carved roofs thrust irregularly into the sky, stands the Stadthuis, the town hall on Groen Plant (the great square). Pink, blue and white, it is built on three levels in three different styles, separated on the second floor by an Italian-inspired gallery. The many polychrome escutcheons and statues reveal the natural exuberance of the Flemish, their taste for complicated forms, luxuriant decorations, feasts of ornamentations, an echo in stone of the colourful fêtes which enliven their paintings and their countryside.

Rubens was happy in the heart of Antwerp where a semblance of riches remained and one could see the nobility, merchants and learned men walking about past the taverns with their opaque windows, which appeared to shield the drinkers from the melancholy of a perpetually lowering sky. And so, when Rubens decided to stay, he chose this part of the city.

In January 1611, fifteen months after his marriage, he acquired some land beside the Wapper canal which supplies water to the town's breweries. Since the couple did not yet have any children, he was simply faced with the question of finding somewhere to live for himself, his wife and their servants. However, for 10,000 florins he purchased a house with a thirty-six-metre frontage which opened onto a long rear garden measuring twenty-four by forty-eight metres. The place was not yet to his taste so over the next five years he spent several thousand florins making changes and took up residence in 1616 in what was then considered the most beautiful house in the town. His contemporaries called it a 'palace', some a 'Renaissance palace'. This was without doubt the impression the building

would have conveyed in a town which was still mostly Gothic. The house remained in the Rubens family until 1669 when it was sold. For a while it was occupied by a riding school, then it was partially destroyed during the First World War. In 1946 historians and archivists helped rebuild it to its original design, and this is how visitors see it today.

The scale of the new house certainly gives a foretaste of future projects and presupposes a wish on Rubens's part to settle in Antwerp, but such a vast building might also be seen as a symbol of boastful pride – Rubens was never particularly modest. In fact Rubens advertised his return to Flanders less with the size of his home than with its style. The final result shows that his native country had won back his heart, and that apart from a few touches which were more humanist than Renaissance, he had cast aside his Mantuan pastel shades and Roman ochres in favour of the black and white tiles of Antwerp.

Rubens's house is the very essence of Rubens, the Rubens who settled down into Flemish civilisation once he had finished his years of apprenticeship and resolved the problem of his early life. When he had the house built he was thirty-five, master of his art and his very existence. He knew how he was going to paint. He also knew how he was going to live. His love of antiquity, his nostalgia for Italy, his acclimatisation to Flanders, his resistance to Spain and the rules which governed how his life developed can all be found in his house. Even if he never confessed to his aspirations and dreams in his correspondence, he embodied them in his house, arranging time and space to accommodate his passions, his interests, his ambitions – all of which he controlled in the manner of a Stoic.

The tone is set right from the entrance: once you have passed the heavy wooden door, and walked through the three-arched portico which separates the paved inner courtyard from the garden, it gave, and still gives, the impression one feels in the backgrounds of certain of his and his pupils' paintings.[16] The central arch is surmounted by a capital which continues upwards with two statues: a helmeted Minerva armed with a spear, Mercury with his winged headdress, the caduceus in his right hand; triumphant effigies capped at either end with two vast urns.

The side arches carry cartouches engraved with mottoes from Juvenal's Tenth Satire, and their choice expresses the everyday wisdom of the master of the house: 'Leave it to the gods to give what is fit and useful for us; man is dearer to them than to himself' and 'One must pray for a sane spirit in a healthy body, for a courageous soul which is not afraid of death, which is free of wrath and desires nothing.'

These three triumphal arches under which Rubens passed each day to enjoy the fresh air in his garden invoke the pomp of Rome in their scale

and protective gods. You might think you were walking into some *palazzo* or the entrance to a majestic drive; the drive exists but it ends at a little temple, scarcely twenty-four metres further on.

You have to pass under the balustrade before coming to the garden which Rubens had 'planted, for his curiosity, with trees of all the kinds that he could find'.[17] The trees would have stood close to the outside walls or have been contained in or bordered the geometric parterres which lead towards the pavilion. The pavilion, in white stone, is decorated with statues of Hercules, Bacchus, Ceres and Honor: strength, drunkenness, fertility and honour. Rubens designed them in pagan homage to the good things of this earth and to their civilised enjoyment. A little further on to the right is a round pond with a fountain; then, encompassing the length of the garden, we find a pergola in dark oak. This structure is supported by caryatids who are smiling, two by two, Silenuses and nymphs, grossly profane amorous couples which were sculpted from contemporary documents.

Everything in the garden is orderly and light, expressing a knowledge of life and the profound desire to master it, just as nature had been mastered here. The rectilinear paths are crossed at right angles by other straight paths in white gravel. The vegetation is constrained, as though it comes from a botanist's album. And if, in ruined Antwerp, the grass grew between the cobbles in the streets, here only the choicest species flourished. The pleasures of the flesh, of taste are exalted in emblematic statuary but subject to the economy of the precepts inscribed on the portico between garden and house which overlooks each living space, whether in the open air or in the secrecy of the house.

The imposing building is divided into two main parts. On the left, turning back from the garden, is the painter's atelier; on the right the house. They are joined by a porchway which, with the portico, demarcates a little paved courtyard.

With its façade uncluttered by embellishments, colonnades or statues, and its narrow windows, the living quarters of the house echo the atmosphere of a country manor house. This wing has barely nine rooms on two floors, impossible to compare with the strings of useless rooms typical of Italian *palazzi*. Rubens, it seems, had not provided for receptions or parties. The only private apartments were the conventional family ones: dining room, kitchen, pantry, laundry room, three bedrooms of various sizes housing beds with baldequins, so short that you would have to sleep practically sitting up. The windows are narrow, decorated with latticework. The kitchen is small and rustic, brightened with blue-and-white delft tiles, and warmed by copper saucepans and the cooking pots which hang from

the fireplace. The floors of all the rooms are covered with worn tiles, the red hexagonals, black, and chequered black-and-white tiles typical of Antwerp.

The present curators have installed dark wood furniture heavily carved in the Spanish style as was the fashion in Rubens's time. The only luxury to be found and which is typical for the period comes from the soft light of golden Cordoba leather which covered the walls of the antechamber and dining room. Natives of Antwerp preferred tapestry because it cost less and lasted longer. No other sign of extravagance exists here: most of the rooms are small, the ceilings of a reasonable height; no space is lost and each room has a specific function.

The arrangement of the house is significant; just as Rubens managed his health and his time, so he managed his space. In the atelier wing of the house only the rotunda gallery in which he kept his art collections is appreciably spacious. As for his studio, he allotted himself the same amount of space for his own use as he had allotted to his family in the other wing.

Rubens's 'palace' is a dwelling designed for a cosseted bourgeois, sober, and a touch on the economical side. Moreover, as his nephew Philip recalled, the painter led a somewhat routine existence here:

He arose every morning at four o'clock and made it a rule for himself to begin his day by hearing mass, unless he was prevented from so doing by gout which troubled him a great deal; after which he would begin work, having always near him a reader who was in his pay and who read out loud some good book, but usually Plutarch, Titus Livius [Livy] or Seneca ... Loving his work above all else, he arranged his life in such a manner as to accomplish it with ease and without damage to his health. It is for this reason that he ate little, since he understood that the odours of meat might prevent him from working, or that his work would spoil the digestion of meats. He worked until five o'clock in the evening, then went for a ride on horseback, sometimes outside the town, or along the fortifications, or he would look for another means of relaxing his mind. On returning from his ride, he would usually meet up with some friends with whom he would dine. But he detested the abuse of wine and high living, and also gaming.[18]

It would not be until 1616 that Rubens took possession of a collection of paintings and antiquities which would become famous. Nevertheless, to house his engraved precious stones, the statues and some canvases which he had brought back from Italy, he set aside a gallery, a vast room as big

as his dining room, an apsidal gallery, surmounted by a dome pierced by an oculus – its sole source of light. The walls of this circular room were of white marble, alternated with marble of a greyish colour, carved with openings and niches. The Italian-style floor design mirrored the alternations of colour and stone. A gallery ran round the rotunda, on which Rubens placed busts of philosophers and Roman emperors. Admirers of the painter have compared this place to the Pantheon in Rome, since it resembled a miniature reproduction of the latter's form and especially of its absence of light.

To reach his studio, the painter had the choice of two routes. He could stay inside and walk through the entire house till he reached his exhibition room, then go up to the next floor and cross an antechamber before reaching his easel. Alternatively he could go out into the paved courtyard where an outside staircase led directly to his workplace. The house's simplicity is matched by the studio's magnificence. Its façade is lit by vast ogive windows, decorated with small columns and carved with niches that were filled with statues of Mars, Jupiter, Juno and Vesta, and busts of Rubens's favourite philosophers: Plato, Seneca, Socrates, Sophocles and Marcus Aurelius.

Inside, the studio in no way resembled the dark, messy 'botteghe' of the Italians. Instead it exhibited the exacting standards of a well-ordered ceremonial, a significant reflection of the deference Rubens felt towards his art, and which doubtless he exacted from his pupils and his admirers. There was nothing bohemian, nothing free and easy in the organisation of his workplace, for it chronicled the progression of a cult, from meditation to celebration.

In order to work on the concept or development of a painting, the Master reserved for himself a room of modest proportions: it was here that he made his drawings and his sketches, posed his models. It was also where he withdrew to read or write to his many correspondents, far from the bustle of the house and also away from his pupils and collaborators. As these were numerous Rubens provided a second studio for their communal use, one bigger than his private cabinet and with a more lively atmosphere. Undoubtedly it was still subject to Rubens's iron hand and the general austerity which reigned in the house. And finally there was a last studio, even bigger than the preceding one, designed as a room where Rubens would welcome visitors. With its dark-wood panelling and the usual black-and-white tiles, this third studio resembled a chapel, almost a temple. Its wooden balustraded gallery allowed potential clients and guests of note to admire the pictorial celebrations of Rubens, the great master in this house.

It is true that the size of the rooms was essential for the immense canvases which Rubens was painting for the decoration of religious buildings, but he could still have painted them without making this room, which also served as his exhibition gallery, so pompous. The scale and tone of the studio corresponded to the elevated, precious conception Rubens had of his art, 'la mia pulchra pittura', or even his 'Philosopher's Stone' (as witnessed in his reply to a letter from the alchemist Brendel, who promised him half of his profits if Rubens helped to construct a laboratory which would turn lead into gold: 'You come too late, my good man, long ago I discovered the Philosopher's Stone. My palette and my paintbrushes are worth more than your secret.'[19])

From early on Rubens's reputation began to spread all over the country and beyond. Orchestrated by numerous friends, it soon dominated the painting scene in Antwerp, indeed in the whole of Flanders, but not without arousing both dislike and jealousy. With his customary cleverness Rubens ignored or disarmed the detractors – or won them over.

Venius, his old master, had aged. Like Rubens he was a painter at the Archdukes' court. In his time he had received the honours he so longed for and now he devoted himself to book illustrations, to allegories which, towards the end of his life, became the essence of his art. Venius watched benignly as Peter Paul gradually supplanted him as Antwerp's leading artist.

Other painters in Antwerp did not share Rubens's vision. Amongst them were the followers of Martin Pepyn, men who refused any kind of innovation and militantly continued to paint on wooden panels at a time when most artists were using canvas.

Then there were the three Franckens – Francis, Jerome, and Ambroise – who came from a family which boasted thirty-four members in the Guild of St Luke, and Cornelius de Vos. This group of artists continued the Flemish tradition of primitive painting: they were careful miniaturists who respected the old painters' methods and their teachings on nature. 'With their fine colour, polished like enamel',[20] they were resistant to Rubens's revolutionary approach, 'the great colourist and his forceful drawing'.[21]

Although theirs was a different kind of art they had no confrontations with their brilliant colleague. Confident in themselves they continued to paint works of incontestable quality in their own style. The same can be said of two other artists who were sufficiently assured of their own genius to stay outside Rubens's illustrious orbit: Henrik Van Ballen and the immense Jan Brueghel, whom Rubens had known in Italy. As a sign of the mutual respect the two schools of painting bore each other, Isabella Brant would later agree to be godmother to Martin Pepyn's daughter.

However there were artists who bitterly resented the honours Rubens had received. One of their number who had had a huge reputation in Antwerp before Rubens returned from Italy decided to challenge the acclaim lavished on Rubens. He was Abraham Janssens (1575-1632). Two years older than Rubens, Janssens had also made the Italian journey but had only spent three years in Rome before returning to Antwerp in 1601 where he became Dean of the Guild of St Luke.

Janssens had brought back the Mannerist style from Italy, gradually abandoning it in favour of the classicism required for the religious compositions he was commissioned to do. He did not take well to his young colleague's fame and supremacy and challenged Rubens to a public tournament: the two artists would paint the same subject and experts would then judge which of the two was the more talented. Rubens put an end to the matter: 'My essays into painting', he said, 'have been examined by experts in Italy and Spain. They are still in public buildings and private galleries in these two countries. You are free to go and hold up your works next to them so that they can be compared.'[22] Rebuffed, Janssens had to make do with being a contemporary of Rubens.

As his fame grew and spread Rubens attracted a great number of young artists and applications to work in his studio flowed in. He frequently had to refuse people. On 11 May 1611, when he had only been back for two years, he had to refuse Jacques de Bie, curator of the Prince de Croy's collections, who had written recommending one of his protégés: 'Similar aspirants are coming to me from all over the place. Some even stay a few years longer with other masters while they are waiting for a vacancy with me. . . . With no exaggeration I tell you quite sincerely that I have had to refuse more than a hundred, among whom were some from my own and my wife's family, and in so doing I have caused great displeasure to many of my best friends.'[23]

Faced with an embarrassment of choices, Rubens kept only the best, those painters who would with and after him guarantee the school of Antwerp's fame: Jacob Jordaens, Francis Snyders, the three Teniers, and especially Anthony Van Dyck, to mention the best known. He also welcomed other artists like Erasmus Quellyn the Elder and Justus van Egmont.[24]

For a long time to come these artists would be destined to live in Rubens's shadow while becoming wealthy and famous in their own rights. Erasmus Quellyn succeeded his master as the official painter of Antwerp upon Rubens's death. Others went abroad, to Italy, England, Austria, Germany, Holland and France, where Justus van Egmont, in particular, contributed to the creation of the French Academy of Painting and Sculpture.

Each one of Rubens's apprentices, as was customary in a studio, had a precise role according to his talents. Rubens's ascendency over his colleagues could be measured by the quality of the 'collaborators' he could attract. For, besides the 'aspirants' as he called the members of his studio, he was backed up by artists capable if not of teaching him a thing or two in the fields of landscape, animal and flower painting, then at least of lending more than just 'valuable' help. If one believes the rumours of the period, the master was not always good-tempered about recognising their talents.

These painters were subsequently known primarily for their own work: it was only afterwards that they were discovered to have been Rubens's pupils and collaborators. Jacob Jordaens (1593–1678) was a prolific painter of fêtes, royal binges, peasant gatherings, and also of religious scenes, which have a passionate quality through the vitality of the characters, the realism of his representations, and the hot colours, especially the vermillions he used. Critics are united in hailing Jordaens as a colourist equal to Rubens.

According to Sandrart,[25] Jordaens would have excited Rubens's jealousy, not only because he equalled him as a colourist, but also because he depicted the passions better, and was more faithful and convincing in his observations. If an occasion to harm his pupil were offered, he let nothing escape: it was a question of painting some cartoons for tapestries for the King of Spain, using gum as a medium. The most vigorous of all the artists [Rubens] thought that tempera painting would spoil the hand of his young rival and weaken the colour. And so he made little sketches in oil and asked his disciple to copy them to the required scale. Jordaens accomplished the task with his usual dexterity, but he could never again find the warmth, the energy and flow in his brush work.[26]

Happily Jordaens's late works show that the trick Rubens played on him had not permanently affected his talent. In the 1640s he was still completing commissions from the widow of the Stadtholder of Holland in his brilliant rubescent style, and he decorated his 'Huis ten Bosch' (Wooden House) near The Hague with epic paintings celebrating Frederick Henry of Nassau. He also received commissions from Charles I of England and earned such a good living that he, in turn, was also able to build a house, though of a very down-to-earth splendour when compared with Rubens's own residence.

Francis Snyders (1579–1657) was more discreet. He made his name as

an animal painter, specialising in hunting scenes and still life. At first he was a pupil of Peter Brueghel and Henrick van Ballen. Then, on his return from Italy, he entered Rubens's studio. For the next thirty years Snyders was the faithful 'filler-out' of Rubens's canvases, the one who painted his animals for him as well as his fruit and flowers. In return Rubens gave life to his paintings through working on Snyder's faces. Their collaboration lasted until Rubens's death, and Peter Paul had sufficient confidence in Snyders to make him an executor of his will.

Rubens enjoyed a similar friendship and collaboration with Jan Brueghel, known as 'De Velours'. They had first met and become friends in Italy, and continued their friendship when they returned to Antwerp. It was Jan who, in 1609, had Peter Paul admitted into the Society of Romanists over which he presided. Brueghel was not compromised by combining his talent with Rubens's for he was used to this type of joint venture as he also worked with Josse de Momper and received 40 florins per picture. In Rubens's studio he painted flowers and foliage for which he had a great gift.

In 1609, when Brueghel and Rubens collaborated in the portraits of the Archdukes, now on exhibition in the Prado, Jan drew the landscapes in the background with his customary finesse: the delicate palaces of a trembling dawn pink, their green roofs like stagnant water standing out from the blue sky – a standard phenomenon in primitive painting. In the foreground Rubens painted the sovereigns, but his vigorous style appears only in the vermillion draperies which mark the boundary of the foreground and accentuate the depth of the canvas. Otherwise the master would paint temperately: a meticulously rendered ruff, the iridescence of a pearl, the silk of a handkerchief, the softness of leather gloves which the Archduke Albert held in his left hand. The paintings were signed by both masters.

Rubens himself was obviously prepared to 'collaborate' for he acted as Brueghel's 'secretary' for twelve years, from 1610 to 1622, translating into Italian the letters which his friend sent his protector, Cardinal Frederico Borromeo, since Brueghel had little mastery of the language. When Jan Brueghel died of dropsy in 1625 Rubens became tutor to his daughters and actively encouraged the marriage of Anne to the famous David Teniers.

It was with the all-too-gifted Anthony Van Dyck that, behind his courteous façade, Rubens had the most stormy relationship. Rubens immediately recognised Anthony's immense talent but, after collaborating with him for three years, he did nothing to retain him. And it is true that Van Dyck did everything in his power to unnerve his master. 'This is how, in a quick, light pencil sketch, I would imagine a portrait of Van Dyck', Fromentin wrote.

A young prince of royal blood, with everything in his favour: handsome looks, elegance, magnificent gifts, the good fortune to be born lucky, pampered by his Master, already considered a master in his own right by his fellow disciples, everywhere honoured, fêted, in demand, even more abroad than in his own country, treated as an equal by the greatest of lords, favourite and friend of kings; . . . always youthful even in middle age, never wise even in his last days; a libertine, a gambler, eager, prodigal, dissipated, . . . loving his art and sacrificing it to less noble passions, a charming man of good stock and fine stature; . . . of a rather delicate, not so virile complexion - the air of a Don Juan rather than a hero, with a touch of melancholy; a man who sought adventure to the end, who married, one might say, under orders, a charming, wellborn girl when he no longer had anything to offer her and little strength, little money, no great charm, nor much certainty of life: a ruined man, who had good luck until the very last, the most extraordinary luck of all being able to conserve his greatness when he painted; finally, a bad lot, adored, disparaged, later libelled, at heart better than his reputation, a man who had this supreme gift which excused him of everything, a form of genius - grace. In sum, a Prince of Wales who died as soon as the throne became vacant, but who, in any case, should never have reigned.[27]

In other words: the opposite of Rubens. Van Dyck died a year after his master, and at the very moment when he alone could have taken his place. His life, one long extravagance, derided Rubens's economic achievements.

Van Dyck was twenty when he entered Rubens's studio beside the Wapper, having been a member of the guild for two years. His fellow pupils soon recognised him as the best among them, as the following anecdote told by a contemporary gossip demonstrates. One day when, as was his custom, Rubens had gone riding in late afternoon, his pupils, as was their custom, bribed the servant who looked after Rubens's private cabinet to open it so that they could look at the new compositions on which the master was working. Once in the room the young painters were jostling each other so much that, as they went up to a canvas, one of them fell on it and wiped off a section of colour which was still wet. Realising they had to repair the damage before Rubens returned they chose Van Dyck for the task. Anthony set to work. The following day Rubens went into his cabinet and drily observed: 'Now here is an arm and a chin which I didn't do too badly yesterday.'[28] He had noticed that someone else had worked on his painting, but the work was so well done that he forgave Van Dyck.

What is more, Anthony was the only pupil to whom Rubens lent his Italian sketchbook, since he considered he was the only one who would understand his lessons. He delegated to Van Dyck the execution in small format of those pictures he wished to have engraved. He entrusted this work, which he hoped would have a wide circulation and spread his fame, to the young man whose name would soon become inseparable from his own.

When Rubens signed a large contract with the Jesuits in 1620 it stipulated that he could enlist the help of his pupils, but only Van Dyck among them was mentioned by name.

That same year an agent of Charles I of England, a great collector who wanted to attract a number of artists of quality, approached Van Dyck: 'Van Dyck lives with Rubens and his works are beginning to have as much value as those of his master.'[29]

Did Rubens resent the rising star of his 'best pupil', as he called Van Dyck? Was he suspicious of the feeling which, according to rumour, Anthony had aroused in Isabella Brant? In this case, as in so many others, there is nothing from Rubens on the subject. Perhaps he was never quite sure whether or not to encourage Anthony to go to Italy as he had done himself in his own youth. But, after living in England for eight months as a result of negotiations with Charles I, Van Dyck did finally leave Rubens's studio and begin his journey to Italy. Before his departure he gave his master a portrait of his wife, an *Ecce Homo*, and a *Christ on the Mount of Olives* which Rubens hung over the mantelpiece in his dining room. In return, and as a token of their friendship, Rubens presented Van Dyck with the best horse in his stables.

So, from 1610 to 1620, Rubens's studio was filled with the best of the artists to be found in Antwerp. At this time more than at any other in his life the painter was completely devoted to his art. The commissions flowed in and his fertile genius alone was not sufficient to fulfil them. So he started a kind of picture factory which was to make him one of the most prolific painters in history.

A catalogue of his work contains more than 1,300 paintings, not counting engravings, sketches and drawings. His first works date from 1599 and he died in 1640 – that makes an average of sixty paintings a year, slightly more than one a week. Throughout his life Leonardo painted no more than twenty, Vermeer of Delft thirty-six, none of which he sold. These painters liked to be given a reasonable margin of time for their work and rebelled against the great patrons – Leonardo refused to contribute to the *studiolo* of Isabella d'Este – and never dreaded poverty. Rubens, concerned about his material welfare, was more accommodating, and so provided the means to satisfy others' requirements.

Since we have no documents on the daily life in Rubens's studio, we must presume that it functioned like any other studio of the period. The apprentices prepared the colours, supervised the warming of solvents. Those pupils who were a little more advanced coated the surface of the canvases or the panels with a layer of size, the half-Italian half-Flemish mix which Rubens preferred.

One can imagine the less boisterous young men being extra careful not to spill oil, varnish or precious mixtures on to the floor, fearing not their master's anger, for Rubens was not given to outbursts of temper but rather to icy comments, a haughty frown. Once pupils had acquired a certain knowledge of how to behave, Rubens left them to their own devices.

Businessman

Rubens left nothing to chance. Every provision had been made for maximum productivity in his studio which resembled a highly efficient business enterprise, the organisation of which drew both admiration and reprobation from a Danish traveller, Otto Sperling, doctor to King Christian IV, when he visited Rubens in 1621.

He has left us the only available first-hand account of Rubens's studio, in his memoirs:[30]

We visited the very famous and eminent painter Rubens whom we found at work, while at the same time having someone read Tacitus, and dictating a letter.

We remained silent for fear of disturbing him, but he spoke to us, without interrupting his work, and while Tacitus was being read and while the letter was being dictated, replied to our questions, as if to give us proof of his powerful faculties.

Afterwards he asked a servant to show us around his magnificent palace and let us see his antiquities and Greek and Roman statues which he possessed in considerable number.

We saw then a vast room without windows, but which was lit from an opening in the centre of the ceiling.

There a good number of young painters were gathered, each occupied on a different work, for which M. Rubens had provided a pencil drawing, heightened in places with colour. The young man had to copy these *modelli* entirely in paint, and then at the end, M. Rubens would add the final touches to the work. All that eventually

passed for a work by Rubens. And this man, not content with amassing an immense fortune from it, has also had honours and expensive presents piled on him by kings and princes.[31]

Sperling was a first-hand witness of how Rubens's studio operated, and passed a judgement as severe as it was widespread on the interesting financial spin-offs of his organisation – Johann Faber used to describe his former patient as 'the painter who amassed 100,000 gold florins by his art'.

Did Michelangelo decorate the Sistine Chapel entirely by himself, or Raphael the immense panel of *The School of Athens* or Veronese *The Wedding at Cana*? Not only was studio work a common practice but it also served the interest of the pupils as much as those of the masters. Had it not been the case, eager postulants, let alone highly talented ones, would hardly have besieged Rubens's door as they did. From all the evidence available, 'aspirants' obviously wanted to be taught by such a master. As we have seen, even artists in full possession of their talent, men who already had a solid reputation, such as Jan Brueghel, Jacob Jordaens and Franz Snyders, were not put off by the thought of associating themselves with such an honoured, wealthy painter. Frequenting a studio of a well-known master had the added advantage of bringing not inconsiderable financial rewards, as is confirmed in the account of Charles I's envoy who, as we saw earlier, was given the task of attracting Van Dyck to London. 'We made [Van Dyck] leave the town somewhat ill at ease, made worse by the fact that the fortune acquired by Rubens was a motive for him to stay there.'[32]

Rubens did not exploit his assistants for they profited both artistically and materially from his renown. As for the fact that Rubens passed off work done by others as his own, something Sperling had accused him of doing, this turned out to have a kickback effect on the painter, forcing him to exploit his 'industry' with more subtlety, as several anecdotes make clear. The Prince of Wales, the future Charles I, would refuse to purchase one of Rubens's lion hunts for reasons which emerge from this letter written by an English diplomat:

But now for Ruben, in every paynters opinion he hath sent hether a peece scarse touched by his own hand, and the postures so forced, as the Prince will not admitt the picture into his galerye. I could wishe, thearfore that the famus man would doe soum on thinge to register or redeem his reputation in this howse and to stand amongst the many excellent wourkes w^ch are hear of all the best masters in

Christendoum, for from him we have yet only *Judith and Holifernes*, of littell credite to his great skill.[33]

Rubens was too concerned about his reputation and his income, on the one hand, to allow works that might tarnish his reputation to be attributed to him (a propensity he had shown ever since his trip to Spain)[34] and, on the other, to allow works done entirely in his own hand to go without being fully appreciated. And so, when William Duke of Neuburg asked him for a St Michael, after several discussions about the proportions and arrangement of the painting, Rubens wrote to him on 11 October 1619: 'As for the subject of St Michael, it is a beautiful but a very difficult one, and I doubt that I can find among my pupils anyone capable of doing the work, even after my design; in any case, it will be necessary for me to retouch it well with my own hand.'[35]

As the following episode attests, Rubens also made a point of making people aware of the difference between his works and those of his studio, emphasising that the distinction between the one and the other should appear more in the valuation than in the technique. Rubens had got to know the English Ambassador to The Hague, Dudley Carleton, a great art lover and of Rubens's paintings in particular. Rubens, for his part, was still as passionate about Roman antiquities as he had been when he was in Italy, and the Ambassador happened to possess a vast collection of antiques. The two men, through Dudley Carleton's agent, an English scoundrel, half secondhand dealer, half artist, by the name of Toby Mathew, would from 1616 onwards enter into a contract. It was Carleton who opened the proceedings. He proposed the exchange of a valuable diamond necklace which belonged to his wife for a painting in Rubens's own hand. Unfortunately the necklace was valued at £50 in Antwerp, while Rubens's painting, a European hunting scene with foxes and lions, was worth twice that sum.

On 21 November 1616 Mathew wrote to Carleton: 'Concerning the chaine, there is noe possibility to accorde the difference betwene your L^p and Reubens; especially considering that whereof I have written to my Lady about the little w^ch will be geven for the chaine here.'[36]

Rubens partly gave in: he went down to £80 but painted a slightly smaller hunt for the Carletons, and let the Duke of Aerschot have the bigger one as he could pay the right price. From then on the painter and the Ambassador had each other's measure and it was Rubens who kept business relations going. He was interested in a number of antique marbles which the Ambassador had brought out from England. The Englishman wanted 6,000 florins for them, Rubens proposed 6,850 florins, i.e. twelve

of his paintings. On 28 April 1618 he sent Carleton an account which clearly shows how he valued his productions: '... 1,200 florins: a *Last Judgement*, begun by one of my pupils after a much bigger painting I did for His Highness The Prince of Neuburg (who paid me 3,500 florins for it). The painting is unfinished, but I am resolved to continue it entirely in my own hand, so that it would easily pass for an original.'[37]

In writing thus he was admitting that a painting, on which the basic work was done by his studio but to which he had added the finishing touches, was equivalent to a work done entirely by himself. As a result, as he established in his note of 1621 to William Trumbull, the English resident in Brussels, the cost of Rubens's studio work and paintings in his own hand were calculated as follows: '... if I had done the entire work with my own hand, it would be worth twice as much'.[38]

Like most of the people who commissioned work from Rubens, Carleton complied. In 1619 Rubens took ownership of a collection which comprised: twenty-one large statues, eight child statues, four torsos, fifty-seven heads of various sizes, seventeen pedestals, five urns, five bas-reliefs as well as an assortment of smaller pieces. He positioned them round his rotunda 'in an orderly and symmetrical manner',[39] and thus through a dealer recommended for his professionalism became the owner of one of the most important amateur collections of his time, in exchange for a dozen of 'his' pictures.

In the first years Rubens was active in Antwerp he worked for religious orders, the local authority, and Plantin's printing press. Not surprisingly he exploited his social contacts. He had already worked for the Jesuits in Genoa: the Order first commissioned a *Visitation of the Virgin*, then in 1620 asked him to carry out the interior decoration and the façade of the church of St Ignatius (now St Charles Borromeo) for the Jesuits. Over a period of several months – he signed the contract on 20 March 1620 for work which was to be finished by the end of the year – Rubens gave vent to the exuberance of his pictorial, architectural and sculptural creativity.

Nothing remains of the thirty-nine paintings done by Rubens, for the church was burnt down in July 1718. Nevertheless a number of drawings, some rare sketches, even the actual conformation of the church, allow one to imagine that these works were intended to create a Flemish Sistine chapel. In fact, Rubens's thirty-nine canvases were each fitted into a ceiling vault, just as in the Vatican chapel, allowing him to put into practice what he had observed and admired in Italy. The Italian masters had joyfully painted lunettes, cupolas and vaults in their churches, using sophisticated perspectives which gave the viewer the impression of observing a scene from a low-angle shot, or which seemed flat, although the scene in question

was painted on a curved support. The vast master altar (the order of St Ignatius wanted to show the greatness of the mystery of the Eucharist which was contested by the Protestants), inspired Rubens to reproduce the columns of Solomon, borrowed from Raphael, which he had used in his triptych of *The Holy Trinity* in Mantua.

For the friezes, the escutcheon of the monogram of Christ which stood over the entrance, the statues in their niches and angles of the façade, he kept to *putti* – the cherubs, garlands of fruit and flowers usual in all ornamentation. But it was Rubens who designed the maquettes of the sculptures and gave the architects the idea of a façade on three levels, of which the top levels were bounded by a volute, in the manner of the Gesu church in Rome. In so doing he demonstrated his domination over Flemish plastic art, ornamenting his town of Antwerp with its first Baroque church, leaving his mark on this building whose white marble walls would make it a celestial Jerusalem on earth.

The burgomaster, Nicolas Rockox, was also a great art lover and soon he became one of Rubens's most loyal friends – they had first met through Philip, when the latter was an alderman of Antwerp. In 1610 Rockox asked Rubens to do him an *Adoration of the Magi* which for a time hung on the walls of the Stadthuis. In 1612 it was given to the Spanish representative, Rodrigo Calderon, Count of Oliva; in gratitude for the services he had rendered the town of Antwerp, the municipality made him a present of 'the aldermen's most precious and rarest possession'.[40] Again through another friend, this time the philosopher and collector Cornelius Van der Geest, Rubens met the vicar and wardens of St Walburga, the oldest church in Antwerp. The meeting was held at an inn, The Little Zeeland, and as a result Rubens signed a contract for an *Erection of the Cross*.

In June 1610 he erected the scaffolding in St Walburga. He had remembered the lesson learnt at the church of Santa Croce in Gerusalemme in Rome, where the light from the windows which fell on his panels was blinding, forcing him to completely redo his triptych. To avoid a similar misadventure he worked *in situ*, creating the painting in relation to the available light.

In 1611 the Bishop of Ghent, Charles Maes, ordered a large painting to decorate the master altar of his cathedral. And finally, for his old schoolfriend from primary school, Balthasar Moretus, the man who had succeeded his grandfather Christopher Plantin at the head of the great printing house in Antwerp, Rubens made a series of ten busts of philosophers and learned men: Justus Lipsius, Plato, Seneca, Leo X, Lorenzo de Medicis, Pic de la Mirandole, Alfonso de Aragon and Mathias Corvinus. His commissions were continuous and assured and those who

could afford Rubens – merchants, princes and prelates – vied with each other to secure his services.

During the first ten years of his stay in Antwerp, before accepting the large commission from the Jesuits for a 'Flemish Sistine Chapel', Rubens finished more than 200 paintings, of uneven reputation, essentially religiously inspired, interspersed with a few mythological scenes, some hunts and about twenty portraits. All, of course, were of the large dimensions required for the decoration of palaces, churches, the walls of municipal buildings and villas. This was no time for small, intimate pictures for private consumption. If he wished to live by his art the artist of the day painted to order, and Rubens did so perhaps even more readily than his fellow artists, for he was undeniably avid for fame and riches. Particularly at the beginning of his career, Rubens rarely had the occasion or the time to paint subjects of his own choice, for his own pleasure. As the commissions flowed in, so he organised his life to fulfil them.

His works are so numerous that researchers have been unable to trace the provenance of many of them. The principal sources of research on Rubens are the guild registers, town archives, and individual families. These papers yield little beyond the accounts, which show only that Rubens signed contracts and was well versed in negotiating the high sums he demanded for his works.

There is nothing else, for Rubens did not confide in his notebook the way Leonardo had. There are no details of his paintings, no secret recipes on how to prepare varnish or a colour. Nor, during his stay in Italy where he was copying the ancient masters and studying anatomy and geometry, did he write down his own thoughts about the paintings or the larger concepts of existence and creation. Rubens was more concerned with his commissions and these left him little time to ruminate in a notebook.

Since his last experience of trial and error in Italy, Rubens had adopted a religion which was as pictorial as it was existential. He submitted to an iron discipline which ruled his professional life as much as his personal one. He followed the precepts laid down in the motto above his portico, preserving a healthy mind in a healthy body, refraining from useless rebellion against the obstacles of fate, since the gods knew better than he what was best for him. That did not mean, however, that he submitted to a passive fatalism. A stoic he may have been but an ever resourceful one who was ready to assist the heavens, adroitly manoeuvring pawns on the chequerboard of ambition, without going out of his way to notice the material misery surrounding him. Perhaps he might have argued that he had had experience of poverty himself. Yet all that was long gone for Rubens now had the 'clear assured [look] of a businessman'.[41]

The organisation of his house corresponded, as we have seen, to this same sense of economy: space was allotted according to the importance, in the eyes of the painter, of the work which would take place there, the living quarters occupying no more room than that allotted for creation, the façade of the studio being the most sumptuous ... while its interior organisation responded to the same rule.

Seated in his cabinet, a room which no one had a right to enter apart from his servant, Rubens drew his sketches, composed his paintings in small format, in solitude and meditation. When he was satisfied with this rough in oil or in grisaille, he took it to his assistants who were gathered in a second studio. Their task was to translate this sketch into its final dimensions. Afterwards, when each had carried out his work according to his speciality, adding landscape or foliage or perhaps animals or fruit, the picture would be lowered into the great studio by a system of pulleys. It was there that the master corrected the painting, retouched it, adding a little light here, a heightening of colour there, a lighter stroke on the carnations, draperies, accessories. Rubens usually reserved faces for himself and unified the different elements with his own hand, with his mark, reconciling the end product with his rough. In some way he thus put his signature on it, leaving it to later experts to detect Rubens pure from half Rubens.

So paintings *entirely* in Rubens's hand are not numerous and are difficult to catalogue, the most easily authenticated being his preparatory sketches. Perhaps, before condemning his manufacturing process, one should recognise Rubens as a 'technical genius who found a method through collective working, a process of execution which left him the final say, and which made everything that came out of his studio look as though it was entirely done by him'.[42] Rubens needed this room to manoeuvre. His fame was so great that his high prices did not deter art lovers and even inspired his fellow painters: 'Here I can but imitate our famous painter, my compatriot Rubens, who when he does business with an art lover who is inexperienced in evaluating works of art, sends him to a painter whose talent like his prices are lower. As for Rubens: his better paintings, although dearer, will never be short of purchasers.'[43]

There are few witnesses to Rubens's art, so what we know of it is found in the same anecdotes which make up the story of his private life, be it the *Vita* of his nephew Philip (retranscribed by Roger de Piles and frequently quoted) or Otto Sperling's account. No one has ever been able to question the testimony of Philip Rubens for there is nothing to compare it with, since Rubens's other table companions were uninterested in relaying the details of how the great master employed his time. When

biographies came into vogue there were no eyewitness accounts in existence which might have modified the information provided by his nephew and, of course, his contemporaries were long dead. The stories which have survived are those which tell of the metronome-like regulation of his daily life and practice of art. However, in the course of time, analyses of Rubens's technique have only served to confirm these eye witness accounts of his fantastic managerial talent for which he apparently applied rules right down to his palette and brushes.

In fact, as far as his painting technique is concerned, he simply followed the process used by Van Eyck - oil painting - but he improved upon it by using a discovery he had made in Italy: a special way of heating. Rubens used a siccative oil, made from linseed oil and lead oxide, and heated it without bringing it to the boil in a bath of sand. He prepared the canvas with a base of white wax, which gave a transparency to the layers of colour which he repeatedly applied and a final lightness to the whole. This shiny malleable medium on its supple base - which had a less harsh finish than canvas on its own - and his broad brushes were particularly appropriate for his technique which used light brushstrokes, in a rapid sweeping style, his virtuosity - and his profitability, perhaps. His palette, which the Ghent painter J. D. Regnier reconstructed in 1847 - is particularly sober: 'All Peter Paul Rubens's paintings are painted with lead white, yellow ochre, madder-lake, ultramarine blue and bitumen, helped in a few places with an opaque light yellow, vermillion and black.'[44]

The same principle of economy found elsewhere in his life also appears in his use of colours, as Eugène Fromentin was to comment later:

These colours are also very limited and appear so complicated only because of the way the painter used them and the roles he assigned them. As far as the number of primary colours go, nothing could be more minimalised, nothing more premeditated than the manner in which he contrasts them; nothing is simpler also than his customary way of mixing them, and nothing more unexpected than the result he produces. None of Rubens's gifts is rare in itself. If you take his red, for example, you can easily tell what the formula is: vermillion and ochre, hardly broken up at all, just as it is when it is first mixed. If you examine his blacks, they are taken from the pot of ivory black, and are used with white for all the combinations imaginable from muted grey and the softest of greys. His blues are accidents; his yellows, one of the colours which he appreciated and managed least well as a colour, and, except for golds, whose warm muted richness he excelled in rendering, have, as the reds, a dual purpose: first, to

make light dazzling elsewhere than on the whites; secondly, to act as an indirect catalyst on colours, and make them change, for example, make a sad, very insignificant and completely neutral grey, as seen on his palette, blossom and turn to violet. All that, you might say, is not so extraordinary.

A brown undercoat with two or three active colours to give the impression of richness to a huge canvas, the greying factorisation obtained through palish mixtures, all the stages of grey between a great black and a great white; few colouring materials and the greatest burst of colour as a result, a great luxury obtained at small expense, light without too much brightness, an extreme sonority with few instruments, a keyboard three-quarters neglected which he skims, jumping many of the notes, and touching the two extremities when need be such is, in the mixed language of music and painting, the practice of the great practitioner. Anyone who has seen one of his paintings can recognise them all, and anyone who saw him painting for a day would have seen the way he painted for the rest of his life.[45]

Just as he managed his space, his time, his technique and his production, Rubens would also manage the distribution of his work. From very early on, he took care to protect his rights. He would even research the origins of copyright in his repeated attempts to obtain it, as is shown over and over again in his correspondence. So often does this theme recur that his English critics discarded the five volumes of letters, because in their eyes it revealed Rubens only as a practical man, without revealing his art.[46]

Albeit somewhat hasty, the judgment of the English critics, Gold and Treves, is not without foundation. Rubens's first letters are in fact simply demands for money to the Duke of Mantua's Intendant. Three years after leaving Italy he was still asking Cardinal Serra's establishment (letter of 2 March 1612) for a 'small sum which is still owing' from the Oratorians for works carried out in the Chiesa Nuova. When the Archbishop of Ghent, Antoine Triest, was on the point of abandoning the commission he inherited from his predecessor, Charles Maes, Rubens did not hesitate to get the Archdukes themselves to intervene. He employs tact in his own clever way. It is not, of course, a question of his personal interest which is 'of little importance'. However, he is most worried by the possible resentment the town's citizens might feel should they be deprived of a public ornament for their city, which is such a shame for 'this design for the town of Ghent is the best thing that I have ever done in my life'. It appears to be a habit of his to regard each one of his works as the 'best of his life': he had

already used the phrase of the canvas for the Chiesa Nuova on 28 October 1608: 'My work in Rome on the three great pictures for the Chiesa Nuova is finished, and if I am not mistaken, is the least unsuccessful of work by my hand. . . .'[47] And, of course, it was only for the salvation of his art and the happiness of the people of Ghent that Rubens, devoted as he was to his Archduke and praying to the heavens that his health would be preserved, allowed himself to be shown so pressing.[48]

In fact, until the 1620s, Rubens's correspondence reads more like the letters of someone fighting a legal battle than an artist's. Even in his letter to the English ambassador at The Hague he humbly presents himself 'not as a prince, but as a man who earns his living with his hands'.[49] One comes across the same deceits when reading the letters of Johann Sebastian Bach, which offer similar disappointments; conditions were just as hard for musicians. Rubens learnt how to appear unrelenting, insistent, even pedantic in his knowledge of his work's aesthetic and above all financial worth.

In fact, at the beginning of the seventeenth century the artist's professional life was almost the same as in Dürer's day – at that time an important painting was only ever undertaken on commission. The ability to conceive of a painting which did not fall into one of the customary categories of religious painting and which had no definite aim in mind, appears only later, when it was recognised that art was a means of 'expressing an artist's personality'. In Germany, at the end of the fifteenth century, the painter had no choice of subject other than traditional religious themes and portraits.

On the other hand, the magical art of reproduction enabled an individual to take the initiative: instead of waiting for a commission he could produce a great number of copies of works of his own invention. As it was within almost everyone's means to buy a print, printed pictures found a market in the same way as the printed book, and although the graphic artist (as well as the writer) must, to a certain extent, take the public's taste into account, it is possible for the artist to educate this taste. Graphic technique thus became a vehicle for personal expression, well before this same personal expression was accepted as a principle of what are called the 'major arts'.[50]

It was thanks to printed engravings that Rubens had first discovered painting, in the Bible illustrated by Tobias Stimmer which he had practised copying as a child. It was through engraving that he had familiarised himself with the great masters of the Renaissance, well before he left for Italy. In Mantua he had become acquainted with the school of engraving begun by Giulio Romano, from whom he had bought some work for his personal

collection, which already included engravings by Marco Antonio for Raphael and several compositions on wood by Titian. In Rome he had been a friend of Adam Elsheimer who was as great an engraver as he was a painter. Rubens had seen Elsheimer use a particular technique which he was keen to recapture: 'I am glad that you have found a method of drawing on copper on a white ground, as Adam Elsheimer used to do. Before he etched the plate with acid, he covered it with a white paste. Then, when he engraved with a needle through to the copper, which is somewhat reddish by nature, it seemed like drawing with a red chalk on white paper. I do not remember the ingredients of this paste, although he very kindly told me.'[51]

As an amateur Rubens was acutely aware of the interest that publication of a minor work of art by an engraver could generate. Of course, he was also a close friend of Balthasar Moretus, the printer, who regularly asked him for illustrations for the books he published. Rubens had only done two engravings himself, but the technique of reproducing pictures for the general public was in no way unfamiliar to him. Once he had mastered this technique for his own works, he completed his studio with a section of engravings. He trained no one, but he anxiously supervised an artisan who engraved on copper the drawings that he, Van Dyck and later Erasmus Quellyn made, after the paintings which he wanted to popularise.

The difference between Rubens and Dürer was that Rubens did not use the engraving to make small pictures of what he was forbidden to express on a large scale. Engraving was a means of personal expression for him, but not entirely in the sense intended by the American art historian Panofsky who sees engraving as a means of freely expanding the artist's fantasy. It was different for Rubens: engraving was certainly a means of making his genius known, but it was less a question of his creative genius than of his unequalled genius in managing his artistic productions. The people who commissioned work from him demanded religious or mytho-logical scenes. He also engraved religious and mythological scenes, for he engraved what he painted. Rubens was not looking for another aspect of himself through engraving, a less constrained, less conformist aspect of his talent. In engraving, as in painting, he produced what his patrons and his paymasters wanted, he conformed to the aesthetic demands of the princes. For him engraving was merely a means of enlarging his audience, of spreading his fame into other areas, into other countries and, of course, of fully exploiting the capital provided by the canvas from which he had drawn his reproductions.

Rubens may have thrown himself into the mass market but he was none the less extremely meticulous, even more meticulous than his predecessors. Only his best pupils were given the task of reducing the initial canvas to

the dimensions of a print. He then personally supervised the work of the engraver who was kept entirely under his control: 'It seemed a lesser evil to have work done in my presence by a well-intentioned young man, than by great artists according to their fancy', he wrote on 23 January 1619 to Peter van Veen, brother of the master Otto Venius, who lived in Holland.[52] He 'spares neither his time nor his attention to obtain all the perfections possible from his translator'.[53] Sometimes Rubens would even totally recompose a canvas to accommodate the engraver. He supervised all the plates, 'pointing out the highlights and shadows for the white and black colours. The engraver had to keep starting again until Rubens was satisfied.'[54]

As he did not use inexperienced artists but employed men of the trade, frictions frequently arose between the painter and the engraver. Rubens would use about twenty artisans among whom numbered some of the best of the day, such as Cornelius de Galle, Peter Soutman and the Bolswert brothers. The latter, as well as Cornelius de Galle, whose reputations in their own field were equal almost to Rubens's, ended up leaving Rubens. Collaborating with Rubens entailed too much work, and they preferred to concentrate on their own commissions rather than serve someone like him. Even more astonishing was the fact that Lucas Vosterman, considered the greatest engraver of the seventeenth century, should have stayed six years, from 1617 to 1623, in the studio beside the Wapper. He finally left on the verge of a breakdown and, in a fit of exasperation, threatened his too finicky painter's life. In 1622 Vostermann had thrown himself at Rubens armed with a poker, which gave rise to a rumour abroad that Rubens had died, while in Flanders Rubens's close friends asked the Infanta Isabella to give him protection – which she did.

Rubens was so concerned about the reputation and marketing of his work that he 'personally supervised [not only] the manufacture [but also] the sale of his prints',[55] wanting to control both the reproductions of his paintings and the profits expected from this mass market. He railed against forgeries, as much from the aesthetic as from the financial and legal point of view. This developed into the interesting battle he conducted for recognition of artistic ownership, as a result of which he succeeded in protecting his signature in the main European capitals.

Rubens's campaign began in the United Provinces – his first engravers were Dutch, and so were his first forgers – where he contacted Peter van Veen, his old master's brother. On 4 January 1619 he wrote to him:

It perhaps will seem strange to you to receive a letter from me after
so long a silence, but I am not a man who indulges in vain

85

compliments; and I believe the same is true of all men of worth. Up to the present, I have exchanged with you only the greetings and return-greetings which one offers to passing friends. But now I need your advice. I should like information about how I ought to proceed to obtain a privilege from the State General of the United Provinces, authorising me to publish certain copper engravings which were done in my house, in order to prevent their being copied in those provinces. Many people advise me to do this, but I, being an uninformed novice in these things, should like to know whether, in your opinion, this privilege is necessary, and also whether it would be respected in such a free country.[56]

Calvinists were not particularly well disposed towards anything emanating from the Catholic states, whether or not it was art, and still less so when the morality of their own nationals was being put into question. But Rubens with his 'unique blend of *savoir-vivre* and *savoir-faire*, formulated his claims precisely, returned to the charge whenever it was necessary and made everyone who could be useful to him interested in his requests. Had his copyright been infringed? He claimed extremely vigorously that it had, made such a fuss, explored every avenue, and without ever losing heart finally obtained justice.'[57] We do not know what Van Veen replied, but Rubens wrote to the States General of the United Provinces anyway, and on 15 May 1619 his demand was rejected. He then turned to Dudley Carleton (from whom he had just acquired his collection of antiquities). Carleton, an occasional painter himself, was also the English representative at The Hague. Rubens appears to have been sufficiently well informed of the political situation to know that the United Provinces would refuse nothing of their powerful ally across the Channel.

And so, thanks to Carleton's intervention, he obtained his first privilege on 24 February 1620. The States General of the United Provinces forbade 'to each and every of the inhabitants of the said Low Countries whose occupation is line engraving or etching, to imitate or reproduce the engravings or etchings of Peter Paul Rubens, a painter domiciled in Antwerp, which have been or will be engraved upon copper and of which he will have submitted proofs to their Highest Powers, and this during the period of seven years, under pain of confiscation of the imitations by engraving or etching, in addition to a fine of 100 Carolus florins'.[58]

Rubens then undertook to obtain the same advantages in France. His friend Jan Casper Gevaerts put him in touch with the humanist lawyer Nicolas Claude Fabri de Peiresc. On 3 July 1619, thanks to Peiresc's advice and intervention, Rubens's engraved work became protected in France for

a period of ten years. This privilege was to be renewed in 1635. On 29 July 1619 the Archdukes extended the same protection, and on 16 January 1620 extended it still further not just in Brabant but in all the States. Spain was to take longer to react for it was not until 1630 that the King heard Rubens's cause. Nevertheless, in Spain the privilege became valid for twelve years and, on Rubens's death, the Spanish state handed it down to Rubens's heirs.

During the first ten years since his return to Antwerp Rubens had established his business, a truly modern enterprise. The artist had proved himself as a manager, an administrator of his human resources, pupils, collaborators and engravers, of his financial affairs, of his production, an expert in public relations and even marketing. Business continued to boom. 'To tell the truth, I am so burdened with commissions, both public and private that for some years to come I cannot commit myself', Rubens wrote in April 1618 to Dudley Carleton.[59]

Stylist

Rubens's contemporaries soon found him a suitable nickname: 'Take heart, our century's Apelles' Dominicus Baudius exhorted him on the death of his brother Philip in October 1611, and ended: 'Would not an Alexander recognise your genius and your merits?'[60] Others used a variant, seeing Rubens only as 'the Apelles of Flanders'. The comparison is no less pertinent, if not particularly flattering.

'Truly, Apelles had no cause for complaint either as regards his money or his time. His natural talent was so fine that, not content with practising the teachings of such a wise master, his ambition drove him to surpass all his contemporaries and his manner of working gave him the appearance of a miracle in their eyes.'[61] This biographical note on the painter of antiquity, the greatest because the best known, is more of a celebration of the artist's power than of his painting talents; so much so that one must ask why Rubens merited this nickname at the early age of thirty-four. Laudatory it may have been, but when all is said and done, is being compared to a painter of antiquity who was so greedy for money and fame really a compliment? Rubens accepted it, or had to accept it, until his dying day. And until then he continued to 'manage' his art and his engravings with the same zeal, painting and earning money, rejecting the romantic myth of the accursed artist dying in misery a few years before posterity discovers his genius, and his canvases sell for unheard of prices.

Rubens fixed his prices during his lifetime, making use of the common

practice of joint studio manufacture and charging double when the canvases were entirely by his own hand. It was for his own greatest good that he complied with the art market practices of his time, in which the painter created on commission, protected by his patrons and his guilds, and died poor only when he had ruined himself on luxuries and women, like Van Dyck, or on antiquities and drink, like Rembrandt.

Rubens was an orderly, even calculating man. His contract with the Archdukes, the privileges which he secured for himself under the very nose of his guild, and the luxury of his house, situated in the midst of poverty-stricken Antwerp, bear testimony to a certain coldheartedness. It seems that he stayed in his native land because it offered bigger and better benefits than he could have counted on in Italy, a country whose artistic influence helped him master his own technique. Does this mean as some have suggested that he was purely mercenary minded or, given his driving ambition, was he aware of what he could achieve most as artist and man?

One of the most fascinating aspects of Rubens's personality is the contrast between the man dressed in black, like one of Castiglione's courtiers, and the creator of an art where dynamism, movement, vigour and vitality can barely be captured in words. The rapacious, calculating *grand seigneur* is also the master of the most full-blooded, the most hyperbolic art in the whole history of painting. To the extent that he appears moderate and economical in his private life, and richly generous and extravagant in his art, he was two people in one: at once both Catholic and pagan, like Baroque art, which sprang into being in 1575 with the church of Gesu in Rome, the two antagonistic styles of its façade joined by a spire.

Even during his early period in Italy, Guido Reni declared that Rubens's colours seemed to have been mixed with blood since the flesh he painted was so lifelike. By around 1612 Rubens had finally freed himself from Otto Venius's cold style without yielding to the Flemish tradition of smaller canvases. He recognised this, saying: 'I confess that I am, by natural instinct, better fitted to execute very large works than small curiosities. To each according to his gifts; my talent is such that no undertaking, however vast in size or diversified in subject, has ever surpassed my courage.'[62]

Venius had already prepared him to take that direction, and the Italians had subsequently reinforced his teaching. His Flemish patrons, having launched the precepts of the Council of Trent, demanded it of him again: Rubens was a painter of large canvases, canvases which would dominate a master altar, cover the walls of a ceremonial hall in castle or guildhouse, illustrate the fate of a character in a retable triptych. From Italy he had brought back a particular technique, a medium which was both supple and easy to work, which suited the sweeping strokes of a large brush. His

pictures portrayed the Bible, the *Golden Legend*, the *Metamorphoses* of Ovid, kings, princes, the powerful, the practice of their faith and their entertainments – following the conventions of the times, and his own natural inclination. He devoted himself to depicting the dogma of the Catholic religion, its Vulgate, and the pagan myths. He is the painter of epic dramatic subjects and has little in common with the reflective intimacy of his predecessors.

As if freed by the pathos of his themes and by his virtuosity Rubens's style evolved, and his paintings became more and more eagerly sought after. He gradually got rid of the shadowy outlines and careful brushstrokes that he was still using when he returned from Italy. He also forgot the pronounced contrasts between light and dark which he had adopted under his contemporaries' influence, like Carracci's and Caravaggio's. His vast canvases obliged him to increase the number of shades in order to avoid colours clashing on the large surfaces. His palette grew lighter, soft clouds of warm light made the flesh he painted palpitate, and through a progressive transition of colours he diluted the contours in the dynamic of his whole composition for which he tended to favour the diagonal. The painter who had once declined to use earth-coloured ochres now seized upon the vibrating colours of the flame from its vermillion heart to its outer edges of white gold.

The over tanned bodies of his Italian period became paler, amber coloured, particularly when it was a question of emphasising the musculature of his males, as in the slave who pulled the ropes which elevated the Cross,[63] or Prometheus fighting off the eagle,[64] or St Christopher laden with his precious burden (on the reverse of the triptych of *The Descent from the Cross*[65]), or even of Christ serenely revealing his side to the doubting St Thomas. For Rubens blue remained a colour associated with the sky and the Virgin Mary: presenting the Infant Jesus to the adoring wise men,[66] ascending into heaven.[67] Green and yellow signal a character in a group: Mary Magdalene at the foot of the Cross, the executioner who scourged Christ.[68] Decorative draperies and the fabric of clothes grew softer. In the first works he produced after his return from Italy they were as smooth and stiff as in sculpture (*The Adoration of the Shepherds*), or quite academic in the careful disposition of their folds or their fluttering in some breeze or other. Rubens would let the fabric fall if it were a heavy velvet or a cotton, or appear crushed if it were a stiff brocade; draperies were only held up if a belt or a tie were there to do so.

Rubens loved dark backgrounds since they provided a wonderful foil to the brilliance with which he would invest a scene. Most of the time people are portrayed in crowds since he seemed to consider an abundance of

characters a criterion of beauty: 'The composition is very beautiful by reason of the number of figures and the variety of men, young and old, and richly dressed women,' he said when talking of his paintings in the Chiesa Nuova.[69] He never changed his opinion, and this logically resulted in his fondness for clusters of cherubs surrounding an ecstatic Virgin, assemblies of soldiers, ordinary people, apostles, male and female saints. The few men and women whom he arranged, as in the old days, in contrasting, dramatic postures in a theatrical setting, now become elements of the dynamic of the canvas. Through their bodies' outline and colouring, their gestures and their clothes, they mark the division of spaces and follow strong lines which serve to lighten the different areas, defined by the painting's overall idea: the ascension into heaven, the fall of the angels, the adoration of the shepherds and the Magi, placing the dead Christ in the tomb, St Christopher and St John taking Christ down from the Cross with his mother, St Anne and St Mary Magdalene weeping over him as they hold him on their knees. With their interlaced limbs they create an arch on whose summit sits our Lord in the Last Judgement.[70] As their size reduces, from apostles to cherubs, they form a pyramid whose pinnacle is the scarf of the Madonna as she ascends into heaven.[71]

The individuals, as in Veronese's or Michelangelo's paintings, are always monumental: imposing, majestic old men, sporting copious beards even if occasionally their hair is thinning, athletic young men at the mercy of a skin tormented by their tendons' sinuosity. Even Rubens's Christs on the Cross, dead and mourned by the women, or risen again, resemble men in their prime, with their broad shoulders and vast pectoral muscles. Rubens seems to have plumped for emulating Michelangelo's plasticity, as seen in his rebellious slaves, and the unrepentant fallen angels in the Sistine. But he is looking for strength and courage, not metaphysical rebellion in the rounded torso of Christ offered to the spear's thrust,[72] in the muscular thighs, bulging calves and nervous arms of St Francis of Assisi kneeling with a gentle smile to receive his last communion.[73]

Worried by the decrees of the Council of Trent, Michelangelo had ordered his pupil, Daniele da Volterra, to paint veils over some of the nudes in the Sistine. Rubens had no such qualms. The Council's recommendations in no way constrained his use of the nude. Not having received commissions of this type in Italy, he had not developed his talents in this field. He turned to it now, elaborating on one of the most successful elements of his art: the portrayal of flesh. He treated the nude with great decency when religious characters and subject matter demanded it: monochrome of pink, amber and burnt umber for the mortals who await the Last Judgement in their birthday suits. In mythological scenes he uses

nudity frequently and shamelessly: Prometheus delivered without even a protective drape to the torture of the eagles; frigid Venus[74] whose back and hind quarters exhibit a nacreous whiteness, a bouncing rump and tortured haunches, in the foreground of a canvas which is otherwise very dark. All through the sixteenth century the humanist glorification of the body had been banned. Rubens followed the precepts of the Council in his own fashion, for his nudes lack the pedagogic focus, the historical references and metaphysical symbols which justified Renaissance nudes. For Rubens, men were made of flesh and blood, and that is how he portrayed them.

Rubens had his own cherished prejudices. His men are solid and self-assured; even his martyrs only reveal their suffering in a whitened complexion. They invariably also have flat stomachs, loose limbs and a strong bearing. The women, in contrast, are invariably flabby. Their figures are basically a circle, whether or not one chooses to refer to *Theory of the Human Figure* signed Rubens, but whose attribution has been contested by the specialists, in which the author affirms that the circle or the circular figure is dominant in the female form.[75] Round stomach, round hips, round buttocks, it would have been pleasing if the breasts could have been round too, but it is here that roundness peters out and fades away into the three academic creases in the abdomen. It would appear that in Rubens's eyes women cannot have angles, for just when one might be expected to appear – on a joint, a knee, an ankle, a shoulder – Rubens immediately fattens it out, hides it, smothers it under a fold, or an avalanche of dimples, a curve. These Rubenesque ladies are not even given the 'young female giant' allure of his very Veronese-like Domitilla in the Chiesa Nuova. For Rubens, woman is tender, she embraces, she cuddles, she weeps, she raises her eyes to the heavens, or is lifted heavenwards by a colony of *putti*.[76]

Rubens's knowledge of humanity is revealed in facial expression. He never ceased to profess his mistrust of the art of portraiture, brusquely refusing to submit to the orders of Vincenzo de Gonzaga who would have liked to have included one of Rubens's later offerings in his gallery of beauties. When he painted the powerful it was only as a means of securing other commissions: the Doria, the Spinola of Genoa, the burghers of Antwerp and, inevitably, the Archdukes. When he agreed to do a portrait he set a value on himself and granted his services as a favour, even if, at the end of the day, he was the principal beneficiary. For example, when Thomas Howard, Earl of Arundel, the most famous art collector in England summoned him, Rubens replied: 'Although I have refused to paint the portraits of more than one prince and gentleman of the rank of His Lordship I feel myself obliged to accept the honour which His Lordship has made

me in seeking out my services, in view of the fact that I consider him as an evangelist in the world of the arts and the great protector of our métier.'[77]

Even though Rubens was a reluctant portrait painter, when he did accept commissions he reserved the faces for himself to paint (his pupils filling in the foliages and landscapes) because there lay the expressivity of the whole work. In Rome he had filled his notebooks with a multitude of sketches of busts or statues, creating a type of portrait gallery. There is no doubt he was fascinated by the human face.

> The human face which he knew well, which he handled like a sculptor kneading clay, and whose assured, pathetic effects he drew daily, the human face interested him for its exterior characteristics, or for the depth it could reveal to him. It mattered little to him what went on inside a skull which was not his own, and what eyes gazing into his might reveal of an enigma unknown to his own. Human eyes, human foreheads became part of a symphony, as instruments he could elicit sound from at the right place and the right time and only as it suited him.[78]

Finally, many of his portraits are devoted to one distant relative, his sister-in-law, Suzanna Fourment. The first was dated 1620 and there would be six others. From this one can conclude that when Rubens liked someone, he gladly painted them. On the other hand, he also knew how to avail himself when it was a question of painting his 'clients'.

Luckily, in his impersonal composition he had only to depict faces which he created from his imagination for his own pleasure – and for ours. His women are pretty, eternally pretty, so that appreciation of a face is not tempered by the reflection 'this is what they considered pretty at that period'. They are still pretty and charming today with a kind of *Belle Epoque* liveliness which endows them with delicate features, upturned nose, light, pale gold hair, drawn strand by strand, like the hair of Yseult who seduced King Mark, and which is often proof enough that a painting is by Rubens. He abandoned his Italian goddesses' well-ordered curls for the scintillating disorders of his Venus's or Mary Magdalene's hairstyles. If he drew back his Virgin's hair into a chestnut chignon, he allowed several wisps to escape, or even let it unwind in an abundant wave over her shoulders. He drew women with small thin lips, their mouths half open in naïve astonishment, pursued into an impish smile strongly reminiscent of Isabella Brant's. However tender he may make them appear, Rubens never credits women with an interesting inner life. In its place they exhibit vain pride in their body (*Venus before a Mirror*),[79] deny it (*Venus frigida*),[80]

raise their eyes heavenwards in an expression of faith or grief, or throw sideways glances at a courting male (*Jupiter and Callisto*).[81]

Looking at the evidence, it becomes clear that in Rubens's eyes only the male thinks, suffers, desires and feels. From this springs the diversity to be found in the male faces, whose expressions are the very models of adoration, respect, horror, cruelty, serenity at their final hour, and incredulity. Giving free rein to his talent as a draughtsman, Rubens meticulously modelled his subjects' faces to fit their contexts, the scenes in which they were the actors and the spectators. Gestures also emphasise the look: the tilt of a head, a smile, a frown, the heaviness of an eyelid or a wide-eyed stare are often enough to convey an emotion. While Rubens loved his canvases to be filled with people he had little interest in painting the gesticulations of a whole crowd, preferring to unfold his movements around a principal activity: flagellation, the erection of the Cross, a deposition, adoration, prayer. The digressions, the particular movements which comment on the subject, are reserved for the position of the hands: hands which St Francis holds out before his eyes to protect them from the divine light; the hand which one of the Three Wise Men places on his heart, his body entirely hidden in his gold-embroidered cloak; hands which hang, powerful and helpless, at the end of the livid arms of a dead Christ (*The Holy Trinity* of Antwerp). Nevertheless the essence of expression, of emotions, is to be found in the face, in portraits dramatically drawn from the shadows by vertical or lateral light, whose source is not always explicable, but is always certain in its effect.

From these multiple expressions is born a dynamism which marks Rubens's freedom from the static stage-sets of Veronese and the rigid gold pomp of Titian which he adopted in his first paintings. He is too great a draughtsman to restrict himself to Mannerism's sinuous lines, lines created by a sculptor, for whom painting was second best. He was not seeking to create the illusion of relief, he did not resort to the arabesque as a graphic metaphor of the living form. His drawing is not a standard clause, a calculation, a reference to an historic ideal. Quite simply, he describes. Rubens's brushstrokes explore the differences, the diversity, the multiplicity of forms and sensations, and use them as evidence of a vitality which has become the essential characteristic of his art. As Elie Faure explains:

Whatever he paints – myth, history, the countryside, the marketplace, games, fighting, portraits – Rubens has no subject other than tireless pursuit, across a thousand symbols of nature in action, of the dynamism of life whose immense river flows over him without ever

exhausting his overflowing springs, and without his capacity for pursuit ever decreasing.[82]

The following story, recounted by Campo Weyerman (in *Rubens* by Alfred Michiels), one of the first historians of Flemish art, goes some way to show that the vitality of Rubens's paintings sprang from studying nature in depth and from a very Flemish preoccupation with exactness in the representation of phenomena. A kermess was taking place in Antwerp, and it included a lion tamer. Rubens asked the man to come to his house with his animal so that he could draw 'this tyrant of African wastes in several postures'. 'As he was occupied with this need, the animal started to yawn and stretch out its tongue in such a picturesque and unusual manner that Rubens hurried to make a sketch of it, hoping thus to copy it when he composed one of his hunting pictures. While he was drawing he asked the tamer if he could not make the beast perform the same movement again, and promised him a good reward. The lion's master tickled the beast under its jaw and once more it opened its mouth. But having repeated the experiment too often, the quadruped grew angry and cast him some terrible looks. His keeper then said to Rubens that it would be dangerous to continue this exercise, that his lion was as proud as a Spanish nobleman and, like an inquisitor, harboured his resentment of an outrage: one should not expose oneself to his vengeance. This observation frightened Rubens: he left his easel, put his sketches in a neighbouring room, and paid the tamer his dues, begging him to remove the beast as quickly as possible.' But the lion had not forgotten his tamer's teasing. Acting just like a 'Spanish nobleman', the lion duly dwelt on his sense of bitterness, and during a subsequent demonstration in Bruges, ate his keeper. Rubens was thus the indirect cause of the man's death, more concerned with his own glorification as a painter than the life of showmen at a fair. Michiels concluded: 'If this anecdote is not false, it goes to show what other hunt scenes of Rubens have proved, that he studied animals faithfully from nature.'[83]

During this period from 1610 to 1620 Rubens painted a dozen hunts for his Belgian lords, to which must be added St Hubert, patron saint of hunters, Diana at work and resting, and a few amorous lions. His respect for zoological truth drove him to make his paintings realistic, applying himself to quite advanced studies of zoology, and buying specialist books for his library. However, if the plates did not satisfy him completely he would refer to sketches brought back from Italy, copies of the animals in the Duke of Mantua's exotic menagerie. He would study also reliefs done in Rome from ancient sarcophagi, which often showed Calydon's wild

boar hunt; while Dürer furnished him with the model of a rhinoceros's head.

As far as the women in his paintings are concerned, tradition has it that, unlike Rembrandt, he never allowed unclothed female models in his studio: he copied faces from life, but only his depictions of the male body were inspired by live models. If you look closely at some of the female anatomies he painted, their degree of lifelikeness seems to owe more to the painter's imagination than to irresolute reality.

Rubens's vitality was not motivated by the Flemish respect for or glorification of nature, nor did it form a celebration of its mystery, as in the work of the primitives. It is much more a case of the painter releasing his own nature, drawing the models and the turbulent composition of his paintings from within himself. Natural phenomena were only a point of departure for Rubens, so he retouched them just as he retouched the drawings of the great masters of the past - according to his own ideas, indeed, his own ideal.

As was his wont, he harnessed his extraordinary capacity for syncretism, and cast in a Rubensian mould whatever he had drawn from the personality in front of him, and what he had retained from his favourite sources of reference: Michelangelo, Titian, Veronese. Rubens abandoned the flat representation of a scene which produced scarcely any depth. Instead he arranged his characters and composed his painting according to his chosen theme, and according to what Eugène Delacroix called 'his science of the master plan' which 'singles him out from all those people who claim they are draughtsmen; for while their plans might seem a matter of luck, it is just the opposite with Rubens whose plans however daring never misfire'.[84]

Rubens composed his paintings on several levels: the principal subject is always accompanied by subsidiary subjects who comment upon the main subject and contribute towards the expression of one meaning. An Assumption is complemented by spectators whose eyes turn towards the heavens as they stretch out their arms, as if to hold back the Virgin who is rising into the air. Slaves pull on the ropes to elevate the Cross. When the dead Christ is taken down from the Cross, the Apostles spread out alongside it to prevent the body sliding while kneeling women prepare to press the body of the crucified man to their breasts. More than a stage or scene-setting, the picture encapsulates action and drama. Every event unrolls before one's very eyes and with the participation of the assembled crowd, whose different elements all have their particular viewpoints on what is happening. Rubens throws the spectator's vision into confusion with a profusion of detail, placing himself leagues away from the exigencies of symmetry and balance imposed not only by the Renaissance but equally

95

by classical academic painters such as Guercino or Guido Reni, his contemporaries in Rome. He draws the viewer well beyond the canvas, well beyond the frame which limits it. Even in a long-finished painting, *The Adoration of the Magi* in Antwerp town hall, he occasionally prolongs the movement without resolving its continuity, and then adds his signature by including his own self-portrait among the faithful crowd.

Rubens's art seems to recognise no rules other than those of rhetoric, of the dynamics of a powerful orator haranguing the crowds, stirring them up, leading them, sweeping them along towards eternal beatitude. He is a part of this new genius of the seventeenth century: 'Artists were inspired by a genius which differed from that of the Renaissance, by an order of values which emphasised not man as a part of the earthly world, but man according to spiritual merits, seeking to win eternal beatitude. Thus a spirited atmosphere, with an element of the fantastic was fostered, encouraging a quest for a different kind of art from that of the Renaissance, for which balance and neatness were no longer exclusive requirements.'[85]

Apart from a few hunting scenes and portraits, Rubens's production in the ten years following his return to Antwerp devolved, as we have seen, essentially from religious art. He was working for the fraternities, the religious orders, in the whirlwind of the Counter-Reformation, a movement which was supported, zealously and ardently, by the Archdukes.

One is tempted to wonder how much of this production, whose quantity was to some extent determined by the Church's power to commission, was judged in terms of quality according to the Council of Trent. To what extent did the persuasive aesthetic of the Counter-Reformation, whose aim was to show heaven in all its power and glory, contribute to the delirium of Rubens's compositions, to the point that the art of this period, dubbed 'Jesuit art', was also known as 'Rubensian art'? Was it the faith of the painter which was being expressed on canvas or merely his conformity? Was Rubens in harmony with what was happening around him? How much latitude was there for his own creativity?

Rubens had been aware of the rules of the game since his stay in Rome. Before giving him the contract for the Chiesa Nuova, the Oratorians had wanted to see explicit sketches of his project, asking in particular for the Madonna and child and the six saints whom they most revered. It was out of the question for young Rubens to have infringed the directives of Cardinal Baronio, the historian of their congregation. When Rubens returned to Antwerp these same rules remained, though even under the domination of Catholic Spain, the Inquisition did not act as ruthlessly in Flanders as it did in Spain, where it oversaw every detail, even down to the painter's brushes, and would continue to torment – and inspire – Goya

until his last days. However, every order had its censors and among the best known was the Jesuits' Father Francisco Aguilon, a mathematician whose learned works Rubens would subsequently illustrate for Plantin's. For his part, Fr Aguilon would endorse all Rubens's works for his order. Since he only occasionally painted landscapes, in order to live, Rubens had no option but to acquiesce to the demands and rules of the censor. It should not have weighed too heavily on his mind: after all, he attended matins every morning and was a pious man with an avowed faith. Rubens was used to working for churchmen, even though, when he painted in his studio, he enjoyed listening to pagan though edifying works being read out loud, Seneca and Tacitus.

Over ten years he produced seven Christs on the Cross, five Descents from the Cross, three Elevations of the Cross, five Holy Families, six Adorations of the Magi and shepherds, several St Francises, Christs with the Apostles – all demonstrating himself to be a painter imbued in the Catholic faith, determined to share it, and particularly sensitive to the pathos of martyrology. All his paintings were accepted, no legal actions ensued, no scandal accompanied them. It would appear that the censors were satisfied with Rubens's art and considered that it provided the support required for their teachings.

But it is difficult to look at Rubens's religious imagery other than as a procession of profane characters. All the men portray their biblical roles standing firmly on their feet, or securely seated on their broad bottoms; his Virgins are resistant to the fainting fits which decimated the fragile medieval Madonnas of the Maitre of Flemalle; and Francis of Assisi, doubtless kept in rude health by his outdoor life among the birds or his incessant travels as a medicant monk, even in his agony still presents a perfect musculature, scarcely bedimmed by his approaching death. Under one of Rubens's brushes the flight into Egypt takes on the atmosphere of a country outing, the Holy Family having a picnic in the forest, Mary and Joseph protecting their child like good parents. Compared with the feverish ecstasy, evanescent Assumptions and the blessed tortures of a Zurbaran, Rubens's martyrs and saints appear incurably happy. His sacred art lacks otherworldliness.

He avoided the flaying and the burnings central to seventeenth-century aesthetics that still belonged to the Middle Ages. But he did make concessions to martyrology in a painting of the Tongue of St Lievin,[86] which the hangman threw to the dogs. Even here, however, he kept the mouth of the tortured man shut and allowed him some clothes. Although it might have been interpreted as questioning the miraculous powers of the founder of the order, Rubens's St Ignatius offers comfort to only two

possessed, a man and a woman. Their eyes are inverted through the malefactions of the wicked. He is convulsing on the ground, she is held upright by a group of the faithful. And yet the tall, dazzling stature of St Ignatius, the imperturbable assembly of Jesuits dressed in black surrounding him, the little pink cherubs who climb the altar, bring an almost immediate serenity to the scene and exorcise the demons. The same goes for the lepers cured by St Francis Xavier: barely two sick people, and what is more well on the way to being cured, just enough to show the miraculous powers of the abbot. Rubens is revolted by horrific scenes. He had a gift for transposing religious scenes into a human comedy, including as modest a reference as possible to the supernatural.

This is also true of *The Holy Trinity* in Antwerp,[87] which was painted in 1617. The greatest mystery of the Catholic Church, that of the hypostasis of the Holy Spirit in the Father and the Son, is no more, in Rubens's vision, than a scene of fatherly grief. An old man holds in his arms the livid body of a young man trying to keep it warm with a panel of his sleeve. His long grey hair falls down his shoulders, his abundant beard spreads across his chest. With a gesture of his hand, with a look that is so sad that a tear is still forming in his eyes, he points to the remains of what can only be his son, since his love for the young man is obvious. The son lies like an obliterated giant, with his feet in the foreground, exposing the soles pierced with vermillion wounds. He is slumped, arms hanging, legs apart; his head falls on his shoulder. He has another gaping wound in the right side of his broad torso, the sides masked by the beginnings of a stomach. When he was alive he must have been very seductive, with his beautiful face, his deep eyes, the long slender nose. Now he is dead, he moves us even more through the expression of intense tiredness which has spread all over his face, the total abandon of his strong limbs to the sleep of the blessed. The father is suffering from having lost his son: perhaps because he is the Father, we are meant through the gesture of his hand to understand that he is showing humanity that his son has died for them, and that the proof of this infinite suffering marks the face of the young man whose very carnal presence forbids all idea of resurrection.

The two children who stand gravely by watching this scene are wearing little wings, and, above the old man veiled in a cloud of red light flies a dove, pointing its beak towards Father and Son. It is the strangeness of the light rather than the bird which signals the Holy Spirit, just as the tiny wings by themselves signify angels. They return us to the mystery of the scene, and the painting is then read differently. The wounds of the dead man seem like ornaments in what amounts to a fairly ordinary drama. Surely the best way of provoking the viewer's astonishment at the mystery

of the Holy Trinity is to create a brutal juxtaposition of divine emblems and the phenomenon of incarnation. Yet in this treatment Rubens seems to be expressing his own incredulity, in the relationship between the old man grieving over the stigmatised corpse.

Perhaps by design, or perhaps unconsciously, Rubens could slide details into the representation of a biblical scene which might otherwise offend Christian morals – like the saints' male vigour, or the representation of the Holy Trinity as a family in mourning. A further example is the foot of Jesus touching Mary Magdalene's shoulder which can be seen in the *Descent from the Cross* in Antwerp cathedral.

> You cannot forget the effect of this great body leaning slightly lopsidedly; the small narrow head with its fine features had fallen to one side, so livid and so perfectly limpid in its pallor, not strained, nor grimacing, a head from which all pain has disappeared and which hangs with such beatitude, momentarily at rest in the strange beauties of death of the just. Note how heavily the body hangs and how precious it is to support. Note its extenuated attitude as it slides the length of the shroud, with what affecting anguish it is received into the outstretched arms and hands of the women. Can there be anything more touching? At the foot of the cross, one of his feet, which has turned blue and bears the stigmata, encounters the naked shoulder of Mary Magdalene. It does not rest on it, just gently touches it. The contact is elusive; assumed rather than perceived. To emphasise it would have been profane; to deny it would have been cruel. All Rubens's furtive sensitivity is in this imperceptible contact that says so many things, all of which show respect and move us to pity.[88]

If Fromentin can see only kindness in the ultimate pleasure that Rubens accords this fallen woman who loved her Messiah, others offer a different interpretation.

> An anti-Christian concept has inspired the descent from the cross, and never has a less pious work decorated a church. It is the work of a pantheist. The body of Jesus is not that of a God who will rise again on the third day: these are the mortal remains of a man whose flame of life will never burn again. Nothing gives rise to hope. Decay has set in. Look at those bluish eyelids, that pupil beginning to decompose; look at the limp flesh and that inert corpse. ... The martyr's body weighs so heavily that, in order not to fall with him, the bearer has to lean and hang on to the glorious gibbet with his

99

other hand. He is therefore forced to grip the shroud between his teeth. . . . The second figure has let Christ slip, and is holding nothing more than an end of the shroud; he leans forward and he stretches out his right arm to grab his burden again. . . . Mary-Salome . . . has no other emotion than fear of seeing the corpse fall on her: so she is getting ready to run. . . . Nothing signifies God: the prophet's family and disciples do not believe in his divinity themselves. They are motivated by one thing only: to take the corpse from the infamous instrument [of torture] and to put it in a safe place. In no work of art have the canons of scepticism or at best incredulity been so proudly displayed, and the very depth of the composition only makes it more audacious. However, the clergy of Antwerp have admired this impious work for two centuries, without ever fathoming its doubtful meaning.[89]

Today, in the sacristy of the Cathedral of Our Lady, the tourist can still buy a postcard showing the sacrilegious detail of the foot of Christ touching Mary Magdalene's shoulder.

Was Peter Paul Rubens, who for a quarter of a century decorated the churches of Europe, an impious, profane sceptic? Or was he the child of an age where one had to see in order to believe, where the faithful's loyalty was gained through trickery, the manipulation of a Virgin who performed miracles, and whose principal historian was the philosopher and pragmatist Justus Lipsius. Was Rubens Baroque? This amorphous concept for which no definition exists, accords well enough with his individuality and his duplicity. His work was quite clearly accomplished at the peak of this artistic movement, which critics see as dating from Roman Jesuit art at the end of the sixteenth century, in total contravention of the principles of balance and harmony dear to the Renaissance. Of course the characteristics of a period should not be read into the personalities who live in it, but Rubens can be seen as representing the Baroque, both as an exponent and a leading light.

Like all aesthetic innovations, which invariably disturb merely by challenging the status quo, the term 'Baroque' was, at the outset, pejorative. It signifies exuberance, absence of rules, bulges, exaggeration, the deformity of the irregularly shaped pearl, and is opposed to the ideals of the Quattrocento. Just like Gothic art, that most elegant, slender style which originated in the barbarian art of the invading Goths from the east, Baroque blossomed thanks to the Counter-Reformation, during which the Catholic Church set about replacing and even doubling the number of sacred ornaments destroyed by the Protestants. It had originally intended simply

to restore church decoration, then somehow the project grew: decorations, simple parables of the divine word, became hyperbole. The Church was not content with just telling a story, it had to prove, persuade, convince. Art theory accordingly passed out of the hands of the aesthetes into those of the clergy. Priests became the censors of the faith and it was they who guided the artist's hand: first the Fathers of the Council of Trent, then the historians of the congregations, who took it upon themselves to apply the Council's resolutions. Rubens did business with them: first with Baronio in Rome, then with Aguilon in Antwerp.

In reality, Baroque would not be catalogued, listed or analysed until after the event, and few have been able to decide upon a date. Alejo Carpentier recognised it in primitive sculptures in the museum of Mexico, inspired by the inextricable foliage of the Amazonian forest, well before sixteenth-century Rome. For others, the term Baroque refers only to a certain type of architecture, and in that sense it can be dated since it gave way at a particular moment to the symmetry of classicism. Bearing these semantic and chronological uncertainties in mind, Eugenio d'Ors saw Baroque more simply and precisely as a state of mind. 'Everywhere', he wrote, 'where we find several contradictory intentions united in a single gesture, the stylistic result belongs to the category of baroque. The baroque – in vulgar parlance – does not know what it wants. It grows distant and closer at the same time in the spiral. It ridicules the requirements of the principle of contradiction.'[90]

If we accept that it belongs to the seventeenth century, Baroque represents a world destabilised by the discovery of new territories, the circulation of the blood, the infinite universe, a world perturbed by the multiplication of beliefs. In the seventeenth century man lost his landmarks, extended his cosmology, rethought his faith, redesigned his frontiers. How could a period thus turned upside-down not be one of incredulity, of the most manifest doubt? How could it not be satisfied except through what it saw and touched? From this uncertainty sprang the century's obsession with present reality – in men of religion as much as in politicians and artists. From this sprang the magnificence of royal fêtes, the triumphal entrées of the Archdukes of Flanders when Isabella's saddle, decorated in gold and precious stones, mattered more than her direct descent from Charles V or the title of Governess which she had given herself.

Thus Baroque, born in 1575 on the façade of the Gesu church in Rome, stretched from the end of the Renaissance to the beginning of Classicism, from the resurrected canon of the Ideal of Ancient Greece and Rome, to the advent of political and aesthetic absolutism. In contrast to what followed, Baroque seems synonymous with anarchy, or at least oblivious

of the logical principle of contradiction. In this sense it spills into everything: artistic creation, behaviour, attitudes . . . This, then, is the most comprehensive sense of the term Baroque, one with a timeless validity and perhaps the only definition relevant when applied to Rubens.

Rubens was Baroque through his manner of existence: simultaneously economical and prodigal, religious and sacrilegious, Italian and Flemish, Catholic and Stoic, making a mockery of the requirements of the principle of contradiction. He was a man of appearances, of the here and now, of evidence, of demonstration. He lived in a palace, ostensibly practised his religion, donned the attire of the nobility, as if carrying a sword was all that was involved in being a knight, wore the black clothes of a courtier, a *grand seigneur*; led the austere life of a burgher, protested that he was a mere artisan, and riddled his paintings with the most subtle avowals of his scepticism. Rubens was a man of the Baroque in his contradictory behaviour towards art and religion, but he is Baroque most of all as the principal painter of the Counter-Reformation, which he became when he returned to Antwerp. He worked according to the wishes of his time, painting the manifestations of his faith at the behest of the Church, still the greatest patron of art, be it painting, sculpture or architecture, all of which contributed to that 'swollen appearance' which came to be known as the Baroque art of the seventeenth century. Rubens epitomised Baroque art, 'in his dynamic, swirling composition, made up of diagonals, curves, orbits, open abysses and concentrated masses formed by whirlwinds; colours flow impetuously like waves of lava, unremittingly, over and over, carrying with them the clearest tones and the most dazzling colours. The future and the past do not dissolve, but intensify sensation, hasten a possession of the present in which all the senses participate.'[91]

PROTEUS
(1622-1626)

The Humanist

Rubens was living in the city of his choice. He had his house there, his friends, his studio, his pupils, his collection of antiquities, the Archdukes' protection. His order book was full for the next ten years. The ghosts of his early childhood seemed banished forever; his future life assured, his family life stable. Moreover, he had found his own style, which lay somewhere between Italian and Flemish. At forty-five, firmly established on home ground in his flourishing studio-hothouse, he could work silently enjoying the fruits of his labour, deploying his art and erudition in tranquillity.

Peter Paul Rubens was, it is true, established - in a social and psychological sense: he would no longer be setting out for foreign lands on a long apprenticeship, no longer be fumbling for a style. But resting on past laurels was not enough for him. Perhaps he felt that painting required too little effort: he had speed, virtuosity, he composed, added colour as easily as others might talk, and he seldom repainted. Curiously enough, he couldn't confine himself to the type of art which satisfied a Jan Brueghel or a Raphael. Nor did he rethink the world as Leonardo had done in his intimate notebooks, or diversify into another art as Michelangelo had done with his poetry. Unlike his old master Otto Venius, he rejected the digressions of the dilettante artists of the Renaissance who delighted in finishing with a pen what they had begun with a burin or brushes. Rubens was Baroque through his propensity to dominate a scene, to be in the limelight; he was not about to abandon painting for a cerebral activity, preferring to commit himself to new public duties. He was driven to this by circumstance and was to become an essential cog in the wheel of European politics in the first half of the seventeenth century.

If life pulsated so obviously through Rubens's painting as the art critic Elie Faure is fond of repeating, it is also true that Rubens nurtured his curiosity, verve and creativity in various ways. The owner of the palace by the Wapper canal in no way resembled the successful patriarch complacently dispensing wisdom. Quite the opposite. He was generous

with his teaching because the young needed him, but he also continued to 'fill' his life. Once he was securely established as a painter he went on to produce a family, to become an architect, a theorist, a humanist, and a diplomat. By the time diplomacy claimed his total attention, between the ages of forty-five and fifty, Rubens was a man of huge and diverse talents whose self-sufficiency illustrated his ambition both as a man and as a painter.

He and Isabella had three children. Clara-Serena, Isabella's and Peter Paul's first child, was born in 1611 and would die at the age of twelve, in 1623. Shortly before she died Peter Paul 'sketched her, her eyes too large for her sick child's exhausted little face'.[1] In 1616, seven years after their marriage, Isabella gave birth to their eldest son, Albert, named after his godfather, the Archduke. He is always considered to have been the painter's favourite child, but this is probably because he was the only one ever mentioned in Rubens's correspondence, and what is more with an unusual amount of tenderness, as in Rubens's letter to Gevaerts on 28 December 1628: 'As for my little Albert who is as dear to me as life itself, I beg Your Lordship to accept him not only in your own home, but in your work cabinet as well. I love this child, and it is with Your Lordship, the greatest of my friends and the friend of Muses, and into Your Lordship's hands that I place him, for you to look after him, along with my brother-in-law Henry Brant, as much during my lifetime as after my death.' The child was only twelve years old at the time, but in the same letter Rubens was already looking into his future: 'For when they will talk of him, it will be not so much about how long he had lived, but how he had lived.' His father sent Albert to be educated with the Augustines and it was there that the boy learnt Greek and Latin. Armed with Latin letters and a knowledge of numismatology, he would produce several learned works on these subjects. Rubens was proud of Albert, boasting of his accomplishments to the humanist Peiresc: 'The passages from ancient authors have been added by my son Albert, who is seriously engaged in the study of antiquities, and progress in Greek letters. He honours your name above all, and reveres your noble genius. Pray accept this work done in this spirit, and admit him to the number of your servants.'[2]

The classics and public affairs were the only interests Albert shared with his father for, perhaps stifled by Peter Paul's gigantic stature, none of his children would touch or even attempt painting. In 1634 Albert undertook the traditional transalpine pilgrimage. On his return he married the daughter of Deodat del Monte, the young man who had accompanied Rubens during his stay in Italy and who had lived with Rubens's family since his marriage to Rubens's sister-in-law. Shortly after Rubens's death Albert succeeded

him in the Archduke's privy council. His life, not only because it was fairly short, but through its preoccupations with law and letters, seemed to resemble his uncle Philip's more than his father's. Albert died in 1657 and two months later Albert's wife also died, devastated by the deaths of her husband and their only child, who died of rabies after having been bitten by a dog.

Nicolas, Rubens's second son, was born in 1618, two years after his brother Albert. Immortalised in one of the most famous of Rubens's drawings, we see a beautiful blond child with chubby cheeks and a chubby neck encircled with coral beads. Like his elder brother, Nicolas had a well-born godfather whose first name he bore: the Genoese banker Pallavicini. (Despite distances, Rubens was adept at maintaining friendships.) From his father Nicolas inherited only his taste for luxury. He became Seigneur of Ramey, married young and died at an even younger age than Albert, at barely thirty-seven years of age, leaving behind seven children.

Rubens wrote little about his children. He did not live in a period which encouraged personal confidences, but the tenderness he felt for children bursts through in his pictures. He never stopped painting them, whether they were his own or other people's, or those born of his imagination. He is the artist of mischievous cherubs, of mutinous pretty faces, gathered in a small group to protect the infant Jesus, stretching their plump little bodies to hang garlands in his pictures, or to fire a bow which will wound Venus with the arrow of love.

Rubens's emotional life appears hidden, either through his discreetness or the lack of correspondence, yet some of his actions do show the depth of attachment he felt for those he loved. On hearing of his mother's fatal illness he had left Italy at the very moment when his reputation was just beginning to be established; and in 1626 it seemed that it was grief, caused by the death of his wife Isabella, which motivated his involvement in politics and caused him to leave Antwerp and find relief in his work and travels. On the whole, however, at least until his second marriage, Rubens's friendships and loves seemed to be a result of self-interest, mutual respect, admiration and homage, rather than of his own deep feeling and choosing. 'He did not give himself to everyone in common,' his nephew Philip wrote, 'making firm friendships only with those of a learned disposition, those with lofty minds, and good painters, whom he cultivated and begged to come to see him often to talk of science, politics and painting.'[3] It would be difficult to imagine him thinking of friends in the words of the philosopher Montaigne, explaining his feelings for Etiènne de la Boetie: 'Because it was him, because it was me.'

His nearest, his only confidant was, as we have seen, his brother Philip. The letters Peter Paul wrote to Philip have not come down to us, but we still have his brother's letters, which indicate the quality and tone of their relationship. Philip was the devoted protector of his younger brother whose genius he recognised as greater than his own. When Rubens was living with the Gonzaga, Philip went to see him in Mantua. When their mother was ill it was Philip who left Italy to look after Maria Rubens, thereby taking all the burden of responsibility from Peter Paul and allowing him to work at his career.

On his return from Spain Philip celebrated his brother in hyperbolic ode (see Appendix). Never did he ask for anything for himself, never did he resort to small talk. Philip's correspondence speaks only of his brother's talent, of how to preserve it, make it grow and be recognised. It was Philip who moulded Rubens's behaviour towards the Duke of Mantua, just as he would shape Rubens's attitudes towards other princes of rank whom he was to come to know. 'Always take care that they do not take up too much of your time. I swear to you by our affection, by your eyes, by your genius, although I am a little fearful [sic], I do not know why, because I am aware of your condescension and I know how difficult it is to refuse such a prince, a prince who begs your services instantly. But be firm and keep your full freedom in a court where it is almost non-existent. You have the right.'[4]

When Peter Paul returned to Antwerp, it was Philip who gave him a home, who introduced him to influential people who might help him. Another indication of the bond which united the two brothers was their successive marriages. Peter Paul dogged Philip's footsteps: as soon as Philip married, he married the girl Philip presented to him: his wife's niece. Rubens led his private life according to Philip's example, and Philip's choosing, in a staggering vow of confidence. When Philip died in 1611, accounts reveal that the painter gave him a grandiose funeral and, as was customary in Antwerp, a good feast was laid on afterwards. This cost 133 florins (was it Peter Paul who paid?), not much less than it cost to feed Philip's family for six months.

Rubens seems secretive with his other friends. One might have been able to evaluate his relationships through his correspondence, but, as we know, such letters are missing. Most of those which remain are frequently written to the same people, but these do not involve Rubens's affection, for he did not write to people because he liked them but because he needed them. And if they proved useful Rubens remained loyal to them. Such a one was Justus Lipsius, a writer as wordy as his conscience was elastic; there was also the dubious 'Englishman' Balthasar Gerbier, whom we will encounter often later.

His closest circle in Antwerp consisted only of eminently respectable people, as his nephew reported. There was Jan Caspar Gevaerts, the town clerk, a humanist educated by the Jesuits, author of poetry and the Latin inscriptions. Rubens painted him, dressed in black, holding his goose quill in his hand, a blank notebook before him.[5] It was Gevaerts who, at the time when Rubens was worried about protecting his copyright in France, put him in touch with Claude Fabri de Peiresc, a lawyer at the parliament of Aix and a great connoisseur of art who would become one of Rubens's principal correspondents.

There was also the burgomaster, Nicolas Rockox, who owned a cabinet full of medals and intaglios. When Rubens decided to try and put together a book on the most beautiful cameos in Europe, he included Rockox among the authors, along with Peiresc their mutual friend, and Jacque de Bie an engraver and former curator of the collections of the Duke of Croÿ. (As we shall see, the project came to naught.) Nicolas Rockox was, as we know, one of the first people to commission Rubens with his *Adoration of the Magi*. His austere and benevolent face, the face of a 'learned and virtuous knight who was often burgomaster with honour and authority, pleasing the king and the people still more'[6] is to be seen on the triptych of *The Doubting of St Thomas* which was painted by Rubens to decorate his tomb. He is shown facing his wife: a thin man wearing a fur-trimmed cloak, with a pointed nose, turned-up chin, outlined with a thick beard. The smile which plays on his thin lips, his frowning eyebrows and his brilliant gaze, attest to a man who is determined, energetic, active, imperious like a Roman consul from whom he adopted the short hairstyle.[7]

Another among those close to Rubens, was Jan van de Wouvere (Jan Woverius), a pupil of Justus Lipsius, who figures in the group picture which Rubens made in Italy of his Mantuan friends. Rich and well thought of by the Archdukes, he acted as administrator of their domains and finances, after having been an alderman of Antwerp for a time. Wouvere was responsible for certain foreign policies which were later to be the cause of diagreements between him and Rubens.

Finally, there is Rubens's childhood friend Balthasar Moretus. Rubens used to receive Moretus at his home in the evenings, when it had become too dark to work, and when, always conscious of using his time well, he liked to surround himself with people capable of debating and clarifying subjects which greatly interested him: classical humanities, art and above all antique cameos and public affairs.

Despite their intimacy, none of his friendships seem to have made a deep emotional impression on Rubens; his friends were useful for commissioning a painting, the exchange of information, or for an evening's

conversation. Like many geniuses Rubens was a solitary figure. Even so, he did seem to need companionship on his travels, whether first in Italy or later in other parts of Europe – someone without responsibilities, perhaps even a little dull, who would act as a foil. Deodat del Monte, who has already been mentioned, played this role, as did Joachimi de Sandrart, who rode to Holland with him in 1627, and Henry Brant, his brother-in-law, who accompanied Rubens when he had to travel abroad for any length of time.

Rubens's most fruitful dialogue was with his painting itself: only there does he seem to bare his heart, let go, show some warmth, open out. It is on canvas that his tenderness for children and his interest in women emerges; there that he reveals himself as he is and how he would like to be. This can be seen in the two self-portraits that he did in his mature years for his friend Peiresc and for the Duke of Buckingham, where Rubens is dressed in his courtier's big black cape, which disguised his status as a painter, just as his large hat concealed his famous baldness.

So many things monopolised his attention and interested him that maybe he had little time for demanding personal relationships. He painted with the prodigality for which he was renowned, he was a member of the Society of Romanists, of which he rapidly became Dean, and at weekends he drew illustrations and frontispieces for the Plantin press.[8] Rubens also provided several maquettes for sculptors, notably Lucas Fayd'herbe, who worked for him until his last days, producing only statues designed by his master. Rubens also painted several decorations for the famous makers of clavicords, the Rückhert, and cartoons for tapestry, such as that relating the story of the consul Decius Mus for the businessman Francis Sweerts in 1617. The price of fame was high, and there were constant demands on his time from all aspects of the creative society in which he lived, which Rubens regarded as stemming from the 'common trunk' of painting.

His creativity was also revealed in other fields. We have already encountered Rubens the architect when he designed the Church of St Charles Borromeo in Antwerp, the first Baroque Jesuit church in Flanders, and drew up plans for his own house. Given his receptive, retentive nature, Rubens had to exploit his contacts to the full, enliven his knowledge and find vivacious expression for it. His interest in architecture stemmed from what he had learned from the façade of the Gesu church in Rome and his studies of the great houses in Genoa. He had acquired the great architectural works of the period: those of Luigi Rossini and Boissard on Roman antiquities, of Vignola on perspective, reprints of Vitruvius and Serlio, *The Idea of a Universal Architecture* by Scamozzi, *The First Book of Architecture* of Jacques Francart. Whilst his knowledge of mechanical

engineering, physics and astronomy was less certain than Leonardo's, and whilst he was less an engineer, less learned, less a builder of worlds than Leonardo, nevertheless he left his mark wherever he could. He would never write in his personal notebook, as Leonardo had: 'I have frittered my time away.'[9]

In 1622, using the sketches he had accumulated fifteen years earlier, he published a vast work, *The Palaces of Genoa*, dedicating it to a Genoese nobleman, Carlo Grimaldo. Two volumes, *Antique Palaces* and *Modern Palaces*, 139 plates from notes made *in situ* by his companion in Italy, Deodat del Monte. But why choose the architecture of Genoa where he had stayed least in Italy – why not Rome, Florence, Mantua or Venice, the quintessence of Renaissance architecture and the most seductive town of his time – and perhaps of ours as well? Why Genoa, a port and financial centre, rather than the arcades, the ogives, the galleries and balconies of Venice, the vast Roman and Florentine palaces, whose walls sheltered the enchantment of secret gardens where engineer/magicians hid the mechanisms for their fountains in exotic plants? Why this disdain for Palladio's villas which line the road young Peter Paul frequently took from Tuscany to Venice? It is because Rubens, a man from Flanders, from Antwerp, child of a city devoted to finance and bourgeois familiarity, took a liking to the Genoese houses 'more suited to housing families than the courts of uncompromising princes'. Following the practice of his native country, he took back designs which could be used to renovate its architectural landscape, entrenched in the Gothic tradition. Perhaps this is why he preferred these Genoese *palazzi*, buildings 'having the form of a solid cube with a salon in the middle, or divided up into apartments one next to the other, not taking their light from the centre'.[10]

His desire to teach and set an example to others was, moreover, clearly expressed in the preface of his book: 'In our countries we are seeing the architectural style which we call barbarian and gothic gradually age and disappear, we are seeing men of taste introduce to the great honour and embellishment of our homeland this architecture which possesses true symmetry, which conforms to the rules established by the Ancient Greeks and Romans. We can see an example of it in the magnificent churches that the Venerable Company of Jesus has just built in the towns of Brussels and Antwerp. It is with good reason – for the dignity of divine office – that one begins to change the temples to a better style.'[11] The text continues on the need to consider private building (see Appendix), for which he himself will show the way with his palace beside the Wapper.

There is no doubt that the great walls of the Baroque churches were more appropriate than tormented Gothic buildings for hanging vast

paintings: even the shape of their altars called out to be crowned by a painting. In pushing the Baroque Rubens was publicising his own technique. 'The caissons of the vaults, the altars of monumental grandeur, the wide choir partitions and the piers were in his eyes pages where his art could be given free rein.'[12] It may be argued that, beyond his personal interest, he contributed to the rebirth of architecture in the Low Countries and a number of churches – St Charles Borromeo in Antwerp, the church of La Chapelle in Brussels, to cite the most famous – attest to his capacity not only to reproduce but to build and transform reality.

Rubens was an indefatigable reader. He used books for his architectural work and his painting, both in the hope of finding models and of learning about human and animal anatomy. There is no catalogue of his library: the greater part of his belongings were dispersed and divided up after his death, and all we know is that it cost his inheritors six florins to draw up the inventory before its sale. Even while he was still alive Rubens was obliged to split it up amongst his different dwellings. The library included scholarly works of antiquity left to Rubens by his brother Philip, and added to each year by publications from Moretus, the printer, as well as new books shown at the Frankfurt Fair, for which he received the catalogue.

The most precise information on Rubens's reading comes to us from the discussions he had with his correspondents on specific books, either one he was recommending or one he had been sent to read. He never seems to have read for simple pleasure. Rather he read to extend his knowledge and satisfy his insatiable curiosity. Literary texts such as Ovid, Tertullius, Cicero and Suetonius, influenced his philosophy of life and his Stoicism, whilst *Metamorphoses* gave him the mythological themes of his paintings. Having been educated in a country which was unaware of romances, poetry and drama, he took greatest interest in theological debate, law and science, in ancient Greek, Roman and contemporary history. All this confirms Rubens's austere character and his aversion to light entertainment – a preference which distanced him from courtly life, since he found it too frivolous. In his correspondence with Peiresc, the most revealing on this subject, he waxes enthusiastic about the *Satiricon* of Theophile de Viaud, Roger Bacon, Aristotle and the work of a certain Father Goulu, which was also much appreciated by Richelieu.

He read, then, serious, edifying works, Goltzius for example, for whom he composed careful allegories. He acquired the book *Capitulars of Charles the Bald*, the theological disputes of Du Perron Bishop of Evreux, who wished to replace the sacrament of the Eucharist with the Mass. He was interested in the Church's quarrels, in the condemnations of dissident Jesuits, such as the Spanish Father Juan Mariana or Father Garasse, author

of a theological work put on the Index, on heretical sects whether it was the Arminians or the Rosicrucians whom he criticised thus: 'To me it seems nothing but a king of alchemy pretending to possess the Philosopher's stones, but in reality a mere hoax.'[13] He associated with the theologian and lawyer Hugo Grotius (1583-1645) who, in leading the opposition against Maurice of Nassau in the United Provinces, pondered over the truth of the Christian religion and set about drawing up a law based on nature. All these authors, all these texts, made up the topical intellectual debates of the first decades of the seventeenth century and were good for discussion at that time. Grotius apart, none of them have stood the course. Other than demonstrating Rubens's erudition they primarily testify to his openmindedness to the world and, once outside his studio, the interest he always displayed in the movement of contemporary ideas, not to mention a certain predilection for sulphurous debates.

Rubens also shows that he was curious about the scientific trends of his age, at the same time as revealing his critical faculties. The fashion was for philosopher's stones, the squaring of the circle, perpetual motion. Although he professed an honest scepticism, Rubens did not, however, completely escape the temptations of the irrational. He learnt about the researches of the Dutch physician Cornelius Drebbel whom he would later meet in a London street - a man whom many considered an arrant charlatan - and studied two of this learned man's instruments and finally shared the general opinion: 'The famous philosopher Drebbel I have only seen in the street, where he exchanged a few words with me in passing ... This man is like those things of which Machiavelli speaks, which, in popular opinion, appear greater from a distance than at close range. Here they tell me that in all these years he has invented nothing except that optic instrument with the perpendicular tube, which greatly magnifies objects placed under it. As for the perpetual motion apparatus in a glass ring that is only nonsense.'[14] However, despite his scepticism towards the 'perpetuum mobile', he himself could not resist the temptation of making one with his friend and compatriot Jan de Montfort, Master of the Purse in Brabant.

Rubens as a scientist is perspicacious enough to see the point in Drebbel's invention,[15] which appears to have been an attempt at the first microscope. He in turn constructed one with his friend which Charles Ruelens, a Rubens scholar *par excellence*, thus described:

Rubens's perpetuum mobile was probably a medium-sized instrument, since it was put into a box, which was sent, without using exceptional precautions, like a common package from Antwerp to Aix-en-Provence. It was composed of a glass tube in which was a

quantity of water and acetate of copper, and another little glass half full of this same green mixture which was the chemical or physical agent of operation.

In this description there are none of the ingredients which would be necessary to create a machine working in perpetuity through the impetus endlessly renewing itself. In Rubens's instrument we see a sort of meteorological indicator. This green mixture is something analagous to the red alcohol which is used today in mercury thermometers in the bulb of barometers.

Rubens and Montfort probably tried to copy the inventions of Drebbel whose renown was considerable, particularly after his book was published in 1621. Now this book deals uniquely with meteorology, and the perpetual motion constructed by the clever physicist for King James I of England could not have been anything other than an instrument connected with the study of the atmosphere.[16]

When the instrument was finished Rubens made a gift of it to his friend, Peiresc.

Rubens was also particularly interested in current affairs. He obtained the *Memoirs* of Ossat, who had negotiated Henri IV's conversion to Catholicism and who later became his finest diplomatic agent. He gathered together all possible eyewitness accounts of the reign of the Vert-Galant (Henri IV) and the accession of his son Louis XIII: the *Memoirs* of Philippe de Mornay, friend of Henri IV and enemy of Spain, the account of the travels of M. de Breves, emissary of the good King. He accumulated the gossip of every period, Rivius on the vices of the Byzantine court, Froissart's *Histories and Chronicles*. He even procured a copy of the edicts of the French government condemning duels, and followed in detail the court case of two aristocrats who had contravened them, outraged that in France people still thought of killing each other as a sort of game, when in his country 'the bravest is the man who comports himself best in the services of the King'.[17] He saw in these practices only a relic of the *furia francese* which had swept through his town amidst fire and blood, and contrasted them with the celebration of stoic virtues at the court of the Archdukes (although even that was too manic for his taste): 'As for the rest, we live in peace, and if someone exceeds the limits of moderation, he is banished from court and detested by everyone, our Most Serene Infanta and M. le Marquis holding in contempt and dishonour all individual quarrels. ... All the uncontrollable passions have no cause other than ambition and a false love of fame.' 'True' love of fame was destined to find other less violent and doubtless more efficacious means of expression with Rubens.

Of course, not everything was in translation, so while Rubens was essentially fluent in Flemish, Italian and Latin, he was not so in other languages. Consequently his reading was restricted. Probably he had a good idea of what was being read and written about, but his preference lay with Latin philosophers and poets. Rubens's taste and humour was essentially Flemish as we saw at his brother's wedding, where he was kept busy entertaining the ladies. Rather than indulging in the dissolute pleasures practised in the boudoirs of the Parisians of his century, Rubens appreciated frank womanising, down-to-earth knowledge, debauchery in the Flemish manner, as indicated in this famous sixteenth-century passage:

Think not of your age nor of your name; be strong beings, free of all formulas, knowing only the song of your heart. In following its counsel, your gestures will never contradict the positive harmonies of nature. The ideal of the world resides in individual improvement: it will grow with your strength, grow beautiful with your perfection. But for you to follow this path, two things matter above all else: an ardent curiosity for life and an unprejudiced mind.[18]

In fact, the best source of information for the painter is still the journalists of the period, those grand men of letters attached to the courts and the academies, who through personal interest or for the good of the scientific community fulfilled the functions of today's newspapers and specialist magazines. Having made connections in Padua or Louvain, or perhaps having discovered each other through a salon or a publication, these learned men, scientists and humanists, pursued their dialogue through a series of letters – hence the interest of the Leibnitz-Clarke, Descartes-Christina of Sweden correspondence, among others, for the history of philosophy. Concentrating on each other's current work they exchanged more or less open letters, since they often read or commented upon them to other initiates.

Rubens, a great collector since his stay in Mantua, was particularly drawn to numismatics. He therefore got in touch with the European specialists in this field, thus also taking part in the grand epistolary game of his century. The quality of his correspondents and the breadth of his own knowledge would prove invaluable in gaining him a respected position among learned men.

The replies which he received not only paid homage to him as a painter but also as a humanist, showing that his interest in antiquity was not merely that of an amateur. Gevaerts said of him: 'It is difficult to say whether it is by his art or by his eloquence that he shines the most.'[19] The Dupuy

brothers, Jacques and Pierre, librarians to the King of France and founders of an academy of learned men, which counted Father Mersenne, famous for his friendship and correspondence with Descartes, among its members, each corresponded with Rubens; and one of the greatest humanists of the time, Nicolas-Claude Fabri de Peiresc, paid Rubens this tribute: 'Although I wrote to you yesterday as usual, I would not like to let this amiable M. Rubens go without these few lines to tell you that if I already had a high opinion of his talent, through his notoriety and the manifest renown of his merits, I can judge his value and his exceptional knowledge for myself, not even mentioning the perfection of his art. I can only admire him highly and I cannot let him go without deploring the loss of the most erudite, most agreeable conversation that I have ever known.'[20]

Peiresc, whom we have already mentioned, was a son of one of the most ancient of Provençal families. He was a friend of the learned Father Mersenne, the poet Malherbe and the astronomer Gassendi, in whose arms he died. A lawyer by family tradition and occupation, he is best known for his works on astronomy. As he suffered from tuberculosis he rarely travelled except for the ritual stay in Italy, at Padua, where he met Galileo, but he drew everyone to his palace in Aix-en-Provence which he turned into a museum, with a library of 5,000 books and a collection of coins, medals and cameos amounting to 18,000 pieces. He constructed an observatory, kept a menagerie of exotic animals: a gazelle from Nubia, angora cats and goats – species he introduced into France. His garden was planted with ginger jasmine from India, lilac from China, medlars from Japan and hyacinths from Persia, creating an unusual and fascinating environment for visitors, whether learned or not.

We have already seen that Rubens and Peiresc were originally put in touch with each other by Rockox the burgomaster and the learned Gevaerts at a time when Rubens was worried about protecting his engravings in France. Peiresc had intervened to protect his rights, and the two men subsequently embarked upon an elaborate scientific correspondence. The two also discovered a mutual passion for the Greek and Latin classics, and over many long years they wrote to each other regularly until Peiresc's death in 1637. The few letters that have come down to us reveal a great deal about Rubens's interests and personality. Unfortunately, not knowing the value of these precious letters, many of Peiresc's old notes and letters were later used to make curling papers.

The first letter saved from the hot iron clearly showed that the men from Antwerp and the man from Aix had a common interest in cameos: an austere, even daunting subject, requiring much attention to detail and the patience to study with a magnifying glass incisions, which had often eroded

through the centuries, made on tiny surfaces of agate, cornelian or ivory. However, as the correspondence shows, patience and discipline can be rewarded and even reveal some indecent surprises which Peiresc and Rubens examined with the coldest of scientific interest.

In July 1623 Peiresc announced to Rubens that he was sending him four particularly curious intaglios and begged him to take an impression of them so that he could have a record. On 3 August Rubens thanked him for his package and wrote that he could not accept such a fine gift, whilst effusing about his favourite of the four stones.

But to return to our gems, the one which pleases me extremely is the *diva vulva* with the butterfly wings, but I cannot distinguish what it is between the altar and the opening of the vulva which is upside down. I will probably discern what it is when I have taken an impression of it, which I cannot do today because of the many tasks I have in hand, not even in Spanish wax. I cannot imagine why they assimilate the vulva into the snail, unless it is perhaps because of the size of the shell, which is a very extended receptacle, which modifies its size according to its contents, or perhaps because it is a viscous moist animal whose feelers can be compared to the crest on either side of the sexual part of a woman, which swells when she is on heat. I mention this freely between ourselves; the explanation is perhaps a little more recherché, but the subject is quite indecent; we will examine it more closely and at our leisure.[21]

Meticulously, Peiresc noted: 'Rubens, 3 August 1623, has received the ithyphallic gems. Perpetual motion promised.'[22]

They kept each other informed about other collections. When a certain M. Chaduc disposed of his cabinet Peiresc alerted Rubens: 'Represented there are all the amorous extravagances of Greek and Roman antiquity and if it were not for the obscenity of the subjects, you could not see more curious examples in antiquity anywhere.'[23] It would seem that the cameos harboured mines of alluring curiosities for two passionate researchers, constant in their quest for the rarest of pieces. 'I hope that I shall shortly have a cornelian on which are sculpted two phalluses which are fighting one on top of the other'[24]; 'I am awaiting another cameo on which there is a flying phallus carrying a snail with the inscription HEL and the letters PAR beside the phallus.'[25]

As promised, in exchange for the package of July 1623 Peiresc subsequently received the decoding of the mysterious inscriptions and the 'perpetuum mobile' put together by Rubens and Montfort, and inspired by

Cornelius Drebbel. Later on, with the Italian Pozzo, the Flemish de Bie and Rockox, they would try to publish a book. Rubens tried to edit the book alone despite his many preoccupations and began to research the cameos and copy them on his own. But it was never completed, and apart from his book on the *palazzi* of Genoa, Rubens never finished any theoretical work. He also began a work called *The Imitation of Statues*; whilst there exists a *Treatise on the Human Figure* it is not authenticated as Rubens's by the experts.

Rubens and his correspondents disseminated international news and, as far as general information went, what was good for the intellectuals was also interesting to the politicians. Theophrastus Renaudot did not launch his news sheet until 1631, but there existed a prototype, *La Gazette rhenane*, which all European diplomats were only too glad to make use of, as well as Jan van de Wouver's *Italian Chronicles* which Rubens read, showed to his friends and which they passed on as this letter from Peiresc witnesses: 'By my cousin I will send you the Italian pages which I have just received from Rubens.'[26] The news they provided was restricted to court life and indigenous events, lacking an international perspective, but it brought together a group of writings and correspondents whose aim was the gathering of more precise international information.

Rubens took an active part, mixing, as was his wont, learned news with political news. As well as describing Demosthenes' head of hair 'neither hirsute nor shaved' he would quickly pass on to the horrors of the war in Flanders.[27] Peiresc, when he was not entertaining him with precious stones, recounted the smallest events at court, news of the Parisian intellectual world: Grotius, the theologian was sick, had taken the waters; Monsieur, the King's brother, had almost lost his life when he threw a metal ball into the air and it landed on his head; the Duchess of Chevreuse had come back into favour; Queen Anne of Austria was expecting or not expecting a child. . . . When Peiresc went back to Provence he was worried how he would relay information to his friend in Antwerp and first gave the task to his brother, Palamède de Fabri, Sieur de Valavès, who in turn transmitted it to the Dupuy brothers, those founders of the most brilliant intellectual circle in the French capital.

A number of reasons led Rubens to seek out and maintain these correspondents in most of the major countries of Europe. He was a distinguished humanist, anxious to refresh his knowledge in every field. He was also a painter of princes and negotiated without using an intermediary, as he has shown us, for example, in his exchange with the Duke of Neuburg. Equally, he acted as his own business manager, leading a campaign for the recognition of 'pictorial' property, entering into relations

with a number of lawyers among whom were Peter van Veen in Holland, and Peiresc in France. Finally, since he was a zealous collector, Rubens engaged agents all over Europe to inform him about curiosities, antiquities, paintings by new Italian masters, that he could acquire. 'He had such a great love for anything that had the character of antiquity that he sent word to buy a prodigious quantity of statues, of medals, and engraved precious stones from all over Italy. . . . And it was in considering these things that he passed his leisure time.'[28]

He had undertaken this kind of mission himself for the Duke of Mantua, and it was thanks to one of his agents, Toby Mathew, that he acquired some of his best marbles. Rubens, the letter-writer, was considered the man to refer to, regarding Antwerp if not Flanders, in the eyes of a great many businessmen at that period. He was also a linchpin in cultural relations, and activities of a quite different nature were to arise from his numerous foreign contacts.

In those days art lovers were the rich, and they were the people in high positions. We have already seen that Dudley Carleton, to whom Rubens would resell his collection of antiques, was the English Ambassador at The Hague. The Earl of Arundel, for whom Rubens deigned to paint a portrait, had the job of acquiring works for the King's gallery and himself possessed one of the greatest collections of the period. Archduke Albert, King Charles I of England, his minister Buckingham and the Cardinal de Richelieu, were well-known collectors and all admirers of Rubens. In that time, art, wealth and authority went hand in hand. In the case of the man from Antwerp they would cross-fertilize.

When Rubens received his commission to portray the life of Marie de Medicis, Queen Mother of France, which occupied him from 1621 to 1625, the series of paintings, which can now be seen in their entirety in the Louvre, draw together the painter's Italian past and European future, the integration of his art into the Baroque, his interest in money, in antique collections, and his more troubling passion for public affairs – which he was already fostering.

Marie de Medicis's Gallery

It might seem odd that a Flemish painter was chosen to carry out twenty-four decorative paintings for the palace of the Queen Mother of France in Paris. There were a host of reasons. In the first place the absence of any French painters of note: Nicolas Poussin and Claude Gellée, called Lorrain, were

in Rome, whilst Philippe de Champaigne had hardly begun his career. The Queen preferred to avoid Simon Vouet (1590-1649), since he was too influenced by Caravaggio's naturalism to treat his models with tact.

The Queen had been exiled to Blois for plotting against her son, Louis XIII, but, having been reconciled with him by the Treaty of Angers, which she signed on 10 August 1620, she had returned to Paris in triumph. To mark her political reinstatement she decided to commission a number of paintings for the gallery of her new palace in Paris, the Luxembourg. The palace was built by Salomon de Brosse a little in the style of the palaces of her childhood, and she wanted a gallery built to celebrate her glory like the one which Vasari had created for her family in the Palazzo Vecchio in Florence. To stave off potential criticism she avoided employing Italian painters; even so Guido Reni was too old and Guercini was busy and did not want to leave Italy. This left Rubens. He was known in France, not only because of the privileges which he had just obtained for the distribution of his engravings, but also for the cartoons Louis XIII had commissioned from him for a series of tapestries celebrating the history of Constantine. Furthermore, he had been Vincenzo de Gonzaga's painter, and Vincenzo's wife, Eleonora, was Marie de Medicis's own sister. Rubens had been present at Marie's wedding and one of her friends, the painter Pourbus, a colleague of Rubens in Mantua, may have spoken to the Queen Mother about his old companion. In addition, Rubens was the Archduke's painter and Marie de Medicis was close to the Infanta Isabella Clara Eugenia.

Negotiations for the decoration of the Luxembourg Palace took place in 1621 and in November, with the agreement of Richelieu, Intendant of the Queen's house, the decision was taken. On 23 December 1621 Peiresc could write to his Flemish friend: 'I learnt afterwards that the motive for your journey is that the Queen Mother would very much like you to embellish her new palace with paintings by your own hand.'[29] In January 1622 Rubens was ordered to Paris, and by the time he arrived fifteen subjects had already been agreed between himself and Claude Maugis, Abbot of St Ambroise, the Queen's treasurer and her counsellor on matters of art – with the agreement, of course, of Richelieu.

Rubens found dealing with so many intermediaries a trial. Working under these circumstances was nothing like composing a celebratory painting for Antwerp's town hall or the Duke of Neuberg's castle, or even the Prince of Wales's collection. Rubens was tackling a piece of contemporary history: it was the fate of the Queen of France which he had to depict, and not some mythological or biblical scene where ultimately the final interpretation rested with him. In the Medicis gallery he had to please the Queen, the King and Cardinal de Richelieu – people who got on badly.

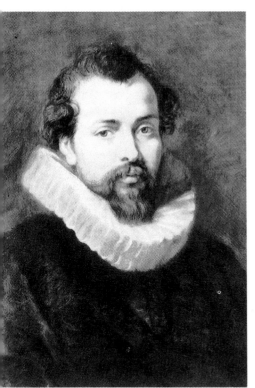

Philip Rubens, by Rubens (Detroit Institute of Arts, all rights reserved)

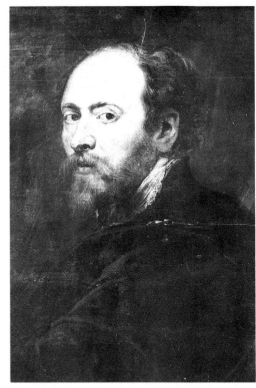

2 *Self-portrait*, by Rubens (Florence, Uffizi, ph. Roger Viollet)

opposite Isabella Brant, by Rubens (Florence, Uffizi, ph. Roger Viollet)

Nicolas Rubens, by Rubens (Vienna, Albertina, ph. Roger Viollet)

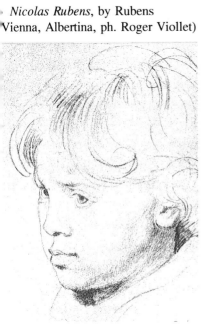

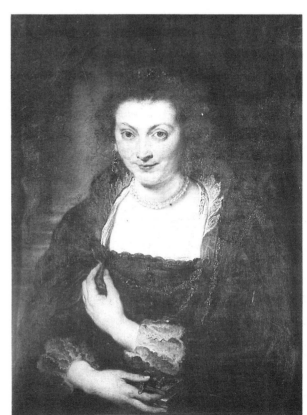

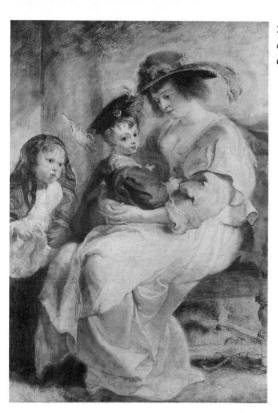

5 *Helena Fourment and her children*, by Rubens (Paris, Musée du Louvre, ph. Giraudon)

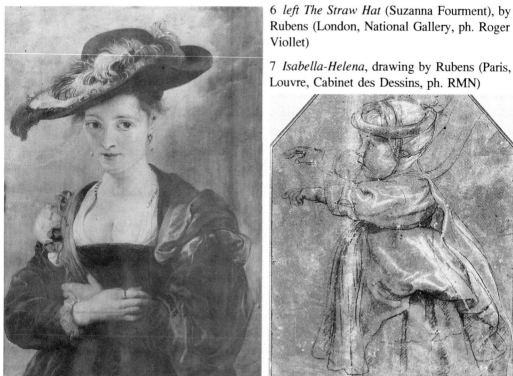

6 *left The Straw Hat* (Suzanna Fourment), by Rubens (London, National Gallery, ph. Roger Viollet)

7 *Isabella-Helena*, drawing by Rubens (Paris, Louvre, Cabinet des Dessins, ph. RMN)

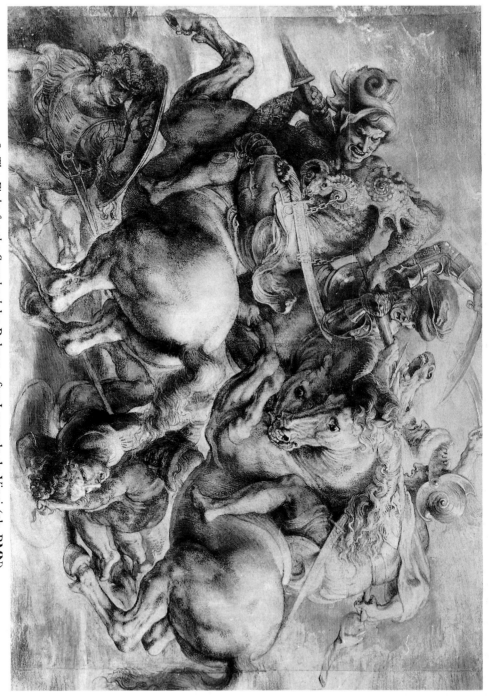

8 *The Fight for the Standard*, by Rubens, after Leonardo da Vinci (ph. RMN)

9 *top left* A page of sketches by Rubens after Tobias Stimmer and Jost Amman (Paris, Louvre, Cabinet des Dessins, ph. RMN)

10 *The Adoration of the Shepherds*, by Otto Van Veen (Antwerp, Maagdenhuis, ACL Brussels)

11 *Rocky Landscape with Bear Hunters*, by Tobias Verhaecht (Paris, Louvre, Cabinet des Dessins, ph. RMN)

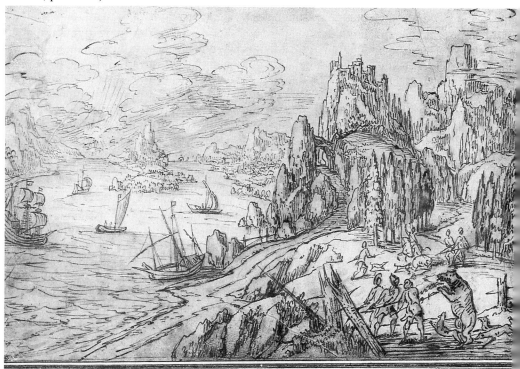

12 *The Belvedere Torso*,
drawing by Rubens
(Antwerp, Rubenshuis,
ph. Giraudon)

13 *The Virgin and Child
with St Elizabeth and St
Anne*, drawing by Rubens
after Raphael (Paris,
Louvre, Cabinet des
Dessins, ph. RMN)

14 *The Prophet Isaiah*, drawing by Rubens after Michelangelo (Paris, Louvre, Cabinet des Dessins, ph. RMN)

15 *below The Fall of the Titans*, drawing by Rubens after Giulio Romano (Paris, Louvre, Cabinet des Dessins, ph. RMN)

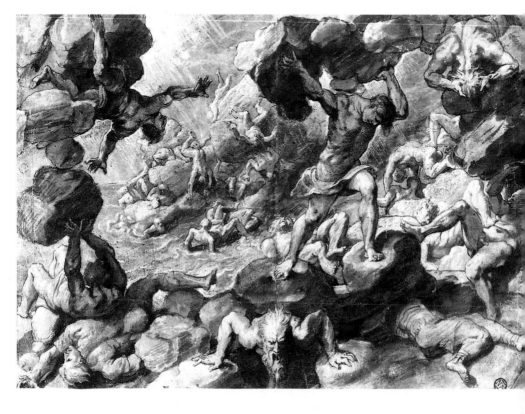

16 *Jan Caspar Gevaerts*, by Rubens (Antwerp, Musée Royal des Beaux-Arts, ph. Roger Viollet)

17 *Justus Lipsius and his students*, by Rubens (Florence, Palazzo Pitti, ph. Bulloz)

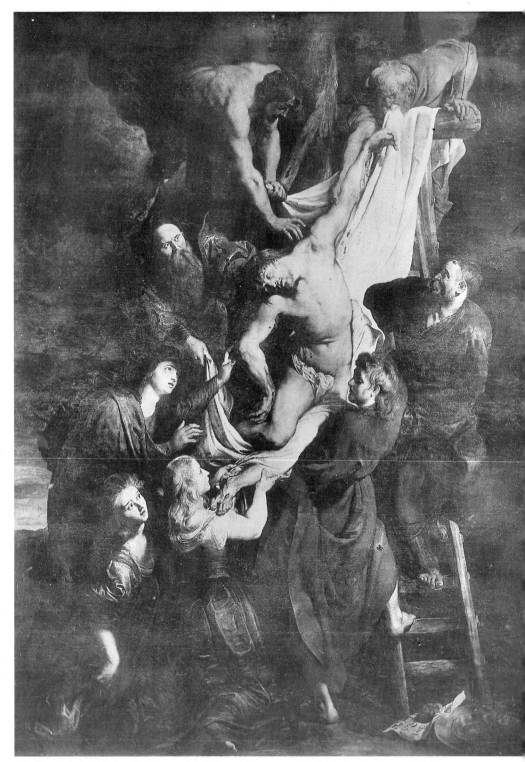

18 *The Descent from the Cross*, by Rubens (Antwerp Cathedral, ph. Roger Viollet)

He also had to take into account facts which certain people would have liked suppressed but which he could not ignore, for posterity required a truthful picture. In sum his task was to create two dozen pictures to the glory of a queen who had no prestige, and who in 1630 would again fall from power and be driven into lifelong exile, ending her days miserably in Cologne in 1643. Marie's sad future was riddled with humiliating anecdotal elements which would not help Rubens's glorification.

Henri IV had not liked the Princess; however, he dreaded her uncle, the powerful Grand Duke of Tuscany, to whom he was widely indebted. Marie de Medicis had only mediocre looks, with the heavy face of an Austro-Tuscan matron (her mother was born Jeanne of Austria) and a detestable character. He had married through duty and had refused to renounce his mistresses who had never ceased plotting against his wife. So when Ravaillac assassinated Henri IV in 1610, Marie knew her hour had come. She relished and anticipated the moment when she could avenge herself for the frustrations she had endured while the King was alive. Her coronation, which had been celebrated at St Denis the evening before Henri IV was killed, now automatically made her Regent of France. It was she who discovered Monsieur de Luçon (later Louis XIII's great minister, more commonly known as Cardinal de Richelieu), whom she had plucked from an obscure bishopric and propelled into one the highest positions in the land. But in 1616 he sided with the young King against his mother's government and Marie found herself outmanoeuvred. The coup ended with Marie's banishment to the provinces.

Rubens would have to be a diplomat as well as a painter in order to glorify such a career. This commission would equally test his famous sense of freedom. The court at Brussels may have been pompous but it was peaceful none the less:

> Monsieur I regret to have nothing very interesting as news to send you. Our court is sterile in this respect if one compares it to that of France, which by its size is subject to the most important changes. Here, one proceeds along an ordinary path, and each minister serves the best he can without claiming other favours than those of the rank he occupies, and thus everyone grows old and even dies at his work, without having hoped for extraordinary favours, or dreaded disgrace. For our princess feels neither great love nor great hate, she is gentle and benevolent towards everyone.[30]

If the Brussels court was too manic for him, that of Louis XIII would be far worse, with its endless plots, of which Rubens seems to have been

well warned. And so he left a devout and devoted Archduchess for an ambitious Queen who had had her day; a small city where he was established for a great one where he was not. Paris, with its 400,000 inhabitants, was at that time the largest city in Christendom with its population crowded into five-storey houses in its three districts. Hygiene as we know it now did not exist and baths were reserved for the very ill. The citizens' diet consisted of a great deal of meat and a few vegetables, whilst only wine was drunk; in the countryside the peasants lived on oatmeal bread. The nobility clothed their dirty bodies with the softest and most costly of fabrics: 'Precious stones were worn in every possible place. Rings and bracelets jangle together, on shoes each buckle is of ruby or emeralds, belts are studded with diamonds, men like women wear pendant earrings and sometimes necklaces. And the clothes themselves are only of fine velvet, silks, brocades, embroidered in gold and silver thread from the Orient, or made in Paris by young Turkish girls whom Marie de Medicis has had brought here precisely for this purpose.'[31]

Corneille, in his *menteur*, gives us an impression of the whole through the mouth of the young Dorante:

To my eyes Paris seems a land of romances
This morning I thought I saw an enchanted isle:
I left it deserted, and found it full of people;
With no mason's help, some new amphion
Had changed these bushes into a superb palace[32]

In creating the Medicis gallery the discreet painter from Antwerp would have to face a double challenge: first he would have to be diplomatic; second he would have to cope with every discomfort Paris could offer – which occasionally would even follow him back to his Flemish retreat. Rubens would never get used to the French capital and he limited his sojourns there as much as he could, using them primarily to paint and visit collections of antiquities, ignoring the intrigues of court life as far as he was able. His work would reflect this attitude in the resolutely allegorical interpretation he gave to the paintings, to the detriment of historical accuracy.

Rubens began by staying in Paris for two months, arriving some time in January 1622 and leaving on 4 March. Whilst there he finally met his friend Peiresc in person, and together they visited exhibitions in the city and its surroundings in their quest for engraved gems for their projected book. He signed a contract worth 20,000 ecus for the twenty-four paintings he was to do for the gallery (a 'good contract', Peiresc judged. 'Binding for both parties, and the work is so well protected that if the person who

commissioned the paintings dies, you will still be paid for what you have finished.').[33] During this first stay Rubens also frequented rue du Vert-Bois, near Les Halles, where he met the Capaio ladies and their niece, women who were sewing at their window; their dark hair made an impression on him.

Returning home he stopped in Brussels to give an account of his journey to the Archduchess Isabella, who entrusted him with a present for Marie de Medicis on his next visit: a little dog with a collar of twenty-four enamelled plaques which Rubens would portray in his series of paintings in the gallery. Then once more to Antwerp where he set to work.

The year which he dedicated to making the gallery was disrupted by a number of hitches which enlivened his correspondence with Peiresc, his principal intermediary with France. First he had to discover the Queen Mother's astrological sign. Peiresc replied that it was Taurus the Bull, although he added that he was not totally in agreement with what he had been told by the astrologers. His effort was wasted. Rubens would show the Queen under the sign of Sagittarius, confusing her date of birth with Henri IV's. Rubens then asked if he could paint the King wearing a gold breastplate and give him, as a point of learned detail, Polack hose, held under the knee with garters, so that they were different from other hose which were not attached to knee breeches. Then he had to sort out the still more learned problem of the *umbo*, the Roman toga, of which he had a different conception from Saumaise, the erudite French publisher of Tertullius, and to obtain from Salomon de Brosse the exact dimensions of the gallery (in the end he had to alter his paintings). Finally it was decided that they would replace the painful episode of the flight to Blois with an evocation of the happier year of the Regency. In spite of these diverse setbacks, by 19 May 1622 Rubens had conceived the entire work.

Meanwhile, in Paris jealous rumours began to spread: the archpriest Nardi was plotting against him and Peiresc wrote to Rubens: 'The painters here are furious to see their reputations in ruins since you arrived and started work, and are stirring up the very devil in an attempt to start some quarrel.'[34] On 14 July 1622 it was rumoured in Paris that Rubens was dead. Rubens sent a courier to reassure Peiresc, who immediately asked Rubens to let Cardinal de Richelieu and the Queen Mother know personally, as they were both anxious about him – in fact this was the incident where the engraver Vosterman, along with a weaver, had assaulted Rubens, incensed by his over fastidiousness. The incident was exaggerated as it grew and spread across Europe, so news of Rubens's death was accepted as true. In Brussels his friends, when they learned it was false, appealed to the Archduchess Isabella to give him special protection; in Paris his enemies, eager to exploit

the news, joyfully anticipated the demise of a dangerous rival. Peiresc almost lost his *sang-froid*. Normally so wise and level-headed, he praised his friend's courage, willing a thousand deaths on his enemies: 'It gave me great pleasure to see you resolved to face this envious trickery with stoic impassivity, and I beg your lordship TO BURST THIS RUMOUR.'[35]

It was at this point that Claude Maugis, Abbot of St Ambroise, asked Rubens to send him some sketches which Rubens interpreted as a sign of the Queen Mother's misgivings about his work, and was offended. He would not yield. Peiresc supported Rubens, arguing that the sketches could fall into the hands of envious people who would not hesitate to make copies of them. In reality it transpired that the abbot had heard how good Rubens's first sketches were and was trying to obtain a few works of art for himself. Roger de Piles later discovered them in his private collection in 1650. But something far graver was happening at this time: the plague was raging throughout Antwerp: 'I am sorry to learn that a sickness is ravaging your country,' Peiresc wrote on 11 November 1622. 'I pray God that He may keep you in perfect health.'[36]

By January 1623 Rubens had almost finished his work. His salon was filled with canvases. He was mulling over the idea of returning to France, making preparations, and wondering if he would find those beautiful dark-haired women again in rue du Vert-Bois – 'because of their superb black hair which is so difficult to find anywhere else'.[37] He asked for two rooms to be reserved for him at the Luxembourg Palace so that he could prepare the final hanging *in situ* with the help of his pupil, Justus van Egmont. Peiresc was always willing to help and being well versed in behaviour at court and welcome in the home of Claude Maugis the Queen Mother's treasurer, he cautioned Rubens on 10 March 1623 to give some thought to the powerful – a little painting for Cardinal de Richelieu perhaps, for 'Paris is a rough sea where it is not easy to find someone if one does not know his exact address'.[38] What is 'certain in these times is that few people will offer you disinterested friendship as far as the court goes'.[39] Still rumours circulated about Rubens's death: in fact since he had first been commissioned to decorate the gallery, news of his death had seemed to circulate annually. But they were as usual false, and Rubens in person showed his paintings to the court at Brussels. The Infanta was well pleased.

In France the situation between Richelieu, Louis XIII and the Queen was fairly peaceful. Except for the chronic rumbling discontent of the Huguenots and the latent hostility between the Queen, her son and his chief minister, all that was happening were the seasonal moves of the court between Fontainebleau, Saint-Germain and the Louvre. On 24 May 1623 Rubens was back in Paris for his second stay. He had brought nine paintings

as well as the Duke of Aerschot's collection of medals, for which he hoped to negotiate a sale. Peiresc had gone back to Provence: the two were never to see each other again. In mid-June the Queen Mother left Fontainebleau for the capital to give her opinion on the paintings of which she was the heroine, and to meet her painter. She would be 'as charmed to hear him talk as to see him painting,' said Roger de Piles.[40] Then it was Richelieu's turn: 'He could not see and admire them enough.'[41]

But, the French were scandalised by another picture which Rubens had done for Louis XIII, *The History of Constantine*. What worried them were some not quite academic parts of the anatomy: bent legs. Michelangelo, Titian, Raphael and Correggio had always painted them straight: 'If you do not, in these twelve paintings for the gallery, decide to accept natural postures where you have bent legs, you will, most certainly, receive little satisfaction,' Peiresc wrote.[42] Discussing a thigh which was too low when compared with its twin, he added: 'One might have wished that you could have retouched each of these two thighs by your own hand.'[43]

Rubens put this second stay to good use and took up his book on cameos again. He copied the beautiful ivory of the *Apotheosis of Augustus* in the Sainte-Chapelle and returned home at the end of June. On 12 September he announced that there would only be another six weeks of work. And he was asked to return to Paris on 4 February 1625.

There he met Palamède de Valavés, Peiresc's brother, and became involved in a series of odd incidents. The town was decked out with flags for the marriage by proxy of Henrietta, Princess of France, and Charles I, King of England. It was Buckingham who had come to marry the Princess by proxy and, just as he had been present at her mother's marriage in Florence, Rubens was present at the daughter's, twenty-five years later in Paris. In the course of the ceremonies on 13 May 1625 the tribune on which he was standing along with Palamède crashed to the ground. Happily he was able to hold on to a neighbouring stand and only Palamède was hurt. Then a bootmaker twisted Rubens's foot while he was trying on a new pair of shoes: for ten days he was unable to stand. To cap everything the French began to question the completion of a second gallery in the Luxembourg to match Marie de Medicis's, which would present the history of Henri IV. Richelieu prevaricated. The Queen Mother said nothing. Maugis was no clearer. If only they would pay him what they owed him for the first series: 'In short, I am tired of this court,' Rubens complained,[44] but, even so, he visited the royal collections at Fontainebleau and copied works by Primatice and Giulio Romano. On 11 June 1625 he was back in Brussels, the next day in Antwerp. He left behind him in Paris one of his most remarkable works, a synthesis of painting, politics, diplomacy and humour.

The gallery of the Medicis contains twenty-four huge canvases, the most imposing of all the famous series done by Rubens who produced similar series on the *History of Achilles*, the *History of Constantine*, the *History of the Consul Decius Mus*, *The Triumph of the Eucharist* and, finally, a series to the glory of James I on the ceiling of the Banqueting Hall in London (painted between 1629 and 1634). It was narrative painting, 'historical film' according to Picasso who found it too descriptive, in which Rubens gave free rein to his taste for allegory, making the canvas a puzzle composed of symbols which came from an agreed iconology. According to the scheme decided between the heroine, her son, Cardinal de Richelieu and Rubens, the entire life of Marie de Medicis was to be shown in it, from her birth right up to the present moment (1625), the reconciliation of the Queen and her son being portrayed in *The Triumph of Truth*. The Flemish painter had conceived compositions full of people in theatrical, dynamic movement, like a sort of Michelangeloesque Veronese. But the colours lack warmth, there are no ambers, and grey predominates, just as in his first Italian canvases and, using his basic palette which Fromentin described, clashing with the vermillion which is the hallmark of his art from beginning to end. On the other hand, the contours of the figures are outlined too heavily to be ascribed to Rubens's own hand alone.

The Queen ages in these pictures, from blonde to a very pale blonde, but never the grey of old age. At every stage she has an august (and wise) bearing, a stiff neck and tucked-in chin: Rubens had extracted the best from her thick, graceless face, although it bore little relation to her active, ambitious, personality. The Queen never loses her royal bearing except when she is pictured giving birth. She lies there in pain in her birthing chair, while Justice holds out the new-born Dauphin to Aesculapius; the Queen has lost a slipper from her right foot.

The whole of Olympus has been convened for the glory of the Queen of France, and critics would reproach Rubens for the excessive use of profane divinities in circumstances that needed to be sanctified by the power of the Church. They would be offended, in particular, by his very nude Mercury standing between the Cardinals de la Rochefoucauld and de Guise, assembled for the Treaty of Angoulême.

The wounding details of the Queen's existence are passed over. Henri IV falls in love as soon as he receives her portrait. He respects and honours her, confiding the Regency to her, and is present at her crowning, a little to one side, in a *loge*. In the nave of St-Denis all the important people in the kingdom process towards the Italian princess, in an elongated composition which David will take up in his *Coronation of Napoleon*. Under Rubens's brush the Vert-Galant and the Grand Duke of Tuscany's niece

form a solid couple, blessed by the birth of the Dauphin, a couple whom only the madness of Ravaillac will separate. The assassin is pictured as a hideous serpent, pierced by an arrow in the bottom left of the *Apotheosis of Henri IV*; the King, in antique armour, rises to the heavens, borne away by Jupiter and Saturn.

All the facts which reflect well on the Queen are carefully catalogued, but the committee which had determined the subject matter preferred to avoid dwelling on her painful flight from Paris. And so one only sees the happiness of her Regency, to which were attributed the renaissance of arts and letters; the diplomatic victory of the Spanish marriages which make Marie de Medicis mother and mother-in-law of the two most powerful monarchs in Europe; the capture of Juliers in face of the Imperial army; the greatness of Marie's soul as she stretches out her hand to her son and is twice reconciled with him at Angers and at Angoulême. Preferring happy conclusions to shameful events Rubens did not fail in his apologic enterprise. It was also no doubt because of this wisely reflected scheme[45] that he won the approval of Richelieu, Maugis and the Queen Mother.

Nevertheless, he did not avoid a few witty asides which once more reveal him as less submissive, less of a courtier than he appears. First of all there was that little dog, Rubens's homage to his protectress, the Archduchess Isabella – an intrigued, slightly mocking spectator at the exchange of rings between the Grand Duke of Tuscany and his niece, at the time of her marriage by proxy in Florence, and still present at the birth of the Dauphin. Later, showing his indulgence for his patroness, the Queen, he did not spare her entourage. The series is lightened with caricatural notes: the sanguine face of the Grand Duke of Tuscany, the sluggish Elisabeth of Bourbon, the unattractive face of Marguerite of Valois, Henri IV's first wife, whom he placed in the foreground at the coronation in St-Denis. Was it his intention to offer Marie de Medicis revenge? Queen Margot looks startled and turns towards the viewer, her globular eyes wide and staring, her swollen lip, puffed and whitened, like a dairy maid caught stealing the milk.

Rubens reveals himself at his most sardonic with good King Henri. Certainly the Béarnais has everything on his side: he is slim, with seductive greying hair, a wheedling smile under a fully knowing gaze. Nevertheless, unless he is climbing into the sky dressed as a Roman, Rubens makes a point of ensuring that his hose are always wrinkled. Curiously, while Rubens's contemporaries took issue with his slightly academic penchant for bent legs, they did not react to the King of France's untidiness. A few centuries later, to Baudelaire's great joy, they would arouse 'the admiration of a republican literary hack who sincerely congratulated the great Rubens for having in an official picture in the Medicis gallery loosened one of

Henri IV's boots and stockings; a treat of independent satire, a liberal blow against royal debauchery'.[46] The poet imagined the painter of princes as a revolutionary: he was wrong. Remember Christ's foot on Mary Magdalene's shoulder. . . .

Rubens returned to Antwerp at the height of his fame. His works hung in the Queen Mother of France's palace and, on 30 September 1623, 'in consideration of his merit and for the services that he has rendered to the King',[47] the Infanta had granted him a special pension of 10 ecus (paid by the citadel of Antwerp). Philip IV would quadruple this sum in 1630, but meanwhile the King ennobled his painter, who had expressly asked him for the honour,[48] and was supported by the President of the Supreme Council of Flanders in Madrid. On 5 June 1624 Rubens was given the right to the sword of which he had dreamed since his return from Italy.

Did he earn these honours just by taking a little dog to Marie de Medicis? Why would the King of Spain have rewarded a Flemish painter for service rendered to the crown of France, his worst enemy? Furthermore, what was the significance of those mysterious journeys that Rubens undertook to Dunkirk and the German frontier in September 1625 so soon after he had returned from Paris? And why on his return trips to France did he always stop in Brussels to be received by the Archduchess?

Rubens's reading provides as much of a clue as his correspondence: he was not only interested in contemporary history but equally in the intrigues, in the smallest occurrences in the European courts, striving to know who was who and who did what. His curiosity did not arise from pure erudition. He informed himself about people and their careers, using various stratagems, and he maintained ties and forged new ones with the responsible politicians of his time to whose children he became godfather, from whom or to whom he bought or sold collections of works of art, while his 'procurers' of precious objects brought him news from the countries in which they were operating. Were these relationships, these sources of knowledge, set up simply to augment his personal collections or to increase the number of commissions for his studio? The truth is that Rubens had ulterior motives.

First Steps in Diplomacy

During the second decade of the seventeenth century the situation in the seventeen provinces was very troubled. The twelve-year truce signed in 1609, which had maintained an uneasy peace between the southern Low

Countries and the United Provinces of the north, had expired on 9 April 1621: as a result, the statute of Spain's Burgundian possessions had to be revised. Both Brussels and The Hague were happy enough with the peace so, shortly before the truce expired, Archduke Albert and Maurice of Nassau tried to prolong it, allowing each other a negotiated settlement which would favour their respective independence *vis-à-vis* Spain. While Albert, in order to stand up to Philip III, looked for support from his cousin, the Emperor, Maurice of Nassau sought help from a lady of Flemish parentage, T'Serclaes, who was willing to serve him as intermediary with the Archdukes.

While she was staying in Brussels the lady shared Maurice's intentions with Don Inigo de Brizuela, the Archduke's confessor, who immediately transmitted them to his master. The Archduke and the Infanta, happily surprised, hurried the Chancellor of Brabant, Pierre Recquius, to The Hague to sound out Maurice of Nassau's real intentions so that everyone could profit from them. But the secret of this mission was so badly kept that the Calvinist ministers at The Hague, who opposed any understanding with the Catholic Low Countries which they considered too tied to Spain, organised an openly hostile reception for the emissary from Brussels who was booed all along the road as soon as he entered the United Provinces. The Stadtholder tried to make him forget this humiliation and received him with great ceremony. The proposals, which committed the secessionists to recognising the King of Spain in exchange for certain advantages were turned down. This rebuff did not interrupt relations, but other events overtook the situation. The year 1621 saw the death of Philip III of Spain on 31 March, followed by that of the Archduke on 13 July. As a result the governments changed in both Brussels and in Madrid, and with them their political priorities.

On the death of her husband the Archduchess succeeded him: she was loved by the Belgians who respected her kindness and appreciated her wish for independence from Madrid. But she had even less autonomy and on 16 September 1621 she received an order permitting her to receive oaths of allegiance from the Belgians to the sovereign King of Spain, each province having to recognise Philip IV as their sovereign. To assist her in this task, but primarily to observe her, Madrid sent Cardinal de La Cueva, who was in favour of military action in curbing Dutch sedition.

In Madrid Philip IV longed for the return of Charles V's empire, yet he exhibited a feebleness of character, possibly the result of a succession of incestuous marriages. Born in 1605 Philip was only sixteen years old when he was summoned to rule over a kingdom 'where the sun never set'. In 1615 he was married off to Elisabeth of Bourbon, Henri IV's daughter,

while his elder sister, Anne of Austria, was destined for his wife's brother, the future king of France, Louis XIII. Philip IV was blond with blue eyes and the hanging lower lip and overlong chin of the Habsburgs. He was good-natured and well meaning but hampered by a natural softness and indolence. From an early age he had yielded to the intrigues of the young and ambitious Gaspar de Guzman, Conde d'Olivares, shortly to be Duke, an Andalucian obsessed by the grandeeship of Spain which had been refused him by the Duke of Lerma, Philip III's favourite. 'Bold and devious,'[49] Olivares would obtain the grandeeship from Philip IV, whose principal minister he would officially become in 1622. It was therefore this unlikely pair – a weak king and a minister of steel – which was to dominate the question of Spanish possessions in the Low Countries.

It was no longer a simple problem of personal glory or of Spanish hegemony, for troubling economic preoccupations were also involved. In fact, the truce had given the Hollanders the right to 'freely carry out their commerce wherever they could'.[50] Encouraged by England and France, who saw it as a means of weakening Spain without going to war, the Hollanders had effectively weakened Spanish commerce with all its consequences: by blocking the lower Schelde, thus ruining the port of Antwerp; by profiting from the inadequacies of the Spanish fleet, to attack the King's galleons on the high seas; by monopolising trade with the sultans of the Indian Ocean; and by closing the Straits of Malacca, through which the Portuguese had access to their trading posts in the Far East. Thus, not only did the Hollanders compromise Spain's resources in the colonies, they also threatened the commercial advantages which Spain was counting on through her union with Portugal in 1580. Portugal deplored the treaty: 'In eleven years of truce, we have lost more than in forty years of war.'[51] Nothing stopped the Hollanders. As soon as the treaty expired on 9 June 1621 they created a new East India company to which, for a period of twenty-four years, they granted the privilege of carrying out 'all the commerce of the west coasts of Africa and the two coasts of America'.[52] Far from manifesting some will for appeasement, they seemed to seize every opportunity to cock a snook at vacillating Spain.

Gold was in short supply in Madrid, and Spain was sliding into a state of chronic bankruptcy, a menace which was causing unrest inside the country and a deterioration in its international standing. Spain was no longer in a position to maintain an army and, far from sustaining the Low Countries whose economy had been ruined, Spain continued to impose heavy taxes, just as it had when the country was rich, thus filling the Belgians with resentment.

For Philip IV the alternative – if alternative there was – was simple: he

could either negotiate a slackening-off of Holland's commercial pressure with Maurice of Nassau, or he could go to war against him and reintegrate the United Provinces into the Spanish fold thus using force to recuperate trade with the Indies. Both projects were equally ambitious. Maurice of Nassau would not abandon his economic advantage without gaining important concessions on Spanish sovereignty over the United Provinces, concessions which Spain could not accept. Moreover, the Spanish army was reduced in number and was currently helping the Habsburgs of Austria suppress the Protestant rebellion in Bohemia and the Palatinate. Faced with the United Provinces, it appeared that Spain could expect nothing more from fighting than from diplomacy.

However, was Maurice of Nassau strong enough to defy Philip IV? He could certainly count on his allies: Protestant England and Catholic France. Yet the two countries were not entirely committed to the United Provinces. James I of England, who was disturbed by Spanish manoeuvres against the Palatinate, for his elder daughter had married the Elector, would have liked a reconciliation with Philip IV, the Emperor's cousin and therefore likely to influence him in his favour. Furthermore, he was jealous of the Hollanders' commercial successes. Also James was more inclined towards negotiation than towards war and therefore not disposed to support Maurice of Nassau's military enterprise. For the moment France was uninterested in the conflict: Louis XIII was far too preoccupied with conquering his own kingdom and suppressing the Protestants in the south-west to embroil himself elsewhere. Maurice of Nassau also had to face problems in his own provinces: his partisans were opposed to the great burghers of the States General who were hostile to every solution negotiated with Brussels; while two religious sects, the Gomarists and Arminians, were at logger-heads. In fact, if the King of Spain's situation was uncertain, then that of Maurice of Nassau, Stadtholder of the United Provinces, was not totally assured either – in addition, a liver complaint was making him anxious and hesitant. Perhaps this was the reason for his contradictory behaviour: for the whole time he was continuing his preparations for war he never abandoned hope of a peaceful solution, and in 1623 he confided negotiations for it to a second secret emissary. This was Jan Brant, known as 'the Catholic' and Rubens's cousin by marriage. And so Jan Brant began to confide in Rubens about The Hague's new overtures.

Rubens now began to prepare a new image, that of a diplomat, which he would develop with the same patience and tenacity he had applied to becoming a painter. This shift is at first only verified by scraps of information, with no official confirmation, contained in the painter's correspondence. In a letter of 10 August 1623 to Peiresc, Rubens noted

for example: 'The Marquis [of] Spinola leaves today or tomorrow for Maastricht, where the arsenal is being established, notwithstanding the fact that he is still negotiating secretly for a truce.'[53] He was therefore presumably in the know about negotiations between north and south in the Low Countries. The first letter which reveals Rubens's real implication in the negotiations between The Hague and Brussels is dated 30 September 1623. Writing to the Chancellor of Brabant, Pierre Pecquius, Rubens exposes Jan Brant's mission as envoy of Maurice of Nassau.

My illustrious Lord
I have found our Catholic very afflicted by his father's grave illness, which in the doctor's judgement is critical; he too is tormented daily by an almost continual fever, so much so that one or other of these two causes or both will detain him perhaps longer than might be necessary. . . . In fact the Catholic took his instructions, and showed me an article in them which I did not like. It said in this article that he must not accept or take back a reply from us which is ambiguous or similar to the preceding one - only a straight acceptance of the truce, or nothing. I told him that these were threats to induce panic, to frighten children, and that it was simply not enough to give our word: this secret treaty was without prejudice to either party, each in the meantime trying to make all the effort it could. His reply was what I have already told Your Illustrious Lordship: that we used the Prince's documents to his detriment, by sending them to France to encourage the King to defy him and to render him suspect in the States. I told him that if the Prince wished to enlighten Her Serene Highness further on this, Her Highness would demonstrate her displeasure about it in such a manner that he would not retain the slightest doubt of her innocence; that these were nothing more than intrigues and chicanery to break off negotiation. He nevertheless persisted in maintaining that it was true and that the Prince could show, as he had done to several people, the very copies which were sent him from the French court. In the end, he let us persuade him to copy our reply in his own hand, to take it to the Prince . . .
 I commend myself with a true heart to the good grace of Your Illustrious Lordship and I kiss your hands. Of Your Illustrious Lordship.
<div align="right">Your affectionate servant[54]</div>

Jan Brant's anxiety was proof that Maurice of Nassau considered it vital to keep his relations with Brussels a secret from his potential French and

English allies. That is why he chose roundabout diplomatic channels and used temporary agents to transmit messages. For these overtures to have any outcome, the Catholic Low Countries needed the freedom to make their own decisions. The Spanish Cardinal de la Cueva, who had become the Archduchess's minister since Albert's death was, however, determinedly in favour of war. When he learned of Maurice of Nassau's prevarication, he thought his hour had come and summoned Spinola, whose armies were currently occupying the Palatinate in Germany. In 1624, Spinola besieged Breda, the strong, traditional seat of the Princes of Orange, in the hope of gaining a symbolic victory.

Rubens was spared neither suspicion, jibes nor humiliation on his entry into the political arena. He had no official role, simply privileged access to the Infanta and Ambrogio Spinola. In Flanders's professional diplomatic circles this gave rise to the suspicion that he had pro-Spanish sympathies and that it was a case of pure and simple *arrivisme*. M. de Baugy, French ambassador in Brussels, commented:

> Proposals for a truce are not unagreeable to the Infanta, wherever they come from, even from Rubens, the famous Antwerp painter who is known in Paris for his work in the Queen Mother's palace, and who talks to anyone who will listen to him on the subject, frequently coming and going from here to the Marquis of Spinola's camp, giving to understand that he has in this regard some special intelligence of Prince Henry of Nassau, who, he says, thinks favourably towards the treaty, from which he thinks his fortune will be assured, and bring the Prince of Orange peace in his old age.[55]

But the Infanta limited herself to exploiting Rubens's recognised talents, and in September 1624 asked him to paint a portrait of the Polish prince, Wladislas Sigismond, who was present at the siege of Breda, which once again excited the French envoy: 'Rubens the painter is in town. The Infanta has commissioned him to do a portrait of the Prince of Poland, in which I believe that he will do better than in negotiations for the treaty to which he can give only superficial colours and baseless, insubstantial shadows.'[56]

Despite this hardly glorious entrée into the world of diplomacy Rubens developed a taste for it and spent two years fighting for recognition of his diplomatic role with the same tenacity he had shown in his battle for recognition of his copyright. From whence sprang a sharpness, a tendency to intrigue which make one doubt some of his deeper motives in political matters, as much as his personality in general.

Through his cousin Jan Brant Rubens had been introduced into the peace

negotiations with the Hollanders. He made it his cause and set about keeping it so. When he returned to Paris at the beginning of 1625 for the hanging of his paintings in the Luxembourg Palace, he sent the Infanta a detailed report on France, the French, the international situation, its protagonists, and measures that were vital. Moreover he emphasised that he was ready to suggest them himself to the Conde-Duke d'Olivares.[57] His peremptory manner scarcely concealed his anxiety and the real purpose of his letter, which was precipitated by the possible intervention of the Duke of Neuburg in relations with The Hague. Aware that the German prince was by birth and office in a better position than he to see the mission to a successful conclusion – a mission which he had undertaken on his own initiative – Rubens sensed the affair slipping out of his hands and tried to convince the Infanta both of the perspicacity of his political analyses and the enthusiasm of his commitment as 'a good patriot [who offers] every service to the general welfare, for which we have worked so hard, that I hope, with God's help, our efforts will not be in vain'.[58] He argued that Neuburg, a German, could appear to be operating not only on her behalf but on France's too. Now, Rubens emphasised, who could confide in him, for 'as far as the French go, it is a principle in their politics that they keep up the war with Flanders and thus cause the King of Spain continual expense and anxiety'?

In spite of everything the negotiations begun by Rubens and Jan Brant would fail. Maurice of Nassau died on 23 April 1625 to be succeeded by his half-brother, Frederick Henry. A new Prince, a new strategy. Frederick Henry was keen to assert his power with a military victory, so all hope of a separate peace treaty between the Low Countries and the United Provinces appeared to be in ruins, as did Rubens's diplomatic career – unless he could find himself another cause. That would happen during his final stay in Paris, thanks to a dubious character with whom the painter would strike up a lifelong friendship.

Contacts with England

In May 1625 the French capital was celebrating the marriage of Henrietta of France and Charles of England. The city was swarming with people of high rank and with those jack-of-all-trade agents who exploited these great assemblies. There was Toby Mathew, who would act as Henrietta's interpreter when she reached England and who was intermediary for the sale of British Ambassador Dudley Carleton's collection to Rubens. There

was Jacques de Bie, curator of the Duke of Croÿ's collections, an intermediary whose standing had fallen thanks to the Duke of Neuburg's intervention in negotiations between Brussels and The Hague. And there was the most famous and most influential of them all, Balthasar Gerbier, the Duke of Buckingham's agent. He would be responsible for putting Rubens in touch with the English King's chief adviser, giving him an exclusive contact with England. In fact he would provide Rubens with a new political cause which would place him on the international diplomatic circuit. This doubtless explains Rubens's loyalty to Gerbier, despite his flagrant and frequent betrayals, for Gerbier was a man with a very suspect character.

Balthasar Gerbier, born in Middelburg around 1591, began life as a painter. In 1615 at the behest of the States General he painted a portrait of Maurice of Nassau. This earned him the admiration of the Dutch Ambassador in London who, when Gerbier took himself to England in 1616, recommended him to the Duke of Buckingham. Once in England Gerbier painted the Princess Maria Theresa of Austria at a time when the Prince of Wales was thinking of marrying her, and in 1623 he became Buckingham's agent. Two years later he represented England at the French court, replying to Berulle's accusation that Charles I had forbidden Henrietta of France to practise her religion.

After the Duke of Buckingham's death in 1628 Gerbier would fall into disgrace, but he continued to prowl the English court as a purchasing agent of *objets d'art* on behalf of the sovereign. Thanks to royal favour he found himself party to items of information which would keep him in the diplomatic swim. In 1631 he was England's official envoy to Brussels, where he welcomed to his home the Belgian nobles who were plotting against the Archduchess – and subsequently denounced them to the King of Spain for 20,000 florins. On his return to England he was knighted and, three years later, naturalised. But when he accused Lord Cottington of having betrayed state secrets, Gerbier lost both his case and his diplomatic post.

He then tried to move into the financial world and to introduce state-owned pawnshops into England, without success. After Charles I's execution in 1649 he opened an academy where he taught, indiscriminately, ethics, foreign languages and military architecture. Three years later the academy collapsed and he returned to Holland. In 1654 he edited a vast tract on ethics for the use of *grands seigneurs*, a work which he illustrated himself and signed as Sir Balthasar Gerbier, Baron Dovilly; his barony was self-created. He continued concentrating on the arts and finance, publishing four other treatises intended to draw the attention of the Low Countries to the mineral riches of America.

Then in 1658 he attempted his great adventure: embarking with his wife and children for Surinam, of which he aspired to be Governor. Unfortunately he was not made welcome by the natives, who killed one of his daughters and put him back on a boat for Amsterdam, where he arrived in 1660. The débâcle had allowed his notoriety to die down in England, and Gerbier found work designing triumphal arches for the restoration of Charles II who named him his Master of Ceremonies – and suspended him almost immediately. Gerbier then put his architectural talents to use. It was while he was involved in this last line of work that death surprised him, in 1667 as he was surveying the building works of a castle.

Whatever Gerbier may have done, whatever he did, Rubens excused him, as is shown in Gerbier's summary of Rubens's letter of 15 October 1632, when Gerbier's role in the Belgian conspiracy came to light: 'I doe believe that you doe your utmost endeavours to serve the King of Great Brittany, your maister, faithfully & punctually advertise him of what passeth.'[59] When attacks against the English were at their most virulent, Rubens would even go so far as to exploit his influence with the Archduchess in Gerbier's favour: 'I wonder att the brutall proceedings of Sr. Nicolaldy & Taylor in your regard; I take to my charge, the first time I shall come to Bruxelles to try the Infanta her pulse on the calumnies laid on you.'[60] Rubens seems to have been prone to such blind spots, something which he had already shown in his admiration for the opportunist philosopher, Justus Lipsius. A recent and more perceptive historian honours Gerbier with this final epitaph:

Balthasar Gerbier, French by origin, Hollander by birth, English by choice and by profession, was one of the greatest rascals ever involved in unlawful intrigue, moreover in an age when it was not difficult to practise. At first an engraver, then a painter, then a teacher, then an agent for England, then an inventor, then a coloniser, always short of money, a spy in a variety of camps, a great wheedler-out of secrets and famous merchant of quackery, he served all masters and betrayed all causes which were confided in him.[61]

That spring of 1625 it was Gerbier who sought out Rubens in Paris since he knew of the painter's reputation as a collector. Buckingham was a man of similar tastes and was interested in Rubens's collections.

Gerbier organised a meeting between the two men during the nine days Buckingham spent in Paris to marry by proxy his king's bride. The Duke ordered two portraits and informed the painter, as a friend of Spinola and the Infanta, that Charles I was anxious about the situation in the Palatinate,

from which the King's sister, Elisabeth, and his brother-in-law, the Elector Frederick, had been driven out. The initial contact was made. Linked by a passion for both art and diplomacy, the painter and the minister would see each other again, for Buckingham had instructed Gerbier to acquire the collections currently in the rotunda of the house by the Wapper.

On leaving Paris Rubens met the Archduchess at Dunkirk and, on her orders, travelled as far as the German frontier apparently to see the Duke of Neuburg, although nothing has come down to us of this interview. This done, he returned to give an account of his mission to Isabella, who was still at Dunkirk overseeing the construction of the small 'pirate' ships designed to harass the English and Dutch merchant ships in the North Sea: a last attempt to destabilise the commercial power which the two countries had wrested from Spain.

On 18 October Rubens was writing to Valavès, Peiresc's brother, from Brussels: he had moved to Laeken for four months to protect his family from the plague which was decimating Antwerp. As usual he was taking care to keep away from the bustle of court life, but his mail shows that he was well informed about events in Europe: the siege of La Rochelle the Huguenot stronghold in France, and Louis XIII's steadfastness with them, Wallenstein and his brutal soldiery in Germany, and Cardinal de Berulle's report on the Catholic Queen of England's freedom to practise her religion.

Rubens was only a part-time diplomat, but his work as a painter gave him the opportunity to hold intimate conversations with the powerful and the influential of his day. He had done a bust of Buckingham in red chalk; a portrait of Spinola on horseback, with a pennant proclaiming 'Fame' floating in the sky, revealing Spinola's protruberant eyes and his curious gnomelike figure; Pecquius and his brush haircut; Don Diego Messia; even the Archduchess Isabella who had stopped at his house in Antwerp on 10 July 1625 on her return from Breda. Rubens showed her dressed as a nun of the order of St Clare, a mode of dress Isabella had adopted on being widowed. Richelieu had ordered two paintings from Rubens, specifying that they were to be in his own hand, and he was still supposed to be creating a second gallery, dedicated to Henri IV, for the French Queen Mother.

Buckingham, who had gone to Holland to conclude a fifteen-year treaty of offensive and defensive alliance with the United Provinces, passed through Antwerp in order to buy Rubens's entire collection for 100,000 florins. Rubens had, however, taken care to keep back his most precious pieces and have copies made of several of the others. According to his friend Joachimi de Sandrart: 'He has shown no less cleverness in this affair than he had in the practice of his art.'[62] Rubens used the transaction to

further his correspondence with France: sending Valavès the Forty Articles of the Anglo-Dutch treaty, at the same time apologising for not having the time to translate them.

In spite of everything, in June 1626 after three years of Rubens nurturing his connections with the powerful and in spite of his occasional coups such as the privileged contact he had established with Buckingham, Spinola ordered him to confine himself to maintaining links with Jan Brant: in his eyes Rubens the painter was nothing more than a messenger. Unofficial emissaries were an integral part of the diplomacy of the period, which was a haphazard affair subject to the whim of an all-powerful sovereign or minister who arranged marriages and military alliances in seeming opposition to previous commitments also often forged by marriage. Wars were seasonal events and often regarded as a spectator sport. Having no military responsibility, the Queen Mother of France took herself off to the sieges of Lunel and Montpellier, just to have a look. The Infanta Isabella invited a Polish prince to observe the siege of Breda as a mark of honour and a form of entertainment. There is nothing astonishing then, if, in the casual manner of his times, Rubens talks of his country's hostilities with the United Provinces as though describing a harvest: 'This happens so peacefully here', he wrote again to Valavès, 'that it seems the two parties have fallen into agreement that they don't want a war. No one talks of embarking on a campaign this summer as in other summers. For although one must wait for the grass to grow before coming out with the cavalry, and there is hay about, the other preparations are ordinarily done early. But there is no sign of that yet.'[63] It is clear from this letter that Rubens is indicating that a resumption of the war was not imminent. What does this mean? Is he being two-faced in revealing this to his country's enemy? How, too, are we to explain what Rubens wrote in January 1625? 'But as for me, I can assure you that in regard to public affairs I am the least impassioned man in the world, my rings and my dignity apart; but understand, *ceteri partibus*, that on behalf of my country I appraise everyone; also I believe that I would be very welcome everywhere.'[64] Should we question the sincerity of Rubens's diplomatic commitment by asking whether the ambitious son of Jan Rubens was merely stirring things up, or was he truly a Flemish patriot like Maria Rubens?

Following Spinola's instructions Rubens maintained his contact with Jan Brant. He also corresponded with Gerbier and transmitted overtures from England to the Infanta: Isabella was interested, Spain was not. Rubens was obstinate: was it because diplomacy attracted him more than he liked to admit, or because it provided a means to augment his fortune, as ambassador Baugy suspected?

136

A personal tragedy would precipitate events and lead to his full-time involvement in public affairs.

The Emissary

After spending four months at Laeken Rubens returned to Antwerp in 1626. That spring the plague was still ravaging the town and claimed the life of his wife, Isabella. A bereft Rubens could not look to Valavès for consolation since he had left Paris entrusting Louis XIII's librarian, Pierre Dupuy, with the responsibility of keeping Rubens informed of French news. It was to this erudite man, whom he hardly knew, that Rubens now confided his grief, his mistrust of the fair sex, and the consolation he hoped to obtain from Stoicism and travel.

Very dear Sir

Your Lordship is right in recalling for me that fate is not always in harmony with our passions, and that being a manifestation of His divine will, it owes us no explanation of His decrees. Fate is supreme master of all things, and we have only to bow to its demands and obey it; this is why we must make our enslavement as honourable and as bearable as we can by willing acceptance of it. However, today, the weight of duty hangs on my shoulder unbearably.

Very reasonably, Your Lordship recommended me to rely on the passage of time; I hope, indeed, that it will act for me the way reason should. I make no claims that one day I shall achieve Stoicism and impassivity, and I cannot believe, moreover, that such natural feelings can be unworthy of an honest man. How can one be perfectly neutral face to face with all the spectacles of life? *Sed aliqua esse quae potius sunt extra vitia quam cum virtutibus* [But there are certain things which are beyond the scope of vice rather than within the scope of virtue] and these feelings are avenged in our soul *contra reprehensionem.*

As for myself, I have lost a very good companion, whom I could, whom I ought to have loved reasonably, for she had none of the shortcomings of her sex; she was neither morose nor weak, but so good, so honest, so virtuous that everyone loved her throughout her life, and weeps for her in her death. Such a loss strikes me to the very depths, and since the only true remedy to all ills is oblivion, born of time, I have the strength to put all my hope in that. But it

will be very difficult to separate my grief from the memory that I shall keep, my whole life long, of that dear creature, who was loved and respected by all.

I believe that a journey would help me, and would wrest me from the sight of those things all around me which fatally renew my grief, *ut illa sola domo moerei vacua tratisque reliciis incubat* [as (Dido) who laments alone in the empty house and weeps on her abandoned couch *Aeneid* 4.82], the novelties which one observes as the country changes before ones eyes occupies the imagination so well, that sorrow does not have the opportunity to spring up again. But, to be truthful, *quod mecum peregrinabor et me ipsum circumferam* [I shall travel with my self and will carry my self with me]. Your Lordship will believe me, however, if I say that it would be a very great consolation to see His Lordship again, as well as his brother, and to render them service as far as I am able. I am very aware of Your Lordship's compassion and of your wise counsel, and I thank you for your kind promise to correspond with me in M. de Valavès' absence. Until the end of my days I shall remain Your Lordship's very humble, and indebted servant.

Of Your Very Illustrious Lordship, your very humble servant[65]

We did not realise that he loved Isabella so much. Bearing in mind the discretion he favoured when dealing with personal feelings, Rubens's grief appears immense in this letter. It was Olivares, the all powerful and extremely arrogant minister of Philip IV, who took the initiative, sending Rubens words of comfort, repeatedly assuring him of the respect in which he was held, and which his letter itself clearly illustrates: 'I speak to you as a discreet man so that you may see that in the midst of my responsibilities and heavy duties, I esteem in you the qualities and the favours that God has granted you and the satisfaction that I feel from the affection you have borne me.'[66] Olivares valued Rubens the man but did not have the same appreciation of Rubens the diplomat.

Rubens had his wife buried beside his mother. To the painting which decorates the tomb - *St Gregory*, which he had brought back from Rome - he added the figures of the Virgin and Child and composed the following epigraph for Isabella Brant:

To the Virgin mother
This painting which he has painted in
his own hand is piously and affectionately dedicated
to the tomb of his excellent mother,

in which also lie the remains of
Isabella Brant, his wife
by P. P. Rubens
The day of St Michael Archangel
The year of our Lord 1626[67]

In November 1626, after completing a brief journey to Paris, Rubens accompanied his gallery's treasures to Calais, the first stop on their journey to the Duke of Buckingham. On the death of the Duke, the King of England took over his favourite's collections; they then passed to the Duke of Northumberland and would eventually return to Antwerp to be dispersed. The inventory revealed nineteen Titians, two Correggios, twenty-one Bassanos, thirteen Veroneses, eight Palmas, seventeen Tintorettos, three Raphaels, three Leonardo da Vincis, thirteen Rubens, eight Holbeins, one Quentin Metsys, two Snyders, eight Anthonis Mors, six William Keys, plus nine metal statues, two of ivory and two of marble and, finally, twelve chests of engraved gems.

The house beside the Wapper was empty, Isabella had gone, and gone were the works of art which the painter had loved to look at in his leisure hours. Apparently Rubens's appetite for painting had weakened a little: during those last three years Rubens, normally so prodigious, had produced only the twenty-four paintings for the Medicis gallery as well as the portraits of men then in favour at court. His 'pulchra pittura' was no longer at the centre of his thoughts; it barely mattered to him. Even so, only Van Dyck, who had just finished his studies in Italy, could touch him. Rubens was and remained the greatest painter of his time.

Rubens's sudden immersion in international politics dates from 1626 when in an attempt to forget his grief over the death of his wife, which drove him from Antwerp over the next seven years, Rubens was to find himself deploying his political talents and enlarging his theatre of operations, thanks to his burgeoning relationship with the English court. Until then he had acted only within the context of the schism in the Low Countries. Now he would move on to the chessboard of Europe.

THE EMBASSIES
(1627-1634)

'The return of peace between Spain and England in 1630, peace negotiated through the intervention of the great painter, Peter Paul Rubens'[1] - this treaty was Rubens's great political achievement. To achieve it he would travel to Madrid and London, no longer restricting himself to negotiating between the northern and southern Low Countries, and in the process he would confront the most powerful ministers of his time in order to bring the treaty to a conclusion. Rubens became embroiled in the great affair of the seventeenth century, the Thirty Years' War, which began in 1618 with the election of Frederick Elector Palatine to the Bohemian throne, and ended in 1648 when peace was declared.

Whatever the extent of the mission Rubens arranged for himself, his role in these tumultuous events which shook the whole of Europe was but a footnote of history. The main protagonists in this struggle were the King of Spain, Philip IV, and his minister Olivares; the English King, Charles I, tragically beheaded in 1649, a year after peace was finally concluded; Cardinal de Richelieu of France; the German Emperor, Ferdinand II; the Kings of Denmark and Poland; and the German generals - Wallenstein, Mansfeld and Tilly. Rubens was neither a great general nor an ambassador. He had no political power, and his strength lay in his painting. His greatest triumph as a diplomat came when he used that strength and combined it with his diplomatic talents. If one compares Rubens's skills with those of other painters, only van Eyck comes close - in his mission to Portugal to find a wife for Philip the Good, Duke of Burgundy. Dudley Carleton, the English King's Ambassador, was only a Sunday painter; Gerbier's canvases could be counted on the fingers of one hand. Rubens the diplomat aroused curiosity through his incongruous position. Despite the fact that the treaty Rubens arranged between England and Spain was only a minor step towards bringing to an end the infamous Thirty Years' War, in which more than half the German population perished, it was still a great personal triumph for him. Yet his reasons in securing it - the re-establishment of peace between the United Provinces and the southern Low Countries - would still take a further eighteen years, until the Treaty of Munster on 30 January 1648, eight years after Rubens's

death. Then the Hollanders obtained their longed-for independence and peace returned to Northern Europe.

A European Context

Rubens's motivations for this public role were a mixture of idealism, personal interest and patriotism, considerations which would colour both his judgement and the judgement of his contemporaries – and posterity.

When Gerbier contacted him in Paris in 1625, Rubens seized this opportunity to take advantage of the situation and find out what the English were proposing. This was primarily a way for him to stay in the diplomatic race, thanks to his friendship with Charles I's English First Minister, at a time when the negotiations with the Hollanders, which were his responsibility, had failed. Rubens would probably have worked out his international strategy only later, for first he needed time to make his mark as an authentic diplomat. Hitherto he had given the impression that he was concerned with his own prerogatives, possibly only motivated by his own social aspirations. At first Rubens appeared to be the ambitious man his detractors described, rather than a pilgrim of peace: hadn't he said that he was quite uninterested in the world of public affairs, apart from 'his rings and his dignity'? Was he then a pilgrim of peace? In his stoicism he might have considered that the conflict was divine will he could not oppose. Yet the conflict which had ravaged his country all his life and which he knew Spain would never surrender showed him that only peace could bring prosperity to his beloved Antwerp.

Rubens was ambitious, but he was also perspicacious and tenacious. He would endure insults and humiliations, he would engage in difficult negotiations, undertake prolonged journeys which would keep him away from home for two years, and confine him to the court life he so detested, yet in spite of all this and the vagueness of his brief he would devote himself, sometimes surpass his duty, in order to achieve his aim.

Rubens's project was simple and clear. He wanted to deliver his country from the war which had ravaged it since his childhood. In order to do that he tried his utmost to create conditions for a separate peace treaty between the Low Countries and the United Provinces by neutralising the Hollanders' most faithful ally: England. England, once allied to Spain, would have to renounce her support for the United Provinces, which would be rendered powerless against a united England and Spain and would be forced to cease hostilities. This Anglo-Spanish treaty would kill two birds with one stone:

it would ensure peace in the Low Countries and, in completing the encirclement of France, it would also neutralise Spain's principal enemy and prevent her from supporting the United Provinces. The scheme had all the ingredients necessary to seduce the Infanta and Olivares, Philip IV's great minister. But was it a viable plan? Or was it only the wild imaginings of a novice, ill-versed in political and diplomatic realities, who believed that everything should be calculated logically?

Rubens's first and by no means easiest task, would be to get the Infanta Isabella, General Spinola, Olivares and Philip IV to consider his strategy. After this he would have to wend his way through the tangle of contradictory interests whose threads made up the political canvas of his time.

The southern Low Countries desperately wanted peace: if not peace, then at least a prolongation of the treaty with the United Provinces, and the greatest possible autonomy from the Spanish crown. However Brussels could not, either financially or militarily, bypass Madrid, where Philip IV held onto the hope of regaining control of the United Provinces. This made any negotiated solution between the northern and southern Low Countries difficult.

As for the Hollanders, even if commerce had made them rich, and they were bolstered by the most important fleet in Europe, the United Provinces could not envisage a war against the Habsburgs of Spain and their Austrian cousins without the support of their European enemies: England, France, Denmark, Sweden and even Russia. All these nations could not be counted on in advance since they had their own interests in Spain and Germany to consider – like the English, who were counting on Spain to help recover the Palatinate for the Elector Frederick.

In addition the strategy had to take into account various local squabbles, such as the current claims of the French and the Spanish on the strategically valuable Italian territories of Mantua, Montferrat and Valtelina. In fact, Mantua guarded the passage between the south and north of Italy, and, as a result of the last Gonzaga's will, it had reverted to the French Duke of Nevers and cut into Spanish hegemony in Italy. Valtelina guarded Spain's passage to their transalpine possessions and, importantly, their ally, the Holy Roman Emperor's territories. The settlement of the conflicts would lead to the intervention of the self-governing powers of Venice and Savoy, who would align with one or the other for preference with the strongest, and in the process redesign the map of Europe.

As a Fleming, Rubens was on the side of the Habsburgs, and thus ranged against their opponents. In order to carry out his mission properly, so that Brussels could conclude a separate peace treaty with The Hague, he would

have to win over the anti-Habsburg league and persuade it to abandon the United Provinces. In order to do this he would be obliged to poach on the preserve of the cleverest minister of his age, Richelieu, for the Cardinal had also undertaken to win the enemies of the powerful Austro-Spanish dynasty to his cause. Like Rubens, Richelieu saw England as top of his list, for England seemed to be France's objective ally. In the first place the King of England was the King of France's brother-in-law. Next came reasons of strategy and European hegemony: Spain had dominated the world for more than a century, and now that France and England had finally achieved internal stability they were exhibiting an expansionism which could be practised only at the Spanish monarch's expense. Finally, France and England were separately pursuing an identical fight: offering financial and military aid to the United Provinces. Logic dictated they should unite their efforts against their common enemy.

On the other hand, in total opposition to Rubens's calculations, a host of denominational and historical reasons made England the sworn enemy of Spain. As a leading Protestant country the English had to support their co-religionists in Holland. To do this, England had in December 1625 on Buckingham's initiative formed a Protestant League with the United Provinces and Denmark, thus provoking the immediate recall of the Spanish Ambassador to London. In addition, Charles I felt an ancient bitterness against Philip IV, as Spanish troops had assisted the Emperor in invading Bohemia in November 1620, chasing the Elector Frederick V from his throne. Frederick, Charles I's brother-in-law, had been living at The Hague on the charity of the House of Orange ever since. And so an old, unresolved bitterness remained between these two powers which seemed likely to compromise permanently any eventual alliance.

From 1614 to 1623 diplomats in London and Madrid had tried to negotiate a marriage between the Infanta Maria Theresa and Charles I when Prince of Wales. The Spanish were hoping this alliance would prevent England's entry into an anti-Habsburg bloc and stop the English fleet linking up with the Dutch and destroying Spain's colonial power. Later England saw the marriage as a means of reinstating the Elector Palatine in his territory. Whatever the potential benefits, this marriage enchanted no one on either side, and a number of ecclesiastics and diplomats were engaged in editing, revising and haggling over the clauses of the contract while the Infanta threatened to retire to a convent rather than marry an infidel. Weary of this shilly-shallying, Prince Charles and Buckingham decided to go to Spain *incognito* in quest of the Infanta.

On 17 February 1623, having finally obtained the King's consent, Baby Charles and Steenie (as James I nicknamed them) set out for Dover without

an escort. They reached Boulogne, bought wigs in Paris, and travelled across France, staying at inns and with peasants, arriving in Madrid on 7 March. In the eyes of the Spanish this jaunt took on an obvious significance: Charles was in love and was ready to be converted to the Catholic faith in order to marry Maria Theresa. The Prince of Wales soon disillusioned them, proclaiming his allegiance to Protestantism, and began to behave in an extravagant manner which was viewed in a poor light by the rigid Spanish court. One day, when the Infanta was taking a walk, he leapt from the top of the wall which protected her from the public and threw himself at her feet: the princess fainted. By the end of April the marriage agreement was still not concluded. Charles felt himself trapped and thinking he would lose face if he returned to England without his bride announced the marriage as a *fait accompli*. Inigo Jones, England's great architect, restored palaces and cathedrals to welcome the new Princess of Wales. The Spanish took advantage of this manoeuvre by upping the ante, removing the question of the Palatinate from the clauses of the contract, delaying the princess's arrival in England, and also that of her dowry – the last serious advantage that London could count on from this marriage.

They were now well into summer. The heat in the Spanish capital was unbearable, and the Pope had just died without giving the necessary dispensation for the marriage of a Catholic Princess to the Protestant Prince. Charles lost patience. On 29 August he left Spain, leaving his Ambassador Bristol to marry Maria Theresa in his name. The further he travelled away from the capital the less he liked his fiancée. When he reached Segovia he sent an emissary to Bristol, begging him to annul the procuration but recommending that he should keep his decision secret until he had left Spanish soil and the dispensation from the new pope had arrived. It was a just revenge for the ill will shown by the Spanish throughout this episode, but it inflicted a stinging humilation on Spain. Two years later, and five weeks after his accession, Charles married Henrietta Maria of France.

When Rubens entered the scene in 1625, in response to Gerbier's appeal, the rift between Spain and England seemed beyond repair.

First Moves

In the meantime certain events had occurred which would modify these historical facts. On Buckingham's bad advice, Charles I was offering help to the French Huguenots, placing himself on a delicate footing with France. At the beginning of 1627, anxious to re-establish the balance of his

alliances, Charles sent a Dominican monk, Father William of the Holy Spirit, to Madrid asking him to convey his excuses to Olivares. It was the same spirit of appeasement that prompted him to order Gerbier to make contact with Rubens to attempt a rapprochement with Spain, using the Low Countries as intermediary. From this sprang the meeting between the two men in Paris and the correspondence which followed.

Rubens, who had acted as the focus for the proposals for peace between the United Provinces and the Low Countries had also in his possession England's proposals towards Spain. Unfortunately, the only person at the Spanish court in favour of an understanding with England and able to smooth over the basic antagonisms between the two nations, the Marquis de Bedmar, had just died. At this juncture Rubens weighed up the extent and the difficulty of his project: 'One idea Bedmar favoured was to negotiate a peace treaty between the Spanish and the English, and I firmly believe that if he had arrived safe and sound at court, he would have strongly persisted in achieving his ends. But the Count of Olivares, who rules absolutely here, as your Cardinal does with you, is England's greatest enemy and especially the greatest enemy of the Duke of Buckingham, and so because of Bedmar's death, no similar negotiation will be attempted.'[2] In other words, in his attempt to draw Spain and England closer together Rubens would have to confront the two most powerful ministers of his time: Olivares and Richelieu. The task appeared insurmountable to him and compromised from the outset.

Nevertheless, working in the shadows in the hope that one day light would come, the painter pursued the negotiations which Gerbier had begun. As agreed, he set off for Paris to find him at the end of 1626, en route for Calais where Rubens would load on board ship the statues and marbles destined for Buckingham. Staying with Baron de Vicq, then Flemish Ambassador in the French capital, he waited three weeks for Gerbier. Gerbier never came. The only thing which kept Rubens company was his gout, which never left him. As a result Rubens left for Calais. His detractors in Brussels would see this escapade on the French coast as a secret and illegal journey to England, and he would find it hard to convince the Infanta and the Spanish envoy to the contrary: this kind of suspicion was the price Rubens paid for the secrecy which had surrounded his negotiations since leaving Antwerp.

In January 1627 Gerbier reappeared and, thanks to Rubens, obtained a passport for the Low Countries. Meeting in Brussels in February, he handed over to Rubens documents which proved England's commitment to the negotiations: a letter of accreditation from Buckingham as well as a memorandum which outlined the basis of an Anglo-Spanish understanding.

This document proposed suspension of arms and freedom of trade not only between England and Spain but also between Denmark and the United Provinces, to be put into effect during the interim period while a peace treaty was being worked out. Rubens transmitted the proposals to the Infanta, who preferred that the clauses related only to the two crowns of Spain and England, a point which Buckingham accepted. The proposals transmitted by Buckingham via Gerbier during the first quarter of 1627 were sufficiently serious for the Infanta to believe in them and send them on to Philip IV. Assured of the total confidence of the English minister, Rubens acted as the pivot of Anglo-Spanish understanding. Nevertheless, the Infanta would not allow him any elbow room, and when he needed to go to Holland for talks, he would have to negotiate his passport secretly with the English Ambassador at The Hague.

During that winter of 1627, the Abbé Scaglia, Duke Charles Emmanuel of Savoy's emissary, contacted Rubens and informed him that in return for concessions his master would be willing to press France with the Spanish claims on Montferrat and Valtelina in Italy. Rubens absorbed, transmitted and commented on the proposition to the Infanta: he did not believe in the Duke of Savoy's offers insofar as Scaglia was on his way to Holland, therefore on his way to meet Spain's enemies. After all, 12,000 of Charles Emmanuel's men were already marching on Genoa.[3] The Infanta duly wrote to Philip IV on the Italian question, passing on Rubens's information.

As a sign of Rubens's diplomatic low standing in Madrid, Philip IV's first reaction was to berate the Infanta.

I feel I must tell your Highness that I very much regret that when dealing with such important affairs, one has recourse to a painter. This is a cause of great discredit to this monarchy, since it necessarily results in our consideration being diminished by the fact that a man of so little importance should be the minister whom the ambassadors look to to make proposals of such great import. In fact, one cannot refuse the person who has proposed the choice of intermediary, seeing that one is committed as one enters negotiations, and that for England there is no inconvenience that this intermediary is Rubens, however for our country, this inconvenience is very great. And so it would be good if Your Highness would end these negotiations with the agent of the Duke of Savoy, but that she continues with Gerbier those negotiations which concern England and Holland, following the circumstances and in the form which I have made known to Your Highness.[4]

Showing a certain amount of consideration for her painter, on 22 July 1627 Isabella replied firmly: 'Gerbier is a painter just like Rubens. The Duke of Buckingham has sent him here with a letter in his own hand for the said Rubens and has asked him to deliver the proposal to Rubens. One cannot therefore refrain from listening to him.'[5] Nevertheless Philip IV formally forbade Rubens any subsequent intervention in Franco-Italian affairs. On the other hand the authorisation which he gave him to pursue matters with Gerbier shows that he attached little importance to this overture with England. In June he even conceded powers to Isabella to negotiate in his name with Charles I, taking care always to antedate the documents by fifteen months (from 24 February 1626) and specifying that she must give nothing away to England but just 'amuse them'.[6]

Fortified by this semi-blessing Rubens resolved to go to Holland to meet Gerbier in an effort to keep these contacts secret: England did not want her contacts with Spain made public, nor did Flanders want hers with England known. As Rubens had no authorisation to cross the frontier towns he proposed to meet Gerbier at Zevenberghen: Gerbier refused, arguing that the King of Denmark's spies could take them by surprise. But Christian IV was ignorant of this new orientation in his nephew Charles I's politics. Rubens returned to Brussels in the hope of tracking down Don Diego Messia, Marquis of Leganes, the Spanish envoy. He had arranged to receive his instructions from the envoy in order to be able to speak on his behalf. Had Rubens succeeded, he would have brought to the English, via Gerbier, the warranty of a messenger of Philip IV, which was badly needed as proof of the Spanish government's serious intentions. Unfortunately Diego Messia was ill and had stopped in Paris, so Rubens went back to Holland without having seen him. He pretended his new journey was a pleasure trip. He met Gerbier again in Delft on 21 July, and then set off for Utrecht, to the house of a fellow Dutch painter, Honthorst, where he was honoured with a great banquet and encountered Abraham Blomaert, Terbrughen and Poelenburgh. Joachimi de Sandrart accompanied him, and it was in the course of this journey that Rubens revealed facts which have thrown light on the source of his artistic vocation as well as his entry into diplomacy: 'As his wife fell ill, and the doctors' remedies could not prevent her speedy death, he made a journey into Holland to forget his grief and to visit numerous and excellent painters of whom he had heard and seen much.'[7]

At The Hague Dudley Carleton, the English Ambassador, was mistrustful:

Rubens had order to come hether into Holland, where he now is, and Gerbier in his company walking from towne to towne upon theyr pretence of pictures: w^ch may serve him a few dayes, so he dispatch

147

and be gone, but yf he entertayne tyme longe here he will infallibly be layd hold of or sent w^th disgrace out of the Countrey, for there they can have no other opinion of theyr doings on y^e other side, but y^t all his fraude and deceit, and they believe of this man as of others whome they style Emissaryes, who upon severall pretences are sent into these Countreyes to espye y^e actions of state and rayse rumo^r among the people; as yf the K. of Spayne and the Infanta were growne by tyme and experience more mild and moderat, and would suffer those Countreyes to live in quiett upon any reasonable conditions.[8]

It was clear that Carleton scented an Hispanic-Dutch rapprochement using England as the expedient. He could no longer believe in the aesthetic motivations behind Rubens's journey, particularly since Philip IV had recommended his cousin the Emperor to be firm with the Protestants of Denmark and the Palatinate: it was difficult in these conditions to give credence to the good will of Catholics in general. But considering that Spain was on the point of ruin, Carleton did not believe that she could negotiate from a position of advantage for long with the States General of Holland. And, finally and most importantly, the perceptive Carleton was having doubts about the nature of the illness which kept Diego Messia in Paris.

Gerbier and Rubens were in a tricky situation: no one believed them and, even worse, they began to doubt one another, the Frenchman reproaching the Flemish artist for the absence of any written commitment from the King of Spain. The situation was clarified by a *coup de théâtre*: the announcement of a Franco-Spanish alliance.

While the two artists were working on an Anglo-Spanish rapprochement, Olivares busied himself doing deals with France. On 20 March 1627 he concluded a treaty with the ambassador Rochepont which stipulated nothing less than the invasion of England to establish Catholicism, using the French and Spanish armies. Since Richelieu appeared well disposed to the idea, it was better not to let him suspect the double dealing to which Spain was a party, hence the false dates on the powers conferred on Isabella to treat with London. Meanwhile over in Paris, far from nursing any illness, Don Diego Messia was actually finalising the terms of the Franco-Spanish attack on England. When he arrived in Brussels on 9 September he made the Infanta privy to the secret treaty.

The affair leaked out. By 15 September Gerbier was in a position to inform Charles I that the King of Spain was assisting the King of France with sixty vessels. He added that the Infanta was in despair and would do her utmost to delay the delivery of the fleet. The Infanta warned Rubens

of the real facts. Rubens realised he was beaten but attempted to salvage his negotiations by completing the news for Gerbier and risking Spanish interests: 'The arrival of Senor Don Diego Messia has enlightened us of the concerted action of the Kings of Spain and of France for the defence of their kingdoms.'[9] On 18 September he assured Buckingham that the Infanta wanted peace just as much as the Messia did and that she should continue to work for it.[10]

Should Rubens have concealed these measures from Gerbier, a man who belonged to the opposing camp? The Junta would condemn him for having said too much: 'As for the affair of Rubens and England, he [Olivarez] is in agreement with the Marquis of Montesclaros and is of the opinion that, without doing injustice to the truth, one could have replied with less clarity.'[11] Did Rubens reveal the Franco-Spanish treaty to Gerbier so that England could prepare her reprisal, thus giving Charles I and Buckingham guarantees of his sincerity, in the hope of putting his meagre experience of negotiations to some use and saving his personal position as a diplomatic agent?

In the Infanta's Privy Council the men who governed Flanders did not mince their words, and as proof of the confidence which Spinola and the Infanta had in Rubens, it was Rubens who made known his compatriots' discontent to the King of Spain: 'Messia has been given first-hand experience of French perfidiousness and the effective help that the King of France was granted the States and would have liked to have given Denmark, and of how the French are laughing at our simplicity, and seeking to force England to conclude an agreement with them, using this scarecrow help from Spain. You will see this is what effectively will happen.'[12]

Judging from all the evidence, Olivares still believed he was living at the time of the Spanish marriages during Marie de Medicis's regency, and refused to confront France's real interests, which were leading her naturally to seek an alliance with England rather than with Spain. He did not realise that Richelieu was striving to break the Habsburgs' encirclement of France only by using 'financial diplomacy', Richelieu's own creation and one which he explained in his *Political Testament*: 'If it is a result of a particular kind of prudence to have spent all your state's enemies' energies in engagements with your allies for ten years, by putting hands on purses and not on arms, to enter into open war when your allies can no longer subsist on their own is an act both of courage and wisdom.'[13] The Cardinal decided on a military engagement only after having played for time, secretly financing the conflicts which would weaken his enemies: and so, when he finally signed the accord with Spain, he had already paid over subsidies to the members of the Protestant League: the United Provinces, Sweden

and Denmark. Whether he knew of this fact or not, Olivares paid little attention to it. If Messia was shaken by protestations from Flanders, Madrid could not renounce a joint expedition. Spinola, although he was not convinced of its wisdom, preferred to lead it himself rather than delegate it to someone else and risk defeat.

Nothing was done. At Dunkirk the French halfheartedly prepared their fleet against England. In Rubens's eyes the Franco-Spanish treaty was just 'thunder without lightning',[14] probably because he was trying to reassure Gerbier whom he had asked to follow up their negotiations: 'We could among ourselves clarify the difficulties already debated. For inasmuch as I have been employed in this treaty constantly since the rupture, I still have in my hands all the papers presented by both sides.'[15] Nevertheless Charles I withdrew, a fact he communicated to Gerbier on 4 October through his minister of foreign affairs: 'But, since your last letters have shown that through the great fault of the ministers of the opposing party, one can expect nothing from this treaty, His Majesty thinks that it befits his honour and his service to suspend every subsequent move towards this treaty.'[16] He would rapidly go back on this decision. At the end of the year, having burnt their fingers through their disastrous attempts to help the French Protestants, the English sought a new alliance with Spain.

In December 1627 Rubens informed Spinola of this turn of events. In January 1628 Spinola accompanied Diego Messia to Madrid where the Infanta wanted him to plead the Low Countries' cause in person to the King of Spain. Shortly afterwards she sent an ultimatum to Philip IV, demanding that he either assume the costs of war or come to an understanding with the United Provinces. Confronted with Spinola's measures for peace, Philip IV decided to keep him close so that he could confide in him, finally sending Spinola to govern Milan, where he would die in 1630. As for Rubens, the painter-diplomat, affairs seemed to be marking time. Olivares, whose confidence and support he had enjoyed, had now distanced himself. Spain was not interested in the English. The outstanding *objets d'art* for Buckingham were on their way in September: Rubens had lost his last pretext for maintaining contact with London. But Rubens's political career was not interrupted for he had his reputation as a counsellor and a confidant to fall back on; in addition he was close to the Infanta. And, living in Antwerp, emissaries from all sides, anxious to avoid paying an official visit to the court at Brussels, could approach Rubens, a Flemish official, under cover of socialising or their interest in painting.

At the end of 1627 he received a visit from the Resident of the King of Denmark at The Hague, Josias Vosberghen. It appeared as if all parties

concerned were now trying to avoid the vast impending conflagration, for the Dane brought Rubens a suggestion for nipping in the bud any European confrontation between Catholics and Protestants. The United Provinces could do nothing without support from the Danes, Swedes and English. For the sake of peace in the Low Countries Rubens should therefore leave the matter to the Protestant League, so that pressure could be put on the Stadtholder of Holland to make concessions to the King of Spain.

These Danish proposals gave Rubens the opportunity to return to the public stage, as he elaborated to the Infanta: 'He [Vosberghen] is happy to have me as his contact, while I obtain Your Highness's authorisation of power to confer with him by mouth and in writing, by which time he will have gone to England, and for this purpose, he would like to leave me a sum of money.'[17] Rubens had put himself forward as sole negotiator with the Protestants – the Danish Resident, en route for England, did not even stop in Brussels – and it went without saying that he could not pursue negotiations of this importance without official accreditation.

The Infanta, as prudent as ever, ordered Rubens simply to transmit this information to Madrid, to the Marquis de Los Balbases. The Marquis sent it on to Spinola who asked for more proposals and suggested the role the King of Spain should adopt. The stakes were revealed. The interests of the entire Protestant community were in question, not just those of the United Provinces, but also Germany, threatened by the Emperor, and their Danish and Swedish allies. This opportunity to make a deal with all of the United Provinces' allies had to be seized, to make them give way: they could probably force the States General 'to allow the King of Spain to maintain the title to his satisfaction, that is, the title without possession'.[18] As the Habsburg Emperor Ferdinand II was the King of Spain's cousin, he could act as mediator. From all the evidence it appears that Rubens did not press his case for the King of Spain's prerogatives but concentrated on consolidating his own position and reiterated his demand to Spinola for accreditation.

As the Danish emissary was an unofficial envoy Spinola, who was also a prudent man, merely instructed Rubens to maintain contact and to transmit any information he obtained. The King of England, on the other hand, showed more determination. Charles I was still preoccupied with the question of the Palatinate and wanted support from Spain against the French, who were annoyed by his expedition to help the protestants of La Rochelle. Conscious of the delays caused by the unofficial nature of his initiatives, Charles gave the Danish envoy accreditation to negotiate peace with Spain. Rubens was now isolated but persisted in spite of everything. In March 1628 he assured Buckingham that 'His Catholic Majesty of Spain

[is] well disposed to make peace with those with whom he is at war',[19] and sent letter after letter to Spinola condemning Spain's obstinacy in wishing to conclude her treaty with France. He was also still doggedly demanding his accreditation.[20]

His stubbornness finally bore fruit. Philip IV began to pay attention to England's proposals for peace transmitted to him through Spinola and the Infanta. The King of Spain could not, of course, leave the task of negotiating such an important treaty to the Low Countries, so he decided that the affair should be dealt with in Madrid not Brussels. On 1 May 1628 he therefore asked Isabella to send him all the diplomatic mail held by Rubens à propos of these negotiations: 'It could in fact be that there are things or words to which Rubens has not paid attention, and it could be that he has cut or added something of his own. It is right that I see the foundations on which his negotiation rests.'[21]

A fresh snub for Rubens: he was suspected of not understanding the messages and of distorting them. Rubens held firm for he knew he possessed the most complete dossier on the rapprochement with England, since he had been its principal artisan for three years. He was also sure that he alone could explain what his documents contained, for they were larded with proposals which had nothing to do with diplomacy, so he exploited the demand to obtain official recognition by the Spanish sovereign: if his diplomatic correspondence must fall into Philip IV's hands, he would take it to Spain and explain its contents to Philip himself.

This was how Rubens presented his case to the Infanta; that was how she understood it. The Infanta took the painter's side and assured Philip IV that Rubens had concealed none of the information he held. On 4 July the Junta met to reply to Isabella: 'Your Highness may tell Rubens to come to this court and bring the said letters and papers which have been asked of him. In addition, one can either continue this negotiation or delay it, according to what will appear necessary and if it is judged worthwhile pursuing it, Rubens's visit will do more good than harm.'[22] In a vain effort to disguise his true mission, Rubens wrote to his friend Peiresc that he was going to Spain to paint the King. He deceived no one, and a French diplomat in Brussels was quick to inform the Apostolic Nuncio Guidi di Bagno: 'Rubens has gone to Spain, where he says he has been summoned to paint the King, but, from what I hear on good authority, he is engaged by Her Highness for the affairs which he is negotiating with England concerning commerce.'[23]

Being an orderly man, Rubens went to his notary on 28 August. He wanted to take an inventory of his property, such as it was at the time of Isabella's death, and sort out his two sons' inheritance. He was rich.

When Isabella Brant died, [Rooses records] Rubens possessed in buildings and annuities, the great house at La Bascule, another house next to rue des Agneaux [today rue Houblonnière], and a house in rue des Juifs, a farm of 32 arpents [about an acre] at Zwyndrect, which he had bought on 11 June 1619 from Nicolas Rockox, and 3,717 florins' income a year from the States of Brabant, the towns of Antwerp, Ypres and Ninove, and several individual properties. After her death, he had acquired the 84,000 florins which he had been paid for the sale of works of art to the Duke of Buckingham, three houses in La Bascule, next to his, and four houses in the rue des Agneaux, next to his property, a farm at Eeckeren, bringing in 400 florins a year, and 13,173 florins's income from the States of Brabant, from Brussels' canal and from properties of Messire Jan Doyenbrugge de Duras. This does not take into account what he still possessed in pictures by his own hand or by other masters, as well as works of art and other precious objects, such as the engraved precious stones which could be valued later, as could his deceased wife's jewels which have been valued at 2,700 florins.[24]

The following day Rubens set out for Spain.

The Public Man

The journey to Spain was Rubens's first official mission. He had been instructed by the Infanta and summoned by the Junta of Madrid. He was no longer a simple conveyor of gifts, the impressionable young man of that first journey in 1603 who spent his time outwitting the jealous Resident's nasty tricks. Twenty-five years had passed and Rubens was now fifty-one years old; he was a man at his peak and the greatest painter of his age. In his hands was the basis for a treaty which could change the balance of power in Europe. He would not be content with merely being presented to the King of Spain, for he was expecting the monarch to listen to his case and sign a treaty with England.

Although it was of no lasting impact on the final outcome of the Thirty Years' War, this important treaty is very revealing of Rubens's personality. He worked towards it by using all his tenacity, his obstinacy, his subtlety, his love of show, his political intelligence and his philosophy of life. Rubens never ceased putting himself to the test, setting himself new goals each time: excellence in his painting in his youth; excellence in diplomacy

in maturity; and excellence in love in the last years of his life. He seemed to have harnessed life's gifts to his personal accomplishments, a solitary genius who transformed the world into a theatre of his own perfections, pulling the strings from his house by the Wapper. An ambitious man, Rubens was blessed with a stoicism which enabled him to overcome reversals of fortune and arrange for each turn of events in his life to be crowned with success. Just as he was his own master when painting, so he conducted his diplomacy alone. His commitment to his role and his progress in public affairs are clearly recorded in his letters to the Dupuy brothers, Pierre and Jacques, his antennae in Paris.

This correspondence, which continued down through the years, is one of Rubens's *tours de force*, revealing a man who wrote weekly letters to close acquaintances of the King of France without ever revealing anything of the negotiations which he was pursuing with the opposite party, serving them intriguing snippets of news to induce interesting snippets in return. Thus, for the whole of 1627, when he was writing to Pierre Dupuy every week, he began each letter or slipped something into the text to the effect that nothing was happening – 'No news', 'The affairs of Flanders are insignificant',[25] 'I shall be brief ... because nothing of importance has occurred'[26] – at the very time when he was working hard with Gerbier to conclude the Anglo-Spanish treaty. In all probability Pierre Dupuy was no fool; he also knew how to present a mix of information for someone who was the Infanta's confidant and Gerbier's partner, and so breathed not a word of the Franco-Spanish treaty. Nevertheless these ultimately confidential exchanges between men who respected one another allowed Rubens to expound on the powerful men with whom he was negotiating his views on the international situation, or the 'techniques' he used in his diplomatic activity.

Rubens possessed a network of informers who kept him in the know about what was happening in Europe. He was the contact of the Englishman Gerbier, the Italian Scaglia, the Dane Vosberghen, the Dutchman Jan Brant. In Antwerp he had played host to the ambassador of Lorraine and his English counterpart before they moved to the Archdukes' court. He received news from Rome, from Germany, knew the state of the finances of the Grand Turk and the Emperor of China.[27] The house by the Wapper was a sort of *poste restante* and antechamber to the royal palace in Brussels. Rubens eventually put together the perfect secret agent's box of tricks to ensure that he could work efficiently. To protect the contents of his messages he chose a number for each correspondent: he used one for Vosberghen, as he told the Archduchess Isabella, chose another for Jan Brant, still another for Gerbier, codes which have been reconstructed since his death:

2x=Scaglia
n=Brussels
104=the Infanta
105=Spinola
70=Philip IV
00=Carleton
89=the United Provinces
87=Buckingham
34V41 67 37 57 59=Holland
61 77 21 57 27 25=Antwerp[28]

He also set up 'letterboxes': Ambassador de Vicq in Paris, whose place was taken by the secretary, Le Clerck, on de Vicq's departure, and diverse antiquarians - Messieurs Frain, Gault, Antoine Souris, who transmitted both *objets d'art* and messages. He certainly had the authorisation to receive mail from Holland, but he took the precaution of having it addressed to a friend (who would become his brother-in-law), M. Arnold Lunden in Antwerp.[29] The painter of *The Descent from the Cross* and of *The Incarnation* also employed his genius in creating these subterfuges. He asked his correspondents to acknowledge receipt of each letter they received and did the same at his end. If need arose he asked them to burn his compromising writings, like the demand for a passport for Holland which he tried to obtain from Carleton through Gerbier.[30] He never revealed his purpose when he embarked on a trip to his contacts, let alone its outcome. As we know, when he set out for Spain he told everyone that he was going to paint several portraits of the King.

Over the years Rubens worked out a negotiating technique which surpassed these artifices: 'Because, in affairs of state, it is always necessary to compensate *quid cum quo* in order to obtain ones goal.'[31] Thus the political philosopher: 'I find by experience that the outcome always corresponds to your conjecture and judgement, which is based partly upon definite information you have of current affairs, and partly upon the prudence that makes you foresee the future.'[32] His friends throughout Europe were there to furnish him with the wherewithal to reach a judgement, the wisdom of which belonged to him alone . . .

Rubens had been trawling princely waters for a long time, for he had been accustomed to courts since his youth. He had held out on Vincenzo de Gonzaga, he had not yielded to the temptations, albeit peaceful ones, of the capital city of Brussels. His experience had been based on favours bestowed by the great and shaped by the intrigues which wove through a jumble of parallel and often contradictory interests. It amused him to hear

of the triumphal welcome which Spinola received at La Rochelle from his former enemies at the siege of Breda, and when later the Generalissimo was fêted and honoured in Madrid he could not resist commenting to Paul Dupuy: 'According to my own experience at that Court, I am afraid that this favour will last only as long as he remains there, but will change as easily to envy and jealousy as soon as he has turned his back',[33] 'for the friendships of princes *sunt meri ignes suppositi cineri doloso* [are live coals with deceptive embers]', citing Horace.[34] He had already expressed his annoyance when faced with 'little young men who govern us'.

Similarly he cherished no illusions about the nations with whom he had to come to terms. He did not form direct judgements on the national character of the French but he was clear about the principle behind their political strategy: France sought only what was unwelcome to the Habsburgs. Similarly Holland and the 'Hollanders are following no other guide in their alliances than their hatred of Spain, and according to the turn of affairs in that country they are changing friends'.[35] He was the preferred representative of Buckingham and Charles I but none the less condemned the 'insolence' and the 'barbarism' of the English, 'Friends of God and enemies of all the world'.[36] He made fun of Buckingham whose disastrous initiatives on the Ile de Ré and La Rochelle would teach him perhaps 'the difference between the profession of arms ... and that of courtier'[37] and made ironical remarks on the pompous welcome which London gave the Duke, who had been so piteously chased from the French coasts.[38] He put forward uncomplimentary opinions on the Spanish, repeatedly denouncing their arrogance, their laziness and their capriciousness which had led the Low Countries to their ruin. He did not even spare the King and his ministers 'who appear to be in a profound lethargy'.[39] 'For a person who deals with the Spaniards finds that, as soon as he turns his back, they postpone the execution of their promises in his absence.'[40]

As the grandson of a shopkeeper and a great manager himself, he offered simple but accurate analyses. Money was short because it was administered by monarchs who were ignorant of business methods and slaves to the bankers' practice of usury. The principles of the Antwerp businessman could be useful to the kingdom of Spain's coffers, and he condemned Philip IV's economic strategy for causing Antwerp's ruin - his city which 'languishes like a consumptive body, declining little by little. Every day sees a decrease in the number of inhabitants; for these unhappy people have no means of supporting themselves either by industrial skill or trade. One must hope for some remedy for these ills caused by our own imprudence, provided it is not according to the tyrannical maxim: Let friends perish as long as enemies are destroyed with them.'[41] A little later,

in August, he continued: 'Our town is gradually falling into ruin and lives only on its savings: only a small amount of commerce is left to sustain it. The Spanish think that they can weaken the enemy by restricting the licences; they are deceiving themselves, for all the harm will fall on the King's subjects ... the Cardinal de la Cueva alone is inflexible and maintains his erroneous opinion so that no one will see he is wrong.'[42]

The Italians were no better according to Rubens. Even Spinola himself had failed to measure up: 'I had at first distrusted him as an Italian and a Genoese.'[43] But Spinola's devotion to the Flemish cause, and perhaps the way in which he would honour Rubens, caused him to change his mind. Spinola, who was 'firm, and sound, and worthy of the most complete confidence',[44] would belong to that rare few in Rubens's good graces: along with Flanders, the Flemish and the Infanta.

Rubens's lack of illusion over the people with whom he dealt helped him form a clear analysis of each political event and its international consequences: 'Today, the interests of the entire world are intimately linked, but the States are governed by men without experience and incapable of following the counsels of others; they do not carry out their own advice and do not listen at all to other people's.'[45]

To this, realist that he was, he added some acute observations. First, that the Hollanders were only claiming as a right what they already had in reality. The King of Spain had not had the advantage over the United Provinces either economically or politically for a very long time; only blindness still led him to believe that he could recover his authority, 'and it is unjust that for the sake of a mere name, all Europe should live in perpetual war'.[46] Secondly, that the interests of Holland's Danish, Swedish and English allies were being played out in Germany where 'the storm will break'.[47] Finally, that once one acknowledged the hispanophobia of the French and Dutch, and the powerlessness of the Spanish, all the alliances, all the outcomes were foreseeable.

From this came his farseeing assessments of successive modifications of the diplomatic map. France and Spain signed a treaty: 'I think that this alliance will serve to iron out the controversies between France and England, but it will have little effect on the conquest of this kingdom or on the submission of the Hollanders, for the Hollanders are strongest at sea. I do not think that France's intention goes as far as that. I believe that for the moment France is adapting to her ally's wishes and exploiting the passion of others for her own designs. At the same time, the King of Spain will be revealed as a true friend in need and a zealous Catholic, without other reason of state, and even to his own cost. I certainly do not believe that the English expected this blow, but they deserve it for their

presumption in declaring war simultaneously against the two most powerful kings of Europe.'[48]

The English were lending support to the Protestants of La Rochelle:

It is very possible that your men [the French] will hasten to rid themselves of the English without our aid, not only to save their reputation, but also to escape from an obligation which they would not be able to honour. I believe that France still remembers the price the Spanish asked for their help at the time of the League and *quanti sterint Gallis isti soteres* [and how dearly the French paid their liberators on that occasion]. I also believe that the English will have rendered the King of France a great service by their temerity in giving him just cause for a serious attack on La Rochelle and a plausible reason for making it surrender. In my opinion, this town, cornered and blocked off by firm land will surrender into His Majesty's hands as soon as the English have left, and I do not believe that the Duc de Rohan can do anything, *nam vanae sine virbus irae* [for anger without force is in vain] Tacitus: *Historiae* 4.75.[49]

This is in fact what happened: La Rochelle surrendered without conditions on 29 October 1628. The Duc de Rohan was pursued into the Cevennes but benefitted from the general pardon granted to Protestants when the Peace of Alaix was signed (1629). Afterwards he went to live in Venice where he was received with honour.

In Mantua the Gonzaga will was going through probate. According to the last Duke's wishes and the laws of succession, the duchy was to return to the French Duke of Nevers: 'I am of your opinion that the death of the Duke of Mantua will bring about some changes, for I cannot believe that the greed of the Duke of Savoy will be satisfied with this marriage of his granddaughter to the son of the Duke of Nevers, from which he will derive no profit. The Spaniards on their part will not look with favour upon France or one of her vassals in possession of a state beyond the Alps and incorporated, so to speak, with the state of Milan. It may be that possession of Mantua will not be disputed, but I strongly doubt that this will be the case for Montferrat, and certainly not for Casale, main fortress of that state and seat of the Spanish garrison.'[50] In fact Spanish and French would confront each other in Italy in 1629.

The Duc de Guise and Don Fabrique de Toledo (Lieutenant General of the Ocean Fleet) had united their forces against their common enemy, England: 'Yet, I cannot believe that the King of France would ever abandon the Hollanders; in defiance of the Spaniards he will probably continue to

assist them. And unless I am mistaken, just as soon as La Rochelle is taken, we shall see France and England easily come to an agreement, and their friendship and complicity will become as close as in the past, or perhaps even more so.'[51] Rubens was later proved right but the Anglo-French treaty of April 1629 would end inconclusively, Richelieu having put every effort into ending it, and on this occasion thwarting Rubens's efforts to obtain a concurrent alliance.

All through this correspondence Rubens kept Dupuy informed with tales about ambassadors, of Dutch and Belgian skirmishes at sea and along the frontiers, and a goodly number of details on the construction of the Marianne channel (at first called Eugènienne) which linked the Rhine to the Meuse, but he revealed nothing of his dealings with England. On the contrary, he stressed the probability of an Anglo-French treaty against Spain and complained of the English when he wrote to Olivarez.

And, of course, as a learned man addressing a king's librarian, he could not resist the odd erudite digression. Rubens recalled an ancient fresco he had seen in the gardens of Vitellius,[52] discoursed on examples of conjugal love in antiquity, the most exemplary in his eyes being Orpheus for Eurydice; he deplored the dispersal of the Duke of Mantua's collections – of which he had once been curator[53] – but criticised his former master, 'For Duke Vincenzo and his sons, lavish spendthrifts, who squandered the funds of their subjects, have always burdened that state with the heaviest taxation.'[54]

Of painting there is hardly a mention. Rubens was still thinking of the Henri IV gallery. To this effect, and with remarkable constancy, he sent messages to Marie de Medicis's artistic counsellor, the Abbé of St Ambroise, and in every letter he wrote to France asked for his greetings to be passed on to the Abbé. On 27 January 1628 he announced that he had begun the sketches,[55] but that was all for 'Painting goes slowly in winter, since the colours do not dry easily.'[56] His friendship with Peiresc had weakened since the humanist's return to Provence, for Rubens could no longer use him as an informant on the capital. Nevertheless, Rubens continued to keep Peiresc up-to-date with his scientific works when he had time, and even promised to send his former confidant a self-portrait.

Madrid

So it was a well-informed man, more diplomat than painter (although, with an eye to the main chance, Rubens took some pictures along with him)

who set out for Spain on 29 August 1628, reaching the peninsula by forced marches and in great secrecy. Rubens did not stop in Paris and also denied himself the pleasure of meeting Peiresc in the Midi, only interrupting his journey to observe the siege of La Rochelle for two days. He reached Madrid on 15 September.

His arrival provoked a great stir in the world of diplomacy. Rumours about the painter's political activities had reached the Spanish capital, and the Apostolic Nuncio, Giovanni Battista Pamphili, was soon in a position to tell his masters: 'It is believed that this great friend of Buckingham is coming to propose a treaty between the two crowns.'[57]

Rubens handed over the documents. He also showed his paintings to Philip IV who was moderately appreciative. The Council of State met on 28 September to discuss the follow-up to the negotiations begun with Gerbier. The English envoy Sir Richard Cottington was expected.

He did not come. England was in the throes of serious internal unrest, for on 23 August in Portsmouth a Puritan had stabbed Buckingham. The news did not reach Madrid until October, almost two months after the event. ... There is a letter of 5 October 1628 attributed to Rubens and addressed to the Earl of Carlisle in which the painter deplores 'the unexpected disaster of the death of Sieur the Duke of Buckingham [which] had severed the thread of our business when it had reached so exactly the point one wanted for a prompt conclusion to our plans. ... I find myself almost at the extreme of despair for my own private loss of such a lord and friend and also for the common good which he had advisedly espoused.'[58]

Was it the Duke's death which delayed matters, or was it the customary 'lethargy' of the Spanish? As usual things dragged on. As we know Rubens had little taste for court life and did not share in the royal passion for the theatre. Save for the fact they were both widowers[59] he also had little in common with Olivares, who 'lived like a coenobite and had in his room a coffin in which he would lie while *De Profundis* was being sung for him'.[60] As he wrote to Peiresc on 2 December 1628: 'I spend my time here painting, as I do everywhere.'[61]

No one had believed Rubens when he claimed that he was going to Spain to paint the King, yet that was precisely what he ended up doing for the eight months he spent in Madrid. Philip IV had a studio installed for him at the palace and paid Rubens a visit every day. Charmed more by the painter's conversation than his art, he nevertheless commissioned several portraits of himself and his family. And so Rubens painted the King's brother the Cardinal-Infante Ferdinand, future Governor of the Low Countries, in his red robe; the Queen, Elisabeth of Bourbon; the Infanta

Maria Theresa, deserted fiancée of the Prince of Wales, who was preparing to marry Emperor Ferdinand II; whilst portraits of the King showed him on horseback and in armour, and earned him a eulogy in verse from the poet Zarate.

Philip IV had asked his court painter, Diego Vélasquez, to open all the royal galleries for Rubens and from then on the Flemish painter fed on the great collection of Titians collected by the Emperor Charles V. The youthful reflexes he had first indulged when in Italy now returned, and Rubens copied the great Venetian, not only because he believed in the instructive benefits of copying[62] but also to enrich his own collections – after his death he was found to have no less than 32 copies of Titian done in Madrid. This, together with his portraits of the King and his family, was his main occupation in Spain, though he enjoyed some conversations and rides with Vélasquez, the only local artist he judged worthy of his company. Together they visited the Escurial, and it is said that Rubens advised the future creator of *Las Meninas* to go to Italy to finish his art education which had begun with his father-in-law Pacheco, a minor painter. In his *Art of Painting*, first published in 1649, Pacheco describes Rubens's stay in Madrid:

He arrived in Spain in August [*sic*] 1628. He brought to His Majesty, our Catholic King Philip IV, eight paintings of different subjects and sizes which are hung in the New Salon, amongst other famous paintings. During the nine months he stayed in Madrid, he did a lot of painting, without neglecting important affairs for which he had come and even though he was indisposed for several days with gout (so great was his cleverness and his facility). First he painted the King and his children, from the waist up, to take back to Flanders; he did five portraits of His Majesty, of which one was on horseback with other people, all excellent. He painted a portrait of the Infanta de las Descalzas, then copies of this painting; five or six portraits of various characters; he made copies of all the Titians which the King possesses, that is to say the two baths, the *Rape of Europa*, *Adonis and Venus*, *Venus and Cupid*, *Adam and Eve* and more still; and some portraits, that of the Landgrave, the Dukes of Saxony, of Alba, of Cobos, of a Venetian duke and many other paintings which did not belong to the King: he made a copy of the portrait of Philip II armed and on foot; changed little details in the *Adoration of the Shepherds* in his hand which was found at the palace; for don Diego Messia (one of his great admirers) he painted a *Conception*, two rods high, and for Jaime de Cardenas a *St John the Evangelist*, of normal size.

It seems incredible that he painted so much in such a short time, in the midst of so many preoccupations. With the painters he mingled little, except for my son-in-law with whom he had previously corresponded by letter and with whom he became friends. He much favoured his works, aware of his modesty, and together they visited the Escurial . . .

When his business was finished, and after he had taken leave of His Majesty, the Conde-Duke gave him a ring which was worth two thousand ducats from the King. He took the post on the 29 April 1629 and went directly to Brussels to see the Infanta.[63]

It seems that Rubens had painted extremely fast in Madrid, just as he had done on that first occasion, in 1603. Even so, he met with Olivares regularly enough, if one is to believe the Nuncio Giambattista Pamphili: 'One knows for certain that the Flemish painter is the bearer of some negotiation, for one is informed that he often confers in secret with the Conde-Duke, and behaves in a very different fashion from the way his profession should.'[64] But since Rubens's letters to the Archduchess and her secretary Pedro de San Juan are lost, only the outcome of these negotiations, that is to say, the decision the Conde-Duke took at the end of eight months, is known: to send Rubens to England.

In fact, the Spanish were not concerned by the pause in negotiations. Once they had been adjourned following Buckingham's death, it was the English who started them up again: La Rochelle had fallen, they were uncertain of the eventual reprisals the French might take, and were looking for support. They sent Endymion Porter to Madrid, asking in return for a Spanish envoy for London. Olivares's and Philip IV's choice was Rubens. No doubt the painter had gained their confidence and had been made party to their delaying tactics. The King and his chief minister appreciated Rubens's freelance style. They sent him to London not as an ambassador but as a scout. He was to go there to do the spadework, as the English envoy had done in Madrid, during the winter. Though they did not consider conferring any decision-making powers on him they nevertheless entrusted Rubens with the difficult mission of sorting out the problems which existed between the two countries, so that when the actual ambassador arrived in London he would only have to sign the treaty. To do that the painter would have to foil Richelieu's dealings with the English; come to an understanding with Soubise, the French Huguenots' leader who had sought refuge in England, and for a fee persuade him to return to France and continue the Protestant rebellion; see on what basis the Elector Palatine and the Emperor could be reconciled, since there lay the essential reason

for Charles I's wish for an entente with Spain; and conclude a truce between Spain and the United Provinces. Had Rubens managed to achieve all these ends, he would have done much to end the Thirty Years' War.[65]

In order to give weight to his duties as a king's emissary, and for services to be rendered to the Spanish court, on 27 April 1629 Philip IV named him Secretary to the Privy Council of the Low Countries, an office Rubens would never assume. From the very beginning the painter seemed happier with a clandestine role and an independent one at that. He accepted the titles but refused the constraints they imposed: he was a painter of Antwerp, enrolled in the Guild of St Luke, yet exempt from any obligations pertaining to it; he was a painter at the Archduke's court but did not live in Brussels; he was Secretary of the Privy Council of Flanders but never took his seat, keeping the post to pass on to eldest son.

Having left Madrid on 28 April he travelled through western France and reached Paris on 11 May. Two days later he was in Brussels. The Infanta gave him the necessary funds for his journey to England. She modified his order of mission slightly, relieving him of his negotiations with the United Provinces, since one of her emissaries, Jan Kesseler, had gone to the Stadtholder to treat with him; she also omitted to give him any funds for the Maréchal de Soubise.

The painter then went straight on to Antwerp to greet his children and to pick up his brother-in-law and travelling companion, Henry Brant. On 3 June the two men embarked at Dunkirk on *The Adventure*, a warship which King Charles had put at their disposal to protect them from possible attack by Dutch vessels. On 4 June they disembarked at Dover and the following day, on Whitsun Eve, they were in London at Gerbier's house. Time was short, for on 20 April, tired of Spain's delays, England had made peace with France.

London

Rubens was keen to set to work and bring his cause to a successful conclusion. With a mandate from Spain and the Catholic Low Countries, he had access to the highest authorities in England. Although he was not totally in charge or endowed with powers of decision-making, he would attempt to appear so, even if it sometimes meant exceeding his brief. His motivations were largely personal, but the steadfastness and the dexterity he deployed to achieve his goals drew admiration. Rubens was the true artisan of the peace treaty of 1630 made between Madrid and London.

The obstacles he faced were diverse and numerous. There was, of course, the international situation, an imbroglio which was simultaneously territorial, denominational and familial. In Germany and Flanders hostilities continued, and the constant shifts in power made life extremely difficult for the diplomats, including Rubens. For example, on 12 May 1629 Christian IV of Denmark, Charles I's uncle, abandoned the interests of his niece Elisabeth, the Elector Palatine's wife, to sign on the side of the Emperor, which meant a fresh realignment of forces.

In London Rubens's work was no longer confined to receiving informers, issuing opinions, assessing circumstances and evaluating situations, as he had been able to do in the calm of his Antwerp retreat. Now he had to confront hardened diplomats on their own ground and had to parry their tricks. Not all were hostile, though. Scaglia, Duke Charles Emmanuel of Savoy's agent, held the Flemish painter in high esteem, even though they were political adversaries, as he revealed to an English colleague: 'As for Rubens, you knew beforehand just how much he was committed to this affair and how much he has contributed and will contribute to it, as a well-informed man who is held in high esteem and credit by his masters.'[66] The painter also found a friend in Barozzi, the Resident of Savoy, and went to his house every morning to hear mass.

On the other hand, an English observer, writing to a relative, mocked him squarely: 'If by any chance you hear of the arrival of the Archduchess's ambassador, it is only Rubens the famous painter, who appears in his personal capacity, and Gerbier the Duke of Buckingham's painter, master of ceremonies to entertain him.'[67] Aelbert Joachimi of the United Provinces was eager to remind people that the painter had no accreditation (which was partly true). Alvise Contarini of Venice depicted him 'as an ambitious and greedy man who makes one think that his main aim is to have everyone talking about him and to use the situation to his advantage'.[68] Soon Châteauneuf, Richelieu's envoy was to arrive, to cement the treaty of 1629. He was to be Rubens's most determined opponent and a highly dangerous one since he had been given *carte blanche* and could therefore make decisions and give prompt answers.

Rubens, however, had to send Olivarez an account of every fact and gesture: 'On my departure from Madrid, Your Excellency ordered me to report everything, however insignificant.'[69] Obstacles can be stimulating if they can be overcome, but poor Rubens was not only battling against diplomatic spite and competing spheres of interest but also with yet another problem, the slowness of the post. A courier took eleven days to reach Madrid and, as Olivares's decisions depended on the Emperor's and the Duke of Bavaria's advice, the principals in the Palatinate affair, such advice

often being delayed by what Rubens thought of as Spanish trickery, Rubens would sometimes wait weeks for orders – hence his impatience and his propensity for personal initiatives. And still further Rubens also had to reckon with the tensions of England's internal politics, controlled by an impulsive, autocratic king.

At court, opinion over the treaty with Spain was divided. Cottington, Chancellor of the Exchequer, was delighted that they had 'sent Rubens to London for he was the most opportune gauge of what Madrid was thinking, for not only did he show much cleverness and dexterity in his manner of dealing with affairs, but he also knew how to win everyone's sympathy, in particular, the King's.[70] But Henrietta Maria of France, Charles I's beloved wife, who listened to her views, was lukewarm about an alliance which would threaten her brother Louis XIII's interests. This was true too of English public opinion which was growing increasingly critical of a king who seemed more anxious to enrich his galleries than fill the kingdom's coffers. Even as the domestic economic situation was growing difficult and with no money to finance Buckingham's expedition to La Rochelle, still the King had offered for and acquired the Duke of Mantua's collections, simply to ensure that neither Richelieu nor Marie de Medicis secured it. As Rubens reported to Olivarez on 21 September 1629, in order to attend to the most urgent matters Charles had pawned his jewelry in Holland in exchange for some cannons.[71] When his coffers were empty Charles invariably imposed new taxes. The English were upset by their King's luxurious lifestyle and the fact that he had married a Catholic; the populace was grumbling and the stirrings of the Puritan rebellion to come were beginning to appear. These austere Protestants were opposed to any alliance with the Catholics; they wanted a strong alliance with the Dutch Protestants.

Charles I paid no attention and suspended Parliament, governing the country alone. He stayed on his throne for twenty more years, until the Puritans won their fights and beheaded him in 1649. As far as foreign affairs went he had only one idea, the restitution of the Palatinate to his brother-in-law and sister Elisabeth. He had proclaimed at his coronation in 1625 that he would pursue the war even if he had to risk his crown. He would get the better of the Spanish and restore order. His brother-in-law would be reinstated. He only wished that all the other sovereigns would do as he did.[72] Consequently, at the time of Buckingham's death he was surrounded by personal advisers devoted to the same cause as himself, the majority of whom were also Catholic: Richard Weston, Lord of the Treasury, who had stayed with Elisabeth through the fall of the Palatinate and Bohemia and her flight to Holland, and Francis Cottington. Both were principal intermediaries with Rubens in London.

In 1625 Charles had insistently asked for a self-portrait of Rubens, whose works he had seen and admired at the Spanish court, at the time of his engagement to the Infanta Maria Theresa. He was particularly delighted by the painter's arrival 'not only because of Rubens's mission, but also because he longed to know a person of such merit'.[73] On the very day after Rubens arrived in London, Charles sent for him at Greenwich where he was residing. Rubens's inferior rank seemed of little consequence to the King who regarded him as a plenipotentiary and confided his personal decisions in him, expecting definitive replies from Rubens in return. The confidence of the King, which invested him with powers he did not have, constituted an additional obstacle to the painter's mission.

Society Life

Rubens stayed in London for ten months. In spite of pitfalls of every kind there was much to make his stay more pleasant than it had been in Madrid. Naturally he complained from time to time – as soon as King Charles revealed himself to be intractable on the question of the Palatinate Rubens said he was ready to go back to Antwerp. He was also anxious about abandoning his studio, and for a time he appeared so preoccupied with domestic affairs that bringing the Anglo-Spanish peace treaty to a successful conclusion seemed secondary.

This aside, London was still a city full of possibilities. He found many like-minded friends: the Pisan painter Gentileschi and his daughter Artemisia, the Hollander Gerard Honthorst and the poet Ben Jonson. Rubens the painter and humanist was better received in the English capital than Rubens the diplomat, and he mixed with people who shared his artistic interests. He could admire Lord Arundel's collections at his leisure in his ancient palace on the Thames where he discovered 37 statues and 128 busts, altars, sarcophagi, jewels, marble engraved with inscriptions gathered from the ruins of Paros. This collection is today housed in Oxford. He met Sir Robert Bruce Cotton, an antiquary, and made the acquaintance of the scholar Cornelius Drebbel whose inventions had inspired his own scientific works. He saw his collections again at the widowed Duchess of Buckingham's house and visited Cambridge where he was made an MA. He almost drowned in the Thames near London Bridge when he travelled in a boat accompanied by his friend Barozzi and a chaplain, on his way to the King at Greenwich. The boatman

managed to rescue Rubens but the chaplain died. Despite this, it was in a relatively lively tone that he wrote to Peiresc on 9 August 1629:

> Certainly, in this island I find none of the crudeness which one might expect from a place so remote from Italian elegance. And I must admit that, when it comes to fine pictures by the hands of first-class masters, I have never seen such a large number of them in one place as in the royal palace and in the gallery of the late Duke of Buckingham. The Earl of Arundel possesses a countless number of ancient statues and Greek and Latin inscriptions, which you have probably seen, since they are published by John Selden with commentaries by the same author, as learned as one might expect from such a distinguished and cultivated talent ... Here is also Cavalier Cotton, a great antiquarian versed in various sciences and branches of learning, and Secretary Boswell. But those gentlemen you must know, and probably you correspond with them as you do with all distinguished men in the world.[74]

Contrary to the image which he had maintained until then, Rubens quite enjoyed a life of pleasure. Even more, he was dazzled by the lifestyle of the English aristocracy, the pomp of the receptions at which he was often, to his great joy, guest of honour. He found himself invited by many including the King's favourite, the Earl of Carlisle, and Cottington, who, he wrote, 'lives the life of a prince, with every imaginable luxury'.[75]

Rubens's life in London was therefore full whilst he awaited the arrival of the Spanish envoy. He continued his diplomatic negotiations with the King and his ministers, he wrote frequently to Olivares to keep him up to date, he attended numerous social gatherings and he did a little painting, accepting some commissions from Gerbier and the court as well as reviving his link with Mantua, for in the King's collection he found Mantegna's paintings of the *Triumph of Caesar* which he copied.

Negotiations

When Rubens had first arrived in London in June 1629 everything seemed compromised. Charles would not cede either on the question of the Palatinate or the treaty with France. On the first point it depended on whether Charles would be content with the withdrawal of the Spanish garrison from his brother-in-law's territory. Such a decision could not be

taken without the agreement of the Emperor and the Duke of Bavaria. It was a pessimistic Rubens who wrote in his first letter to Olivares, 'I have also written to the Most Serene Infanta, begging her to grant me permission to return home. The duration and present state of the siege of Bois-le-Duc [The Prince of Orange had gone on the offensive and laid siege to Bois-le-Duc – Hertogenbosch – in May 1629.] which holds both sides in suspense, in addition to the sorry state of affairs here, do not allow me to hope for any success.'[76] To add to his problems, since Isabella had not given him the funds that the Duc de Soubise required to continue the Huguenot uprisings in France, the Duke complained to Rubens, who had to turn to Olivares to ask for help. Richelieu's treaty with the Huguenots and Soubise's capitulation would soon offer Rubens some consolation over this part of his mission.[77]

The English in general, and Charles in particular, seemed totally dependent on France's wishes. In addition they were also being harassed by the Hollanders who, in implementing the 1625 alliance, were reclaiming financial support for their part in the war effort against the southern Low Countries. To play for time, Charles I sent them an emissary. To make matters worse for Rubens the envoy from Piedmont claimed that relations between Spain and England were *his* master's responsibility, so distancing Rubens from the negotiations. At this point the French Ambassador arrived in London fully empowered to conclude a defensive and offensive alliance with England, and offering French help to recapture the Palatinate. But Rubens consoled himself when 'He [the Ambassador] was greeted with little enthusiasm and the reception was so small that the carriages going to meet him were for the greater part empty, although there were not more than twenty of them in all.'[78] But it did not improve Rubens's mood for he added bitterly:

If I had had the authorisation in my pocket, as he thought I had, to offer similar concessions, I should have been able to break the peace treaty between France and England within twenty-four hours, in spite of the French Ambassador and all the opposing factions. For the King of England told me with his own lips that we were to blame for this peace treaty with France, because we would not decide to give him the chance to make an agreement with us while safeguarding his faith, conscience, and honour.[79]

What is more, the canny Cardinal de Richelieu was putting his hand in his purse rather than resorting to arms, thus financing the English nobility's luxurious lifestyles and thereby tying them to his cause. 'Public and private

interests are sold here for cash. I know from a reliable source that Cardinal de Richelieu is very generous and very adept at winning support in this way, as Your Excellency will see in the enclosed report.'[80] Rubens wrote to Olivares, seemingly in the hope that he too would resort to this diplomatic expedient.

Olivares understood neither this suggestion nor the urgency of the situation. Rubens then tried to counter French manoeuvring on his own. In a move to involve Charles I more deeply in negotiations with Spain, he pretended his memory was faulty and asked the King of England to put in writing the concessions which he had given him verbally. Charles agreed, even though it might have meant being snubbed by the Privy Council.

In fact, Charles was playing a double game, as was customary then. Everyone made promises which everyone else suspected. Charles I did not believe in Richelieu's advances, by which Richelieu pledged to make peace with the Huguenots, his own enemies, merely to come to Charles's aid: 'The King simply laughed at it, and said he was well acquainted with the wiles and the tricks of Cardinal de Richelieu, and that he would prefer to make an alliance with Spain against France than the other way round.'[81]

The Duke of Savoy proposed that he should join with France to help against Spain, but there was no knowing whether he would keep his promise. In the document he had given Rubens, Charles had committed himself, but he still continued to negotiate with the French. They, whilst also negotiating the alliance with England, 'still continued to seize English ships to the great loss and disgrace of the entire nation which resents this bitterly',[82] while Richelieu with his full purse sowed seeds of discontent among the English hispanophiles through his agent Furston. The agent tried to undermine the very basis of Anglo-Spanish reconciliation by arguing that 'the restitution of the Palatinate, which the King of Spain promises, does not lie within his hands, but depends upon the consent of the entire Empire, in particular of the Duke of Bavaria'.[83]

Thanks to his privileged connections with Charles I, on 1 July 1629 Rubens managed to obtain the appointment of an English envoy to Madrid: Francis Cottington. He was a pro-Spanish Catholic and the same man who had convinced Rubens to stay on when he encountered the many problems of his arrival. The date of Cottington's departure was fixed, and Rubens considered his mission accomplished. On 22 July, thinking that Spain would honour its part in the agreement by sending its Ambassador to London, he asked if he could return to Flanders. It was not to be; he would have to wait a further six months. Six months of confusion, during which

France became more and more insistent both diplomatically and militantly, six months during which Rubens kept the Anglo-Spanish negotiations alive, quite often against Spanish wishes.

'Secretary without a secret',[84] it was through the envoy from Savoy that he learned that a certain Don Francisco Zapata would replace him in London. Then on 17 August, when he was about to announce to Charles I the name of the true Spanish envoy which Olivares had told him was Don Carlos Coloma, he heard that Coloma had been detained at the Flemish front, so the date of his arrival was uncertain. The English lost patience. The re-establishment of relations with Spain had to be carried out according to the terms of the agreement of 1604; an exchange of Ambassadors had to take place. The English were insistent even though the proposals from France were much more to their advantage. Richelieu now considered allying his country with England without demanding military compensation for their operations in Germany, in order to secure the assistance of the English fleet in conjunction with the Hollanders to conquer the Spanish possessions of the East and West Indies.

For Rubens it was essential to avoid the break-up of Anglo-Spanish negotiations which would signal an end to any hope of peace between the United Provinces and the Low Countries. At the height of this crisis he spent 24 August 1629 at his writing desk sending Olivares five long letters to persuade him to speed things up and whispering the solution to him – 'All this lies in Your Excellency's hands, so that, with the promise of relinquishing a few places in the Palatinate, a great step could be made: for it is certain, in every prudent man's opinion, that once this peace is made, all the others will follow.'[85] The painter was so convinced of this fact that he had put this idea to Charles I.

By 2 September Spain had still not reacted. The French rejoiced. In London the hispanophiles lost hope, and Francis Cottington 'thinks that his journey to Spain will only serve to precipitate the rupture, since he will be empowered to make no proposals other than those contained in the document' (the document Rubens had extracted from Charles I). Up against his Privy Council, Charles I was alone in opposing the French proposal to capture the Spanish colonies with the help of the Hollanders. Richelieu kept up his pressure, the Spanish failed to make any decision, so Charles, tired of war, signed another agreement with France on 16 September at Windsor. Rubens was not, however, depressed, for he heard that the gold plate had not been brought out for the occasion, and the day after the ratification he rejoiced even more when he learned that the French had inspected 'seven English ships, richly laden' near the island of St Christopher, off the coast of Virginia.[86]

Meanwhile the Spanish had suffered two important military reversals, the first at Wessel, then at Bois-le-Duc. News of this prompted the French to push their advantage and press Charles to give the Spanish the *coup de grâce*, since the might of Spain had been checked by little Holland. In London, their Ambassador Châteauneuf led his own campaign, claiming that according to secret information Spain would not keep a peace with England and had no intention of sending Coloma to London. Exploiting the Puritans' anti-Catholic feeling, he claimed that the Catholic Francis Cottington was a traitor who had been sold to the Spanish, even going so far as to spread the rumour that Cottington was delaying his departure by agreement with Madrid.

At court, misgivings and anxieties grew. The King himself was concerned about Spanish intentions and Philip IV's duplicity. Gradually Charles lost hope of seeing his claims for the Palatinate satisfied and felt certain that the Spanish still held him in contempt for the fiasco over his betrothal to Maria Theresa. Rubens became more and more insistent with Olivares, reporting back Charles's feverish exclamations: 'Let Cottington hurry there as soon as possible; let Cottington go at once',[87] emphasising the favour the King had granted him by inviting him, the Spanish envoy, to his meetings with the French. Olivares, deaf to these signs of confidence, still prevaricated. Rubens stood firm.

Since he was living in a world of intrigue and subterfuge, Rubens also resorted to underhand manoeuvres. In September 1629 he intercepted a secret letter addressed to the Duke of Savoy, in which an English captain asked the Duke for permission to arm four warships which would leave from Villafranca to fight the Moors in Tunis, Algeria and Bougie. 'But, considering how advantageously this port [Villafranca] is situated for infesting the Gulf of Leon and preventing passage from Barcelona to Genoa, it seemed advisable to inform Sir Francis Cottington about it, who had heard nothing of this project. I think this matter is of the utmost importance, since these four ships could easily be increased to twenty and could cause the greatest annoyance to Spain. He has promised me to inform the King and to try in every way to prevent it.'[88]

In November the arrival of the Spanish envoy was finally imminent: his baggage was announced at Dunkirk. But it was still not until 11 January 1630 that Don Carlos Coloma appeared in London. The King ordered a sumptuous reception for him at the Royal Banqueting Hall and, as Dudley Carleton Viscount Dorchester wrote to Cottington, there 'were there many fallings out for spoyling one another's ruffes by being so closely ranked'.[89]

Rubens's mission was over and he was ready to go home. He had kept the negotiations alive and paved the way for Coloma. He still had to hand over information and documents to the Spanish envoy which took him two months, but on 6 March 1630 he finally left London. On the eve of his departure, accompanied by Gerbier, he went to see the Hollanders' envoy, Aelbert Joachimi, to ask for the release of the Dunkirk sailors detained in Rotterdam. Joachimi, who was well aware of Rubens's convictions, could see that the true motive behind his visit was to assess how matters stood between the northern and southern Low Countries. Rubens had no illusions about the consequences of the Anglo-Spanish peace treaty for a truce in the Low Countries. He knew that Charles I was only thinking of the Palatinate, that Philip IV would remain convinced that they could subdue Holland through war. And so, despite his official embargo in dealing with the affairs of the Netherlands he had on his own initiative sought a direct understanding with the Hollanders' envoy: 'telling Joachimi', so Dudley Carleton's report read, 'the States might make peace if they would, and ther[e]by bring quiett and rest after long ware to all the seventeen Provinces.'[90]

During his two years in Madrid and London the painter had dreamed only of one thing: ending the war in Flanders. Did his recent success with the English and Spanish monarchs go to his head? Did he allow himself 'to be carried way by his own inspirations, by his need to make an appearance', was 'he duped by appearances, a slave to ceremonies: decent, affable, seductive, handsome, well dressed, somewhat self-important'?[91] He still believed in the possibility of a negotiated settlement between The Hague and Brussels which would re-establish peace between the northern and southern Low Countries. But 'Joachimi answered, there was but one way ... chasing the Spanyards from thence'.[92]

Rubens's most tangible success from his English adventure was social. On 3 March 1630 Charles I made him a knight and enriched the painter's coat-of-arms 'with a piece borrowed from the royal escutcheon of England: a Canton *gules*, a lion *or*, that Rubens placed at the top right of his own coat-of-arms'. He also received a sword encrusted with precious stones, a hatband decorated with diamonds, and a ring similarly decorated, which the sovereign took off his own finger and gave to Rubens. 'It would be impossible to ply a minister with more favours, so eminent was he', commented the Venetian envoy Giovanni Soranzo.[93]

Furnished with a passport in which it was written that the Hollanders must leave him in peace if their vessels encountered his, Rubens reached Dover, happy to be going home. But his goodheartedness and his devotion

to his faith would keep him in England a little longer. What happened was that a group of young Catholics wanted to take advantage of his embarkation to get to Flanders: the girls wished to enter a convent there, the boys to study at the Jesuit College of Douai, but they lacked the necessary authorisations to leave the country. Rubens spent eighteen days in negotiating their passage with the Spanish Ambassador and the English minister concerned. Alas, the outcome is not known; what is, is that he embarked on 23 March, with or without the young Catholics. On 6 April Balthasar Moretus could write: 'M. Rubens is at last returned from England.'[94]

Archduchess Isabella reimbursed the expenses he had incurred during his stay in England and dealt with the money he was owed by the Spanish court for the paintings he had left there. She gave him a silver ewer and saucer and, since he was not able to use his English knighthood in Flanders, he asked that he be similarly honoured by his own king. The Council of Flanders sent the following favourable notice to Madrid:

Sire
Paul Rubens, Secretary to Your Majesty in his Privy Council in the Low Countries, points out that he has served him, with all faithfulness and satisfaction, in the affairs which are known to him and his ministers. Desirous of continuing to do so with more prestige and authority on future occasions which might arise, he begs Your Majesty to honour him with the title of knight.

Her Most Serene Highness the Infanta recommends this claim to Your Majesty most strongly, in appreciation of the supplicant's services, Your Majesty knows him; He can appreciate his merit; he know how eminent he is in his profession. For this motive and in consideration also of the services that he has rendered in important affairs, and bearing in mind that he already has the position of Secretary to Your Majesty, the granting of the favour he solicits can only be to the good of other artists. The Emperor Charles V made Titian a knight of St James. It seems therefore to the Council that Your Majesty could accord to the supplicant the title of knight to which he lays claim.

Madrid 16 July 1631[95]

Philip IV yielded to his Council's advice, and Rubens received his knighthood on 20 August 1631.

The peace treaty between England and Spain was signed on 15 November 1630. Essentially the treaty stipulated the end to hostilities between the

two countries and the resumption of diplomatic relations: in point of fact a reversion to the conditions of 1604. Of the Palatinate: nothing. (In a separate document Spain undertook, however, to return the lower Palatinate, occupied by her armies, and to intervene with the Emperor with a view to restoring the Elector Frederick to his states.) Of the treaty between the United Provinces and the Low Countries, nothing either. While he may have won a diplomatic battle, Rubens had not changed the course of history. He had failed in his ultimate attempt with regard to the United Provinces: the radical solution Joachimi had commended – 'chasing the Spanyards from thence' – was alien to a man of prudence like Rubens, a man who stood for negotiation, for compromise.

The End of the Embassies

On 17 December 1630 Philip IV, in Madrid, and Charles I, in London, swore to respect the clauses of the treaty. When Coloma, who had been called to the Flemish front, was preparing to leave London, Spain had to choose a new ambassador. The Privy Council met and put forward proposals: as the Venetian envoy Giovanni Soranzo surmised: 'It is believed that this painter could still return as ambassador in ordinary.'[96] Rubens's name figured on the list of eligible candidates, but being an English knight, even a Spanish one, carried little weight. The Count of Onate soon gave his verdict: these distinctions could not efface the artist's inescapable 'ignoble' origins. 'As this man is a tradesman who works with his hands for money, it seems to him, according to his manner of seeing, that His Majesty could only grant him the title of his minister with some difficulty.'[97] For the Spanish, creative genius and experienced services rendered counted little compared with birth. It was Don Juan de Necolalde, the King's secretary and Spanish Ambassador to the Low Countries, who was appointed to London.

Nevertheless in a way, though not altogether in the way he wished, the painter's qualities were recognised and were seen as indispensable even to the King of Spain, in view of recent events in Europe. At the French court, Marie de Medicis had fallen into disgrace for good and Philip IV thought that he might be able to gain from this development in some way. He therefore asked Rubens to accompany his new Ambassador to London, acquaint him with the city, and prepare the ground for a reorientation of the alliance with England. This would certainly include an offensive pact against France.

Rubens is well viewed at the English court and a very suitable person to negotiate all sorts of affairs owing to his prudent manner in which he deals with them. The fortuitous detention of the Queen Mother may allow for some negotiation at this court, particularly with the Queen, so that she might be disposed to declare herself in favour of her mother, in such a manner as she may think fit at the time. Your Highness will order Rubens to take himself to London immediately: there are pretexts for this. When he is there, he will find out for himself what he will have to do. On occasions such as this wherever they are, one needs ministers who have proved their intelligence and given satisfaction. I the King'[98]

Philip IV explained to Isabella on 6 April 1631.

Rubens did not say how aggrieved he must have felt at being passed over for the embassy in London. Though he had no deep desire to settle on the other side of the Channel, none the less his love of honour and fame is evident enough to suppose that he bitterly resented the Junta's decision. His political ardour may have cooled and his wish, oft repeated to Olivares, to return to his own country after many months abroad attests to the sincerity of the vow he made Caspar Gevaerts: 'Best of all, I should like to go home and stay there for the rest of my life.'[99] Rubens was fifty-four years old. He had done a great deal of painting in Spain but little in England. In his two years' absence his pupils had deserted his house. Moreover, since returning to Antwerp he had set up his studio again and remarried – a very young woman, Helena Fourment – and was re-establishing his home. The only journey he actually wanted to make for pleasure was to see Italy again and visit his friend Peiresc in the Midi on the way. When Isabella was told how her painter and counsellor felt she replied to Philip IV: 'I would have sent Rubens there already; I have not done so, through lack of opportunity and because I have not found him willing to accept this agency, unless it were only for a few days.'[100]

Rubens did not by any means relinquish diplomatic life, for his house remained the meeting place of emissaries from all over the world. When Dudley Carleton needed a passport he turned to Rubens for help. The painter still continued to make use of his coded numbers in his correspondence, as is revealed in the margins of a letter to the Abbé Scaglia of 6 November 1631.[101] An account of the Council of State of 23 May 1631 records the missives that he sent Olivares informing him of Holland's warlike intentions. He would intervene twice more in public affairs: when Marie de Medicis attempted another uprising against her son Louis XIII and, at Isabella's behest, in a final attempt at securing a peace treaty

between the Spanish Low Countries and the United Provinces, a matter which coincided with his own dearest wish.

The Poor Flemish Hours of Marie de Medicis

In France Richelieu was determined to banish the Queen Mother for good. After the Day of Dupes on 12 November 1630, when Marie and her younger son, Gaston d'Orléans, had unsuccessfully tried to have Richelieu dismissed, he counselled Louis XIII to exile Marie to Compiègne. To escape Richelieu and her son, Marie de Medicis took refuge in Hainaut on 20 July 1631, after having vainly attempted to seize Aix-la-Chapelle [Aachen]. In the meantime the court in Brussels had become a quasi-refuge for those opposing Richelieu, whom the Archduchess and her ministers welcomed with just sufficient warmth to prevent a break in their relations with France. Infanta Isabella had a certain affection for the fallen Queen Mother. Loyal to their friendship (but also conscious of the need to avoid any confrontation with the French), she allowed Marie de Medicis to enter further into her territory, advising her at the same time to seek help in Lorraine. Rubens hurried to Dunkirk to the Marquis d'Aytona, Philip IV's new envoy, to apprise him of the facts. In the Marquis's view, Marie de Medicis's presence in Flanders was 'a good occasion to avenge ourselves of the wrongs that France had wrought us'.[102] However, as he was dealing with the war with Holland, he made Rubens responsible for French affairs. When, at Isabella's invitation, Marie de Medicis went to Mons on 29 July 1631, Rubens accompanied her. While waiting for the Infanta to join them on 11 August to take the Queen Mother to Brussels two days later, Rubens reflected on ways of using the recent political developments in France in his own country's interests.

Rubens had changed. As the initiative he had taken with Joachimi in London had shown, it appeared that his recent diplomatic successes had gone to his head. Doubtless encouraged by his bonuses from the Kings of England and Spain and his close relationship with Isabella, he grew bolder and gave free rein to his new self-assurance in calculations whetted by old feelings of bitterness against Richelieu, who had delayed work on the Henri IV gallery, undermined his mission to London, and compromised the reconciliation with The Hague. Rubens was aware that Louis XIII's younger brother, Gaston d'Orléans, had taken refuge in Francha-Comte (a Spanish possession which he hoped to implicate in the anti-Richelieu rebellion), where he tried to raise an army to march on Paris and dethrone

his brother. Rubens wanted to exploit these troubles which had rocked France, give Richelieu the *coup de grâce* and thereby undermine the security of the United Provinces who were dependent on Richelieu's generosity. Spain, acting according to its own self-interest, would support the Duke of Orléans and the Queen Mother against Louis XIII and Richelieu. In a long letter dated 1 August 1631[103] he unveiled his plan to Olivares in what, without a doubt, was Rubens's most interesting piece of diplomatic correspondence, for he reveals his skills in courtly life, political analysis, and the efficiency of his sources of information.

He expounded the facts: the mother of the King of France and of the Queens of Spain and of England was in the King of Spain's power. Marie supported her second son, Gaston d'Orléans, direct successor to Louis XIII since he had no heir. Therefore by supporting the Queen Mother and the Duke of Orléans they were taking sides with the future King of France, and thus seizing the opportunity to conclude a proper peace treaty with this kingdom. Here Rubens alluded vengefully to a short-lived treaty concluded with Richelieu in 1627, whose sole effect had been to compromise the peace treaty with England, concluded essentially thanks to him, Rubens. Just as he could put himself in good odour by recalling the past, Rubens knew equally well how to conjure up its ghosts: any support lent to the French rebels would not be as disastrous as the time when Philip III supported the League. In fact, Marie de Medicis and Gaston could count on numerous partisans in France: manifestly well-informed, Rubens listed all the French dukes who supported the two rebels. To them he added the powerful German general, Albert von Wallenstein, Duke of Friedland and a number of German princes: a way of saying that the Habsburg Emperor himself was implicated in the affair.

He let it be known that his friend Gerbier, Charles I's Ambassador in Brussels, saw the enterprise in a favourable light. He assuaged the religious scruples of the Spanish: Marie de Medicis would not appeal to the Huguenots. He played the card of flattery, appealing to Olivares's megalomania. He praised Olivares's 'natural generosity which loves great enterprises'; carrying straight on, he praised Philip IV, 'the greatest monarch in the world', who would not fail to be associated with the most just causes. Finally he stirred the first minister of Spain against Richelieu's duplicity, a man 'who had only ever wanted the destruction of Spain', and brandished the threat of the advantages the United Provinces could draw from the situation should they decide to lend their support to the Queen Mother and Orléans, whom their numerous and valorous supporters could lead only to victory. In conclusion he demanded 300,000 gold crowns for Marie de Medicis and her son: even if it were ten times more than Spain

was ready to agree to, in Rubens's eyes great enterprises entailed great expenses. His plea was well presented. It convinced no one.

When Olivares received Rubens's analysis it was read in the Privy Council in Madrid on 16 August. The Conde-Duke gave his opinion: the six pages sent by the Antwerp painter 'were full of absurdities and Italian verbiage'.[104] Economically and militarily Spain was in a bad way, and Olivares had begun to realise that he could do nothing faced with Richelieu's pitiless determination. Richelieu had never stopped manipulating Olivares: promising his alliance, notably against England, while at the same time continuing to seize Spanish and Portuguese galleons and openly contesting the Duke of Mantua's inheritance, thereby compromising the conclusion of the Anglo-Spanish peace treaty. In Paris the situation of the Marquis de Mirabel, the Spanish resident, reflected the level to which Franco-Iberian ties had sunk and Richelieu's desire to carry the struggle against the Habsburgs to its conclusion. Mirabel was treated like a prisoner in his own embassy, even wounded in scuffles started by the French against his household staff. He was on bad terms with Louis XIII, Richelieu had closed his door to him, and Mirabel's authorisation to visit the Queen, Anne of Austria, who was a Spanish Infanta, had been withdrawn. All that remained to Mirabel was to help in plotting the Duke of Orléans rebellion. Even so, whatever Rubens's arguments, Spain was neither disposed nor prepared to undertake steps against France.

A year later, in November 1632, when one of the most ardent defenders of Protestantism and the sworn enemy of the Habsburgs, Gustavus Adolphus, King of Sweden, was killed at Lutzen, Olivares was on the point of reconsidering Rubens's analysis: 'The moment has come to finish everything, to put in order the affairs of the empire, to proceed to the election of the King of the Romans, to conclude the peace treaty with Holland, to restore an honourable peace in Italy, to obtain the restoration of Lorraine, to sow discord in France.'[105] But as usual, cautious Olivares took half-measures and obtained results in proportion. In granting Marie de Medicis the wherewithal to form a small army in Trèves, he only stirred up French vindictiveness. And so skirmish after skirmish continued on land and sea until open war between Spain and France finally broke out in 1635, to the great detriment of Spain.

This was four years hence, and for the time being, as he had been asked, Rubens limited himself to supplying Madrid with information on Marie de Medicis. For fear of Richelieu no action was taken, and the Queen Mother soon came to understand that she could hope for nothing from Flanders. At the beginning of autumn 1631 she took up residence in Antwerp at St Michael's abbey from where she visited Rubens. Lacking the necessary

funds to raise an army, she tried to pawn her jewels. In France the rebels were checked time and time again. In January 1632 Gaston d'Orléans was forced to take refuge in Brussels. His supporter, the Duke of Bouillon, wanted to take Sedan and asked the Spanish for their support in doing so. Rubens transmitted his request to Isabella in two letters, to which she failed to reply. Orléans, who had left Brussels to lead military offensives in the south-west of France, was obliged to sign an act of reconciliation with King Louis XIII at Béziers in September 1632. Meanwhile Marie de Medicis had returned to Brussels where she would live until 1638 before taking her demands to Holland, Germany and England, meeting with no more success than she had had in the Low Countries. She died, a forgotten woman, in Cologne at Rubens's old house Sternegasse on 3 July 1642.

As for Rubens, in April 1632 he had obtained an authorisation from Isabella to abandon French affairs. He was needed in negotiations of another kind, which were more important in his eyes.

Final Mission, Final Rebuff

In Holland Frederick Henry of Nassau, Prince of Orange, had in no way abandoned his plans for independence. As Joachimi had bluntly told Rubens in London, he saw no other solution to the conflict but to boot the Spanish out of the seventeen provinces. Though he did not actually go to war in 1631, his preparations for it were none the less known to the Flemish. Isabella was becoming alarmed. Aware of Philip IV's obstinacy and powerlessness, she tried to negotiate a separate peace treaty with the Prince of Orange using Rubens as her intermediary. In December 1631 he went to The Hague at her behest, but since Isabella was aware of the Belgian nobility's jealousy of Rubens's privileged position she kept Rubens's mission a secret.

In spite of everything, on 19 December Gerbier wrote an account of it to Charles I: 'Sir Peter Rubens is gon on Sunday last, the 14th of this month, with a trumpetter towards Berg op Zom, with ful power to give y^e fatall stroke to Mars, and life to this State & the Empire.'[106] Moretus was also in the know and placed great hope in his childhood friend: 'Rubens has already been once on the Infanta's behalf, to see the Prince of Orange and the Dutch to negotiate a peace treaty, and he has almost succeeded. He has already shown how to make peace with England, and is therefore capable of concluding a peace treaty with the Dutch, considering that he is well known and well liked by the Prince of Orange.'[107]

The printer was no doubt dazzled by Rubens's recent diplomatic successes and by the fact they were friends. When the Prince of Orange realised the extent of Isabella's anxiety and isolation, he sensed his advantage and was determined not to let it pass. He could rely on support from France and from the European Protestants as a whole while Spain could scarcely count on anyone except the Emperor. As for any affection he might have felt for Rubens – Rubens was the son of the man who had held his family up to ridicule. What is more, in his eyes just as in those of the French, the Belgians and the Spanish, Rubens was still only a painter.

Rubens spent nine days in Holland but only one at The Hague, time enough to endure fresh sarcasm from his ancient enemy, the French ambassador Baugy, who noted: 'The painter Rubens is here on an errand, which though very secret has not failed to agitate and disturb many people who do not know what he is meddling in. He was here only from the evening to the morning and conferred for only half an hour.'[108] Shortly afterwards Grotius informed Pierre Dupuy: 'Our good friend M. Rubens, as you will have learned, has accomplished nothing; having been sent back by the Prince of Orange almost as soon as he arrived.'[109] In fact Frederick Henry had simply indicated to the Infanta's envoy that any decision to make peace was the sole responsibility of the States General. The situation was worsening in the seventeen provinces. Frederick Henry's troops laid siege to Maastricht on 10 June 1632. Risking her all, the Infanta came round to Frederick Henry's suggestion and accepted to treat with the States General of Holland. To this end she delegated Rubens to go to the Protestant assembly in Liège on 26 August. He stayed there for three days and returned empty-handed: the Dutch no longer wanted to negotiate with Spain.

In Flanders the nobility were irritated not only by the favours shown to Rubens, but by the fact it emphasised their own exclusion from the high offices of state which had continued under the reign of the Archdukes. Count Henri de Bergh, a friend of Spinola, departed for the United Provinces while others of the nobility plotted against the Infanta. They received strong support from Richelieu who exploited their fierce pride in their lineage which motivated them more than their patriotism. They held secret meetings at Gerbier's house, but once he realised they were unlikely to succeed he betrayed them to the Infanta for a large sum of money – he at least got some personal profit from the affair. The rebel leader, the Duke of Aerschot, repented and grovelled at the Archduchess's feet. Isabella wisely decided to convene the States General to negotiate with the United Provinces. In December 1632 ten deputies were chosen to negotiate at The Hague, although Philip IV's suspicious nature prevented him from giving them

adequate powers. Rubens was asked to accompany the deputies to look after Spanish interests on behalf of the Infanta and the King, and on 22 January 1633 he received a passport from the United Provinces – together with the final insult which would terminate Rubens's diplomatic career.

What had happened was that Aerschot, who was leading the Flemish delegation, had been offended by Rubens's role, and when on 24 January 1633 the Flemish States General was in session the bishops of Ypres and Namur had demanded clarification of Rubens's mission from the Infanta. She told them that he had received a passport from the Prince of Orange 'so that he can be at The Hague when the deputies of the Assembly need to see the documents relating to his negotiations for the treaty, but not to intervene in the treaty begun by the said deputies'.[110] News reached Rubens of Aerschot's declared hostility, and so when Aerschot and the nine other Flemish deputies stopped in Antwerp en route for The Hague on 28 January 1633 Rubens did not join them, but next day wrote a courteous note justifying himself to the Duke:

Monseigneur

I am very sorry to hear of the resentment which Your Excellency has shown at my request for a passport, for I go with the best of intentions, and beg you to believe that I shall always be accountable for my actions. Moreover, I swear before God that the duties allotted me by my superiors have never been other than to serve Your Excellency, in every possible way as mediator in this affair, so necessary in the service of the King and the preservation of the country, that I would estime anyone who for his own interest sought to delay its execution unworthy of living. I cannot see how it can be so inconvenient for me to take my documents to The Hague and convey them into Your Excellency's hands, with no other function or official capacity than to render you most humble service, and with no desire in this world so much as occasion to show through this that I am, with all my heart, etc. . . .

Aerschot replied:

I note in your letter your sadness that I should show resentment at your request for a passport, and that you have good intentions, and beg me to believe that you will always be accountable for your actions. I could well have abstained from the honour of replying to you, for the reason that you have so notably failed in your duty to come and find me in person: I could have done without your behaving

in a familiar manner by writing me this note, which is proper only for people of equal rank, since I was at the tavern from 11 o'clock to half past twelve, and again this evening at half past five, and you have time enough to spare to talk to me. Nevertheless, I will say to you that the assembly in Brussels has found it very strange that after having asked Her Highness and required the Marquis d'Aytona to ask you to convey to us your documents which were promised us and which you write me that you have, that instead, you have requested a passport; it matters little to me how carefully you tread or how accountable you are of your actions. All that I can say to you is that I would feel more comfortable if you could learn from henceforth how people of your sort should write to people of my sort. And then you can rest assured that I shall be, etc . . .[111]

Aerschot's letter was made public. At The Hague the Duke let everyone know that 'We have no need of painters'.[112] This could have amounted to defamation as far as Rubens was concerned. The English envoy Boswell aptly concluded: 'I heare S^r P Rubens is quit of, of any employments this waie, especially by the opposition of the Dep^ties, because hee is none of their bodie, if not rather because he is an immediat minister of their king, and having more sperit then any number of them, hath aquired so much more envie among them.'[113]

The fact is that in the course of his diplomatic career Rubens had taken more trouble than anyone else in Flanders in his efforts to end a war which was bringing his country to ruin. The Belgian nobles put their privileges and their social position before their responsibilities to the state, and neither worked towards re-establishing the peace treaty with the United Provinces nor attempted to join with them in delivering their country from Spanish domination. As Boswell had said, Rubens was working for the good of the Low Countries harder, more skilfully and with more patience than they were. He was devoting himself to the cause despite everything and everyone, despite his humble birth, and despite being confronted by ministers of the most formidable and unrelenting kind – undoubtedly the least rewarding aspect of his work – in order to convince his own side that being a commoner and performing manual work precluded neither political perspicacity nor intercourse with the powerful. Predictably enough, he would not totally succeed on that level, for Rubens alone could hardly overturn a social order which had lasted for centuries.

The confidence and friendship which existed between himself and the Infanta Isabella certainly influenced his strategy *vis-à-vis* Spain, but their complicity was based on a common desire to be left alone by their Spanish

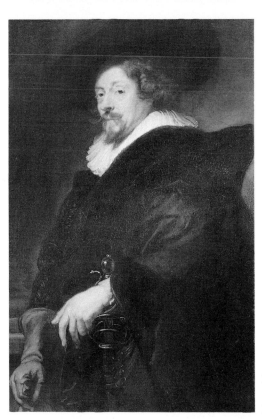

19 *Self-portrait*, by Rubens
(Vienna, Kunsthistorisches
museum, ph. Bulloz)

20 Rubens's House in Antwerp, engraving
1684 (Paris, Bibliothèque Nationale, ph.
Roger Viollet)

21 *Archduke Albert*, by Rubens
(Brussels, Musées Royaux des
Beaux-Arts, ph. Giraudon)

22 *Archduchess Isabella*, by Rubens
(Brussels, Musées Royaux des
Beaux-Arts, ph. Giraudon)

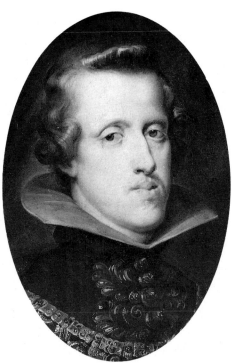

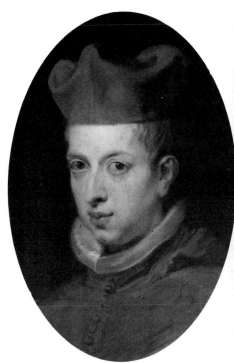

23 *Philip IV*, by Rubens (Private
Collection, ph. Bulloz)

24 *Cardinal-Infante Ferdinand*, by
Rubens (Munich, Bayerischen
Staatgemaldesammung, ph. Bulloz)

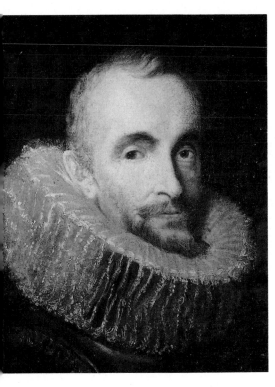

25 *The Duke of Buckingham*,
by Rubens (Florence, Uffizi,
ph. Bulloz)

27 *Ambrogio Spinola, Marquis de los
Balbases*, by Rubens (U. Moussali Collection,
ph. Bulloz)

6 *Marie de Medicis*, by Rubens (Paris,
ouvre, Cabinet des Dessins, ph. Bulloz)

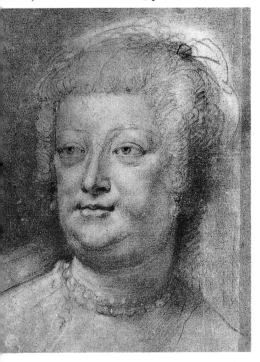

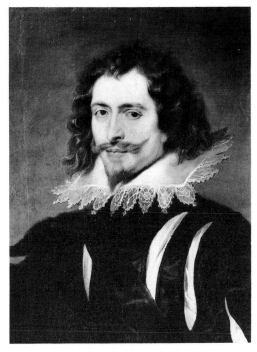

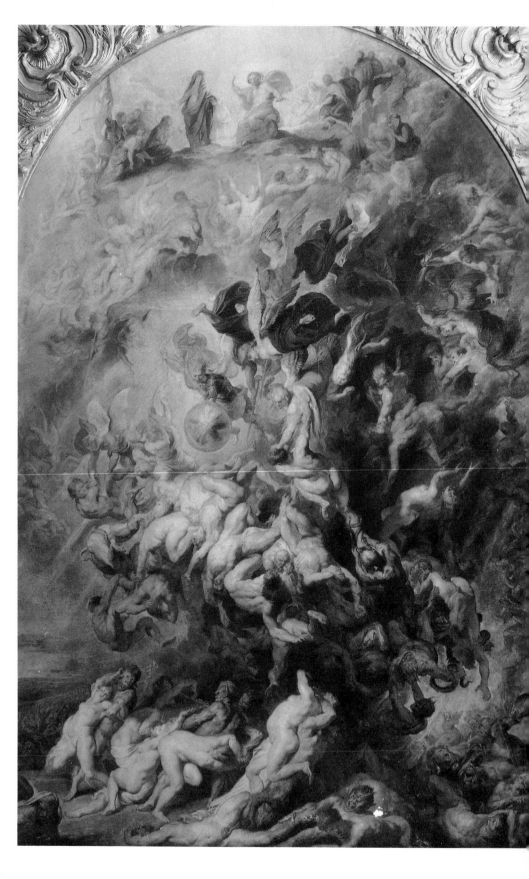

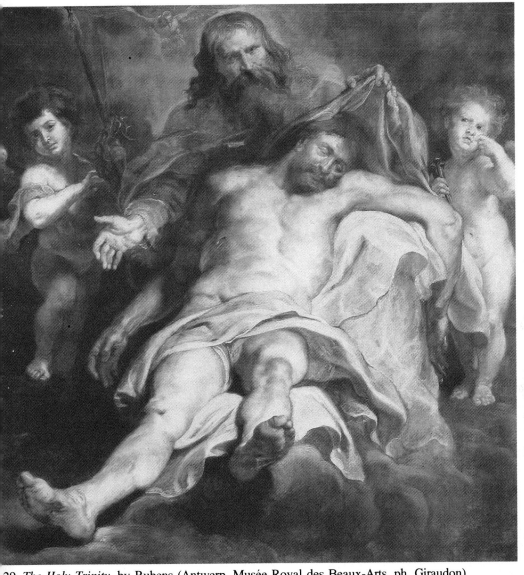

29 *The Holy Trinity*, by Rubens (Antwerp, Musée Royal des Beaux-Arts, ph. Giraudon)

28 *The Last Judgement*, by Rubens (Munich, Pinacothek, ph. Bulloz)

30 *Study of a male nude*, by
Rubens (Paris, Louvre, Cabinet
des Dessins, ph. RMN)

31 *Knight with Breastplate*, by Rubens
(Paris, Louvre, Cabinet des Dessins, ph.
RMN)

32 *Study of Trees*, by Rubens (Paris,
Louvre, Cabinet des Dessins, ph. RMN)

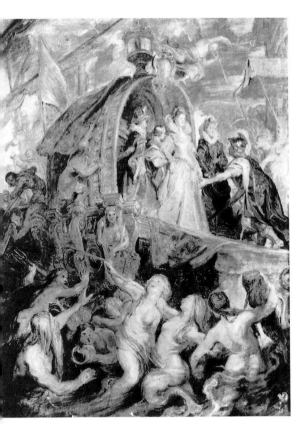

33 *Marie de Medicis
disembarking at Marseilles*, sketch
by Rubens (Munich, Pinacothek,
all rights reserved)

34 *below The Baptism of Christ*,
drawing by Rubens (Paris, Louvre,
Cabinet des Dessins, ph. RMN)

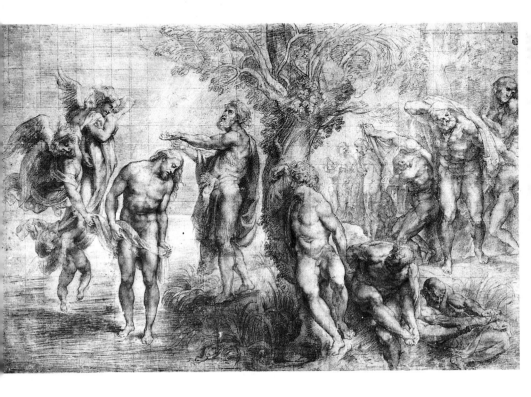

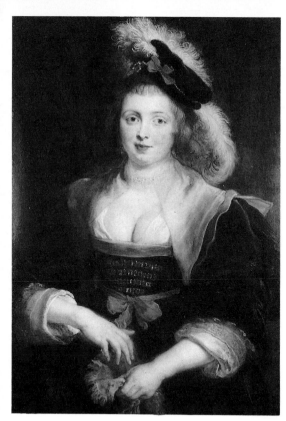

35 *Helena Fourment*, by
Rubens (Munich,
Pinacothek, ph. Giraudon)

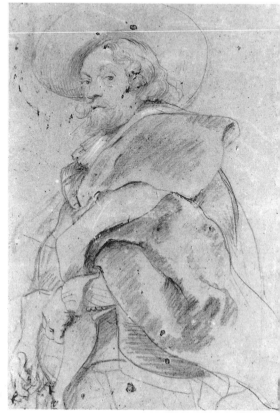

36 *Self-portrait*, by Rubens (Paris, Louvre,
Cabinet des Dessins, ph. RMN)

rulers. As a consequence, and unlike the Hollanders, he never envisaged a radical solution to the conflict which ravaged the ancient Burgundian possessions of Charles V. Rubens would have been content with legal autonomy in the southern Low Countries, allowing the King of Spain the symbolic title of sovereign which he seemed so desperate to keep. Philip IV should cease to control politics in Brussels, should cease viewing Flanders as a source of wheat and soldiers for Spain. In this, and this was his principal error, Rubens paid too little heed to Philip IV's prerogatives and obstinacy. Rubens's overwhelming desire was to end the war which had ruined his childhood and his city, and which, in the twilight years of his painting career, still haunted him. So much so that he depicted his horror in a painting, *The Horrors of War*, which, unique among his numerous works, he explained in writing:

The principal figure is Mars who is emerging from the Temple of Janus, which according to Roman custom was closed in times of peace, and rushing forward, with his shield on his arm, his bloody sword in his hand, threatening the people with the greatest of catastrophes. He takes little notice of Venus his beloved, who embraces him and tries to hold him back with her caresses, and who is accompanied by little Cupids and *putti*. In another part, Mars is dragged by Alecto the fury, torch in hand. Crowding round him are monsters, the Plague and Famine, inseparable companions of war. On the ground a woman lies on her back holding a broken lute, symbol of harmony, incompatible with Discord and War; another woman, with her child in her arms, personifies Fertility, Maternity and Charity, all disturbed by the War which ravages and destroys everything. You can also see an architect lying on his back, his instruments in his hand, which is meant to show that everything built in peacetime as useful and decorative in a town is knocked down and ruined by the violence of war. If my memory serves me, I think you will also see a book and some drawings on the ground beneath Mars' feet, which signify that he crushes the arts and all that is beautiful underfoot. There should also be an unbound sheaf of arrows or javelins which, when tied, symbolize Concord, and finally Mercury's caduceus and the olive branch, symbols of Peace lying on the ground where they have been thrown. The mourning woman, dressed in black, without jewel or ornament and covered in a torn veil, is unhappy Europa, for so long griefstricken by the pillage, devastation and misery which has done countless damage to everything. Her symbol is a globe of the Earth, carried by an angel or a

genie, and surmounted by a cross, which shows that it concerns the Christian world.[114]

For Rubens war meant an end to love of the arts and letters, music and beauty, harmony, everything which he had been deprived of in his infancy, and for which as a boy he found compensation in copying Tobias Stimmer's engravings in the family Bible. War was the ruin of all he had conquered in his mature years and guarded behind the Renaissance façades of his palace by the Wapper. Here lies the origin of his preference for negotiated solutions, to the exclusion of all military enterprises which would threaten his universe and return him to the indigencies of his youth.

Epilogue

Why did Rubens give up his diplomatic career? Was he disgusted with his treatment, the conceit and jealousy of others, or was it a desire which grew with advancing age to return to painting and to his family? He offered an explanation in a letter to Peiresc:

> I made the decision to force myself to cut this golden knot of ambition, in order to recover my liberty. Realizing that a retirement of this sort must be made while one is rising and not falling; that one must leave Fortune while she is still favourable, and not wait until she has turned her back, I seized the occasion of a short, secret journey to throw myself at Her Highness's feet and beg, as a sole reward for so many efforts, exemption from such assignments and permission to serve her in my own home. This favour I obtained with more difficulty than any other she ever granted me. In fact, there were still a few secret negotiations and state matters reserved for me, but these I was able to carry out with little inconvenience. Since that time I have no longer taken any part in the affairs of France, and I have never regretted this decision.[115]

Rubens was not being entirely truthful in his view of events, for when he relinquished public affairs Fortune had well and truly begun to turn her back on him. It is quite true that Isabella had given him authority to negotiate with the States General of Holland, showing a dazzling display of her confidence in Rubens, but neither Frederick Henry nor the Dutch deputies, still less the representatives of his own country, paid him similar homage.

184

The Marquis of Spinola had died in 1630 on his way to Milan in quasi-exile. Rubens wept for him: 'In him I have lost one of the greatest friends and patrons I had in the world as I can prove by a hundred of his letters.'[116] Isabella Clara Eugenia, Infanta of Spain, daughter of Philip II and Governor of the Low Countries suffered from kidney stones. She died on 1 December 1633 worn out by the burden of responsibility which she had carried as head of Flanders since her husband's death, and more hindered than helped by her nephew Philip IV. The country was on the verge of bankruptcy; Isabella had ruined the state pawn shops by drawing out money which had been invested in them, pledging only her own superb jewels which were insufficient. On 4 November 1634 her successor, the Cardinal-Infante Ferdinand, made his entry into Brussels.

Rubens's two protectors had gone and his diplomatic career was clearly waning. But in the spring of 1635 he would undertake further secret missions to Holland at a time when Sweden and France had jointly decided to invade the Spanish Low Countries in the hope of turning them into a state independent of Madrid. Led by the dynamic Cardinal-Infante, the Spanish valiantly resisted and the Hollanders were both surprised and shaken, became discouraged and proposed peace. In July, with Ferdinand's agreement, Rubens was approached to negotiate, using the fact that he wanted to see some Italian paintings which had recently arrived in Amsterdam as a pretext. But a general outcry from foreign residents in Brussels put an abrupt end to the painter's return to public affairs.

In the autumn of the same year, he would attempt a trip to England with the excuse that he had to transport the paintings, in praise of James I, which Charles I had commissioned for the Whitehall Banqueting Hall. When the French envoy at The Hague exposed the manoeuvre, the passport he needed for the crossing was delayed. Rubens backed down: 'I stayed in Brussels for several days against my will, regarding some business matter which concerned me. Don't think that it was for the reason you suspect (I say this in good faith and you can believe me entirely). I swear, it is true, that in principle I was invited to take part in this affair; but, as far as I was concerned, it would not have given me sufficient material, and since my passport proved to be giving me some difficulties, and I felt the need to delay things somewhat and as there is no shortage of people who are extremely keen to do such work, I opted for peaceful domesticity and, with the grace of God, I shall remain peacefully in my house.'[117] In October 1635 he travelled only as far as Dunkirk, leaving the task of conveying his work to its destination to a third party. Diplomacy was finished.

Rubens once more revealed his unshakeable attachment to Gerbier by showing him the minutes of the Duke of Aerschot's court action which

revealed Gerbier's treachery at the time of the conspiracy of 1632. Gerbier denied everything. Rubens believed him and defended Gerbier against his detractors. These were the last known exchanges between Rubens and Gerbier. On the other hand, Rubens's letters to Peiresc began to flow regularly once again now that he was no longer plotting against Peiresc's country. Rubens also took up his artistic activities once more. He began to draw for Moretus, the printer; he revived the dream that one day he would be able to create Henri IV's gallery. For an Antwerp businessman he designed *The Story of Achilles*, a series of eight cartoons which were to be reproduced as tapestry; notable men, clergy and lay people asked him for retables.

Paintings, engraving, humanism, the economy, the family: these went to make up Rubens's universe, which was itself adorned with a new star, Helena Fourment, whom he had married on 6 December 1630. In 1635 he abandoned all diplomatic digressions. It was to Helena, and his art, that he devoted the remaining five years of his life.

RUBENS'S LAST SUMMER
(1635-1640)

A Time for Living

'He plunged his brush furiously into the cadmium, or the cobalt with its new range of tones, and with fluid strokes trailed madder lake across the gold and green of the sky [Hermann Hesse wrote in *Klingsor's Last Summer*].' In an hour or less he would have to stop; night would be falling. Tomorrow would be the first of August, that feverish month offering its infusion of bitterness and fear of death. The scythe had been sharpened, days were growing shorter; hidden under the browning foliage lay death's grimace. Colours must now surpass themselves: cadmium as dazzling as a battle flag, the voluptuous splendour of madder, lemon yellow like a burst of laughter. For both of us, the sombre blue of far-off mountains, the matt, muted green of the trees. Poor trees, such resignation in your exhausted branches. These gentle images have entered my very soul, and I'm investing them with an appearance of permanence and immortality. I, the most ephemeral being of all, the most unbelieving, the saddest, the most defenceless against death's anguish. Now that July has passed, August too, in its turn, will pass, and suddenly in the morning dew, the great spectre will surge through the yellowing leaves and freeze us with fear. One day soon, November gales will sweep the forest: we'll shiver when we hear the spectre laughing and feel our flesh crawl, while in the solitude the jackal howls and the vulture emits his raucous, accursed cry ... Troubled by these thoughts, he angrily spread a band of Prussian blue under the green caravan. The bitterness overflowing in him was translated into a violent stroke of chrome yellow on the edge of a stone. His despair was painted heavily in vermillion on a surface which was still intact, and whose provocative whiteness he was smothering. His work was but a bloody battle against oblivion; his calls to a pitiless God were transmuted into light green and Naples yellow. His cry dictated to him the blue tone with which he outlined the burnt-out green of the foliage, and his supplication illuminated the evening sky with more inner fire. Loaded

with pure colours, intensely luminous, his palette was his consolation, his fortress, his arsenal, his prayerbook and the platform from which he fired his volleys against cruel death. The colour purple expressed a refusal to die, and vermillion laughed at decomposition. He was well armed, and his strength of attack, even when reduced, lacked neither splendour nor valour: his blows would carry. Of course they were useless, but shooting was good, it made you happy, reassured you, it proved that life was there, it made life triumphant.[1]

Thus Hesse described the painter Klingsor's last summer season. It might also describe Rubens's final five years. They too sparkled with this pathetic incandescence, lit by the flame of his love for Helena Fourment, during which he reveals another persona, another painter. Could this be the real Rubens?

He married Helena on 6 December 1630, six months after his return from England. He was in a hurry and asked for, and obtained, a special dispensation from the Archduchess for the wedding to be celebrated during Advent, counter to the rules of the Catholic religion. In his frank, naïve, even shameless way, he confided in Peiresc why after four years he had so suddenly married a second time:

> I resolved to marry again, not yet being disposed to the austere celibate life, and reflecting that, while continence must be placed above everything, we may also seek legitimate pleasures, in thanking God for those He grants us. I have therefore married a young woman of honourable though bourgeois birth, though everyone urged me to choose a court lady. But I was afraid of finding my companion subject to pride, that chief vice of the nobility, especially among the women, and therefore I chose someone who would not blush to see me take up my brush. And, truly, I loved my liberty too much to exchange it for the embraces of an old woman.[2]

Aerschot's snub, Rubens's dismissal from the embassy to England, Philip IV's reluctance to see a painter dabbling in politics: all these rebuffs suffered in the pursuit of his knighthood had left their mark, and he had learnt from the experience. 'Fortune and I have come to know one another.'[3] 'I retired for a time, and I have never had the least regret for any of my decisions at any time.'[4] Also, as he had mentioned in 1629, he was beginning to feel his age: 'I deploy my declining energies and no longer have time to enjoy the fruits of so much labour, *nisi ut, cum hoc resciero doctior moriar* [All I shall have gained from it will be to die the wiser].'[5]

Rubens the careerist was no longer prepared to make concessions for the sake of honours, especially when his domestic happiness and his art were involved; nor was he prepared to make concessions to religion either, as can be seen by his almost sacrilegious haste to be married.

He was fifty-three, she sixteen. In marrying Helena he renounced Stoicism: the man in black took on the vermillion plumage of his painting, the man of ambition finally relented and decided to enjoy life, the frustrated *bon viveur* became wildly indulgent. There evolved a Rubens whose paintings contained such bombastic flourishes, rich coloration and sensuality of figure painting that one wonders whether for nearly half a century he had been trying to suppress the sensualist in himself as well as denying the painter.

In his self-portraits, for instance, he had only once shown himself holding a palette, even then it was barely discernible in the shadows. Otherwise he is draped in a black cape, wearing a hat and sword, more of a gentleman, a courtier, than an artist. In his contemporaries' or admirers' paintings he appears practising his art, holding palette and brushes, but still wearing a black doublet and wide lace collar, as though he was able to paint without ever soiling his clothes. For many years he masked the creator within himself, the great eclectic, the 'great impersonator' as Delacroix[6] would call him. In addition he painted essentially on commission and sometimes under the supervision of a religious authority, often leaving the actual painting of his canvases to his assistants, limiting his contribution to touching up, as if he took no pleasure in painting but merely did it as a quick way of exploiting his talent and making high profits. In so doing he gave the impression that he was content with a type of painting that had little in common with his sumptuous sketches. When for four years he became absorbed in diplomacy, he was satisfied with producing dozens of copies and put his creative work into abeyance. There seems a contradiction between his declaration of exclusive love for his painting, as he still wrote to Peiresc – 'I have found my peace of mind again, having renounced every sort of employment beyond my beloved profession'[7] – and his repeated betrayals of this passion in pursuit of political honour.

Again, there seems a discrepancy between the work and his real self, for though he painted the most sensual women in the history of painting and was called 'the incomparable love-poet/magician of the female body and childhood',[8] yet as far as we can tell Rubens lived a chaste existence. He is quite clear about this in his letter to Peiresc announcing his marriage: he did not look down on pleasure but preferred to indulge in it with God's blessing.

Peter Paul Rubens, a painter of buxom, generously naked women, a

painter who glorified in flesh, has left us with no tales of sexual adventures. Not only was he the faithful husband of the very proper Isabella Brant and her inconsolable widower but, secretive as he was, he had also pushed prudery to the extremes by banishing unclothed female models from his studio.

Was there no scandal attached to this man? Was he really so virtuous? Is it possible to find some anecdotes? There were a few murmurs – some discontent about St Domitilla in the Chiesa Nuova, for the characteristics he had given the young girl caused the Oratorians to refuse her and insist on a second version. It is also said that Rubens, perhaps influenced by Caravaggio, had taken a Roman courtesan for his model. We might ask – so? When he offered Duke Vincenzo de Gonzaga the rejected version it was the Duchess who refused it because St Domitilla's features portrayed an 'air of impassive malice, at once cultivated and detached, as one might find in a member of the oldest profession'.[9] (According to Campo Weyerman, the anecdote related to St Catherine of the *Holy Trinity*.) And, during that first stay in Paris in the spring of 1622, he mentions the Capaio ladies with the beautiful dark hair sewing at their window in the rue du Vertbois. But why does he need to pursue them all the way from Antwerp? Was it only to use their hair as a model for his naïads in the Medicis gallery? He only painted blondes! We shall never know.

A question mark also hangs over his relationship with Suzanna Fourment, his wife's eldest sister. With her large forehead and tiny chin, under a so-called straw hat (in fact of beaver) she fixes her enormous eyes on the painter and gives him a little smile.[10] She is the most 'intellectual' of Rubens's female models. It is curious that a man who disliked the art of portraiture would paint no less than seven portraits of this young woman, more than he ever did of Isabella Brant, and keep four for himself which were found in his private collection on his death.

None of these 'murmurs' tells us anything substantial about Rubens's sexual life, and the truth is that no scandal attached to his name. So it is best to let him speak for himself as he did in that letter to Peiresc.

At fifty-three Rubens forsook the stoical maxims that had governed his life hitherto, maxims that were even engraved on the entrance arches of his home, overtaken by the passion which he felt for Helena, a young girl of barely seventeen. It is possible that Rubens was applying Juvenal's principles literally and, by remarrying, sought to preserve a healthy body for a healthy mind.

As with Isabella Brant, Rubens did not look far for his second wife. Just as he had chosen his first from among the family of his sister-in-law, so he found this young girl among his own kith and kin.

An examination of the inventory of his possessions at the time of Isabella's death reveals it to be the same as that presented on 29 November 1630 to the Supervisory Council which administered Albert and Nicolas's inheritance from Isabella, which he had made over to his two sons after his marriage to Helena when he made a new will. Besides diverse houses in Antwerp, Rubens also owned a small medieval castle at Eeckeren, which he had bought on 29 May 1627. It was a verdant, almost lush place where in summertime the patricians of Antwerp retreated. When Rubens had to go abroad on his diplomatic missions and leave his sons in the care of his in-laws, this property was there for them to enjoy. They spent holidays at the castle and received family and friends there. Clara Brant, Isabella's sister, had married Daniel Fourment who had ten brothers and sisters, among them Suzanna, Rubens's favourite model for his Virgin child in *The Education of Mary*[11] when she was eleven years old. Whether out of filial piety or premonition, he had then given St Anne the face of his own mother, Maria Rubens. When he returned from his mission to England in the spring of 1630, he probably joined his children in the country. There he found Albert, Nicolas, the Brants and their cousins, the Fourments, among them Helena, who was the same age as Albert.

With naïve haste Rubens again chose his second wife from among the family circle. And so a man in his fifties, a knight twice over, married a girl who had barely blossomed into sixteen.

Canons of beauty have changed and nowadays Helena's pink and white complexion would hardly stir anyone's heart, but at the beginning of the seventeenth century she had many admirers, several of whom were highly placed men in the land. Her husband apart, two we know of were Jan Caspar Gevaerts and the King of Spain's brother, the Cardinal-Infante Ferdinand, the Governor of the Low Countries.

At the time of Rubens's and Helena's marriage Gevaerts issued a compliment appropriate to the circumstances if not to the real qualities of the bride:

When Zeuxis wished to paint Greek Helen with her brilliant eyes and her sweet face, he chose five young virgins from Cotone, in order to compose her form in all its perfections. From one he took the incomparable whiteness of her brow, from another still her crimson cheeks, her ivory neck, her eyes as brilliant as stars, her pink lips, her velvet shoulders, her round breasts, her throat as white as snow, her hands as white as milk, and thus the artist put into one single image all the gifts which nature had given them separately. But Zeuxis is surpassed by Rubens, of whom it is difficult to say whether

it is through his art or through his eloquence that he dazzles us most, and how he possesses Helena of Flanders, who far outshines Helen of Greece. Whiter than snow, no way can she be the daughter of the deceitful Leda's swan. Nor does she have the stigmata between her brows, which, so they say, distinguished the forehead of Tyndarus's daughter. In her pure spirit, she brings together all the gifts which the virgins of Hellas and Latium bore. Like her, Venus with her golden hair emerged from the bosom of the seas. Like her, Thetis became companion to Peleus, in times when Thessaly was sanctuary to the gods. The beauty of her form is surpassed by her charming nature, her spotless simplicity, her innocence and her modesty.[12]

The Cardinal-Infante Ferdinand, a soldier unused to flowery rhetoric, sent his brother the King, Philip IV of Spain, a similar although briefer assessment of the qualities of Vrouw Rubens: 'The Venus in the centre is the very lifelike portrait of his wife, who is certainly the most beautiful person one can see here.'

Helena became the catalyst for her husband's buried passion, and whilst the political situation had worsened and war raged, Rubens lived only to live, paint and love.

As far as Rubens and diplomacy were concerned, everything was over, the grand political design forgotten. Rubens no longer sought to forge the same kind of relationship with the Infante Ferdinand of Habsburg that he had shared with the Infanta Isabella. Ferdinand, moreover, needed no confidant or counsellor, for he understood affairs of state better than his aunt.

The King had chosen him to govern the Low Countries because of his military talents: Ferdinand was alert, audacious, a good strategist, and enjoyed a greater degree of latitude and more authority in governing Flanders than Isabella had been granted. The Belgians had hoped for a less brutal transfer of power, and that the new Regent would be initiated into the realities of Flemish politics before arriving to take over the Government. But the Archduchess's death had taken her successor by surprise while he was lending support to his cousin the Emperor against the German Protestants. He therefore arrived in Brussels knowing nothing but covered in glory from his victory over the Swedes at Nordlingen. The Belgians, who had been shaken by the numerous military reverses they had suffered since Spinola's departure, gave this young victor their support.

Ferdinand was very much a Spaniard and, unlike the Archduke, had come to Brussels to preserve his family's authority not to gain a kingdom. He was not interested in settling in Flanders nor in listening to its representatives, however eminent. He undoubtedly shared Philip IV's

prejudice against artist-diplomats and, of course, Rubens had been discredited at the Spanish court after sending Olivares his lyrical letter on how to exploit the dissentions between Marie de Medicis and her son Louis XIII to solve the Franco-Spanish conflict. One way and another, a lesson had been drawn from that episode. While the Archdukes had plied Rubens with honours and honorary posts, they had rarely called upon his artistic skills and had commissioned only ten or so paintings. Ferdinand, ignorant of Rubens's political role, would be the first of the Habsburgs to consider him purely as a painter. On 15 April 1636 Ferdinand confirmed Rubens's official title. Instead of diplomatic correspondence, which had formed the main basis of his relations with the Archdukes, now all Rubens would receive from Brussels were orders direct from the King of Spain. He would use up his last surge of energy, achieve his greatest masterpieces, in a state of indifference to the political battles which continued to ravage his country and which he surveyed from the side lines.

The international context had in fact crystallised. On 8 February 1635 France had concluded an offensive and defensive alliance with the United Provinces. Richelieu and the Stadtholder of Holland, Frederick Henry, had called on the Belgian provinces to rebel against Spain, promising them independence if they rallied to their cause. If they refused they threatened to share the Belgian provinces between France and Holland. On 19 May 1635 Richelieu declared war on Spain. French soldiers immediately invaded Flanders; 40,000 Franco-Dutch soldiers threatened Brussels, but they were so badly trained and so slow in their attack that the Cardinal-Infante was able to drive them back, winning several battles, even seizing the Duchy of Cleves. The French army retreated and took up their winter quarters in Holland where they were slowly decimated by typhus. It was then, as we have seen, that at the instigation of the Bishop of Ghent, Antony Triest, who wanted to use the occasion to end the war, Rubens was summoned to negotiate with the Prince of Orange, since he had been invited by his colleagues to Amsterdam to admire a batch of newly arrived Italian paintings. But when the delivery of his passport for Holland was delayed, Rubens regretfully renounced this last mission and also cancelled the visit he had planned to London to accompany his paintings destined for the Banqueting Hall – instead he sent them off via Dunkirk. (On this occasion Charles I made him a present of a gold chain weighing $82^1/_2$ ounces and settled his debts for the paintings in instalments.) Rubens wrote of these events and his new arrangements to his friend Peiresc on 16 August:

Here public affairs have changed their aspect; from a defensive war, we have passed with great advantage to the offensive, so that, instead

of having 60,000 of the enemy in the heart of Brabant, as we did a few weeks ago, we are now, with an equal number of men, in control of the country. By the capture of Schenkenschans, we have the keys to the Betuwe and the Veluwe in our hands, imparting terror and dread to our adversaries, yet at the same time leaving Artois and Hainaut well prepared against any outside assault. It is incredible that two such powerful armies, led by renowned captains, have not accomplished anything worth while, indeed quite the contrary. It is as if fate had upset their judgement, so that through tardiness, poor management, lack of resolution, and without order, prudence or counsel, they have let slip from their hands all the many opportunities which presented themselves for making great progress. As a result, they were finally forced to retreat in disgrace and with great losses, reduced to small numbers through desertions, and by the butchery which the peasants have inflicted everywhere upon isolated detachments, and also by dysentery and plague which have taken the majority of them, as one hears from Holland. Please believe, that I speak without the slightest passion and say only the truth. I hope that His Holiness and the King of England, but above all the Lord God, will intervene to quench a blaze which (not put out in the beginning) is now capable of spreading throughout Europe and devastating it. But let us leave the cares of public affairs to those whose concern it is, and in the meantime console ourselves with speculating upon our own trifles.[13]

Realising the consequences of having too small an army, in 1636 Cardinal de Richelieu gave up his military operations and returned to his preferred strategy: putting his hand in his purse rather than to the sword. He agreed to give the Hollanders an annual payment of one and a half million pounds.

Later the deal was reversed and 'French arms which had rusted during a long peace'[14] once more began to shine. Richelieu's generals resumed their campaign and were victorious. Spain had suffered great reverses overseas, which contributed towards the ruin of its economy as the Hollanders gradually seized her colonial possessions and so deprived her of much of her wealth. Experiencing increasing difficulty in paying her own troops, Spain ran into more and more problems in sustaining the Flemish war effort. Philip IV would not budge from the intransigent and blind position he had taken on his Burgundian possessions; the Hollanders were 'rebels' and he would entertain no talk of their independence. The Hollanders replied by retaking Breda in 1637. The following year they

failed to take Antwerp, basically because their own merchants in Amsterdam, who owed their prosperity to Antwerp's decline, feared its revival as the chief port of the North. The merchants of Holland therefore did everything in their power to help Flemish resistance against the Franco-Dutch attempts to free them, providing the citizens of Antwerp with food and ammunition. Their intervention checked the Stadtholder's expedition against Belgium's second city and politics yielded to commerce.

So began a series of defeats for Spain, which would eventually lead to the much feared legal secession of the United Provinces, an event which neither Rubens nor the Cardinal-Infante would live to see. In 1639 the Spanish fleet sailing towards Belgium with reinforcements was annihilated by the Hollanders' admiral, Martin Tromp. Arras fell into French hands. There was no money left in the coffers. The Cardinal-Infante asked his cousin the Emperor for financial aid as well as attempting a political diversion by supporting a seditious plot by French nobles against Richelieu. It came to naught as Richelieu thwarted it. Ferdinand died at the age of thirty-three on 9 November 1641, seven years before the break-up of Charles V's Burgundian possessions and a few months after his court painter.

Just like his compatriots, Rubens suffered as the economic and political situation in Flanders deteriorated. Writing to Peiresc,[19] he told him he was no longer politically active. His was now the life of a painter and a father. To the north of Antwerp the Cauwensteen dyke had collapsed, so water flooded into the polder and the little castle of Eeckeren was beset by damp and became uninhabitable. It was also situated close to the battle zone and became subject to military raids. Rubens therefore sold this property to buy a bigger one near Brussels, which was better protected from both the war and bad weather. On 12 May 1635, in the presence of a notary, he signed a document acquiring the estate of Steen at Elewijt. The deed specified: 'A lordly residence with a great house of stone and other fine buildings in the form of a castle with garden, orchard, fruit trees, drawbridge, with a great mound, in the middle of which rises a high square tower, having a lake and farm with farmhouses, granaries, diverse stables and sheds, measuring altogether 4 bonniers 50 yards, the whole surrounded by forests.'[15]

Rubens soon transformed the site just as he had done with the house beside the Wapper. He got rid of the tower, the drawbridge and the machicolation in the main building, which was of a Renaissance style in red brick decorated with string courses of white stone and still retained signs of the ancient fortified castle. He undertook a further 7,000 florins' worth of work on an estate which had already cost him 93,000, and in the

years which followed he continued to extend his property, so much and so well that on his death he had quintupled the original area. 'Het Steen' no sooner bought he took the title of the *Seigneur* of Steen, a social flourish, and which would appear first, in front of all the rest, on his tombstone.

Although he had unburdened himself of all his political work, Rubens was still obliged to fulfil certain duties in his capacity as official court painter, member of the Guild of St Luke of Antwerp and local notable. The honour of decorating his city for the triumphal entry of the new Governor of the Low Countries therefore fell to him. The ceremony was initially planned for the beginning of 1635, at a time when the Cardinal-Infante was in the middle of fighting off French troops and when the Schelde was frozen solid. It was therefore delayed until 17 April of that same year. All the Antwerp guilds were under his command - sculptors, carpenters, painters, masons - and Rubens spent more than a year drawing up sketches. For inspiration he mainly fell back on the architectural notes he had made in Italy in his youth. Ever since that time he had continued to refine his notes, corresponding with and entertaining emissaries to Lombardy and Rome, so that he could have copies of antiquities made for him.

Five triumphal arches, five scenes, porticoes, of which one had twelve arcades, to the glory of the twelve Holy Roman Emperors, sprang from these sketches and his powerful imagination. They were decorated with statues, friezes, frescoes and paintings on which Jordaens, Cornelius de Vos, Erasmus Quellyn III, Lucas Fayd'herbe all worked. Rubens had to ensure that his models were faithfully copied, then had to supervise the erection of the monuments, the hanging of the paintings and the placing of the sculptures. The sites were spread all over the town, and Rubens visited them on horseback or was taken in a wheelchair when gout prevented him from walking. He paid dearly for he grew tired and complained to Peiresc of 'work which is wearing him out, preventing him from writing, from living even'.[16]

It took an entire day for the Cardinal-Infante's triumphal journey as far as the cathedral where, in their best finery, the burgomaster and notables awaited him while a *Te Deum* played in the background.[17] Rubens, however, was confined to his bed and so Ferdinand visited him in his house by the Wapper. That night the town was illuminated by 300 barrels of burning tar, under whose flames the citizens of Antwerp at a gigantic fair continued to celebrate the arrival of their new governor.

When a governor entered a Flemish town his arrival not only signified that the authorities welcomed him as their Prince but that he came at their invitation. Such an event was highly symbolic of the vestiges of independence which the great cities of the Low Countries still retained.

Generally such occasions were used to convey messages to their sovereigns. Rubens used Ferdinand's arrival to plead Antwerp's cause in one of those allegories of which he was so fond. On the St John Bridge, near the port, he had put up a portico decorated with a fresco representing the Schelde obstructed with chains and lined with sleeping sailors. Under the picture, in Gevaerts's writing, the inscriptions called for the resurrection of the town. The idea was clear: closing the Schelde's estuaries had decimated the port's economy, and the city was dying through lack of the commerce and banking activities from which it had drawn its wealth. Rubens's plea would not be heard for a century and a half.

Antwerp had been bled white and Rubens had witnessed its collapse. However, he did not renounce the pension the Citadel had given him, nor any of the privileges which exempted him from all municipal tax (since 8 August 1630), and taxes from the Guild of St Luke (ever since being appointed painter to the Archdukes on his return from Italy). In payment for his work as the organiser of Ferdinand's ceremony he received almost 5,600 florins out of the 80,000 which he had spent. The town hall tried to recoup some of the expenses by dismantling the monuments and auctioning them off, but to no avail. Rubens's expansive visions had pushed the cost of *Pompa Introitus* twice as high as had been originally estimated. Needless to say, Antwerp's impoverished citizens did not have the money needed for such works of art. In the end some of the decorations were restored and installed in the royal palace in Brussels, and Rubens spent several days in the capital in February 1637 overseeing their hanging.

The Cardinal-Infante to whom so much artistic and financial effort had been dedicated never grew accustomed to Flemish ways. He wrote to his brother: 'Yesterday was the great festival called Kermesse; there was a great procession with many triumphal carriages. It was in my opinion more beautiful than in Brussels. After the procession, everybody went off to drink and eat, and by the end they were all drunk, for without that it would not have been a festival here. The people here truly live like animals.'[18]

Having completed the festivities for the Cardinal-Infante's triumphal entry into Antwerp, Rubens took no further role in public affairs. He turned instead to his painting and those pursuits which gave him pleasure: his correspondence with friends like Peiresc, renewing his friendships with Rockox and Gevaerts, pursuing the acquisition of treasured *objets d'art*, and illuminating books of his childhood friend, Balthasar Moretus, at his Plantin Press.

He had broken off relations with France but still received commissions from Cologne, Prague, Tuscany and even the Stadtholder of Holland. His catalogue of work notes approximately sixty paintings during these last

five years, without counting the hundred or so canvases ordered by Philip IV, the frontispiece for Moretus, the drawings and studies. His rotunda museum, which he had nearly emptied when he sold its contents to Buckingham, was once more full of acquisitions made in the course of his wanderings in the service of the King of Spain. As Rubens explained: 'I have never failed, in my journeys, to observe and study antiquities, both in public and private collections, or missed the chance to acquire certain objects of curiosity by purchase. Moreover, I have kept for myself some of the rarest gems and most exquisite medals from the sale which I made to the Duke of Buckingham. Thus I still have a collection of beautiful and curious things in my possession.'[19] Thus he adorned the house by the Wapper and continued to embellish it right up until his last day. On 17 April 1640 he once more thanked Francis Duquesnoy, a Brussels sculptor living in Rome, for the models and a plaster cast of *putti* which he had sent him from Italy.[20] Rubens returned also to another preoccupation which he pursued with as much determination and deviousness as before – the recognition of his author's rights.

On 8 December 1635 Rubens 'remembered', in a postscript of a letter to Peiresc, a court case with which he had become involved in France and which he now asked Peiresc to study and comment upon. Rubens's first permission to distribute his engravings in France had been renewed in 1632, but a German of French citizenship had reproduced an engraving issued by Rubens's studio without permission and for his own profit. The court found the German guilty, and he had appealed to Parliament. Rubens felt disarmed. 'I understand nothing of chicanery, and am so simple as to have thought that a decree of the Parliamentary Court was the final decision in a lawsuit, without appeal or subsequent rejoinder, like the sentence passed by the Sovereign Councils in this country.'[21]

The case involved an engraving of the Crucifixion and the key question was whether or not it was a forgery. According to Rubens, the date which the German's proof carried was illegible: 1631 or 1632? Rubens claimed it was 1631. What is more he argued, 'Everybody knows that in 1631, I was in England and this engraving could not have been done in my absence, since it has been retouched several times by my hand (as is always my custom).'[22] The painter decided from this that the 'forger' had falsified the date to his advantage and he could prove it. But Rubens was not being truthful. Not only had the *Crucifixion* been engraved by Pontius in 1632, but in 1631 he had already been back from England for almost a year and was well and truly settled in Antwerp. Of course, Rubens did not admit this; in his eyes, the outcome should not have depended on legal quibbles but on superior causes: 'It is certain that the rupture between the two crowns

is reaching its climax. That causes me great embarrassment, for I am by nature and inclination a man of peace, the sworn enemy of arguments, lawsuits and quarrels, private and public. What is more I do not know if, in times of war, His Majesty's permission will still be valid. If this is not the case, all our efforts and all our expenses to obtain the decision from Parliament to maintain it will be vain.'[23]

He lost his case in 1636.

Rubens decided to take on no more pupils, only assistants whose art was well advanced, who had their own careers. They were Jacob Jordaens, Cornelius de Vos, the van Ballen sons Jan and Caspar, Theodore Van Thulden, Jan Van Eyck, J. P. Gouwi, J. Cossiers, J. B. Borrekens, T. Willeborts and Erasmus Quellyn III, to whom in 1637 Rubens handed over the engraving for the Plantin Press, and Lucas Fayd'herbe, the sculptor, who looked after the house beside the Wapper when the Rubenses were absent and who worked exclusively on the painter's models. Both Quellyn and Fayd'herbe had come to Rubens's assistance when he could not meet commissions. But a significant change had occurred: these assistants now signed their canvases with their own names. Rubens's authoritarian rule had mellowed.

He spent less and less time in Antwerp and stayed longer at Eeckeren and then after 1635 at Elewijt as he developed a more relaxed attitude to life. He ceased to brace himself against fate by seeking success and profit. 'It would be better to forget, rather than recall the past', he wrote to Jan Casper Gevaerts when Gevaerts lost his wife.[24] He did not forget the past, but his perceptions changed and he began to paint traditional Flemish subjects: people and nature, which he had neglected under the Italian influence. Unfortunately, however, his technique adapted badly to the small canvases, as he had little experience in this genre. It seems that Rubens was now painting for pleasure, no longer needing to please his patrons. After his death several paintings were discovered in his private collections which had not been commissioned: *Prometheus*, *The Drunkenness of Hercules*, *Iphigenia*, the four portraits of Suzanna Fourment and a very special portrait of Helena, *The Little Fur*. These paintings suggest that at the end of his life Rubens, the admirer and disciple of classic harmony, the painter who recognised Titian, Michelangelo and Veronese as his masters, was turning back to his Flemish roots.

'The man who eats well prays well' says an old Flemish proverb. Late in life the greatest creator of retables in the seventeenth century became fervently religious. He led a perfectly regulated existence: attending mass each morning, riding at dusk when failing light prevented him from painting

and while he was still able to exercise his healthy body, returning as night fell to eat a frugal meal, avoiding meat dishes and excessive alcohol. Abstaining from wine did not protect him from gout and arthritis, however. So perhaps he began to appreciate wine more, for his correspondence reveals that when wine stocks were exhausted he would grow anxious about new supplies as he told Lucas Fayd'herbe: 'We think it strange to hear nothing about the bottles of Ay wine; those that we brought with us are all gone.'[25]

Rubens's life changed; he lived differently as he now surrounded himself with his new wife's numerous family, joining them in a lifestyle much removed from the rigid discipline of his earlier days.

His new relatives, the Fourments, became the models as his painting now turned more to its Flemish roots, reflecting the lives of those around him. The *Conversation à la mode*, also known as *The Garden of Love*, shows a pastoral fête on the mythical island of Cytherea, similar to country feasts given by the Antwerp bourgeoisie. These parties usually went on so late that the meal known as the 'medianoche' was generally eaten by moonlight, after which, to quote the contemporary Father Poiter, the pace hotted up: 'One would sit under a leafy bower, or perhaps take a boatride to give one an appetite, or in the afternoon ride in the carriage to make the pilgrimage of Venus to the Tower, as was the fashion. When evening came, one sang, danced the whole night through, and made love in a manner that cannot be recounted here.'[26] The only bitter note in Rubens's painting is the indifference of the young woman to the amorous advances of the older man courting her.

Rubens enjoyed these parties. He relaxed his tough ambitious business image so the true Rubens began to be seen, one who could flirt with women, enjoy a saucy joke like he used to, as when he wrote to Lucas Fayd'herbe at the time of his marriage recommending that he spend less time sculpting ivory statuettes of children so that he could 'make a child in quite another way'.[27] He had always had this side to his nature but in his drive to further his ambitions he had little time to give vent to it. Remember the exchange with Peiresc on the 'ithyphallic precious stones' and later when writing to Peiresc he mentioned Procopius's history of Theodora, Empress of Byzantium, which details 'Theodora's debaucheries, passages omitted in the edition of Allemanus, doubtless through modesty and a sense of decency, and which have since been found, as well as extracts belonging to the Vatican'.[28] Whether it concerned the 'diva vulva' or Theodora's vices, Rubens made the most of it in his letters.

Rubens's less formal approach to life may shed light on his distaste for court life in Brussels. He had written to Peiresc on 16 March 1636 that 'I

have a horror of staying at Courts.' He disliked the formality, and the priggish arrogance of the courtiers, whereas he now found the simple pleasures of his new relatives and his Antwerp friends more suited to his tastes. It was this attitude that had persuaded him to choose a young bourgeois bride over a more mature noble woman who might sneer at his painting, though perhaps his somewhat naïve view of women may not have considered the pain such a union could inflict. His painting suggests that it may not have been easy, as we have seen in the young woman's indifference to her elderly lover in *Conversation à la mode*.

With Isabella he had had three children in eighteen years. With Helena he would have five in ten years: Clara-Johanna (1632–89); Frans (1633–78), whose second son, Alexander-Joseph who died in 1752, would be Rubens's last direct male descendant; Isabella-Helena (1635–52); Peter Paul (1637–84) who would become a priest; and Constantia-Albertina (1641–57) whom the painter would never know and who would enter a convent. We can see a further indication of Rubens's social emancipation in the choice of names: unlike Albert and Nicolas, baptised respectively with the names of the Archduke of Austria and a Genoese banker, his later children were not named after powerful protectors. The two Benjamins embraced the religious life: a curious fate for the offspring of a union founded on sensuality and self-interest.

The Rubenses gave the overriding impression of a bourgeois couple. Between Rubens the great man enslaved by his wife's body and Helena who took advantage of the adulation piled upon her, stretched the same age gap as that which separated David and Bathsheba and without doubt the same difference of feelings. He was besotted with her and made no attempt to hide his passion, painting her to his heart's content, even undressed. But in all her portraits Helena's expression clearly shows that she preferred to be portrayed as a lady rather than a goddess.

When he married Helena, Rubens presented her as a wedding present several costly pieces of jewelry: five gold chains - two with diamond settings, another decorated with black and white enamel - three strings of pearls, a diamond necklace, a pair of diamond earrings, a gold anchor set with diamonds, another large diamond which came from England (perhaps the one that Rubens had received from Charles I), gold and enamel buttons, a purse filled with gold coins. He would also give Helena dresses of brocade, silk, velvet, satin and gauze, furs, horses and the carriages which were to feature in numerous portraits. In short, the accoutrements of a great lady.

To paint these precious materials Rubens followed the techniques of the early Flemish painters and reverted to the precision he had employed in his youth when he had structured his paintings in the manner of Veronese, by

exploiting the stiffness of satin or brocade. Until then he had delegated the painting of dress to his studio, reserving faces and expressions for himself. As Delacroix believed: 'Rubens painted his faces and did the background later: he did it in such a way as to show them to advantage: he had to paint on white backgrounds; in fact the local colours had to be transparent; although a half tint, it actually imitated the transparency of blood under the skin.'[29] But when painting Helena, Rubens painted body, soul and dress. He no longer treated them separately, as he had done when clothes appeared as part of a set piece, encasing a public figure, more than as an expression of personality. When he had painted Veronica Spinola Doria[30] he used Van Eyck's technique in his meticulous rendering of the spiderweb ruff, the heavy dress material, the jewels of her corselet-breastplate, hiding the young woman's personality so as to better convey her aristocratic demeanour. In his portraits of Helena, however, he was after something other than a material or social image. The woman and her finery – or its absence – are in symbiosis, and meld to capture a momentary emotion: his model's impatience, a young mother's tenderness, the pride or vanity of a patrician lady, or even the adoration of the man painting her.

In the portrait of the young bride,[31] her overdress of dark velvet has fallen open to reveal a skirt embroidered in gold. She is wearing everything that a jeweller could fashion: brooches, necklaces, rings, pendants, bracelets. With slashed sleeves over white organdie and a wide lace ruff, she appears like a sparkling cloud posed on an armchair whose back can scarcely be glimpsed behind her sumptuous dress. She is not sitting upright like Veronica Spinola enthroned for eternity, she is leaning on one of the armrests, as though ready to take flight, just as her eyes evade the painter whom she graces with only a tight smile. Then there is Helena, 'with the glove'[32] generously décolletée: under the gauze, her plump breasts have escaped the velvet corselet studded with precious stones. Her eyes are vacuous and she has no expression except in the line of her shoulders and nape of her neck. She looks pleased with herself, with diamonds in her ears, pearls around her neck, her little plumed hat cocked over one ear, a little constrained but ready to dazzle. In another painting[33] she has grown into a tender young mother, fresh and soft as the light cotton of her blouse and skirt, the brush strokes of which resemble the coloured caresses of Goya's early paintings. She hugs her eldest son Frans while Clara-Johanna tries in vain to attract her attention and Isabella-Helena's little hands stretch towards her from the left edge of the canvas. Helena has a full pale face, with a pulpy, sullen mouth; her bulging eyes have an absent look.

When Rubens paints a picture of Helena as a lady of quality awaiting her carriage by her door, we find her looking at her husband with a little

of that complicity which united Isabella Brant to Rubens. Wearing a dress of black silk, cape, jewels, hat, while one of her sons serves as page, Helena looks content and no longer averts her gaze nor her step. She poses, mistress of numerous staff – two servants, a cook, a footman, two coachmen – and of the greatest painter of the age. Without opening her lips, her sour expression has lightened. Beneath it she gives the artist a sidelong, conniving glance.[34]

If Helena revels in bourgeois life, Peter Paul sees her uniquely as a heroine of antiquity, as the dozens of mythological paintings where she is the central figure demonstrate. Was it because he 'lived with the ancients as though they were friends'[35] or perhaps because antiquity offered greater pretexts for nudity? She is Venus lying langorously on the clouds; she is the white nymph in the *Garden of Love*, the three Graces all at once, the mortal whom Paris prefers to Minerva. Never cruel Judith, nor treacherous Delilah, but always innocent, virtuous, attractive in spite of herself, resisting the assaults of the satyr in *The Fête of Venus*, the embraces of an older man in *Conversation à la mode*. Rubens was so proud of Helena that he even opposed Philip IV's wishes when he painted her in *The Judgement of Paris*: 'It is without doubt the best painting that Rubens has ever painted. It has only one fault: the goddesses are too naked; but it has not been possible to persuade the painter to change that; he maintains that it is essential in order to bring out the beauty of the painting', the Cardinal-Infante explained in the letter which accompanied the painting to Spain.[36]

He captured her even at the moment she stepped from her bath with only a fur to protect her from the cold, reminding us of Titian's *Venus with a Fur*.[37] His painting is an exhaustive caress, an exploration whose precision is unlikely ever to arouse the viewer's enthusiasm, even that of Rubens's greatest admirers, as much as it did Rubens's. Take these lines of Emile Michel: 'She has evidently adopted the pose her husband has indicated: her breasts are pressed upwards by her right arm, her tiny, sweet left hand, clutching the edge of a thick fur to her stomach. In this all too accurate portrait, parts of her body which do not shine with elegance have been scrupulously copied. The flesh no longer has a primitive firmness, and one can see on the torso the unmistakable marks caused by her tight corset and on her legs, with their pronounced kneecaps, garter marks. If her looks lack distinction, the painting seduces through its expression of life and youth.'[38]

Helena allowed herself to be posed thus. She is looking away as if offended by the shameless passion which forces her to unveil herself. The absent look is her way of announcing her position. 'You are the master and the painter, I obey' her big blue eyes seem to say, while naked for all to see she pays off the ransom for her social status. She is the wife of the

Secretary of His Majesty's Privy Council, of Rubens the knight honoured by the Kings of England and Spain, and moreover of the painter. It is his wish, she is his model, although she has it all, and it is entirely his fault if she is a goddess who is too naked. *The Little Fur* would remain in Rubens's private collection and be left in his will to Helena, thus protecting a moment of intense intimacy. When her husband's collections were broken up Helena bought back the paintings in which she appeared nude.

Was it really Helena whom Rubens painted as an inexpressive creature of generous proportions? Many people believe so, and also consider that the three women in his life, Maria, Isabella and Helena – his mother and his two wives – 'burdened his memory with their disastrously fat figures'.[39] In Emile Michel's eyes – a man who considers Rubens in the same unflattering light as a 'painter of fat women' – Rubens painted only very Flemish nudes: 'those boatwomen of Antwerp, robust viragos, strong and well built, and capable of rowing a boat across the Schelde in rough weather'.[40] Max Rooses goes further: 'The contemplative beauty that the Italian and Flemish primitives had given the saints held no attraction for him; the academic beauty of Raphael's madonnas left him cold. What he was looking for in a woman was a fresh pink companion for a vigorous male, a fertile mother, a plump nurse for healthy children.'[41] But Rooses is closer to the truth when he wrote that 'His Marias, his Venuses, his nymphs, his female saints are colour and light incarnate, and so is Helena Fourment'.[42]

How would one describe these nymphs? Venus, Diana, the Sabine women, Helen, Nacira or Phoebe (daughters of Leucippus) all look the same: invariably blonde, with narrow shoulders, small high breasts, long heavy limbs, wrists and ankles so fine that they threaten the balance of these abundantly fleshed women, whose flabby collapse the viewer dreads. The volume and softness of the daughters of Leucippus are their best defence against the brigands who are attempting to carry them off: how would you grasp an arm with its flesh as soft and slippery as silk? In a very Baroque but profoundly anti-Flemish fashion, Rubens's flesh is symbolic, impalpable, a translation of his own personal drama, his profound sense of his art, where the real is but a pretext for allegory.

Rubens, artist of the Counter-Reformation, who in his profane, almost blasphemous compositions (remember the episode of the foot of Christ on the shoulder of Mary Magdalene in *The Descent from the Cross* in Antwerp) made heaven fall to earth, became a bard of the body. While his representation of religious subjects followed the tradition of Flemish realism, which 'placed Christianity amidst the gustatory voluptuousness of kermesses',[43] he followed the reverse movement in his exaltation of the female body. His brush spiritualised it as a symbol of chastity, tenderness,

the thrill of life. Under the dual grip of love and professional obligations – enslaved by Helena and subject to the King of Spain's demands – Rubens changed from being a religious painter to being more a painter of flesh than one of sensuality. His genius and his life were in harmony with his sovereign's wishes, and it was for Philip IV, the lover of women and sensual pleasure, that he deployed this aspect of his art in a final outpouring which synthesised the two schools he had transcended.

Painter of Women

Philip IV had changed his opinion of Rubens. When Rubens was in Spain in 1628 the King had perfunctorily glanced at the paintings offered by the Archduchess's emissary and then fobbed them off by commissioning him to paint a few portraits of his family and courtiers. For a long time Philip appreciated Rubens neither as a diplomat nor as a painter, but by dismissing the diplomat from his service he drove the painter back to his easel and then used him – by 1636 he had twenty-five paintings by Rubens. Philip then embarked on a project he had conceived of ten years before.

He had three palaces in Madrid and a little hunting lodge, 'La Torre de la Parada', on the Buen Retiro estate, which he also used for his amorous adventures. When Rubens was in Madrid Philip had asked him to take measurements with its future decoration in mind, and in January 1637 he decided to go ahead with the project. Through the intermediary of his brother, the Cardinal-Infante, the King of Spain commissioned Rubens to paint the first of three series of paintings, a task which would occupy him until the day he died. Approximately a hundred paintings in all were planned for the twelve rooms on the first floor and the eight on the ground floor of the lodge. However fast Rubens painted he could not manage the commission on his own, and so he resorted to his assistants, allocating work in the usual way: animals to Snyders, landscapes to van Thulden, whilst Rubens of course, reserved the figures for himself.

Philip IV chose the themes from Ovid's *Metamorphoses*, selecting from the fifteen books episodes with amorous themes to suit the light atmosphere he wanted to create at the lodge, with its dual purpose of hunting lodge and secret rendezvous. In fact the Torre de la Parada became to Philip IV what the Palazzo del Te had been to Federico de Gonzaga. Both princes needed a den of delectable, refined sensuality and they chose the same pictorial décor, drawn from the same text. The Duke of Mantua had commissioned Giulio Romano for his work, and so Rubens would have to pit himself

205

against Mantua's artists – the other being Mantegna – whom the Duke had preferred. Did Rubens imitate Romano's art or merely the source of his inspiration?

The same could be asked of Mantegna. In the 1600s Rubens had resisted Mantegna's geometric, glacial compositions in the *Camera degli Sposi*. And while he may have copied some of the paintings and done several drawings, it was in London that Rubens paid Mantegna his greatest compliment. In the royal collections he had discovered Mantegna's *Triumph of Caesar* series, the last of Ovid's *Metamorphoses* and had copied all eight paintings. Perhaps he saw them as potential models for Henri IV's gallery, a project he always had in mind? Nevertheless it was Rubens the humanist rather than Rubens the painter who reacted to this work, for he never sought to copy Mantegna in the way he had sought to copy Titian, to absorb his *savoir-faire*. Rather he was rediscovering one of his favourite texts from antiquity and recalling his first aesthetic emotions as he stood in front of Giulio Romano's frescoes, in Mantua. No doubt the theme of Mantegna's compositions had impressed Rubens as much as the painter's draughtsmanship and colour, because it corresponded to Rubens's view of his art, an idea which had persisted from Mantua to London, from youth to maturity. At the end of his life Rubens was able to recapture it again so well that it seemed to encapsulate the very essence of his creativity.

Rubens had drawn his inspiration for the first mythological scenes from the vast coloured frescoes in the Palazzo del Te: *Hero and Leander*, *Hylas borne away by Nymphs*, *The Triumph of Scipio*. His memory of Giulio Romano was still fresh and no doubt the sketches he had made of his work were so evocative that thirty years later in the Torre de la Parada Rubens was still using as models *The Birth of Venus*,[44] *The Fall of the Titans*[45] (which he left for Jordaens to do), *Cupid and Psyche*, *The Fall of Phaeton*, *The Death of Procris* (which he transposed into a death of Eurydice), *The Death of Meleager* and *The Death of Adonis*. Nevertheless his interpretation varied from Romano's, since Rubens preferred a less anatomical celebration of love. Giulio Romano had depicted love-making and 'transformations' quite matter-of-factly. Rubens kept to dazzling allegories, such as *The Fête of Venus*, *The Judgement of Paris*, and *The Three Graces*, which reveal his quite individual notion of flesh tone.

Otto Venius had taught him to use pale pink with a heavily outlined contour of the limbs, so producing a frigid realism, as can be seen in *Adam and Eve* now displayed in Rubens's House in Antwerp. Under the influence of the Italian masters Rubens had made the flesh tones browner, turning them to ochre in the manner of Titian but without making great use of the change in hue except for a few nereids or goddesses when painting in the

scenery. When he returned to Flanders, it was Flanders that provided him with models and more importantly with its own special light.

Notice the different appearance objects have according to whether you are in a dry country like Provence or the district around Florence, or on a damp plain like the Low Countries [Taine observed]. In dry country, line predominates and first attracts the eye: mountains in grand noble style form a cutout against the sky with their stage architecture, and all objects stand out in strong outline in the clear air. Here, the flat horizon is without interest, and the contours of things are softened, blurred, misted over with imperceptible vapour always floating in the air; masses predominate ... The object emerges, it does not come out of its surroundings suddenly like a detached cutout; it is its modelling one notices, that is to say, its different degrees of progressive light and its diverse gradations of deepening colour which change its general colour into a relief, and communicate to the eye a feeling of its volume. You have to spend several days in the country to sense this subordination of line to mass ... I have spent many occasions standing on the quays of the Schelde, watching the great pale, weakly rippling waters ... The river glistens and the murky light on its flat belly here and there kindles vague reflections. All along the circle of the horizon, clouds rise incessantly, and their pale lead colour, their motionless procession bring to mind an army of ghosts: these are the ghosts of a damp country, spectres constantly renewing themselves, bringing eternal rain. As the sun sets, they grow purple, and their bulbous mass, all enmeshed with gold, recalls the damascened copes, brocaded gowns, embroidered silks in which Rubens and Jordaens wrapped their bleeding martyrs, their grieving madonnas. Below the sky, the sun seems like an enormous dying, smoking furnace ... At the end of several days, the experience is complete: in an atmosphere such as this only nuances, contrasts, harmonies, tonal values have significance.[46]

The light Flemish complexion responds to this flat sunless country: 'It owes its luminous freshness, its tender satiny glow to the transparency of its skin which is subject to blushes; a generous blood supply irradiates the milky base with shades of crimson across the bluish traceries of veins.'[47] Far away from the sunburnt figures of Italy, Rubens discovered the revelation of a body in relief, in volume. Until now complexions in Rubens's paintings had been influenced only by Venius's teaching which showed an Italian bias and then by his rediscovery of Flemish painting. Following

Rubens's marriage to Helena Fourment and his work for the King of Spain, the skin tones in his paintings achieved their final metamorphosis. They became enriched with rediscovered mythology and with the perceptiveness of a man in love. Pearl-like, dappled, shaded with pink or light amber, illumined by golden reflections of hair, the skin captures the light in a painting, an open space, so tender, so trembling, so soft to the touch that it seems a hand or a kiss could touch this immaterial pallor. The body and its limbs, their curves, planes, folds and tensions are but pretexts for colour and subtle brushwork in the rendering of 'tonal value' and moving line.

Rubens's nudes are never passive, lascivious, abandoned, crudely disported, unless it is in the eye of the beholder. Charles Baudelaire aptly described a Rubens's nude as 'a pillow of cool flesh forbidden to embrace'.[48] In his eclectic manner which is so characteristic, Rubens chose Michelangelo's heroic sculpturalism for his male nude: muscles clenched in action, fighting, physical effort, mooring a boat, holding the body of Christ at the Deposition, or even St Francis of Assisi kneeling mystically, his long thighs barely appearing to touch the ground while the hands of the surrounding monks hold him down rather than help him in his last communion. In the same manner Rubens's women are never still. He often takes his models from Titian – *Frigid Venus*, *Venus in a Fur*, *Fête of Venus* – appropriating the scenery or the composition but ignoring their outlined contours, the compact flesh, as though congealed in pale bronze. Rubens's women never put the full weight of two feet on the ground, they never show their full length on a couch. They dance the sisterly round of the Three Graces, drawing back, stepping forward, turning, resisting the person trying to drag them away, twisting their bottoms like the waves from which they are emerging, or like Helena, looking away evasively.

In the great work in Vienna, *The Fête of Venus* (a painting which Philip IV kept in his room at the Torre de la Parada), only the tender intertwining of the little cherubs in the foreground gives a hint of carnal love. The nymphs, *putti*, the goddess herself appear only as ivorine mists. The movement of the characters forms the composition of movement of the whole picture in which bodies dissolve in shimmering intensity, identically with the *Fête*.

Landscapes

A nymph raises arms and eyes heavenwards as she is carried off by a satyr with soft leathery skin; a cherub pushes the young woman into the arms

of her courtier in the *Garden of Love.* . . . Rubens, now tired and aging and in need of those pastoral pleasures mentioned by Père Poiters, left the city taking Helena away to their castle. 'I have found peace of mind, having renounced every sort of employment outside of my beloved profession', he wrote to Peiresc in that letter of 18 December 1634.[49] At Elewijt he did not have a studio like the one in Antwerp, but he painted as he had never done before. Since the countryside was no longer the transient scenery of his travels but where he was actually living, he now had a new model: Nature.

Rubens had of course always been capable of painting trees and foliage, rocks, mountains, rivers, sky, though he had treated nature as background to a painting: the bosky dell of Eden for Adam and Eve, the honeysuckle bower for Peter Paul and Isabella; it was never the subject of a painting. In this he had broken with tradition, the great Flemish tradition of landscape painting with contemporaries such as Bril, Brueghel and Momper, following in the footsteps of great masters like Patinir and Met de Bles. Careful as always to affirm Rubens's supremacy, Max Rooses denigrates his predecessors' representation of nature: they 'considered it their duty to soften it, polish it, trim it, to make shelves of knickknacks from their rocky crags, woods and stretches of water. They treated a mountain or a distant lake like toys on a table'.[50] He considered Rubens's concept of landscape painting as the only one which truly acknowledged its realities and grandeur. Viewed objectively, however, Rubens's own vision of nature was just as visionary as Met de Bles's or Patinir's.

In summer the land with its abundance of water exhales a silvery mist through which the light is filtered, the flatness of the vast plains relieved only by hayricks as far as the eye can see, fields furrowed with ditches bordered with ash and poplar. Flanders is flat, calm under the sun, as though sated by a vaporous torpor. In winter the land is frozen in *grisaille*, deprived of the tempestuous heroism with which Rubens's clouds, rainbows, fallen trees and steep rocks endow it.

He would ride over the land on horseback or in a carriage when his gout was giving him pain. He had finished his garden of love at Eeckeren and painted *The Hunt of Meleager and Atalanta* and *Andromeda* at Steen. But were these paintings created from real life? No doubt Rubens carried a sketchbook and perhaps paints and a brush with him, as he must have done during his youth when he rode through France and Piedmont to Venice and through Italy. We can assume that he would stop to sketch a view, a peasant scene, the shape of a plough or cart, for he had always made quick sketches: in the Roman forum, on his excursion to the Escurial with Velasquez from which he had returned with a view of Philip II's

fortress. But even when he did take up landscape painting (he would paint a hundred or so canvases), it is difficult to imagine Rubens in his straw hat, brilliant hose and clogs like one of Brueghel's peasants, actually painting in the open air with his easel stuck in the ground.

Rubens's representation of nature had nothing of Van Eyck's botanical precision. He would never make an accurate site drawing or a large-scale survey. The way his figures are finished, the perfect composition of his scenes and the golden light which features in his paintings – so unlike the opalescent light of Flanders – go to prove that Rubens was an indoor landscape painter. He embellished sketches drawn from life and then, under his own roof, indulged his liking for perspective and broad vistas. His concept of the countryside can be glimpsed in his criticism of an engraving that Peiresc had sent him:[51]

I have looked with pleasure at the engraving of an antique landscape which seems to me a pure caprice on the artist's part, representing nothing *in rerum natura*. Those arches, one after another, are neither natural nor manmade and it would be difficult for them to remain standing as they are. ... And as for those little temples scattered on the top of the cliff, there is not enough space for buildings of that kind, and there are no paths for the priests to use, let alone the faithful. That round reservoir is useless, since it cannot retain the water it receives from the heavens, as it is pouring it out through many huge orifices into the ornamental lake, and delivering more water than it can possibly receive. In my opinion the whole thing could be termed a nymphaeum, a confluent of numerous fountains flowing from every side (*multorum fontium undique scaturientium*). That little temple with the female statues could be dedicated to the nymphs of rivers and mountains, or to certain divinities of the fields or the mountains. The square building is perhaps a hero's tomb, because arms are hung at the entrance (*nam habet arma suspensa prae foribus*), the corniche is decorated with foliage and the columns with garlands and torches. At the corners are baskets in which fruit and other sacrificial offerings can be placed for their dead and as some form of entertainment for their heroes (*quibus inferias et justa solvebant defunctis et tranquam oblatis fruituris Heroibus parentabant*). The goats must be consecrated to some kind of divinity, for they are grazing without a goatherd. It seems that the painting is the work of a good painter, but, as far as perspective is concerned, certain rules have not been very strictly observed, for the lines of the buildings do not meet at a point on the line of the horizon; in other words, all the perspective

is out of true. One can see similar errors on the reverse of medals which are otherwise correctly made, and particularly in racecourses which have been drawn using defective perspective. Some bas-reliefs, even by good artists, suffer from a similar fault, but this ignorance is more excusable in sculpture than in painting. From which I deduce that, notwithstanding the precise rules of perspective which Euclid and others established, this knowledge was not so widely known at that time as it is today.

He allowed nothing to slip past: each object in a painting should have a meaning, a purpose, a function; it should neither defy the laws of nature (a reservoir, for example, should not discharge more water than it can hold), nor should it flout rules of drawing. These constraints, however, did not disallow transfiguration. On the contrary, they favoured the persuasive force of the imagination anchored in reality. Rubens was steeped in these principles of perspective, optics and the coherence of an image, and when he painted nature he did not take notes or invent: he composed.

Into his landscapes he painted the light of every fine morning, the dense clouds of every storm whether it had been in Italy, Flanders, or any of the countries he had visited, every wood, every tree, every kind of foliage. He turned his vision to the sky which always filled a large part, often as much as half, of the painting with lapis lazuli, navy blue or as in the celestial vault of the *Last Great Judgement,* a pale blue mist irradiated with gold (which Turner would later copy). In painting landscapes Rubens mixed reality with religion and myth: *The Return of the Prodigal Son*[52] took place in a barn, *The Hunt of Meleager and Atalanta* was transferred to the woods at Eeckeren. He loved magical atmospheres, rainbows, whirlwinds of clouds, mists and moonlight. It is the taste for touches of fantasy which distinguishes his art from his predecessors', artists who had patiently researched natural phenomena, who deviated only in simple symbolism – like Jan Brueghel whose oak tree was meant to remind man of his insignificance when face to face with divine creation, or Patinir and Met de Bles, who expressed their wonder and terror in the fantastic much more than in what they saw. Rubens's paintings are voyages, journeys that in their intense use of perspective carry a kermess dance like an arrowhead right up to a miniscule village perched on an imperceptible hill on the green and pink horizon which melts into an immense sky.[53]

Rubens's seascapes also reveal his taste for invasions of the supernatural into reality. The tritons lend a helping hand to the sailors in *Christ's Miraculous Haul.*[54] The waves are peopled with nereids or sirens, and painted dark like Arnold Böcklin's Romantic rollers; they have nothing in

common with the grey current of the Schelde or the great crests of spray on which Ruysdaël would perch his ships. He would have been more likely to have painted Gericault's *Raft of the Medusa* there had the events it depicts occurred in his lifetime, because it corresponded to his conception of a natural world which was not tragic but uncontrollable and which he liked to depict as perpetually evolving. Taine said:

> He made even more of his effects by his arrangement of them . . . as if he had the key to a natural world beyond ordinary nature, a hundred times richer, and with his magician's hands could draw from it into infinity, without the free play of his fantasy ever ending in an unharmonious muddle, but rather with such vigorous fluency and such natural extravagance that his most complicated works seem like an irresistible outpouring from a mind which is overflowing. Like an Indian god he assuaged his urge for procreation by creating worlds and, from the incomparable crimsons of his crumpled, pleated robes to the snowy whites of his flesh tones or the pale silk of his blonde heads of hair, there is not a single tone in any of his paintings which was painted without giving him pleasure.'[55]

Though this may be true of every painter, one has to agree with Taine that Rubens, more than any other painter, has created his own worlds. He has painted everything but in doing so he was never guilty of a 'literal rendering of phenomena', which was how Paul Valéry described Leonardo's written work, and which would have been more appropriate in describing Flemish primitive art. He was guilty of it only when he was guided by mythology in a painting such as *The Head of Medusa*.[56] Like Hieronymous Bosch, Rubens amused himself mimicking creation, expressing its mystery through devices which were as phantasmagorical as they were preposterous. He did not go into ecstasies when he saw forests and rocks as did Patinir or Met de Bles, who transformed them into gigantic precious stones or dusky gardens of Eden. He did not examine the world meticulously like Leonardo, anxious to discover how it worked, how it began, the reason of existence, the purpose of life. He did not hunt down the first traces of the world in the strata of rocks and he did not imagine the world being wiped out by the flood. Instead he concentrated on the evidence of what Baudelaire called 'elusive nature'. It is this sense of perpetual movement, as in those of his characters whose 'very repose is poised on the brink of action',[57] which animates Rubens's paintings and makes them 'a hundred times richer' because he has caught nature in the act of metamorphosis.

Rubens analysed the signs of mental alienation so finely that, three

centuries later, the first French psychiatrists, Charcot and Richer, were to find in his paintings examples of nervous disorders which they had only just identified. They wrote that 'His possessed offer personalities that are so true and so striking that we cannot think of or imagine a more perfect representation of the crises which we have described at length in our recent works and of which our sick patients at the Salpetrière offer typical examples daily.'[58]

Metamorphoses

Was it the flatness of Rubens's native Flemish countryside or its mysterious light which moulded his vision? His deviations from accepted wisdom are evident: the rainbow in the storm, carnal temptation in mystic love, the incarnation of the Holy Spirit, the universal soul in female flesh. We know him as a man between two worlds: eclecticism and synthesis, Italian and Flemish, Baroque and Renaissance, painter and diplomat, uniting one and the other in the transmutation of identity. He did not transform the world. There is nothing Promethean in Rubens's art, unlike Michelangelo's. It does not have the anger of Michelangelo's slaves, depicted in their brilliant deeply sunken eyes, their energetic features, lips half-opened to speak or cry out, the turbulent musculature of his male characters. Rubens never mistook himself for the Creator and neither challenged nor revolted against God. He did not measure his creation against the Almighty's, no more than he tried to symbolise his art's superiority to an artisan's by leaving his paintings unfinished, like Leonardo and Michelangelo. Delacroix commented that Rubens knew 'when to be careless at the right moment, as a way of being different'.[59] He was receptive to the multiplicity of views the world offered. He reconstructed it by painting according to his mood which Argan has described as 'Panic and Satyric',[60] undoubtedly under the influence of Latin and Greek literature, with their metamorphic legends. But Rubens would have been familiar as well with *The Golden Legend*, a Christian analogy of supernatural tales in which divine and human intermingle, in which things are never what they are but are always in transition. If we look at Rubens as someone who captured opposites simultaneously we might say, in an ultimate definition of the imprecise aesthetics of the seventeenth century, that he was a painter of transformation: 'We are not talking of variation of the truth as regards subject, but the condition under which the truth of a variation appears to the subject. This is the very essence of Baroque perspective.'[61]

Rubens himself never ceased to 'metamorphose', both socially and physically, and these transformations did not escape his notice. As a painter of the natural and human worlds over the years he did not spare himself, from the time of his *Honeysuckle Bower*[62] in which he confessed his ambitions, right up to his final self-portrait in which he at last reveals himself as he really was. He did not often indulge in self-portraiture, because using oneself meant one always had a convenient and cheap model, but when he did it was more through a desire to leave, if not a monument to his glory, at least a personal testimony of his existence. Most painters had difficulty in avoiding the pitfalls of subjective bias in this exercise and Rubens also encountered this problem. But although he never rivalled Rembrandt in his detachment – whose sixty paintings and twenty engravings pitilessly chronicled the progressive blemishes on his face – Rubens told his own life story without the pretensions which are evident in his correspondence.

His first self-portrait dates from his time in Italy. It was a group portrait showing a gathering of friends in Mantua, near the window of his apartment in the Reggia which overlooked the calm waters of Lake Mincio. The young painter can be recognised in the careful, highly finished and slightly sombre technique. He is in the foreground with his head turned three-quarters on towards the viewer. He has a round, almost chubby face, his youthfulness accentuated by a short fringe and small curly moustache; life appears easy and the company agreeable. Were it not for the scarcely discernible palette he is holding Rubens would look more like a burgher on a visit than an artist, with his lace collar and heavy green cape. In this painting he appears to be following the advice of Karl van Mander, the first historian of Flemish painting, who wrote at the beginning of his book, 'Every vice bears its punishment. Don't believe the proverb that claims that the best painter is the most disorganised. Anyone who leads a bad life is unworthy of the name of painter. Painters should never fight or quarrel. There's no skill in wasting your fortune. When you are young avoid chasing women. Be on your guard against loose women who are many painters' downfall. Think hard before going to Rome, for it offers too many opportunities to spend money and no way to earn it back. Always thank God for His gifts.'[63] Rubens would go to Rome and would earn money, but he did lead the life of the sensible, well-behaved man who figures on this canvas, now in Cologne Museum.[64]

In the same way, as soon as he returns home he marries a young girl from his own class. He is so replete with happiness that his eyes are almost closed, the smooth curve of his blond eyebrows barely sketched in above. His half-open mouth breathes out a sigh of contentment, unless he is

mouthing a kiss to Isabella seated at his feet. The bower of honeysuckle cocoons the young couple, makes them dizzy with its heady scent: it is springtime for flowers, emotions, life. Although Rubens is posing languidly, he was nonetheless a level-headed man intent on fulfilling the hopes that summer would bring, hopes that he placed in himself and carried at his side (in the form of the famous sword). . . . He was a painter but also a humanist who honoured his spiritual masters, Justus Lipsius and Seneca.

Rubens painted further self-portraits: one at the behest of the King of England and another for his friend Peiresc. The first dates from 1622-3, when Rubens was forty-five. Certain historians have questioned the veracity of this portrait, particularly regarding Rubens's hairiness: did he or didn't he have such a luxurious beard and such a gallantly curled moustache? Van Dyck, who made an engraving from this painting, added to it to such an extent that one wonders why Rubens obstinately hid his curls under a large hat. But his hair is not important. The man had changed. His fame as a painter was well established in the Low Countries and throughout Europe. When he returned to Antwerp life had perhaps been less easy than in Italy, everything had yet to be built. In Mantua, and even when newly married, he appeared carefree in comparison with this thinner man with searching eyes whom he had become twenty years on.[65] His cheeks are flat, his eyes sunken. He has a fine long nose with the plunging nostrils of a curious, enterprising person. His lips, which were always red and fleshy, are tight, almost pinched; the gentle arch of his eyebrows has taken on the shape of a circumflex accent. There is a certain air of abandon about him, as though he is ready for anything that might happen. Though rather vague, his look is haughty and circumspect - Rubens is no longer a dreamer. He observes and evaluates facts, people, the international situation and the price of his paintings.

Five years later (the self-portrait of 1628[66]) Isabella Brant was dead. After many trials and tribulations he had become the King of Spain's special envoy to England. He was fifty. Beneath his forehead, which is now larger and which catches the small amount of light in the painting, his face seems narrower, his eyes smaller. Crow's feet have made an appearance, the first wrinkles on his smooth pink face. His chin is lowered and he is looking away, as if absorbed in his inner world now that he has come to terms with reality. He accepts it with a small understanding smile; a little of his arrogance has gone. The lesson is understood and with his newfound wisdom there is a contentment; the line of his eyebrows is less tense, he has recovered the calm of youth.

Two years have passed. In 1630, laden with honours, he married Helena Fourment. When they walk together in the garden of the house by the

Wapper, Helena's dress, overdress, apron and slashed sleeves are so voluminous that they hide the husband standing beside her. He has to bend his head – his forehead ever larger – over the balls which decorate his wife's blouse as far as her shoulders, in order to appear other than as his constant accessory, the black hat.[67]

Rubens always appears robust in his paintings though, as we shall see in his last self-portrait, he daringly showed the scars of his gout. In fact he was careful to preserve his health with an appropriate diet and without much reliance on doctors. He had been ill on several occasions as when he had pleurisy which kept him to his bed in Rome and which a doctor friend of the painter Elsheimer, Johann Faber, cured. It would be another twenty years before he turned to medicine again – and not without scepticism, for in 1626, shortly after Isabella had succumbed to the plague, he himself began to suffer from feverish attacks. 'I feel drained, body and soul,' he wrote to Jacques Dupuy. 'You can guess that in spite of the remissions of the fever, my days are punctuated by doctors, purges, bloodlettings and other remedies, which are often more painful than the illness itself.'[68] It was in Spain that he began to suffer permanently from gout. He complained of it on 22 January 1627 to Dupuy, and on 29 December 1628 to Gevaerts: 'These last few days I have suffered a great deal from gout and fever.' In Madrid he was cared for by Fabrice Valguarnera from Palermo, a dubious character against whom several accusations of theft were made. Perhaps Rubens's suffering can be understood by his insistence on thanking the man who cured him. Three years after meeting Valguarnera in Madrid, where Rubens had certainly already recompensed him for his services, he was keen to paint him an *Adoration of the Magi* 'by his own hand'. The man who once had to be begged to paint a portrait of the Earl of Arundel is seen bowing and scraping to the doctor:

> Sir, I am astonished that you have not replied to me regarding the subject and the measurements of the painting that I see it my duty to paint for you in my own hand. I possess an *Adoration of the Magi*[69] which is seven to eight feet high, and almost square; it is not entirely finished; it will serve for the altar of some private chapel or could decorate the fire place in a big room. This is why I should like to know if the subject is agreeable to you: I beg you to make your wishes known to me in total freedom and confidence. I am ready to serve you whatever your taste is because of the obligation I feel towards you. Your very affectionate servant . . .
>
> I am risking writing to you here, not knowing if you are in Naples

or Palermo or elsewhere: I hope however that my letter reaches you at your address; I know that gentlemen of your rank are known everywhere.[70]

The doctor from Palermo's skill would only help for a time for the gout persisted and was no doubt aggravated by the many exhausting journeys he undertook on horseback or in barely more comfortable post carriages, as he noted to Pierre Dupuy: 'Seeing in so many journeys and in so little time, so many different countries, would have had more point in my youth than now at my present age, and would have been more useful, for my body would have been more robust to support the inconvenience of journeys by post.'[71] As we have seen, it was in a wheelchair that he surveyed the work for the Cardinal-Infante Ferdinand's Triumphal Entry. In 1635 he had to stay in bed for a month because of gout. In April 1638 the gout in his right hand prevented him from painting. In February 1639 he was so crippled that when he was summoned to the Assembly of the States General he had to be represented by his son Albert. Even though he was in the grip of gout Rubens nevertheless fathered another daughter whom he would never know and finished several religious paintings: *The Ascent to Calvary*, *The Martyrdom of St Lieven* and *The Massacre of the Innocents*. The Cardinal-Infante came to Antwerp to press for completion of the paintings destined for the Torre de la Parada. The first batch of fifty-six arrived in Madrid in April 1638. Philip IV sent a second order in June that same year, which the painter honoured in February 1639: eighteen paintings in eight months. Little of the work was painted in Rubens's own hand even though he made all the sketches, some of which can be seen today in Brussels, others in the Prado. There is a painful contrast between these luminous works in light coral on an old ivory-white background and the atrophied hands which produced them, which makes one think of the paralysed Renoir painting his last exuberant nudes. Rubens was withering away on his feet as he painted the passions of love, the legendary deeds of heroes, the inexhaustible vitality of the gods. In October 1639 Philip IV asked him for a further eighteen paintings, and he began to work on them.

Ecce homo: Behold the man in his final self-portrait:[72] the bloated face, the nose with rosacea, the sunken red swollen eyes under heavy lashless lids, the cheeks etched with deep wrinkles. The beard and moustache have grown sparse and he gazes on the world with a disenchanted look. The ruff of pleated batiste which covers his neck comes right up to his ears. It is not that his head has sunk into his shoulders - he had shrunk. Under his black courtly dress his chest is swollen with experience, with the

suffering of these last years and his unconquerable pride. No smile, no sigh, no pursing of lips. His expression is neither happy nor unhappy. His mouth is a straight impassive line from which all emotion has been drained. He still carries his sword and on its pommel rests a bare left hand deformed by arthritis; his right hand is gloved. He has painted himself how he wishes to be remembered – self-mocking, life has nothing further to offer this man. He has accomplished more than he had ever hoped for; he is so rich that after his death even three months of public auctions scarcely sufficed to sell off his collections. Rubens's total fortune had risen to 400,000 florins, an enormous sum, and his private art collection included no less than 319 paintings, of which ninety-four were originals by his own hand, nine Titians, five Tintorettos, one Raphael, four Veroneses, one Dürer, three Holbeins, four Elsheimers, twelve Brueghels (Peter the Elder), ten Van Dycks and seventeen Adriaen Browers.

As was customary, as soon as their wedding was over Peter Paul had taken legal steps to secure Helena's future. In 1631 the couple had made a first will. In 1639 when the attacks of gout became increasingly frequent and severe, Rubens added a codicil which stipulated that each of his children would receive an equal part of the inheritance. On 5 April 1640 the Cardinal-Infante wrote to his brother that Rubens had to stop working because both his hands were paralysed with gout. Twelve days later the painter heard the sentence of the gods: 'If I were not retained here by age and by gout which renders me useless,' he wrote to the sculptor Francois Duquesnoy, 'I should go there to enjoy with my own eyes, and admire the perfection of works so worthy. Nevertheless, I hope to see you here among us, and that Flanders, our beloved country, will one day be resplendent with your illustrious works. May this be fulfilled before I close my eyes for ever.'[73]

On 27 May 1640 he summoned his lawyer Guyot and made a second will: his books would go to Albert as well as a part of the collection of agate, gems and medals which he would share with Nicolas. He left his paintings to certain friends as well as gifts to the poor and to charity. His drawings, as we know, were intended to go to whichever of his children would become a painter; it would be a long time before the youngest came of age to choose a career, after which the drawings were dispersed. None of his children would follow in his footsteps and no painter among his pupils in Antwerp or in the Low Countries would take his place. Van Dyck died too young and Jordaens was of a later generation, thundering long and loud over his copper engravings which he had introduced into Flemish art.

At this point perhaps we should try to decide whether or not Rubens was essentially a Flemish artist. Flemish art historians are keen to have

him so, to see him as the painter who 'restored Flanders to herself'.[74] Yet many artists, from every country, have drawn inspiration from him, diffracting his creation, and Rubens himself said: 'My country is the entire world.'[75] As Delacroix enthusiastically wrote: 'With his prodigious output Rubens seems like a lighthouse shedding its light over numerous brilliant schools.'[76] In fact, Piero de Cortone and Bernini were to be his first disciples in Italy; they never admitted it but their work is imprinted with his 'exuberant pathos'.[77] In France, in the century which followed, Rubens was at first decried by those idealists of Reason for his abuse of allegory. 'It is rare for painters to succeed in this genre, because it is impossible in such compositions to make their subject distinctly recognisable and make their ideas accessible to the most intelligent of viewers ... he can only put a small number of figures into this composition, and these figures are not easy to recognise. If one cannot readily understand a painting it becomes like gibberish,' said the Abbé Dubos in his *Réflexions Critiques* of 1719.[78] The Luminaries did not want myth and argued that middle-class people, not heroes, should be the subjects of painting.

Then, when painters gradually began to distance themselves from the classicism of Poussin (which examined the senses rationally and tried to define what was beautiful before embarking upon a painting), Rubens came to symbolise an art freed from the restraints of reason. Watteau clothed his characters in the costumes of Louis XIII which Rubens had used and which he saw when he went to admire Rubens's paintings in the Luxembourg palace. He drew his *fêtes galantes* from the misty *Garden of Love* which he suffused with the bitter light of his own consumptive illness.

A little later, in the spring of Romantic, pastoral England, it was John Constable and Joshua Reynolds who called upon his spirit. Constable elaborated on Rubens's sensitivity to atmospheric phenomena and their corresponding alterations of light, which he used to render the glistening of water and movement. Reynolds called him simply 'a god descended from the heavens' and as a portrait painter himself tried to capture the personality of his models by challenging the classical tradition, the enemy of subjectivity. In contrast to many artists who each had their purgatory, their time of oblivion, after his death Rubens remained a constant point of reference for painters either for or against him.

In the nineteenth century he was the Lighthouse, 'the Homer of painting' whom Delacroix celebrated no less than 169 times in his *Journal*. Fromentin, the Orientalist, wrote a book about him, as would numerous subsequent researchers, thereby compiling one of the most prolific bibliographies in art history. 'A debauchery of painting,' the Goncourt brothers would say between gritted teeth as they stood before *The Last Judgement* in Munich.

'Just a painting,' said Panofsky of Rubens's portrayal of nature, while carefully enthusing over van Eyck's meticulous reconstruction of his visible world.[79] Picasso detested Rubens but still needed to talk about him with the dealer Kahnweiler. 'He's gifted, but he's used his gifts to make nasty things, a nothing. Rubens's paintings say nothing. It's journalism, historical film.'[80] André Malraux, on the other hand, retraces the Romantic line of descent from Michelangelo to Rubens to Rembrandt:

> Poussin had continued in the manner of Raphael in an apparently rational world. But what was the connection between Rembrandt and Titian, Rubens and Michelangelo if not through the fascinating unknown world with which Romanticism countered reality? This world encapsulates that world which the great masters conquered and breaks beyond its bounds. It is revealed through the plurality of paintings which display it. Art becomes a sovereign world, because, beyond his lost holiness and his vain power, man finds himself and himself alone, his obscurely Promethean grandeur; through his very nature, through this reflection of infinity in which he recognises himself, he must take up man's protest against the human condition and base it in immortality.[81]

Rubens belonged to universal history rather than to his country, for he had quickly outstripped Flanders' limitations, its earthly and artistic frontiers, to nourish his art in Italy, in France, in Spain, in antiquity, and gain experience of other countries and other centuries. He extended his art into humanism, Greek and Latin literature, architecture, the sciences and public affairs, outgrowing his era, his nation and his duties, just as his compositions extend beyond their frame. Of course he was Flemish, he was a man who liked order, obedient maternal women, the exact sciences, night life and the River Schelde and his town of Antwerp, which was present in almost every one of his paintings with that vermillion which, coming from cinnabar, so the alchemists said, held the secret of turning base metal to gold. Peter Brueghel 'of Hell' is represented most in his personal collections, and Rubens renders homage to Brueghel in his *Kermess* which is in the Louvre, painted in one day in a rare concession to the pictorial and festive traditions of his fatherland.

Rubens also betrays his country, for while the couples of Brueghel the Elder dance in a gross pitching and tossing which throws them into the centre of the canvas and brings them dangerously close to the earth, Rubens's couples seem like tumbleweed swept by the wind towards the colourless horizon into which the painting dissolves. He had feasted his

art on too many foreign elements ever to express the essence of a nation, but the very particular light of Flanders gave him a medium for his metaphorical painting. But neither his women nor his masculine heroes, nor his landscapes, nor his assemblies, are a faithful rendering of the Low Countries and their society in which he spent the greater part of his life, to which he had devoted his political life, and where he was regarded as a hero.

On 27 May 1640 Rubens dictated his last will and fell into a coma. Two doctors, Lazare Marquis and Antonio Spinosa, opened up one of his veins. The news that he was dying spread through the town and 4,000 people accompanied the priest of the parish of St James who brought him the last sacrament. To those who asked if a mortuary chapel had been erected for him, Rubens had replied that 'if his widow, his eldest son and the tutors of his younger children felt that he had merited such a monument, they could have such a chapel built, without any other order on his part, and that they could use a painting of the Holy Virgin carrying the Infant Jesus on her arm and surrounded by many saints etc. for it; and a statue in marble of the Holy Virgin'.[82]

On 31 May, Gerbier wrote from Brussels: 'Sr Peter Rubens is deadly sick; the Phisicians of this towne being sent unto him to try there best skill on him.'[83] Rubens had died the previous day. The infection had reached his heart, and he died at midday holding Albert and Helena's hands.

Two days later he was buried. 'The clergy of [St James church] and the chapter of the cathedral walked in front of the coffin; then came the mendicant orders, with their solemn picturesque costume. To right and left advanced sixty orphans each holding a lighted candle. Behind the body, one saw the great man's family, the magistrate, the Painters' Academy [the Guild of St Luke], a party of noblemen, merchants and rich burghers. The crowd formed a hedge on either side.'[84] The funeral convoy moved upstream beside the Wapper, turned to the right, crossed the Meir where Rubens had spent his childhood, took a little street at the end of which was the square tower of St James with its pointed arris and black roofs. The coolness of the church could be felt in the doorway as it met the feverish heat of this last summer. 'In the church the choir was dressed in black velvet from vaulted ceiling to the ground, and the altar was also decked in black velvet. A cenotaph stood in the middle of the reserved enclosure. The musicians of Our Lady played throughout the whole of the mass, accompanying the funeral psalms and the *Dies irae*. Then the bier was lowered into the Fourment tomb.'[85]

That day four banquets were held in Rubens's honour, at his house, at the town hall, at the Brotherhood of Romanists and at the Guild of St Luke.

Over the next six weeks masses were celebrated for the repose of his soul: one hundred and fifty by the brothers of Our Lady, one hundred by the Augustines, Dominicans, Capucins, Franciscans and the barefoot Carmelites, fifty among the Beguines and the Minims, fifteen in the Emperor's chapel, twenty-five at Elewijt, ten at Malines.

The paintings for the Torre de la Parada were unfinished; Erasmus Quellyn III added the final touches.

'In this great life of his,' wrote Fromentin, 'which is so rigorous, clearcut, brilliant, adventurous, and yet so transparent, so correct even when his behaviour was astonishing, so sumptuous and yet so simple, so unsettling and yet so lacking in pettiness, so fractured and yet so prolific, can you discover a single cause for regret?'[86]

PRINCIPAL WORKS CONSULTED

Ardents, Prosper - *La Bibliothèque de P.-P. Rubens* (Brussels, 1961)

Argan, Claudio - *Storia dell'arte italiana* (Sansoni, Milan, 1983) *L'Europe des capitales 1600–1700* (Skira, Geneva, 1964)

Armangaud, Françoise - *Titres* (Méridiens Klincksieck, Paris, 1988. Académie Anquetin, Cahiers, 1971)

Baie, Eugène - *L'Épopée flamande* (Paris, 1917) *Le Siècle des gueux* (Brussels, 1953)

Baudelaire, Charles - *Pour Delacroix* (Éditions complexes, Paris, 1986)

Baudoin, Franz - *Rubens* (Antwerp, Paris, 1977) *La Maison de Rubens à Anvers* (Antwerp, 1957)

Bertolotti, Antonino - *Artisti belgi e olandesi a Roma* (1880)

Blunt, Anthony - *Rubens architect* (*Burlington Magazine*, London, September 1977)

Bukofzer, Manfred D. - *La Musique baroque, 1600–1700* (Lattès, Paris, 1982)

Burckhardt, Jakob - *La Civilisation de la Renaissance en Italie* (Denoël-Gonthier, Paris, 1964)

Carmona, Michel - *La France de Richelieu* (Éditions complexes, Paris, 1985)

Castiglione, Balthasar - *Le Livre du Courtisan* (G. Lebovici, Paris, 1987)

Cauchie, Alfred - *Histoire de la Flandre au XVIIe siècle* (Brussels, 1904)

Clark, Kenneth - *The Nude* (Penguin, London, 1976)

Claudel, Paul - *L'œil écoute* (Gallimard, Paris, 1964)

Delacroix, Eugène - *Journal 1822–1863* (Plon, Paris, 1981)

Deleuze, Gilles - *Le Pli* (Éditions de Minuit, Paris, 1988)

Devèze, Michel - *L'Espagne de Philippe IV* (S.E.D.E.S., Paris, 1972)

Faure, Elie - *Histoire de l'art* (Gallimard, Paris, 1988)

Félibien - *Entretiens I et II* (Les Belles-Lettres, Paris, 1987)

Friedlander, Max - *Von Eyck bis Bruegel* (Berlin, 1921)

Fromentin, Eugène - *Les Maîtres d'autrefois* (Pléiade, Paris)

Gachard, Louis-Prosper - *Histoire politique et diplomatique de Pierre-Paul Rubens* (Office de Publicité, Brussels, 1877)

Goldwater, Robert and Treves, Marco - *Artists on art from the 14th to the 20th century* (John Murray, London, 1976)

Gombrich, Ernst - *The Story of Art* (Phaidon, London, 1972) *Symbolic Images* (Phaidon, London, 1975)

Gregg, Pauline - *Charles Ier* (Fayard, Paris, 1984)

Guichardin, Louis - *Description des Pays-Bas* (Paris, 1613)

Hanoteaux, Gabriel - *Sur les chemins de l'Histoire* (Paris, 1924)

Haskell, Francis - *Patrons and painters in baroque Italy* (Yale, 1980)

Hautecœur, Louis - *Littérature et peinture en France du XVIIe au XXe siècle* (Armand Colin, Paris, 1963)

Held, Julius - *Rubens's drawings* (Phaidon, London, 1986)

Jaffé, Michael - *Rubens and Italy* (Phaidon, London, 1977)

Justus Lipsius - *Traité de la Constance* (Brussels/Leipzig, 1873)

Male, Emile - *L'Art religieux après le concile de Trente* (Armand Colin, Paris, 1932)

Mechoulan, Henry (edited by) - *L'Etat baroque, 1610–1652* (Vrin, Paris, 1985)

Michel, Emile - *Rubens, sa vie, son œuvre et son temps* (Paris, Hachette, 1900)

Michiels, Alfred - *Rubens et l'école d'Anvers* (Armand Colin, Paris, 1854) *Histoire de la peinture flamande depuis ses débuts* (Paris, 1865–1867)

Michiels, Sylvestre, Manz, Wauters - *Histoire des peintres de toutes les écoles* (Paris, 1864)

D'Ors, Eugenio - *Du baroque* (Gallimard, Idées/art, Paris, 1968)

Pacheco, Francisco - *L'Art de la peinture* (Méridiens Klincksieck, Paris, 1986)

Panofsky, Erwin - *Early Netherlandish Painting* (Harper and Row, New York, 1971) *La Vie et l'art d'Albrecht Dürer* (Hazan, Paris, 1987) *Studies in iconology* (Harper and Row, New York, 1972) *Idea, a concept in art theory* (Harper and Row, New York, 1968)

De Piles, Roger - *Dissertation sur les ouvrages des plus fameux peintres dédiée à Monseigneur le Duc de Richelieu* (Paris, 1681) *Réflexion sur les ouvrages de P.-P. Rubens* (Paris, 1838) *Conversation sur la connaissance de la peinture* (Paris, 1677)

Pirenne, Henri - *Histoire de la Belgique des origines à nos jours* (La Renaissance du Livre, Paris, 1973)

Van Puyvelde, Léo - *Peintres flamands du XVIIe siècle* (Brussels, 1953)

Ravensburg, Goeler von - *Rubens und die Antike* (Iéna, 1882)

Rooses, Max - *L'Œuvre de P.-P. Rubens. Histoire et description de ses tableaux et dessins*, vols I to V (Antwerp, 1886–1892) *Rubens, sa vie et ses œuvres* (trans. from Flemish) (Flammarion, Paris, 1903) *Art in*

224

Flanders (W. Heinemann, London, 1914) *Le Musée Plantin-Moretus* (Antwerp, 1920) *Plantin et l'imprimerie plantinienne* (Antwerp, 1878)

Rosand, David - *Tiziano* (Garzanti, Milan, 1983)

Sainsbury, William Noel - *Some original unpublished papers relating to Rubens* (London, 1859)

Sandrart, Joachimi de - *Academia nobilissimae artis pictoriae* (Nuremberg, 1683)

Schama, Simon - *The embarrassment of riches* (Fontana, 1987)

Schizzerotto, Giancarlo - *Rubens a Mantova* (Mantua, 1979)

Schoy, Auguste - *Rubens et la fermeture de l'Escaut* (Brussels, 1878)

Taine, Hippolyte - *Philosophie de l'art* (Paris-Geneva, 1980)

Tapié, Victor - *Baroque et Classicisme* (Le Livre de Poche, Paris, 1980)

Tolnay, Charles - *Michelangelo* (Princeton, 1960)

Vasari, Giorgio - *Vite* (Einaudi, Turin, 1986)

Vinci, Leonardo da - *Carnets* (Gallimard, Paris, 1987)

White, Christopher - *Rubens* (Yale, 1987)

Woelfflin, Heinrich - *Renaissance et baroque* (G. Montfort, 1985)

WORKS BY RUBENS

Palazzi di Genova, 1st edition, 1622. Plans and façades of 12 palaces, 72 plates.

2nd part: Plans and façades of 19 palaces et 4 churches. 67 plates. Antwerp, 1652.

Théorie de la Figure humaine considérée dans ses principes (attributed to Rubens). Paris, 1773.

Les leçons de Pierre-Paul Rubens ou fragments épistolaires sur la religion, la peinture et la politique, ed. Ch. Reg. d'Ursel, abbé de Gembloux. Brussels, 1838. (Text by a monk who lists correspondence with Rubens, of which he alone has traced.)

The letters of P. P. Rubens, edited by Ruth Saunders-Magurn. Cambridge, Massachusetts, 1955.

Correspondance de P.-P. Rubens et documents épistolaires. Charles Ruelens and Max Rooses: vol. I: 1600-1608. Antwerp, 1877; vol. II: 1609-21 July 1622. Antwerp, 1898; vol. III: 27 July 1622-22 October 1626. Antwerp, 1900; vol. IV: 29 October 1626-10 August 1628. Antwerp, 1904; vol. V: September 1628-26 December 1631. Antwerp, 1907.

NOTES AND REFERENCES

INTRODUCTION

1. *Artists on Art*, compiled and edited by Robert Goldwater and Mario Treves, p. 192

A DIVIDED CHILDHOOD

1. Munich. Alte Pinacothek
2. Henri Hauser, *La Préponderance espagnole, 1559–1600*
3. Jean Cassou, *La Vie de Philippe II*, Paris 1929
4. Alfred Michiels, *Histoire de l'ecole d'Anvers*, p. 65
5. Alfred Michiels, *op. cit.*, p. 698
6. Max Rooses, *Rubens, sa vie et ses oeuvres*
7. Emile Michel, *Rubens, sa vie, son oeuvre, son temps*, p. 27
8. *Ibid.*, p. 26
9. Eugène Fromentin, *Les Maîtres d'autrefois*, p. 586
10. Max Rooses, *op. cit.*, p. 45
11. *Ibid.*
12. Emile Michel, *op. cit.*
13. *Histoire de toutes les écoles. L'école flamande*, p. 9
14. Erwin Panofsky, *Early Netherlandish Painting*, p. 2
15. Paul Manz, *Histoire de l'école flamande*, p. 2
16. Erwin Panofsky, *op. cit.*, Vol. 1, p. 142
17. Paul Manz, *op. cit.*, p. 5

ITALIAN JOURNEY

1. M. Rooses, *op. cit.*, p. 49
2. Sebastiano Serlio (1475–1564), author of a treatise on architecture intended for amateurs rather than professionals, which was very popular and was widely translated in Renaissance Europe. He was architect and painter to François I of France and in France the design of Château d'Ancy-le-Franc has been attributed to him.
3. Guide to the Palazzo del Te
4. *Correspondance*, Vol. 1, p. 392
5. *Letters*, p. 269

6. *Ibid.*, p. 367
7. Ludovico Muratori, *Rubens a Mantova*
8. *Ibid.*
9. J. Burckhardt, *op. cit.*, Vol. 1, p. 85
10. Francisco Pacheco, *L'Art de la peinture*, p. 121
11. Salvatore Rosa to Antonio Ruffo 1 April 1666, in Francis Haskell, *Patrons and Painters. Art and Society in Baroque Italy*, p. 22
12. *Correspondance*, 9 June 1607. Paul Colin. Vol. 1, pp. 38–39
13. Emile Mâle, *L'Art religieux après le concile de Trente*, p. 2
14. Jules et Edmond de Goncourt, Madame Gervaisais, in Victor Tapié, *Baroque et Classicisme*, pp. 9, 10
15. Claudio Argan, *L'Europe des capitales*
16. E. Michel, *op. cit.*, p. 61
17. In M. Jaffé, *op. cit.*, p. 12
18. Julius Held, *Rubens's drawings*, p. 43
19. Michael Jaffé, *op. cit.*, p. 80
20. Peiresc, a passionate collector of antique cameos in a letter of 14 January 1633 to Guillaumin, recommended him, when he was carrying out the ornamentation of a vase, to enlist the services of a certain Flesche, 'since he had practised M. Rubens's technique of moulding, which would be a help'. Quoted by Giancarlo Schizzeroto, in *Rubens a Mantova*, 1978, p. 169
21. J. Held, *op. cit.*, p. 44
22. In M. Jaffé, *op. cit.*, Pierre Crozat, 1741
23. '*Rubens, ses maîtres et ses élèves*', catalogue of the 1978 exhibition in the Cabinet des Dessins, Musée du Louvre, Paris
24. *Ibid.*, p. 116.
25. In Max Rooses, *op. cit.*, p. 58
26. 8 June 1601, *Correspondance*, 1
27. Félibien in E. Michel, *op. cit.*, p. 58
28. *Correspondance*, 1, p. 27
29. *Ibid.*, p. 25, 18 March 1603
30. *Ibid.*, p. 32, 24 May 1603, Valladolid
31. *Ibid.*, p. 33
32. E. Michel, *op. cit.*, p. 64
33. *Letters*, p. 34
34. *Ibid.*, p. 35
35. E. Michel, *op. cit.*, p. 86
36. M. Jaffé, *op. cit.*, p. 69
37. *Letters*, p. 42
38. 23 February 1608, Rome. *Letters*, p. 44

39. *Ibid.*, p. 46
40. *Ibid.*, p. 46
41. *Le seicento dans les musées français*, Paris, Grand Palais, 1988
42. Ugo Bazotti, *Rubens e Mantova*, Mantua, 1978, p. 39
43. M. Jaffé, *op. cit.*, p. 100
44. November 1603, from Valladolid. *Letters*, p. 38
45. *Ibid.*, p. 52

THE PAINTER OF ANTWERP

1. 10 April 1609
2. H. Pirenne, *Histoire de la Belgique*, Vol. 3, p. 73
3. Letter of Philip Rubens to Peter Paul on his return from Spain
4. Roger de Piles, *Dissertation sur les plus fameux peintres*, Paris, 1681, p. 12
5. *Correspondance*, Vol. II. Letter of 5 November 1609 from Philip Rubens to the Low Countries' ambassador in France, Pierre Pecquius
6. 10 April 1609, Johann Faber, *Letters*, p. 52
7. *Ibid.*
8. *Correspondance*, II, p. 22 sq
9. Roger de Piles, *Dissertation . . .*, p. 27
10. Justus Lipsius, *Traité de la Constance*, p. 217
11. In H. Pirenne, *op. cit.*, p. 179
12. *Ibid.*, p. 179
13. In Noel Sainsbury, *Papers relating to Rubens*, p. 11
14. In M. Rooses, *op. cit.*, p. 113
15. Émile Verhaeren
16. Galerie de Marie de Medicis, in the Louvre, *Diana at her bath* of Jakob Jordaens
17. Roger de Piles, *op. cit.*, p. 13
18. *Ibid.*, p. 30
19. Rubens's reply to the alchemist Brendel who promised him half his treasures if he would help him construct a laboratory to turn base metal into gold. In A. Michiels, *op. cit.*, p. 231
20. *Ibid.*, p. 451
21. *Ibid.*, p. 454
22. *Ibid.*, p. 131
23. *Correspondance*, II, p. 36
24. Because of his privileges granted by the Archdukes, Rubens did not have to register his students at the Guild of St Luke, which is why the names of all his early pupils are missing
25. Joachimi de Sandrart (1606-88), a pupil and confidant of

Rubens. Author of *Teutsche Akademie der Edlen Bau-Bild-und Mahlerey Künste*, a book in three parts, the first being devoted to architecture, the second to biographies of certain artists, for which he borrowed material from the works of Vasari and Mander among others, the third relating to artists from his own native country of Germany

26. A. Michiels, *op. cit.*, p. 247
27. E. Fromentin, *op. cit.*, pp. 644–645
28. A. Michiels, *op. cit.*, p. 199
29. A. Michiels, *op. cit.*, p. 200
30. Doubtless this is why H. Hymans presented him to the Belgian Academy as 'of such great interest to art history'
31. Waldemar de Seidlitz, *Repertorium für Kunstwissenschat. Bericht eines Zeitgenosses über den Besuch bei Rubens. Repertorium Xer Band*, p. 111
32. Letter of Lord Danver to Carleton, 27 May 1621. *Correspondance*, II, p. 277
33. A. Michiels, *op. cit.*, p. 200
34. Cf. chap. II, p. 71
35. *Letters*, p. 72
36. *Correspondance*, II, p. 91
37. 28 April 1618, letter to Carleton. *Correspondance*, P. Colin. Vol. I, p. 60
38. 26 January 1621, to William Trumbull. *Letters*, p. 76
39. Roger de Piles, *Dissertation*, in E. Michel, *op. cit.*, p. 218
40. E. Michel, *op. cit.*, p. 132
41. A. Michiels, *op. cit.*, p. 136
42. Cahiers de l'Académie Anquetin, p. 71
43. 9 April 1615, Letter from Balthasar Moretus to a buyer in Toledo, in E. Michel, *op. cit.*, p. 175
44. J. D. Régnier, *Matières colorantes et procédés de peinture employés par P.-P. Rubens. Découvertes faites par* ... Ghent, 1847
45. E. Fromentin, *op. cit.*, pp. 601–602
46. R. Goldwater and M. Treves, *Artists on Art*, p. 144, in which they point out that almost the whole of Rubens's vast correspondence is devoted to business matters. The letter concerning the death of Adam Elsheimer, a young German painter from whom Rubens had learnt a great deal while they were together in Rome, is the only one which shows a personal human interest
47. *Letters*, p. 46
48. 19 March 1614. *Letters*, pp. 56–57

49. Quotation from psalm 128.5. 12 May 1618 to Dudley Carleton. *Correspondance*, II, p. 62

50. E. Panofsky, *La Vie et l'art d'Albrecht Dürer*, p. 81

51. 19 June 1622, to Peter van Veen. *Letters*, p. 88

52. 23 January 1619, to Peter van Veen. *Letters*, p. 69

53. Joachimi de Sandrart in E. Michel, *op. cit.*, p. 272

54. M. Rooses, *op. cit.*, p. 335

55. E. Michel, *op. cit.*, p. 272

56. 4 January 1619. *Letters*, p. 68

57. E. Michel, *op. cit.*, p. 278

58. M. Rooses, *op. cit.*, p. 328

59. 28 April 1618, to Dudley Carleton. *Letters*, p. 60

60. 4 October 1611. Letter from Dominique Baudius to Rubens on the death of his brother. *Correspondance*, I, p. 45

61. Félibien, *Entretien . . .*, p. 147

62. 13 September 1621 to William Trumbull, James I's agent in Flanders. *Letters*, p. 77

63. Antwerp, Our Lady Cathedral

64. Philadelphia, Museum of Art

65. Antwerp, Our Lady Cathedral

66. Malines, Our Lady

67. Brussels, Musée Royal des Beaux-Arts

68. Antwerp, Church of St Paul

69. 2 February 1608. *Letters*, p. 43

70. Munich, Alte Pinacothek

71. Brussels, Musée Royal des Beaux-Arts

72. Antwerp, Musée Royal des Beaux-Arts

73. *Ibid.*

74. *Ibid.*

75. Attributed to Peter-Paul Rubens, *Théorie de la figure humaine . . .*, p. 6

76. *The Assumption of the Virgin Mary*, Brussels, Musée Royal des Beaux-Arts; Vienna Kunsthistorisches Museum

77. 24 July 1620. *Letters*, p. 75

78. E. Faure, *Histoire de l'art. L'art moderne*, Vol. I, Paris, 1988, p. 45

79. Vaduz, Liechtenstein

80. Antwerp, Musée Royal des Beaux-Arts

81. Kassel, Gemäldegalerie

82. Elie Faure, *op. cit.*, p. 45

83. A. Michiels, *op. cit.*, pp. 188–190

84. Eugéne Delacroix in E. Michel, *op. cit.*, p. 145

85. Victor Tapié, *op. cit.*, p. 145
86. Brussels, Musée Royal des Beaux-Arts
87. Antwerp, Musée Royal des Beaux-Arts
88. E. Fromentin, *op. cit.*, p. 611
89. A. Michiels, *op. cit.*, p. 113
90. Eugenio d'Ors, *Du baroque*, p. 29
91. C. Argan, *L'Europe des capitales*, p. 95

PROTEUS

1. Vaduz, Liechtenstein
2. August 1630 to Peiresc. *Letters*, p. 367
3. Life of Peter Paul Rubens by his nephew Philip, in A. Michiels, *op. cit.*, p. 134
4. 5 July 1602, Philip Rubens to Peter Paul. *Correspondance*, I, p. 62
5. Antwerp, Musée Royal des Beaux-Arts
6. L. Guichardin, *Chronique d'Anvers et des Pays-Bas*, Paris, 1613, p. 144
7. Antwerp, Musée Royal des Beaux-Arts
8. For Plantin's printing works, Rubens would make frontispieces and illustrations for twenty books on theology and Church history; thirteen history books; nine books on archeology and philology; five books of poetry and one scientific work
9. Leonardo da Vinci, *Carnets*, Vol. II, Paris, 1987, p. 512
10. *Correspondance*, II, p. 425
11. *Ibid.*, p. 424
12. *Ibid.*, p. 427
13. 10 August 1623, letter to Peiresc. *Letters*, p. 93
14. 9 August 1629. *Letters*, pp. 321–323
15. 'In reality, Drebbels's invention was in all probability only an instrument to measure atmospheric disturbances, that is to say the perpetual movement which is there in the milieu in which we live.' *Correspondance*, III, Charles Ruellens, p. 35
16. *Correspondance*, III, Charles Ruellens, p. 36
17. *Correspondance*, III, p. 414
18. Eugène Baie, *L'Epopée flamande*, p. 293
19. In M. Rooses, *op. cit.*, p. 500
20. *Correspondance*, II, p. 135
21. *Correspondance*, III, p. 219
22. *Ibid.*
23. *Correspondance*, III, p. 193
24. *Ibid.*, p. 199
25. *Ibid.*, p. 199

26. *Ibid.*, p. 110
27. *Ibid.*, p. 28
28. Félibien, *Entretiens* . . ., p. 14
29. *Correspondance*, III, p. 323
30. *Ibid.*, p. 474
31. Michel Carmona, *La France de Richelieu*, Paris, 1985, p. 77
32. *Ibid.*, p. 35
33. 23 September 1622. *Correspondance*, III, p. 48
34. 17 March 1622. *Correspondance*, II, p. 353
35. 4 August 1622. *Correspondance*, III, p. 13
36. 11 November 1622. *Ibid.*, p. 71
37. *Ibid.*, p. 332
38. *Ibid.*, p. 140
39. *Ibid.*, p. 165, 4 May 1623
40. E. Michel, *op. cit.*, p. 330
41. *Correspondance*, III, p. 181
42. In E. Michel, *op. cit.*, p. 326
43. *Ibid.*
44. *Letters*, p. 110
45. Cf. appendices
46. Charles Baudelaire, *Pour Delacroix*, Paris, 1986, p. 199
47. E. Michel, *op. cit.*, p. 330
48. 29 January 1624, in Louis-Prosper Gachard, *Histoire* . . ., pp. 7–8
49. Michel Devèze, *L'Espagne de Philippe IV*, I, p. 35
50. *Ibid.*, p. 49
51. *Ibid.*, p. 50
52. *Ibid.*, p. 52
53. 10 August 1623 to Peiresc. *Letters*, p. 93
54. 3 September 1623 to Pecquius, in L.-P. Gachard, *op. cit.*, pp. 21, 22, 23
55. Baugy to the Secretary of State of Ocquerre, 30 August 1624, in L.-P. Gachard, *op. cit.*, p. 26
56. Baugy, 13 September 1624, in E. Michel, *op. cit.*, p. 334
57. 15 March to Archduchess Isabella, in L.-P. Gachard, *op. cit.*, p. 29 *et seq*
58. To Jan Brant, 20 July 1625. *Letters*, pp. 113–114
59. *Ibid.*, p. 386
60. *Ibid.*, p. 388
61. Gabriel Hanoteaux, *Sur les chemins de l'Histoire*, p. 271
62. In E. Michel, *op. cit.*, p. 376
63. 2 April 1626 to Valavès, *Correspondance*, III, p. 435
64. *Ibid.*, p. 320

65. 15 July 1626 to Pierre Dupuy. *Correspondance*, Paul Colin, Vol. I, pp. 100-101
66. Olivares to Rubens 8 August 1626. *Correspondance*, III, p. 454
67. In A. Michiels, *op. cit.*, p. 154

THE EMBASSIES
1. Michel Devèze, *op. cit.*, Vol. I, p. 83
2. 5 November 1626, to Pierre Dupuy. *Correspondance*, IV, p. 10
3. *Letters*, p. 183
4. Philip IV to the Infanta Isabella, 5 June 1627. *Correspondance*, IV, p. 84
5. *Correspondance*, IV, p. 85
6. *Ibid.*, p. 75, 1 June 1627
7. E. Michel, *op. cit.*, p. 27. Joachimi de Sandrart, *Teutsche Akademie* in *Correspondance*, IV, pp. 88-89
8. 25 July 1627 Dudley Carleton to Lord Conway. *Correspondance*, IV, p. 100. Also PRO.
9. *Correspondance*, IV, p. 124
10. L.-P. Gachard, *op. cit.*, pp. 68-69. Cf. appendices
11. Report of the meeting of the Junta on international affairs, 7 October 1627. *Ibid.*, p. 156
12. *Ibid.*, p. 127
13. Cardinal de Richelieu, *Testament politique*, p. 134 in M. Carmona, *op. cit.*, p. 148
14. *Correspondance*, IV, p. 137
15. *Letters*, p. 182
16. *Ibid.*, p. 141
17. 26 January 1628. *Correspondance*, IV, p. 166
18. *Letters*, p. 236
19. 18 March 1628. *Letters*, p. 246
20. *Letters*, p. 252
21. *Correspondance*, IV, p. 214
22. *Ibid.*, p. 231
23. *Letters*, p. 227
24. M. Rooses, *op. cit.*, p. 451
25. *Letters*, p. 209
26. *Ibid.*, p. 211
27. *Ibid.*, p. 176
28. 19 May 1627 to Balthasar Gerbier. *Letters*, pp. 181-182
29. *Letters*, p. 198
30. *Letters*, p. 182

31. To Olivares, 21 September 1629. *Letters*, p. 343
32. To Pierre Dupuy, 29 June 1628. *Ibid.*, p. 271
33. To Pierre Dupuy, 13 April 1628. *Ibid.*, p. 256
34. *Ibid.*, p. 238. 17 February 1628, to Pierre Dupuy. Horace, *Carmen Saeculare* 2.1.8
35. 11 May 1628. *Letters*, p. 261
36. *Ibid.*, p. 191
37. *Ibid.*, p. 209
38. *Ibid.*, on Buckingham's triumphal welcome after the Ile de Ré and La Rochelle expeditions
39. 20 July 1628 to Pierre Dupuy. *Correspondance*, IV, p. 448
40. 6 July 1628 to Pierre Dupuy. *Letters*, p. 272
41. 28 May 1627. *Letters*, p. 185
42. *Correspondance*, V, 8 August 1630
43. 27 January 1628, *Letters*, p. 234
44. *Ibid.*, p. 234
45. 20 July 1628. *Correspondance*, IV, p. 448
46. To Spinola, 11 February 1628. *Letters*, p. 236
47. 30 September 1627. *Letters*, p. 207
48. 23 September 1627. *Ibid.*, p. 205
49. 28 October 1627. *Ibid.*, p. 211
50. 6 January 1628. *Letters*, p. 228
51. 13 January 1628. *Ibid.*, p. 230
52. *Letters*, p. 263
53. *Letters*, p. 269
54. 20 April 1628. *Letters*, p. 258
55. *Ibid.*, p. 234
56. *Ibid.*, p. 231. 20 January 1628
57. In M. Rooses, *op. cit.*, p. 455
58. *Burlington Magazine*, September 1977
59. Cf. chapter 4, p. 188
60. M. Rooses, *op. cit.*, p. 463
61. In M. Rooses, *op. cit.*, p. 465, 2 December 1628
62. Particularly in his sketches for studies of statues
63. F. Pacheco, *op. cit.*, pp. 121–122
64. L.-P. Gachard, *op. cit.*, p. 95
65. Letter from Philip IV to Isabella, in L.-P. Gachard, *op. cit.*, p. 114 *et seq*
66. 28 May 1629. *Correspondance*, V, p. 39
67. *Policy and paint, some incidents in the lives of Sir Dudley Carleton and Peter Paul Rubens*, anon, London, p. 173

68. In E. Michel, *op. cit.*, p. 416
69. 6 July 1629 to Olivares. *Letters*, p. 309
70. L.-P. Gachard, *op. cit.*, p. 157
71. 21 September 1627 to Olivares. *Letters*, p. 349
72. P. Gregg, *op. cit.*, p. 152
73. *Ibid.*, p. 209
74. *Letters*, p. 322
75. 24 August 1629, to Olivares. *Letters*, p. 324
76. 30 June 1629. *Letters*, p. 301
77. *Letters*, p. 319
78. 6 July 1629, to Olivares. *Ibid.*, p. 309
79. 30 June 1629, to Olivares. *Ibid.*, p. 306
80. 22 July 1629 to Olivares. *Ibid.*, p. 314
81. *Ibid.*, p. 316
82. 2 September 1629 to Olivares. *Ibid.*, p. 336
83. 22 July 1629 to Olivares. *Ibid.*, p. 315
84. Gabriel Hanoteaux, *op. cit.*, p. 172
85. 24 August 1629, to Olivares. *Letters*, p. 330
86. *Ibid.*, p. 341
87. *Ibid.*, p. 347
88. 21 September 1629, to Olivares. *Letters*, p. 349
89. *Correspondance*, V, p. 27
90. *Letters*, p. 357
91. G. Hanoteaux, *op. cit.*, p. 272
92. *Letters*, p. 357
93. L.-P. Gachard, *op. cit.*, p. 187
94. 6 April 1630. Balthasar Moretus, in M. Rooses, *op. cit.*, p. 497
95. L.-P. Gachard, *op. cit.*, p. 200
96. L.-P. Gachard, *op. cit.*, p. 197
97. L.-P. Gachard, *op. cit.*, p. 196, *Account of Council of State*, 21 December 1630
98. *Ibid.*, p. 198
99. 23 November 1629. *Letters*, p. 350
100. 8 June 1631. L.-P. Gachard, *op. cit.*, p. 199
101. *Letters*, p. 381
102. Marquis d'Aytona to Olivares, 30 July 1631, in M. Rooses, *op. cit.*, p. 512
103. Mons, 1 August 1631, in L.-P. Gachard, *op. cit.*, pp. 213–223, appendices
104. *Account of the Council of State* 19 August 1631, in L.-P. Gachard, *op. cit.*, p. 226

105. Michel Devèze, *L'Espagne de Philippe IV*, Vol. I, p. 146
106. *Letters*, p. 360
107. *Ibid.*, p. 360
108. M. Rooses, *op. cit.*, p. 457
109. *Letters*, p. 360
110. L.-P. Gachard, *op. cit.*, p. 247
111. M. Rooses, *op. cit.*, p. 518
112. L.-P. Gachard, *op. cit.*, p. 17
113. M. Rooses, *op. cit.*, p. 519
114. 12 March 1638. Rubens to Justus Suttermans in M. Rooses, *op. cit.*, p. 585. *The Horrors of War.* Florence, Palazzo Pitti
115. 18 December 1634. *Letters*, p. 392
116. 9 October 1630, to Pierre Dupuy. *Correspondance*, V, p. 340
117. 16 March 1636 to Peiresc. L-P Gachard, *op. cit.*, p. 261

RUBENS'S LAST SUMMER
1. Herman Hesse, *Klingsor's Last Summer*, Paris, 1973, p. 198
2. 18 December 1634, in M. Rooses, *op. cit.*, p. 501
3. *Letters*, p. 392. Quote from Tacitus, *Historiae 2.47. Experti sumus invicem fortuna et ego*
4. L.-P. Gachard, p. 283, Rubens to Gerbier
5. *Letters*, p. 320, to Pierre Dupuy, 8 July 1629
6. Eugène Delacroix, *Journal*, p. 737
7. To Peiresc, 18 December 1634. *Letters*, p. 392
8. Eugène Baie, *Le Siècle des gueux*, Vol. VI, p. 363
9. Giancarlo Schizzerotto, *op. cit.*, p. 142
10. Paris, Louvre
11. Antwerp, Musée Royal des Beaux-Arts
12. In M. Rooses, *op. cit.*, p. 500
13. *Letters*, pp. 400–401, 16 August 1635
14. Mémoires de Richelieu, in M. Devèze, *op. cit.*, Vol. I, p. 224
15. M. Rooses, *op. cit.*, p. 571
16. *Ibid.*, p. 559
17. *Ibid.*, pp. 500–501
18. *Ibid.*, p. 556
19. *Letters*, p. 394. 18 December 1634 to Peiresc
20. *Ibid.*, p. 413
21. 31 May 1635. *Letters*, p. 397
22. *Ibid.*, p. 398
23. *Ibid.*, p. 398
24. *Ibid.*, p. 337

25. *Ibid.*, p. 410. 17 August 1638
26. Père Poiters, in M. Rooses, *op. cit.*, p. 592
27. *Letters*, 9 May 1640, p. 415
28. *Correspondance*, V, p. 155, 9 August 1629
29. E. Delacroix, *Journal*, p. 316
30. Karlsruhe, Stadtliche Kunsthalle
31. Munich, Alte Pinacothek
32. Munich, Alte Pinacothek
33. Paris, Louvre, *Hélène Fourment et ses enfants*
34. Paris, Louvre
35. G. von Ravensburg, *Rubens und die Antike . . .*, p. 35. Quotation from Winckelmann
36. Ferdinand to Philip IV, 27 February 1639, in M. Rooses, *op. cit.*, p. 599
37. Vienna, Kunsthistorisches Museum
38. E. Michel, *op. cit.*, p. 468
39. A. Michiels, *op. cit.*, p. 124
40. E. Michel, *op. cit.*, p. 345
41. M. Rooses, *op. cit.*, p. 501
42. *Ibid.*
43. Eugène Baie, *L'Epopée flamade*, p. 221
44. Mantua, Palazzo del Te, Room of Medals
45. Palazzo del Te, Room of the Titans
46. Hippolyte Taine, *Philosophie de l'art*, Vol. I, p. 271
47. Eugène Baie, *Le Siècle des gueux*, Vol. VI, p. 36
48. C. Baudelaire, *Pour Delacroix. Les Phares*, p. 48
49. *Letters*, p. 392
50. M. Rooses, *op. cit.*, p. 573
51. 16 March 1636. *Letters*, p. 403
52. Antwerp, Musée Royal des Beaux-Arts
53. Paris, Louvre, *La Kermesse*
54. Malines
55. H. Taine, *op. cit.*, Vol. II, p. 57
56. Vienna, Kunsthistorisches Museum
57. H. Taine, *op. cit.*, Vol. II, p. 55
58. Eugène Baie: *L'Epopée flamande*, p. 336
59. E. Delacroix, *op. cit.*, p. 246
60. C. Argan, *op. cit.*, p. 172
61. Gilles Deleuze, *Le Pli*, Paris, 1988, p. 27
62. Vienna, Kunsthistorisches Museum
63. In H. Taine, *op. cit.*, p. 51

64. Walraff-Richartz Museum
65. Windsor, Royal Collection
66. Rubens's House, Antwerp
67. Munich, Alte Pinacothek: *Rubens, Helena Fourment and Nicolas Rubens*
68. In Frans Baudoin, *Rubens*, Antwerp, Paris, 1977, p. 274
69. Leningrad, Hermitage Museum
70. *Correspondance*, IV, p. 382. To Fabrice Valguarnera, 20 June 1631
71. F. Baudoin, *op. cit.*, p. 276
72. Vienna, Kunsthistorisches Museum
73. *Letters*, p. 414
74. Paul Manz
75. *Letters*, p. 320
76. Eugène Delacroix, 15 July 1857, *Revue des Deux-Mondes*, in Louis Hautecoeur, *Littérature et Peinture en France du XVIIᵉ au XXᵉ siecle*, p. 185
77. F. Haskell, *op. cit.*, p. 71
78. In L. Hautecoeur, *op. cit.*, p. 21
79. E. Panofsky, *Early Netherlandish Painting*, p. 271
80. P. Assouline, *L'Homme de l'art*, p. 335
81. A. Malraux, *L'Intemporel*, Paris, 1976, p. 11
82. F. Baudoin, *op. cit.*, p. 281
83. *Ibid.*, p. 280
84. A. Michiels, *op. cit.*, p. 181
85. *Ibid.*, p. 183
86. E. Fromentin, *op. cit.*, p. 638

APPENDICES

A LETTER IN LATIN
FROM PHILIP RUBENS TO PETER PAUL
ON HIS RETURN FROM SPAIN

To Peter Paul Rubens on a ship

The mother of Achilles the Thessalonian was not so frightened as I am now, when discovered by a ruse of Ulysses, he engaged in a cruel war on Menelaus' behalf, and hurriedly departed for the ramparts of Ilium; Penelope, the epitome of Greek modesty, was less disturbed by the dangers her beloved husband ran than I am now, each time she heard the roaring of the waves at Cape Malis or round the rocks of Caphareus and in the perilous Ionian Sea; Aegeus was less anxious than I am now, about the fate of his dear Theseus, when on his native shore at Pireus he sacrificed himself to the spirits of Androgenes; for my heart is torn apart by anxiety for you my brother, who is more worthy of love than daylight itself; for you, whom a small ship now bears away across the Tuscan sea, and for you, who must, alas!, put your trust in the inconstant sea; now that the terrible power of the winds is unleashed and the waves churn under the influence of malevolent stars. Ah! may the first man who built a ship and dared set sail on the immense ocean eternally bewail his deed. Since then, we have become playthings of the waves and winds, and a pathway to sudden death has opened up.

Ajax, the Locrian chief, who often resisted the great Hector and the Phrygian phalanges with the invincible son of Telemon, Ajax was swallowed up by the irresistible power of the waters and became the hideous prey of seabirds. And you, King of Ithaca, what use on the Ionian Sea was your refinement, your inventive spirit, which made you superior to all mortal men? Alas! your ploys, your subtle advice were completely useless. It is the same for you my brother: nothing will help you, neither your knowledge of literature, nor what you have achieved through hard work and your energetic, active mind, nor your manual skills which so cleverly paint excellent portraits and pictures worthy of Apelles.

Oh, all of you Gods and Goddesses! you who inhabit the luminous temples of the heavens, the earth, the sea ploughed by ships, and above all, you Gods who reign over the Tyrrhenian Sea, offer him, if you can,

241

your welcoming help, defend his ship against fearsome stars which stir up storms and the waves' anger! May the cruel barbarians and he whose hands are impure or sacrilegious fear Aeolus' powerful rage, may the one fear the shuddering black Ocean, may the other pale at the sight of the threatening waves which beat against the sky. But you, who know not the damage caused by Auster's sudden squalls, nor the violence of Orion's storms, may it not be your fate, when already paralysed by numbing fear and trembling, to seek our welcoming Tyndarides. But may a favourable wind, a gentle Zephyr, carry you over the laughing, softly lapping waters, and may your boat reach the shore, a crown at its prow, and be acquitted of its vow to the Sea Gods. When will the quickly passing hours bring this day, and the shining god of Delos reach us on his white-winged chargers? When will I be able to run to my brother, and our hands lock in a sweet embrace? It is then that the wild waves of Tages will come under my roof, and I shall welcome the opulent gifts of the oriental sea.

But now, alas! everything is turning bitter for me in my unhappy state: I am suffering from a number of different ills, since once again I shall not have the pleasure of your company. Now I feel an aversion even for these studies, which were once the dearest thing in the world to me, everything that delighted the mind, even the globe of the sun itself, believe me, gives out only a feeble light, the same can be said of his sister, with her blunt horns; the fiery stars which stud the heavens are dark to my eyes, and even honey has the bitterness of gall!

INTRODUCTION TO *THE PALACES OF GENOA*
BY P. P. RUBENS

In our countries we are seeing the architectural style which we call barbarian and gothic gradually age and disappear, and we are seeing men of taste introduce to the great honour and embellishment of our homeland an architecture which possesses symmetry, which conforms to the rules established by the ancient Greeks and Romans. We can see an example of it in the magnificent churches that the venerable Company of Jesus has just built in the towns of Brussels and Antwerp. It is with good reason – for the dignity of divine office – that one begins to change our temples for a better style; however one must not neglect consideration of private buildings which, as a whole, form the body of a city.

Furthermore, the convenience of movement in a building is almost always in direct proportion to its regularity and the beauty of its form.

I therefore hope I have produced a rewarding work for the public good in all the provinces beyond the Mountains, in publishing the drawings of some palaces in the superb city of Genoa, drawings which I assembled during my journeys in Italy. And as this republic is made up of nobility, the houses are very beautiful and very convenient, but more suited to housing families of simple gentlefolk, however numerous they are, than princely courts such as are, for example, the Palazzo Pitti in Florence, the Palazzo Farnese in Rome, the chancellery in Caprarola and a host of others in Italy, or even the famous palace built by the Queen Mother, in the Faubourg of St-Germain in Paris. All these latter, because of their size, their situation and running costs, are beyond a private gentleman's means. My aim is to be useful to the general well-being, and I would like to provide a service to many rather than to a few.

Consequently, here is how I establish a distinction. I would describe a palace of a sovereign prince as having an empty space in the middle with buildings all around, an edifice which has the capacity to house a court. On the other hand, I would describe a palace or private house, however large and opulent it might be, as an edifice having the form of a solid cube, with a *salon* in the middle, or divided into adjoining apartments which no longer take their light from the centre; these for the most part are what the palaces of Genoa are like. It is true that among the buildings

243

whose plans I give there are some, mostly those in the countryside, which possess small interior courtyards, but they do not resemble the ones I have just mentioned above.

In this small work, I will therefore give the plans, elevations and façades with their carved windows, of some palaces which I have collected in Genoa, with a certain amount of difficulty and expense, having had the good fortune to be able partly to use the services of others. I have given measurements in each compartment, not everywhere, but wherever I have been able to procure them. If these measurements do not always correspond exactly to the measurements of the compass, you must use your discretion and excuse the draughtsmen and the engraver, who have been put to considerable trouble by the cramped space allowed for the plans. I should also warn that the four points of the actual horizon are not placed in the usual order, going from east to west, but in reverse, an inconvenience of engraving. But it is of little importance. I have not given the names of the owners of the buildings, because everything in this world *Permutat dominos, et transit in altera jura.*

In fact, some of these places have already passed out of the hands of their original owners, with the exception of two which have become, by chance, I believe, the best known in *Strada Nuova.* For the rest, I refer to the plates; if, by chance, you feel there are but few, that does not alter their merit, for these are the first that have been collected for publication until now.

Beginnings are always tentative; perhaps mine will open up the opportunity for others to do more.

PREPARATORY PROGRAMME*
FOR WORK IN THE MEDICIS GALLERY

FIRST PAINTING OVER THE FIREPLACE OF THE GALLERY.

The Queen will be painted as a triumphant queen, helmeted, with sceptre in hand, under her feet will be helmets, breastplates, piles of arms, drums, and above her head two cupids with butterfly wings, symbol of immortality, holding a crown of laurel on the Queen's head to signify that her Fame is immortal, and in the Heavens, two Renowns (divinities) holding trumps, proclaiming her virtues and the fame of her good management of the government of the State, and below her feet will be written HIC ILLA EST, saying here is the greatest queen on earth, the rarest virtue in the world unparalleled down all the centuries.

2. PAINTING ON THE SIDE OF THE FIREPLACE.

Right hand.
The Grand Duke François, father of Her Majesty, will be painted full length in his dress of Grand Duke of Tuscany.

3. PAINTING ON THE OTHER SIDE OF THE FIREPLACE.

Left hand.
The portrait of the Grand Duchess Jehanne, Archduchess of Austria, Queen [mother crossed out] born of Hungary and Bohemia, mother of Her Majesty.

4. THE PAINTING BEGINS THE QUEEN'S HISTORY.

Three Fates spin a thread of good omens which will extend as far as Florence and the whole Tuscany for the birth of Princess Marye.

5. PAINTING. BIRTH OF THE QUEEN.

The Goddess Lucina is shown with a torch in her hand, descending from Heaven, she presents Florence with a newly born baby girl surrounded by light, a sign that she will be the greatest princess in the world, whom

*Note that this is preliminary, since it consists of only 19 paintings; the final number was 24. The original was written in French by Rubens.

Florence, shown as a nurse, is holding in her arms. Below are shown the Horae in the form of angels with butterfly wings who are scattering flowers as a symbol of joy, and near the Hours, a Genius holding a horn of plenty which contains a sceptre, a crown and a hand of justice, a sign that she will become the greatest Queen in the world. Above is shown Sagittarius, the heavenly sign which dominates her birth. Below, the river Arno is represented by the figure of a man, accompanied by children, representing the fertile quality of the area.

6. PAINTING. THE QUEEN'S EDUCATION.

The Queen is being taught by Minerva in all sorts of p [. . .?], accompanied by three Graces. Mercury descends from Heaven holding his Caduceus to teach the Queen how to speak well. Near the Queen is an Orpheus with his lyre, a sculptured head, a palette with colours and paintbrushes to show that the Queen loves music, painting and sculpture.

7. PAINTING OF THE MARRIAGE OF THE KING WITH THE PRINCESS MARIE.

Jupiter and Juno, with the prayers of France, are consulting as to who to give the King Henry the Great as a wife. They send Hymen with Cupid to carry the portrait of the Queen to the King who is in the act of contemplating it with amorous devotion. He is consulting Cupid, who points out with his fingers the Beauties of this Image. At the foot of the painting two cupids, one is carrying off the King's helmet and the other a shield to show that the Marriage of the King will establish a long period of peace in France.

8. PAINTING. THE WEDDING OF THE QUEEN.

The Queen dressed in white with her company, and in the Council of the Grand Duke Ferdinand and the Grand Duchess Christine, receives the ring sent by the very Christian King from the hand of M. the Grand [Duke]; the Grand Duke marries the Queen in the name of the King; the ceremony of the marriage is performed by the Pope's legate who marries them in Ste Marye del Fiore; the goddess Juno is present; a rainbow appears as a symbol of nuptials.

9. THE QUEEN'S ARRIVAL AT MARSEILLE.

A Galley will be painted, which is very beautiful and excellent, all in gold, on which is the Queen, who disembarks into the port of Marseille, accompanied by the Grand Duchess and the duchess Léonore her sister. The Queen is received by France and by the City of Marseille personified in a provincial figure of Antique form and below, Neptune with the Nereids

who push the Galley in [. . .] which is steered by good Fortune as guardian, and also in the sea is Proteus in the act of producing great things, and in the air the god zephyr and a Deity with a trumpet who is going off bearing the news of this arrival to the King.

10. PAINTING. THE ARRIVAL OF THE QUEEN AT LYON.

King Henry the Great represented by Jupiter and the Queen by Juno are embracing; in the middle of the two is Hymen, and below, five little cupids holding torches in their hands; above their heads a rainbow appears and the star Hesperus; below is a magnificent chariot on which is a woman who represents the town of Lyon holding the town's coat-of-arms; the chariot is drawn by two lions to represent all that has been done for the entry of the King and Queen at Lyon.

11. PAINTING. THE QUEEN GIVES BIRTH TO MONSIEUR LE DAUPHIN.

The Queen is shown sitting, exhausted by her confinement, but joyful and happy, looking at M. le Dauphin whom the Genius of safety is holding. At their side is Themis who takes him into her protection; behind the Queen is Sibyl, mother of the Gods, and on the other side is Fertility, the horn of plenty in her hand, five little children in whom are represented all the royal race, a Genius who holds the bed curtain, and in the sky a rising Sun with the star Lucifer preceding it.

12. PAINTING. PREPARATIONS BY THE KING FOR THE WAR IN GERMANY.

The King wearing armour is ready to depart and gives into the Queen's hands M. le Dauphin and his children and France, giving full powers to the Queen to rule his kingdom as if he were there in person; the Queen is accompanied by Prudence and Generosity; behind the King the lords [?], already fully armed, are ready to follow the King.

13. THE CORONATION OF THE QUEEN.

The Church of St Denis is shown in perspective with the great altar beautifully decorated with ornaments and silverware needed to celebrate the mass; beside the altar a small room is shown, hung with purple velvet embroidered with fleurs-de-lys, from which the King watches the ceremony; on the other side is a low dais on which are the ambassadors; above is another dais for choir and oboists who play and sing throughout the mass. Around the church are platforms for the lords and ladies, gentlemen and officers who are watching the ceremony; before the great altar there is a small dais three feet high, on which there is a great drapery of purple velvet sprinkled with embroidered fleurs-de-lys. In the middle of the dais

is a square of purple velvet with the same embroidery, on which the Queen on her arrival in the church kneels before the great altar. The Queen has a bodice and overdress of ermine decorated with huge diamonds, her royal cloak of purple velvet sprinkled with gold fleurs-de-lis is trimmed with ermine; her Majesty's headdress is garnished with huge diamonds and pearls of inestimable value. As soon as the Queen has arrived and knelt before the great altar, M. le Cardinal de Joyeuse begins the sacred ceremony, dressed in his pontifical vestments, assisted by Msgrs the Cardinals de Gondy and de Sourdy, with archbishops and bishops. We have to omit all the sacred ceremony, and show only M. le Cardinal de Joyeuse placing the crown on the Queen's head; beside the Queen on her right are M. le Dauphin and Madame his sister, on her left M. d'Orléans and the Queen Marguerite, behind the Queen, three princesses of the blood bearing Her Majesty's train, they being Madame la Princesse, the mother of Madame la Princesse de Conti, Madame de Montpensier. Beside the Queen, M. de Vendome holding the sceptre and Mr le che[va]lier de Vendome the hand of justice, Mr le Prince de Conti carries the crown in front of the Queen. There are benches covered in cloth of gold, on which are the Queen Marguerite, Madame de Guise the dowager, Mad^elle de Vendome, Madame de Vendome, Madem^elle du Maine, the princesses of the blood dressed in petticoats, bodices of golden tulle, overdresses of ermine decorated in precious stones, ducal cloaks of crimson velvet trimmed with ermine.

The princesses not of the blood and duchesses, dressed in petticoats of silver tulle, overdresses of ermine ducal cloaks of crimson purple velvet with the [. . .] of gold.

The [. . .] princesses and duchesses dressed in petticoats of black velvet, overdresses of ermine without precious stones, cloaks of crimson velvet, but shorter, crowned as the others. In the sky are shown glory and honour who place the crown on the Queen's head.

[SIC] THE KING TAKEN AWAY TO HEAVEN: THE QUEEN'S REGENCY

The gods are shown in heaven judging King Henry the Great more worthy to be numbered among the Gods than mortal men, they deputise Jupiter and Saturn to bear him away to heaven and give him a place there; having been borne away, two Victories weep for the loss felt by his kingdom and the whole world for the greatest King and captain there has ever been. One of the Victories [word left blank] raises a trophy of arms to the glory of the King; on the other side is the Queen dressed as a sad widow and afflicted by her great loss, accompanied by Minerva and Prudence, to whom the Providence of God hands the tiller. France is on her knees in front of

the Queen, who presents her with a globe sprinkled with fleurs-de-lys which symbolises the government. France is surrounded by people who beg the Queen to accept government of the State.

15. PAINTING. AGREEMENT OF THE GODS FOR THE RECIPROCAL MARRIAGES OF FRANCE AND SPAIN.

Jupiter and Juno consult in order to bring peace to Europe through the alliance of France and Spain. Juno as goddess of Marriage places a golden yoke on two pairs of white doves; there are two doves held by Cupid which are resting on the globe of the world split in two, where the weapons of France and Spain are; with the help of Peace and Concord, Apollo Minerva chases away Discord, Fury and Fraud who wish to prevent the marriages taking place; Mars wishes to help the Furies, but is held back by Venus.

16. PAINTING. THE CAPTURE OF JUILLIERS.

The town of Juilliers is shown surrounded by its entrenchments and canon; in the foreground of the picture there is a white horse, beautiful in its perfection, in its fiery movement, standing on its hind legs, its great mane plaited and roped, its harness embroidered in gold, bearing huge plumes on its head, and on which the Queen is riding, sumptuously and magnificently dressed, helmeted, her hair hanging down, holding a baton in her hand, accompanied by Victory who is placing a crown on her head; to one side a Deity proclaims the greatness of the Queen; beside the horse is Generosity who places one hand on a lion and in the other holds the rings which she is making a show of distributing; at the bottom of the painting there is an army of cavalry led by M. le Marechal de la Chastre, who returns Juilliers to the protestants as promised by the King.

17. PAINTING. THE EXCHANGE OF THE TWO WIVES OF THE QUEEN OF FRANCE AND SPAIN.

France is represented by a beautiful woman dressed in a blue dress covered in fleurs-de-lys, who draws the Queen towards her and gives Madame to Spain, represented by a Moor who will take Madame to Spain. In the air will be a ballet and dance of cupids shown as led by Felicity from a golden century spreading from a horn of plenty with flowers and fruits, and below the cupids a rain of gold; high up in the picture is a rainbow.

18. PAINTING. THE KING'S MAJORITY, THE QUEEN HANDS OVER HER AFFAIRS TO THE KING.

A ship which is guided into the port by Strength, Prudence and Justice, in the middle of which is France; the King who receives the tiller from the

Queen Mother; Temperance lowers the sail; the Deities in the air tell of the good conduct of the Queen in the management of the Kingdom's affairs.

19. PICTURE. THE QUEEN'S RETIREMENT FROM PARIS TO BLOIS.

The Queen chased by Calumny; above the Queen's head, Lying is shown expelling fire from its mouth; a dog is barking near the Queen who is led by innocence accompanied by the princesses who weep at her departure; her carriage awaits her.

LETTER TO CHANCELLOR OF BRABANT, PIERRE PECQUIUS, OF 30 SEPTEMBER 1623
(RUBENS'S FIRST DIPLOMATIC LETTER)

Most Illustrious Lordship

I found our Catholic [Jan Brant] very afflicted by his father's grave illness, which in the doctor's judgement is critical; he too is tormented daily by an almost continual fever, so much so that one or other of these two causes or both will detain him perhaps longer than might be necessary. It is quite true that he proposes, in such an event, to have his uncle come to Lillo, in order to give him *ex propinquo* an account of his negotiations; but I shall try, so far as I am able, to prevent him from so doing, at least for a few days. When I communicated the reply to him, his fever almost doubled, although I did this after a lengthy preliminary discourse, and he admired the great industry, prudence and elegance which that note contained. In fact it would seem impossible to treat the same subject in a more varied manner or with greater skill than has been done. Finally the Catholic took his instructions, and showed me an article in them which I did not like. It said in this article that he must not accept or take back a reply from us which is ambiguous or similar to the preceding one - only a straight acceptance of the truce, or nothing. I told him that these were threats to induce panic, to frighten children, and that it was simply not enough to give our word: this secret treaty was without prejudice to either party, each in the meantime trying to make all the effort it could. His reply was what I have already told Your Illustrious Lordship: that we used the Prince's documents to his detriment, by sending them to France to encourage the King to defy him and to render him suspect in the States. I told him that if the Prince wished to enlighten Her Serene Highness further on this, her Highness would demonstrate her displeasure about it in such a manner that he would not retain the slightest doubt of her innocence; that these were nothing more than intrigues and chicanery in order to break off negotiations. He nevertheless persisted in maintaining that it was true and that the Prince could show, as he had done to several people, the very copies which were sent him from the French court. In the end, he let us persuade him to copy our reply in his own hand, so that he could take it to the Prince at the first opportunity. He would have done so right away, had I not

251

advised him to wait until his attack had passed and he was completely free from fever. Consequently, I took the note away with me, promising to go back and see him, because I wished the copy to be made in my presence, at his convenience and mine. He was happy with that, and so we will gain a little time.

I commend myself with a true heart to the good grace of Your Illustrious Lordship and I kiss your hands. Of Your Illustrious Lordship

Your affectionate servant

Antwerp, 30 September 1623.

I have written with more freedom, because of the great confidence I place in the reliability of the bearer of this present letter, who has promised me to deliver it into the hands of Your Illustrious Lordship. I will use the same means when I send the original of the reply back to you in due course.

The Catholic told me, as well, that the Prince's Secretary, through whose hands negotiations pass, is called Junius and that he is a very corrupt man who will take bribes with both hands, but that his uncle would not use such means to win him over, as his own integrity would regard such procedure as contemptible. Nevertheless I thought it proper that Your Illustrious Lordship should know this.

It also seems to me very dangerous in the future for the Catholic to come to Brussels, because of the suspicions this will arouse in Cardinal de la Cueva. For this reason, if the negotiations are not broken off this time, it would be better for him, when he returns, to remain in Antwerp, and for me to send his reply or deliver it in person. But this suggestion must not come from me, for he might perhaps become suspicious of me and think I want to exclude him, and take over all the negotiating for myself. It would be better then, if Your Illustrious Lordship thinks it necessary, if I could show him some note or order for Your Illustrious Lordship on this matter.

Here they talk of nothing else but the Prince of Wales's return to England: but the report is not generally believed, since the news came from Zeeland.

RUBENS'S LETTER TO THE INFANTA ISABELLA
OF 15 MARCH 1625
[WRITTEN FROM THE FRENCH COURT]

Serenissima Madame,

Since writing to Montfort by the last post, I have received another very peculiar piece of information regarding the coming to this court of the Lord Duke of Neuburg, bearing the King's authorisation to negotiate and conclude the truce with the Hollanders. Although I recognise the value, the capability and the industry of this Lord Duke, it does seem very strange to me, all the more so since we know for sure that this decision of His Majesty's is based on very feeble reasons, and the whole thing is due to the persuasion of the Secretary de Bie, who thinks that he has made an important negotiation with the King's favourite, a man called Toiras, through a certain Fouquier. And since, before my departure from Brussels, I had some indication of this, I informed myself carefully about the quality of these personages. Seeing that it was no secret, and taking Seigneur de Meulevelt's prudence into consideration, I told him everything, so that I could learn of his intention and his opinion on this matter. Your Highness will learn of his opinion from his letter, which is enclosed, which however is not so explicit as mine, because he had not been informed about what has been transacted by other agents, and in particular with the Catholic. And, although I am certain that Your Highness has been informed of all that is going on, and perhaps has reasons, of which we are unaware, for approving this action of de Bie, I hope that Your Highness will not take it badly if I tell her my opinion, according to my capacity and with my accustomed frankness: I do this with more deliberation since Seigneur de Meulevelt considers the matter of great importance. That is why he deemed it necessary to send this express messenger to Your Highness, so that we can know how we should conduct ourselves when the Lord Duke arrives at this court, which could be soon.

It appears then that this affair ought to be considered both in terms of its origin and its author, who is called Fouquier, as I have said, and who is asking for I don't know what at this court - he is a man of very evil reputation, accustomed to taking money for totally illfounded claims, to the detriment of others. It was he, who, last year, brought de Bie to Paris,

253

and put it into his head that in order to obtain the truce, he must win, or even bribe, the King's favourite, named M. de Toiras, with whom he claimed to be on very intimate terms; and this is the course de Bie has proposed to the Lord Duke of Neuburg, who through his kindness and credulity (which is a quality peculiar to well-intentioned people), had put his entire trust in de Bie and has informed the King and his ministers about it; unless I am mistaken even the price of the bribe has been determined, which would not be considerable since most of it would go to the contractors, if ever the plan were to be carried out. But we are not of this opinion, considering the present state of this court, and we firmly believe that no decision could be taken which would be more contrary to the end we desire, or more shameful to His Majesty, firstly because the Duke, coming from Spain, would be suspect; he might even be thought to be interested in the truce for the sake of his own estates, which are suffering greatly from the war in Flanders, and so he will be little trusted, and it will appear that Spain, through this Lord Duke and (what is worse) through the French, is trying to come to an agreement with her rebels, which seems directly counter to His Majesty's reputation, since His Majesty would make the first advances, which in our opinion would be vain and fruitless. For with the French it is a state maxim to keep the war in Flanders ever alive, and to cause the King of Spain constant expense and anxiety, as they have proved with all the help in money and men they have given the Hollanders from the beginning of Henri IV's reign until now. Your Highness may recall that the Prince of Orange has always protested, through the Catholic, that if the negotiations should come to the knowledge of the Kings of France and England, they would be broken off at once; and that he complained (although wrongly, I think) that we had sent his dispatches to France in order to destroy the confederation of states and the friendly relations with that crown. The Duke of Neuburg's proposal will only serve to disclose our secrets and warn our French enemies in time to oppose our plans with greater certainty and violence, and with all their power, and so disgust the Prince of Orange entirely, and break up all other negotiations on this subject, when, as Your Highness knows, the whole matter is already so advanced. I do not see how the French can in any way remove the obstacle which alone prevents the success of our enterprise, since they are supporting the opposing party with as much persistence as if its failure concerned their own interests. And it seems ridiculous to me to believe, that by their persuasion, we are expected to abandon the siege of Breda, or the Prince to give it up at their demand, and that the French want this, or that they can find some convenient means for the cessation of hostilities any more easily than we can do ourselves if we want to. Finally, we don't

need their favours, as Your Highness knows, nor the mediation of the Lord Duke, nor to purchase from the French what we can have for nothing.

As for Toiras, may Your Highness believe me, it is sheer folly to expect from him something that is not within his power, because he does not interfere in affairs of state, he is taken for a wise and modest man who has no other role than the command of the fort of St Louis, near La Rochelle. He came to court, at Soubise's instigation, to negotiate for a port which he wanted to build at this fortress, and it is thought that, within a few days, he will be leaving. One must realise that the entire government of this kingdom is today in the hands of the Queen Mother and Cardinal de Richelieu, who oppose Toiras whenever they can, and who would be hostile to anything whatsoever contracted by him or for him. As for the King's special inclination towards him, he is, in His Majesty's good graces, well below his new favourite, called Barradas, whose favour is such that it astonishes the whole court, and excites the jealousy of the Cardinal himself, who is trying by every sort of artifice to put him under obligation to himself.

Considering all the reasons mentioned above, I beg Your Highness to allow me to state my opinion plainly, since she has occasionally done me the honour of consulting me on this same subject. I find the Lord Duke of Neuburg very capable of negotiating this treaty, but not at this court, which abhors truces more than anything else in the world. Moreover, I hear from several sources, much to my great regret, that there is little hope of success. And I suspect, knowing the manner of this Prince, that the affair will soon be made public everywhere, and I leave it to Your Highness to consider what the consequences will be. It would appear to Seigneur de Meulevelt and to me to be necessary for Your Highness to detain de Bie by every means, since he says he is willing to meet the Duke, and will go as far as Orleans by post, in order to assist him in his negotiation. It would be good also if Your Highness would warn the Lord Duke in time that he should make no overtures here before having communicated with her, and that she invite him, as a consequence, to go directly to Brussels, without stopping at all at this court; then Your Highness, having had the time to think about it, having talked to the Duke and learnt of his instructions, you can decide together whatever seems the most appropriate.

In the meantime, I beg Your Highness to advise me as soon as possible how I am to conduct myself toward the Duke in this affair. The Seigneur de Meulevelt too, supposing that the Lord Duke would wish to make use of his support at this court, would like to know if Your Highness's intention is that he support him or that he prevent him from sticking his fingers in this pie. I myself, although a very small accessory, I could, in view of the

favourable inclination the Lord Duke has always shown me, serve to divert him from the plan he seems to have, if I were instructed of Your Serenissima Highness's will, to which I submit most humbly. I dare hope that Your Highness will pardon my boldness, begging her to believe that I am moved solely by my enthusiasm for the service of the King and Your Highness, and thus for the public good of my country.

On this, I close; with all reverence I kiss the feet of Your Serenissima Highness.

<div align="right">Pietro Pauolo Rubens.</div>

As the Marquis de Mirabel, Catholic ambassador at this court, a very prudent and discreet person, has got wind of the order given the Lord Duke to treat this matter, and thinks ill of it, I believe that he will try to prevent it: it is therefore necessary that Your Highness make known her will as soon as possible so that no false step be taken here, which is counter to the intentions of Your Highness, who perhaps knows some mystery we cannot fathom, and which it would not be convenient if we did, or myself at least, for whom the least word from Your Highness will suffice and I will obey.

Even if it is a question of general settlement of the differences existing between the crowns of Spain and France, it would be better, in our opinion, if the first overture were made by the Pope's legate, who, it is said, will certainly come to this court soon, as a neutral person. And if, afterwards, there was a desire to include the question of the truce, in order to remove the obstacle of this war in Flanders, which causes great inconvenience and ruins good relations between the two crowns, it would be preferable for such a proposal to come from a third party, who is neither interested nor suspect, such as the legate, instead of it coming from a prince who has very great interests in Spain and comes from the court of Madrid, since this is not an affair one can negotiate in passing; at least if this Lord Duke must do it, it would be more opportune and seemly to do it after the legate's arrival and after he has made proposals for settling affairs in Italy and the Valteline. It would be easy to connect this truce with the other again, should there be an occasion that the King of France offers assistance to the Hollanders, or some other reasons. Again I beg Your Highness's pardon for the presumption which leads me to speak with such freedom of things of such importance.

If I were informed of Your Highness's will, I could write on this subject to Lord Don Diego and to the lord Conde d'Olivares; I could also have written to the lord Marquis Spinola; but I dared not risk a letter; if Your

Highness finds it a good idea, she can communicate her approval to His Excellency. What I beg Your Highness is that she maintain secrecy, and that this letter be thrown in the fire: for I am a very affectionate and very devoted servant of the Lord Duke of Neuburg, and I have no motive for the slightest malice towards the Sieur de Bie (as God knows): quite the opposite, I am his friend, and I would not like in any manner to arouse his hatred. But the public good and Your Highness's service move me more strongly than any other passion. I commend myself therefore to the prudence and discretion of Your Serenissima Highness.

NEGOTIATIONS WITH ENGLAND
DISCOURSES HELD BETWEEN THE SIEUR RUBENS AND GERBIER SINCE THE YEAR 1625, UPON A TREATY PROPOSED BETWEEN THEM

My Lord the Duke of Buckingham being in Paris in the year 1625 in the month of April, the Sieur Rubens painted his portrait there, and on that occasion had communication and made proposals to Gerbier, the Sieur Rubens saying after the return of the Prince from Spain, that the Serenissima Infanta Isabella Clara Eugen and Sire, the Marquis Spignola had a lively sense of the wrong which had been done to My Lord the Prince during his Stay in Spain, in not having received his mistress in his arms the third day after his arrival in Madrid, which eagerness, the Serenissima Infanta was of the opinion ought to have been exhibited in this affair, seeing he had so honoured the house of Austria and acted so generously and so like a Cavalier. Upon which consideration the Sieur Rubens made it known that he apprehended that great difficulties might ensue between these Crowns of Spain and Great Britain. That, nevertheless, every honest man should do all in his power to nurture the continuation of good relations which had existed between them until then; and since wars were a scourge from Heaven, they must be avoided. These discourses were accompanied by an openly zealous desire that the My Lord the Duke might have the inclination and the power to pacify the King his Master, whose Heart must be very much wounded. Gerbier replied it was evident God had made known to his Maj. of Great Britain that he had made the Lilies to unite with the Roses, that in the joy of this desired union every unfruitful pretention that he had had in his voyage to Madrid should be forgotten, except that which affected the particular Interests of his dearest sister the Queen of Bohemia, whose wrongs needed a cure, to which My Lord the Duke was obliged to contribute as much as lay in his power.

The Sieur Rubens had recognised in My Lord the Duke's conversation a charitable zeal for the affairs of Christianity. After his departure from France and the Rupture between Spain and England he wrote to the said Gerbier continually, greatly deploring the present State of affairs, hoping to see again the past Golden Century, and conjuring Gerbier to

make the said Lord Duke of Buckingham understand the Serenissima Infanta's deep regret that affairs were in their present state, protesting that she ought not to suffer, since she desired nothing more than a good understanding, which she thought very reasonable, as she had neither been a party to the disputants nor contributed to their discontent. That if His Majesty of Great Britain had a design to claim the restitution of the Palatinate, it was to the Emperor he should apply, and to the King of Spain, supposing he had the power; but that at least the good understanding which existed between England and the Sereniss. Infanta should be preserved, and put on a proper footing, since there were no points of difference between them.

The Sieur Rubens enlarged upon this subject, saying how praiseworthy and happy this work of reconciliation would be, believing it easy, provided His Majesty of Great Britain would lend an ear and the Duke of Buckingham was well enough disposed for his assistance to be reliable, this is what Rubens told him, dwelling strongly upon Spain being willing to listen to reasonable conditions, Begging the said Gerbier to say so to the Duke of Buckingham, who ordered Gerbier to reply to Sieur Rubens, that he would never lose any opportunity which might offer Peace to Christianity, to which he would contribute all that lay in his power, that if Spain had a Real and Charitable design he would meet it with open arms, on condition that the King of Bohemia was taken into consideration. This Answer (according to what Sieur Rubens wrote) was sent to Spain, from whence they expected good news; some weeks after, the Sieur Rubens wrote, that he had received orders from Spain to keep up this correspondence with Gerbier, and that in a short time, the Sereniss. Infanta would have more ample explanations and instruction.

Soon after the English Fleet retreated from Calis [Cadiz], Sieur Rubens wrote that changes had been made to the resolutions due to the general state of affairs, and that it had come to be known that Spain had no real intention, in view of the present circumstances, and was bent on adjusting things as they stood at present which more clearly appeared by the change of affairs in Denmark and afterwards by the impression which was made by England raising an armament for the Fleet; which nevertheless was destined against France and not against Spain, but at which Spain was so jealous, that the taking of Groll happily for the States General succeeded. The Marquis Spignola having kept his forces on the coast of Flanders, fearing the army of England intended an invasion, the Sieur Rubens retraced his first overtures, and wrote to know whether it were the intention of England to treat, that the Infanta and the Marquis were doing their utmost to procure full powers from Spain, upon which Gerbier received

259

orders to reply. The following is a copy given into Sieur Rubens's own hands, Gerbier having gone to Antwerp to see him about the purchase of Statues, Medals and Paintings which My Lord the Duke was making from the said Rubens.

<div align="right">

Philip IV to the Infanta Isabella
(Order for Rubens's mission to England
by King Philip IV of Spain, 27 April 1629)

</div>

Serenissima Lady.

I have judged it agreeable that the peace talks begun with England, of which Your Highness is aware, continue. As a consequence, I have resolved that Peter Paul Rubens go to that country with the instructions given him on my orders, by the Conde-Duke, which he will show Your Highness. As it is said therein, he will follow those instructions which Your Highness gives him, the only thing which I recommend you is, in case of there being no appearance of reaching an agreement with the Hollanders on the terms on which we have been working until now (and not otherwise), to order Rubens to take the opportunity to let the Lord Treasurer Lord Richard Weston know that it is sometimes said here that in order to conclude the peace treaty it could take more time here than is thought in England, and it would therefore be a good idea to suspend arms; that as far as I am concerned I will not in any way hinder any agreement to that effect with Charles and with the Dutch, nor try to persuade the emperor to use arms against the King of Denmark. If agreement can be reached on the suspension of arms, Your Highness would be able to put it into effect, by stipulating that in order to ensure peace the King of England shall send someone who conforms to the specifications laid down in Rubens's instructions. On the aforementioned hypothesis, I empower Your Highness with the authority to accept and conclude the said suspension; the Hollanders are not mentioned here, since Your Highness already has the authority to treat with them. If this suspension of arms is achieved, an accommodation with the Dutch should conform to what I wrote Your Highness at the beginning of Kesseler's negotiations. But, if the suspension of arms with the Dutch cannot be concluded by the said Kesseler, Rubens will have to limit himself to treating for a suspension with England and to taking steps to do so with the Emperor, in order that he can achieve a similar one with the King of Denmark, without involving the Hollanders in this.

In his instructions, Rubens is also ordered to treat with M. de Soubise on the proposal he has made to return to France. For this, he must negotiate

according to his instructions. Your Highness will provide the money which he should be given; and any money she advances will be reimbursed promptly and with all diligence.

　　May Our Lord Keep Your Highness as I would wish

　　　　　The good nephew of Your Highness

　　　　　　　　I the King

　　　　　　　　　　　From Madrid, 27 April 1629

LETTER GIVEN TO RUBENS BY THE LORD TREASURER OF ENGLAND, RICHARD WESTON

(Disturbed by the French Ambassador Châteauneuf's machinations, Rubens asked to have Charles I's spoken assurances put in writing.) The original was written in French.

The King of Spain having made an offer, through Monsieur Rubens, his secretary to the privy council in the Low Countries, of a suspension of arms with the Serenissima Infanta donna Isabel as signatory [who in turn is] authorised by His said Majesty as signatory, and the King my master not having found it convenient to accept the said offer, for certain reasons pertaining to the present state of his affairs, and the said Rubens by reason of his instructions having made other overtures towards a peace treaty between the two Kings, it was not considered good to send the said Rubens away without giving him some response which could help the advancement of such a good proposal, one which is so useful and necessary to the public good of the two crowns and to all Christianity.

It is declared therefore that the said Rubens, having confirmed his master's, the King of Spain's good intentions, through his instructions which have been sufficiently publicised and approved, to conclude a treaty of perfect peace and eternal friendship with the King of Great Britain, who on his part is swayed by the same affection and good will to make the said permanent and inviolable agreement, and seeing that the interests and differences pertaining to the two individual crowns are not so considerable, and could be discounted or accommodated, but that the greatest difficulty will be in regard to his relations and friends, to whom, beyond the obligations of blood ties and nature, the King my master finds obliged and committed by treaty and very strict confederations not to neglect their interests, and cannot abandon them without ruining his trust, honour and conscience, [he] cannot make any treaty with the King of Spain to their disadvantage and exclusion; and since the catholic King cannot in any way dispose of things [which are the province] of others and which are not within his power, but has promised always to carry out his duties and good offices to the best of his ability towards the Emperor and the Duke of Bavaria, for the contentment and satisfaction of His Majesty's relations

with regard to the Palatinate, the King my master does not wish to lose the opportunity to send his ambassador to Spain, and the said catholic King to do likewise towards him. And so it is has become very necessary for the King of Spain to organise, in order that the affair be advanced, that the Emperor and the Duke of Bavaria send their ambassadors to Spain simultaneously, with the required authority to settle this difference promptly, with the intervention of all the interested parties in Madrid. But, considering that this negotiation, notwithstanding all the duties which must be performed in order to speed it on its way, requires the appropriate time and convenience to consider it fully, the King my master declares, by this letter, his royal wish not to make the said peace treaty without being assured, at all events, that the King of Spain will deliver to him the places which he holds in his hand and through his garrisons in the Palatinate, and being moved solely through the desire not to delay the public good, and only to anticipate the fruits that this peace treaty can presently bring to the interests of the two crowns, declares that the royal promise and pledge the King of Spain will give him, should the said King, through his intercession, authority and employment of all his good offices bring the Emperor and the Duke of Bavaria to a reasonable settlement on the subject of the Palatinate with both in agreement, to the satisfaction of his relations, to deliver him the said places which he holds in the Palatinate, this will be one of the great and principal motives leading to a good and prompt peace treaty between the two crowns.

This the said Rubens may impart to the King his master. And while he gives orders to expedite the ambassadors from one side to the other, and to relieve the King of Spain of any feeling of umbrage that a peace treaty made between the King of Great Britain and that of France might give him, the King my master promises, by royal pledge, not to form any league with France against and to the prejudice of Spain during this treaty.

<div align="right">Weston</div>

A LETTER FROM RUBENS TO THE CONDE-DUKE
D'OLIVARES

(The Conde-Duke d'Olivares has reproached Rubens for having exceeded his brief. The painter defends himself.)

Excellency*
I have received Your Excellency's dispatch of July 2 and read the orders it contains. I do not think I have acted contrary to these orders, for I have governed myself strictly according to the instructions Your Excellency gave me on my departure from Madrid. The Lord God know this, and the nobles here, in particular the Lord Treasurer and Cottington, will bear witness that I have never proposed to the King or his ministers to enter into any negotiation other than a suspension of arms. But, as I have informed Your Excellency, the King had me summoned expressly to Greenwich, and laid before me the conditions which I mentioned in my dispatches of June 30 and July 2. I told him that these things would have to be referred to the Ambassador. But he answered that my instructions, as shown to Weston, would permit me to listen to his communications and make reports where suitable, in order to gain time until the Ambassadors on both sides take up their duties. I have not given the King any indication whether his proposals would be found good or bad, whether they would be accepted or rejected in Spain; I simply promised him to inform Your Excellency, on condition that no league with France against Spain be made as long as negotiations with Spain continue. This I did on the order of the Most Serene Infanta, who dispatched a special messenger to me at Dunkirk; and it was very necessary, seeing the great effort the French Ambassador was making, and in another way, Cardinal Richelieu also, as Your Excellency will see in the document here enclosed. I have always insisted, above all, that an authorised person should be sent to Spain as soon as possible, but the nomination of a minister was, so to speak, pushed into oblivion at my arrival, even though Cottington had written to Your Excellency that the minister would leave at once. He said this simply because they feared here that negotiations would be upset by the peace

*Translation taken from *The Letters of P. P. Rubens*, Ruth Saunders-Magurn.

with France. With the assistance of Barozzi – and Barozzi well knows what efforts I have made and what difficulties I have overcome – I succeeded in obtaining this nomination at the very moment of the arrival of the French Ambassador. I succeeded in the naming of the minister and the day set for his departure, as I informed Your Excellency in my letters of July 2. And when the King of England insisted, as I have told Your Excellency several times, upon receiving a reply to his proposals before Cottington's departure, I prolonged the discussions under the pretext that I had to have these propositions in writing before I could lay them before Your Excellency. In this way there is no time left in which to expect an answer. I have managed, however, that this fact shall not delay the Ambassador's departure by a single day, as Your Excellency will see from the letters of the Lord Treasurer and Cottington. The day before yesterday Cottington told me that he would go by sea, and that he preferred to land at Lisbon rather than at Coruña, for certain reasons which he explained to me. He believes the route is no longer from one port than the other, and so he has already engaged the ship and settled the bills of exchange. I believe, however, that the endless number of his duties might delay him for several days; since in all political and state affairs he is, if not outwardly, certainly in effect, the first person of this Court. I say, therefore, that nothing will delay his departure except his duties here, which I fear he will not be able to finish as rapidly as Weston told me. All this will be decided within a few days, and I cannot do more than I have done already. But it will seem strange to the King of England if in the interval the person who is to come to England is not designated. I do not feel that I have employed my time badly since I have been here, or that I have overstepped in any way the terms of my commission. I believe that I have served the King, our master, with the zeal and prudence appropriate to the importance of the negotiation which has been entrusted to me. Your Excellency will recall, I pray, that the instructions given me contained the following articles: I was to assure the King of England that His Catholic Majesty had the same good wishes for an agreement as he did, etc., and that whenever the King of England should send to Spain a person authorised to negotiate the peace, our King, in turn, would send someone to England, etc.; these two points, it seems to me, I have carried out punctiliously.

And 'as for the interests of the relatives and friends of the King of England, His Catholic Majesty, with the Emperor and the Duke of Bavaria, will do what I can.' I have mentioned this in general terms to the King of England and have faithfully reported his reply to Your Excellency, as I was obliged to do, with all the details which the King added of his own accord. If the King of England has pledged himself by his word and in

writing, with full liberty left to us, I do not think this could give rise to any inconvenience. Since the departure of Cottington will not be delayed by a day, and since Your Excellency charges me, in the same instructions, to prevent as far as possible the accord which might be concluded with France, I feel that I have fulfilled my duties completely.

I shall not mention the affair of M. de Soubise since it came to an end with the peace between the King of France and the Huguenots.

I have also advised Your Excellency, as I was charged to do, of everything that came to my notice through diligent inquiries; and I do not recall having reported anything false, which I rashly accepted as true, or anything untimely.

Having therefore carried out the orders which the King, our master, and Your Excellency did me the honor to give me, I beg Your Excellency to give me permission to return home. It is not that I place my own interests before the service of His Majesty, but, seeing that for the moment there is nothing else to do here, a longer stay would be a hardship for me. I intend, in any case, to remain here for the short time which the King of England may consider necessary in order that I may report to Your Excellency how far the King carries on negotiations with the French Ambassador. The first proposals he has already told me with his own lips, and he will continue to do so through Cottington. In the meantime I beg Your Excellency to have the goodness to let me know your wishes on allowing me to retire to Flanders as soon as possible. In awaiting your word, I commend myself most humbly to your benevolence, and with a sincere heart and due respect I kiss Your Excellency's feet.

<div style="text-align: right">Your Excellency's most humble and devoted servant,</div>

London, July 22 1629 Peter Paul Rubens

The Agent of Savoy has told me that Don Francisco Zapata is coming as Ambassador to England. I beg Your Excellency to let me know whether this is true, so that I can give information where it is fitting to do so.

I gave Cottington Your Excellency's letter, which he read in my presence. He was surprised that he was expected so soon in Spain, for he does not recall having written in this sense. I believe, however, that he wrote more than he thinks, fearing that the peace with France might cause some alteration in Spain's inclination toward a peace with England, as the King of England admitted to me himself. It is certain that on my arrival it was still undecided whether he or someone else was to go. They were in no hurry to make a decision. and if Barozzi and I had not urged it, perhaps no one would yet be named, Cottington or anyone else. But even now, in

spite of the favourable state of affairs, and all the reports I have made in my previous letters, Your Excellency or the Abbé Scaglia might, without knowing the present situation, write something to these Lords which might alter it. I believe, therefore, that Your Excellency will give me the authority and approval, in regard to the letters you have sent me, from which I can infer the content of the others, if I use my own judgement whether to send these letters on or keep them in my possession for the greater security of the negotiations. When Your Excellency has received this present letter, you will perhaps give me new orders about what I ought to do. The best and safest thing would be to send me these letters under a separate seal.

I should have liked to keep back the letters which the Abbé wrote to the King and to several other Lords in the dispatch of July 3, but after Barozzi had seen them, it was no longer in my power to hold them.

It is certain that if they do the negotiation no harm, neither can they render it any more favorable than it is now.

DIPLOMA OF KNIGHTHOOD
DELIVERED TO RUBENS BY CHARLES I

(Conclusion of negotiations to the satisfaction of the King of England and the painter. Translated from a French version.)

[Charles, by the grace of God King of Great Britain, of France and Ireland, Defender of the Faith etc. To all those, Kings, Princes, Dukes, Marquises, Counts, Barons, important personages, lords and nobles, who will see the present letters, Greetings. As our nature welcomes nothing more than a desire, and our fortune nothing greater than the power to reward virtue justly, and as we know that we have been so elevated in dignity by Divine Grace, in order that the worthy know they possess, after God, a public remunerator of human merits, we have chosen, from amongst the worthy, Peter Paul Rubens, a resident of the town of Antwerp, secretary of the Serenissimo King of Spain, Philip, and member of his privy council in Flanders, gentleman of the court of the Serenissima Infanta Isabella-Clara-Eugenia, and who is particularly dear to us, not only through his affection and his merits towards us and our subjects, but yet more so because he has proved his recommendation to our court through his distinguished fidelity to the King his master, through his wisdom and through the practical skills which so eminently enhance his nobility of mind and glory of his race; as, in addition, we take into consideration the integrity and intelligence which he has shown in his working towards a peace treaty recently concluded between us and the King his master. We have, in recognition of the good qualities of which he has given proof and our special affection, added to the family nobility of the said Peter Paul Rubens, the dignity of Knight of the Golden Spur, and we have freely conferred on him this order, and so that there remain for his descendants an evident proof of our favour, we have, after mature consideration, with knowledge of the cause and according to the fullness of our royal powers, added to the coat of arms of the said Peter Paul Rubens an addition of arms taken from our own royal coat of arms, namely a canton gules, lion or, such as is more clearly shown in the margin of the present letters; wishing and confirming that the said Peter Paul Rubens and his legitimate male heirs, bear and use in perpetuity the said addition of arms on their coat of arms,

268

never doubting that all these things and each in particular are agreeable to the Serenissimo King of Spain and the Serenissima Archduchess of Austria. Trusting in this we have drawn up these letters patent. Thus made in our palace of Westminsters, the fifteenth day of the month of December, the year one thousand six hundred and thirty after the happy deliverance of the Virgin, of our reign the sixth.

Charles R.]

RUBENS'S LONG LETTER FROM MONS ON 1 AUGUST 1631

(Feeling rather pleased with himself, Rubens wrote to Olivares on how he should behave towards France at the time of Marie de Medicis's flight and the Duke of Orléans's rebellion.)

Your Excellency*
Your Excellency need not be surprised that I am still here, for you know that up to now there has been no reply, on your part, to the objections made by the Most Serene Infanta and by me regarding the nature of my mission. In the meantime, such remarkable opportunities have been offered me here, to employ myself in the service of His Majesty, that I dare leave it to the judgment of the Abbé Scaglia himself, whether it is advisable for me to give them up to go to England, now that Señor Necolalde has just gone there; however, we have not yet received news of the arrival of M. l'Abbé at that Court. In any case, Your Excellency may expect of me nothing but pure and simple obedience in all things, and may believe that I do not remain here or interfere in anything except under precise orders from Her Most Serene Highness and the Marquis d'Aytona.

Great is the news from France. The Queen Mother has come to throw herself in the arms of Her Highness, cast out by the violence of Cardinal Richelieu. He has no regard for the fact that he is her creature, and that she not only raised him from the dirt but placed him in the eminent position from which he now hurls against her the thunderbolts of his ingratitude. If this were only a question of the interests of a private person, I should be in doubt what to do; but considering that the great princes have to base their reasons of state upon their reputation and the good opinion of the world, I do not see how, in this regard, one could desire more than this: that the mother and mother-in-law of so many kings should come, with such confidence, to place her person under the arbitration of His Catholic Majesty, offering herself as hostage for her son, who is likewise a fugitive from the kingdom in which he is in direct succession to his brother.

Surely we have in our time a clear example of how much evil can be done by a favorite who is motivated more by personal ambition than regard

*Taken from *The Letters of P. P. Rubens*, Ruth Saunders-Magurn.

for the public welfare and the service of his King; to the point where a good prince, badly advised, can be induced to violate the obligations of nature toward his mother and his own blood. On the other hand, as everything receives greater lustre from its opposite, the world sees in the person of Your Excellency how great a support and help for a monarchy like ours is a minister endowed with courage and prudence, who aspires to nothing but the true glory and grandeur of the King, his master. And this will be all the more evident, according to how Your Excellency takes advantage of the opportunity which the Lord God has placed in your hands.

If Your Excellency, with accustomed generosity, will permit me to give my opinion, it seems to me that the more averse Your Excellency appears to be to every intercourse or collusion with Cardinal Richelieu, the more will the hatred and infamy which he has brought upon all favorites of princes decline, and the greater will be the increase and confirmation of the well-justified opinion which is universally held of Your Excellency's sincerity and the success of your administration.

I should not believe the reports of the Cardinal's enemies if I had not proved, in my negotiations with England, that by his perfidy he has rendered himself incapable of ever betraying anyone in the future; this seems to me the worst *raison d'état* in the world, since confidence alone is the foundation of all human commerce. This policy of his has caused the flight of the Queen Mother; it has rendered irreconcilable her cause and that of Monsieur. For that reason the Queen has told me with her own lips that she will never come to an agreement with the King, her son, while the Cardinal remains on earth; she knows for a certainty that if ever they trust him, under pretext of any sort of treaty, they will be irrevocably lost.

I have never worked for war, as Your Excellency can confirm, but have always tried, insofar as I have been able, to procure peace everywhere; and if I saw that the Queen Mother or Monsieur were aiming to cause a break between the two crowns, I should withdraw from this affair. But since they assure me that they have no such intention, I do not feel any scruples, for their reasons are very clear. If they should openly avail themselves of the arms of Spain against the Cardinal, who hides behind the person and the mantle of the King of France, they would render themselves so odious to all the French that it would ruin their party. Also this would make it almost impossible for Monsieur to succeed to the crown of France, to which he is as far from aspiring during the lifetime of his brother, as it is certain that he is simply defending himself against the violence of the Cardinal, and taking up arms by necessity. For he finds no guarantee for his own life and that of his mother in any kind of peace they offer.

271

It is probable that his party may be large, being composed of three factions. Since the King of France does not have too strong a constitution, everyone looks toward the rising sun, and wishes to obtain the goodwill of Monsieur. I could furnish Your Excellency with a good account of this, since the Marquis d'Aytona has charged me to make every effort to inform myself explicitly. But this is a subject in which it is necessary to trust what one is told, for one cannot demand written proof of secret agreements, and these are indeed very great with regard to Monsieur alone. The Queen, moreover, during a period of thirty years, has won over and bound by obligation to her an endless number of princes and noblemen who form the sinews of the French kingdom. But above all in their favor will be the universal hatred of the Cardinal, which increases every moment, owing to the extreme severity he shows toward all, imprisoning some and exiling others, confiscating their property without a trial. It only remains for Monsieur to raise his banner and open his campaign, so that his adherents can unmask and gather at the arming place; for as long as the party has not yet been formed, no one dares reveal himself.

I am told the party has made arrangements with those in control of the fortresses. The Duke of Bouillon, for example, will receive Monsieur's troops in Sedan, in order to defend it against the King of France. The Count de la Rochefoucauld, Governor of Poitou, will do the same with all that province, as I have been assured by his own brother, the Marquis d'Estissac, who is here in person. They say also that the Governor of Calais, whose brave brother, the Commander de Valençay, has been for some time in Brussels, has offered to deliver Calais to Monsieur, and that the same is true of the city of Reims and other places in Picardy. They also claim there is an understanding with the Dukes of Guise and Epernon and other nobles of high rank, and even with the very colonels and captains of the regiment of His Majesty's guard, who promise to change sides if it comes to a fight. Part of the nobility has already gone over to Monsieur, such as M. de Lignières, the Count de la Feuillade, the Marquis de la Ferté, M. de Caudray-Montpensier, M. du Roy, brother of the Duke of Bouillon, M. de la Ferté. There is no need of naming the Duke d'Elbeuf, or Bellegarde, or the others who have already declared themselves, or are now with Monsieur, such as the Count de Moret, natural brother of the King, the Duke of Rohan, brother-in-law of the Duke d'Elbeuf, the Marquis de Boissy, his son, and many others who offer to raise their own troops, as is the custom in the civil wars in France. In the first place, the Duke of Bouillon will furnish 4,000 infantry and 1,500 horses; a foreign prince will furnish the same number of infantry and 500 horses; M. de Vateville, a Swiss, 4,000 infantry; an anonymous person, 3,000 infantry and 500 horses.

In addition, a countless number of French nobles offer to recruit troops for Monsieur – in such numbers that he finds it hard to decline them. But all this will go up in smoke in a short time if Monsieur is not promptly furnished with money to pay the recruits. Moreover, as I was told by the Marquis de la Vieuville, who occupies first place in the Queen's retinue, if we allow this enthusiasm peculiar to the French nation to cool without availing ourselves of its first impetus, we shall allow time for the Cardinal's tricks. Meanwhile the enterprise will be frustrated, for its soul is secrecy and prompt execution, and all will come to naught. And as a reward for their goodwill the friends of Monsieur and the Queen will receive the most cruel punishment. They will pay with their blood, their lives, their property, for the failures of others. And if, for lack of our assistance, Monsieur is unable to make a success at the beginning, he will lose the confidence of his followers, and will never be able to recover it.

The sum which he now asks is so small that it does not seem to us likely that it can produce any great effect. It is true that I have explained at great length to the Queen how unfavorable the circumstances are, with our army facing the enemy in the field, so that we cannot, without incurring great inconvenience, divert any of its pay for use elsewhere. The needs of Monsieur, however, are so urgent, and it would be so unreasonable to let slip an opportunity the like of which has not presented itself for one hundred years, that one ought to make a virtue out of necessity, and give one's blood for the reputation and state-interests of His Catholic Majesty. For surely the Catholic League with the Duke of Guise and his brother, for which King Philip II wasted so many millions, cannot be compared in any way with the present occasion.

It has been a great disadvantage for Monsieur that the Duke of Feria did not pay the 200,000 crowns on the date fixed; after much delay the sum was remitted to the Marquis de Mirabel, who then assigned it to the Marquis d'Aytona. He could probably have paid it if the million destined for Germany and France were really available; but since it is only a million on paper, and the bankers are unwilling to make any advance, poor Monsieur remains without funds, and the Queen Mother is cheated, for she told me the Marquis de Mirabel had offered her this sum in Compiègne, through an intermediary.

Your Excellency alone, next to God, can remedy this situation. Your natural generosity loves great enterprises, and you have not only the prudence and the courage, but also the means to carry them out. But it will be necessary to send some assistance promptly, to arrive in time to begin the campaign before provisions fail and the granaries are empty. This is not a thing to be done by halves, because unless Monsieur is

273

supported in such a manner that he can carry out his plan, it means a double ruin for him. And upon this, more or less, depends whether he will be eternally obliged for the success of the enterprise, or whether he will be lost, along with all the advantages that might result. Finally, if he is not able to subsist with our help, he will be forced to throw himself into the arms of the Hollanders; already the Prince of Orange has offered his dominion as a refuge. What a disadvantage and disgrace this would be to His Catholic Majesty I leave to the prudence of Your Excellency to consider.

The Queen and Monsieur have resolved not to make use of the Huguenots in any way, or to restore that party either wholly or partially, or to seek the ruin of anyone in the kingdom of France except the Cardinal, who, in truth, has never done other than devote all his industry and power to undermine, insult and abase the monarchy of Spain. This monarchy, therefore, ought to be willing to pay, even at a cost of millions, for the ruin of so pernicious an enemy, and it will never obtain this at so low a price as by the hands and the blood of the French themselves. Perhaps, after having availed themselves of our aid, they will not recognise it with due gratitude. But one may expect that a great number of French will perish by internal discord, and that that proud nation will be weakened by its own hands. And so whichever party triumphs or loses, we shall have one less enemy.

It is not to be feared that the Hollanders will undertake anything this year. We have a powerful army mobilised, and could, it seems, reorganise some regiments, in order to let them pass over to Monsieur. This has been practised at all times, and particularly during the truce, without dismembering the companies, but only changing the orders. Thus we should not run the least risk of a rupture. This sort of help, even if one were to grant passage to some of Monsieur's troops for the Calais or Sedan enterprise, would not equal the smallest part of the assistance given to the Hollanders by the King of France. He permits them to beat their drums even in the middle of Paris, and not only provides but expedites and signs with his own hand the commissions of rank and office for the regiments which he maintains at his expense in their service, commanded by marshals, dukes, and peers of France. Surely it would seem, to me, the greatest indignity and sign of weakness to allow such a thing without daring to do the same, for a cause as pious and honorable as the assistance of the mother-in-law and the brother-in-law of His Catholic Majesty. For my part, I am glad to be able to congratulate Your Excellency that there has fallen into your hands, as from heaven, an opportunity so suited to lend lustre and glory to your administration. I hope that Your Excellency will be willing and

able to carry it out in a manner that will bring eternal glory to the King, our Lord, and to Your Excellency immortal fame and great honor among all those who are well disposed toward this monarchy.

The sum which is asked to mount Monsieur on horseback is 300,000 gold crowns (at twelve reals to the crown), and this includes the 200,000 from the Marquis de Mirabel. It would hardly provide for two months in Flanders, and with this he will make his expedition. If the enterprise succeeds, it will gain nourishment from the vitals of the kingdom of France itself. But if perhaps Monsieur does not have the following he anticipates, we, on our part, shall have given him satisfaction, and for this small sum. And even if it should be necessary to continue this subsidy, I believe the royal finances could be employed in no better way, for our security, than in supporting a civil war in that kingdom; then at least it could not in the meantime give assistance to our enemies in Flanders and Germany.

The Marquis de la Vieuville has told me that the Duke of Friedland has offered his services to the Queen. He believes that the Duke will come in person, with other princes of Germany, if His Catholic Majesty permits them to make levies in his states for the service of Monsieur. And this seems to me to be a thing of no small importance.

M. Gerbier is making great offers to Monsieur on the part of his King. The Abbé Scaglia will therefore arrive in London at a favorable time. He has certainly given his good friend the Marquis de Santa Cruz very poor information on this matter. But I believe that if they were together for one hour (as far as I understand the temperament of the two), he would easily bring the Marquis to his opinion. If, therefore, Your Excellency takes the present affair to heart, as I hope and as your honor requires, it will be necessary to provide at once for the urgent needs of which I have spoken, and to allow the Most Serene Infanta and the Marquis d'Aytona to act according to the circumstances which present themselves from hour to hour. On the other side, the Marquis de Santa Cruz will serve as a shield against the Hollanders, who, in my opinion, will undertake very little. The Prince of Orange also secretly favors Monsieur's party, since he is annoyed by the Cardinal's betrayal of the fortress of Orange. It would be desirable, if the affair succeeds, that there should finally be a good general peace, at the expense of the Cardinal who keeps the world in a turmoil – a peace with the intervention of France and England, and not only in Flanders, but also in Germany and throughout all Christendom. I hope that the Lord God has reserved his task for Your Excellency, who, for piety and holy devotion to the service of His Divine Majesty and of our King, deserves this greater glory of being the sole instrument of such a great good work.

I cannot refrain from telling Your Excellency that the Marquis de la

Vieuville, exiled as he is, and with the greater part of his property confiscated, is contributing 50,000 pistoles for the support of the common cause. When I conferred with him on the matter, by order of the Queen and the Marquis d'Aytona, and with the intervention of M. Monsigot, the first Secretary of State of Monsieur, he told me that if he had his customary funds, he would have no hesitation in aiding a friend with such a sum as Monsieur requires. This seems to me a very generous offer, which ought to encourage the greatest monarch in the world to do even more, for his own brother-in-law and mother-in-law, in order not to be surpassed in magnanimity by a private individual. And therefore I beg Your Excellency to redeem the generous Spanish nation from that opprobrium in which it is wrongly held, by a deep-rooted general opinion that it can never decide to seize opportunities promptly when they present themselves, but, after endless deliberation, usually sends *post bellum auxilium*. But this does not correspond to the decisiveness which is the peculiar virtue of Your Excellency.

I do not think that the Marquis de Mirabel will urge Your Excellency to do much for Monsieur (for what jealous reason I do not know). To tell the truth, these French Lords dare not communicate to him their secret enterprises, in spite of his efforts to know them; it is not because they distrust him personally, but because of the lack of discretion of one of his secretaries. I do not know who it is, and do not wish to accuse anyone; I only report what has been told to me on good authority. It is true that the Marquis de Mirabel has ordered that Monsieur be paid 50,000 crowns. But this is so little that it will vanish without any result. In my opinion, assistance ought to be given in proportion to the need, or else not at all, lest one lose both the friend and the money at the same time. In this matter I expect great decisions from the generosity of Your Excellency, although it has been hard for me to convince these Lords, who have not observed the heroic nature of Your Excellency as closely as I have.

And so I commend myself most humbly to the favor of Your Excellency, and with the sincerest heart I kiss your feet.

Mons in Hainault, August 1 1631 Peter Paul Rubens

The Queen told me, in expressing thanks to Her Highness for the gifts she had sent her (which were indeed very nice and most pleasing to Her Majesty), that the greatest and dearest gift would be prompt aid to her son, and on this all her happiness depends. She said that, for the rest, there need be little concern for her person, but asked that all favor and grace serve this particular cause, according to the need. She is willing to send someone

to Spain for the express purpose of throwing himself at the feet of His Majesty, although the need is so pressing that, if one must await a response before receiving aid, it will be too late. For the King of France is already mobilising many troops to crush Monsieur, who is still unprepared.

Index